PERFORMING THE VISUAL

PERFORMING THE VISUAL

The Practice of Buddhist Wall Painting in China and Central Asia, 618–960

SARAH E. FRASER

STANFORD UNIVERSITY PRESS

STANFORD, CALIFORNIA 2004

Stanford University Press
Stanford, California

MM

Publication of this book has been aided by a grant from the Millard Meiss Publication
Fund of the College Art Association.

The Northwestern University Research Grants Committee has provided partial support
for the publication of this book. We gratefully acknowledge this assistance.

Printed in the United States of America
on acid-free, archival-quality paper.

Library of Congress Cataloging-in-Publication Data

Fraser, Sarah Elizabeth.
 Performing the visual : the practice of Buddhist wall painting in China and
Central Asia, 618–960 / Sarah E. Fraser.
 p. cm.
 Includes bibliographical references and index.
 ISBN 0-8047-4533-1 (alk. paper)
 1. Mural painting and decoration, Chinese—China—Dunhuang Caves—Tang-
Five dynasties, 618–960. 2. Mural painting and decoration, Buddhist—China—
Dunhuang Caves. 3. Mural painting and decoration—China—Dunhuang Caves—
Technique. 4. Artists' preparatory studies—China—Dunhuang Caves I. Title.
 ND2849.D86 F73 2003
 755'.943'095145—dc21 2003010278

Original Printing 2004

Last figure below indicates year of this printing:
13 12 11 10 09 08 07 06 05 04

Designed by Janet Wood
Typeset by Integrated Composition Systems in 11/14 Adobe Garamond

This book is dedicated in loving memory of my grandmother,

Blanche Elizabeth Morse (1904–1975)

Contents

Appendix 4: Sets of Near-Identical Banners. 251

List of Illustrations

Preface

This book emerges from a decade-long study of materials from Dunhuang, China's most comprehensive and extensive Buddhist site, encompassing both wall paintings and manuscripts dating from the fifth to the eleventh centuries. Buddhist cave shrines were built near Dunhuang and other northwestern garrison towns established by the governments of the Han (206 B.C.E.–220 C.E.), Northern Liang (421–39 C.E.), Northern Wei (439–534 C.E.), Western Wei (535–56 C.E.), Northern Zhou (557–81 C.E.), Sui (581–681 C.E.), and Tang (618–907 C.E.) dynasties. The dry climate of Dunhuang and an extraordinary hidden library of 42,000 scrolls, artists' sketches, and paintings discovered there in 1900 account for the wealth of medieval material no longer available in other parts of China. A busy scholarly tradition has ensued since this discovery. Because the library's contents were scattered to European, Japanese, and Indian collections, the study of these materials has remarkably international dimensions. In the 1920s Chinese scholars focused on the relationship of Dunhuang's vernacular literature to long-held views about traditional classical Chinese literature. Identification of the subject matter in the murals located in the 492 decorated cave temples has occupied scholars at the site itself. More recently, Chinese historians have investigated the historical dimensions of the Silk Road and Dunhuang's role in a regional Central Asian culture with the Sogdians, Khotanese, and Uighurs. Japanese scholars, concerned with the origins of their own traditions, have excelled in iconographic analysis as well as detailed studies of Buddhist philosophy, the monastic tradition, and land tenure and contracts. French sinologists have been the most precise in their identification and discussion of individual manuscripts and paintings. They have explored all aspects of medieval cultural traditions, Buddhist practice, and the complex pantheons in ritual texts and paintings. British scholars have compiled catalogs of their Dunhuang holdings and identified the range of manuscripts once held by many monasteries. Sinologists in the United States, where Dunhuang studies are less pervasive, have explored aspects of popular religious festivals and have undertaken complete analyses of individual caves. My contribution to this vast literature is a comprehensive theoreti-

cal and historical interpretation of the Buddhist art was made and deployed at this site, a subject with implications for art in temples and towns across the Chinese empire. I closely track the status of the artist's sketch in considering these broader themes and offer a new, distinct way of discussing the painter's preparatory materials and cognitive process.

This book is divided into two sections. The first addresses the history of the mural workshop and how art was produced there: the organization of labor, methods of compensation, modes of cognition, forms of expression, and indices to medieval artistic concepts. The second concentrates on more abstract problems associated with performance, art, and oral culture. The ephemeral realm of freehand drawing and the role of the sketch link these two parts. Throughout, the book addresses bodily practices of oral culture evident in both extant preparatory sketches and in discursive traditions in ninth-century art histories. The painting of the late ninth and tenth centuries—falling at the end of the long Tang dynasty and continuing through the ensuing Five Dynasties (907–60), when China and Central Asia were divided into regional kingdoms—has often slipped unnoticed between the two cultural highpoints of the Tang and Northern Song (960–1127) dynasties. This book is the first comprehensive analysis of the art of this transitional period, which despite a lack of scholarly attention actually has a wealth of extant texts, paintings, and sketches. Yet the reader will not find a detailed iconographic analysis of painting or perhaps even a useful guide to works dating to this period. Instead, broader interpretive problems about visual and oral culture are addressed to resolve fundamental questions about the medieval professional painter.

This study was made possible through the extraordinary kindness and generosity of the curators of Dunhuang materials. Five played critical roles in allowing me to study at their institutions: Fan Jinshi, Director of the Dunhuang Research Academy; Monique Cohen, Director, Oriental Manuscripts, Bibliothèque nationale de France; Frances Wood, Curator, China and India Office, British Library; Jacques Giès, Chief Curator, Musée national des arts asiatiques-Guimet; and Anne Farrer, former Assistant Keeper, Oriental Antiquities at the British Museum. All institutions made extraordinary efforts to provide photographic material; this book would not have been possible without the backing and commitment of their academic and technical staff. Countless other curators of sites and collections in China, Japan, the United States, and Europe provided much-needed access.

At the doctoral stage at the University of California, Berkeley, I was fortunate to have as mentors the two leading art historians in my field. From them I learned the art of research. James Cahill demonstrated the value of thinking broadly and asking comprehensive questions. His strong interest in the atel-

ier and the physical qualities of paintings has influenced me enormously; his knowledge of Chinese painting collections opened doors around the globe. Joanna Williams, Professor of Indian Art, taught me the importance of field-work and of relying on my interests and instincts. Further, I was fortunate to take two seminars with her on narrative and folk art theory that shaped my thinking in fundamental ways. Several other scholars were instrumental in my formative work. Study with Michael Baxandall gave me tools to address problems of wall painting and the economics of art. Michel Strickmann introduced me to a catalog of the Dunhuang artist's sketches in the Bibliothèque nationale and heightened my interest in Buddhism. Su Bai, Professor Emeritus, Archaeology Department, Peking University, and Ma Shichang, also of the Archaeology Department at Peking University, shared their knowledge of Buddhist sites and readily lent their good offices to facilitate access to Chinese sites. At the Palace Museum, Beijing, I received guidance in my research into the history of Chinese sketches from curator Shan Guoqiang and training in calligraphy from Dong Zhenghe. Akio Donohashi and his graduate students in residence at Kobe University during my year of doctoral research there in 1990–91 shared the broad literature in Japanese on monochrome and Buddhist painting. Terukazu Akiyama, the preeminent specialist in the French collections of Dunhuang paintings, guided me during this early stage as well.

I owe thanks to the scholars who carefully read my work and gave me venues to share versions of the manuscript. Jean-Pierre Drège, President of the École française d'Extrême-Orient, Paris, invited me to lecture frequently and also arranged for my appointment as Directrice d'Études at the École Pratique des Hautes Études, where I delivered the bulk of the book's themes in a series of workshops in May–June 2000. Richard Vinograd, Professor and former Chair, Art Department, Stanford University, gave me the opportunity to teach seminars on Dunhuang, which were critical in helping to consolidate my ideas. Benjamin Elman, Professor of Chinese History, UCLA, invited me to join a group at the Institute for Advanced Study in his capacity as Distinguished Visiting Mellon Professor in the fall of 1999 where I received critical feedback on drafts. Wu Hung, Professor of Chinese Art History, University of Chicago, arranged for my frequent lectures and workshops and with his graduate students focused on key issues in the manuscript. Brook Ziporyn, in Northwestern University's Religious Studies and Philosophy departments, guided me through readings in relevant Daoist literature. Lothar Ledderose, Professor, University of Heidelberg, provided early support in working out the complex problems associated with this study.

Patricia Berger, University of California, Berkeley, Stanley Abe, Duke University, and an anonymous reader offered close readings of the text. I am grateful to them and to my editor at Stanford University Press, Muriel Bell, for their

detailed comments. Richard Gunde improved considerably the accuracy and precision of the text. Tim Roberts, Production Editor at Stanford University Press, provided logistical and editorial leadership in the book's final stages. Karin Myhre, Felicity Lufkin, Christina Kiaer, Charlotte Eyerman, Dorothy Brown, Kirtana Thangavelu, Krystyna von Henneberg, and Mei Lin unstintingly gave regular feedback in the early (dissertation) writing stage of the manuscript. Melissa Macauley, Hollis Clayson, Whitney Davis, and Sandra Hindman, all colleagues at Northwestern University, gave the right kind of advice when necessary. My mother, Barbara Morse Hamilton, provided unwavering support and assistance for many crucial years. From 1999 to 2001 Harlan Wallach willingly gave months of his time each year to secure pictures at Dunhuang tailored to meet the needs of this project. He also created much of the book's photographic winning design. Wenshing Chou, Limin Teh, Matt Taylor, Nell Crawford, and Cecile-Ann Sison supplied crucial technical and bibliographic support. Heather White, Ebenezer Akinremi, and Alfred Equitz offered years of personal support. Early on at the University of Michigan, Professors Kenneth DeWoskin and Virginia Kane taught me advanced Chinese literature, research tools, and archaeology, and inspired my later work. Tang Naiyun, retired from Princeton University, shared her gift for classical Chinese with me in 1981 at Middlebury.

Any problems that remain in this study are, of course, my own.

The Andrew W. Mellon Foundation under the leadership of William G. Bowen, President, provided crucial funds and photographic materials. The foundation's interest in Dunhuang has improved the quality of this work immensely. The Luce Foundation made it possible to establish a cooperative project with Dunhuang and Chinese universities, which gave me regular access to sites and resources in China. Rong Xinjiang, Professor of History, Peking University, was always helpful, unstintingly sharing his vast knowledge of Dunhuang history. He proved a steady intellectual partner for research projects in China. Other granting agencies that gave me crucial funding were the American Council of Learned Societies, the Committee on Scholarly Communication with China (formerly administered by USIA), the American Oriental Society, Northwestern University's Office of Research and Scholarly Projects (ORSP), and the University of California. The Lurie Foundation and Mrs. Sally Hambrecht provided crucial resources for photographic reproductions. President Henry and Mrs. Leigh Bienen of Northwestern University supported this project since my arrival there in 1996; their deep interest in Buddhist art and the transmission of cultures along the Silk Road generated significant fascination in my book project within the Northwestern community. It is their generous support and interest that supplied the necessary fuel to see this manuscript to completion.

PERFORMING THE VISUAL

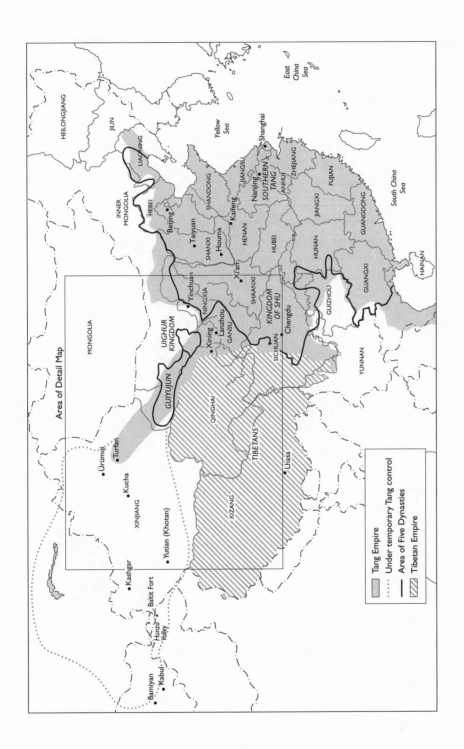

East
China
Sea

HEILONGJIANG

JILIN

Yellow
Sea

INNER
MONGOLIA

LIAONING

Shanghai

HEBEI

SHANDONG

JIANGSU

Beijing

Taiyuan

SHANXI

Houma

Kaifeng

HENAN

SOUTHERN
TANG

Nanjing

ANHUI

ZHEJIANG

Xi'an

HUBEI

FUJIAN

South China
Sea

MONGOLIA

Yinchuan

NINGXIA

SHAANXI

Xining

Lanzhou

GANSU

KINGDOM
OF SHU

Chengdu

HUNAN

JIANGXI

GUANGDONG

GUANGXI

HAINAN

Area of Detail Map

UIGHUR
KINGDOM

GUIYUJUN

Turfan

SICHUAN

GUIZHOU

YUNNAN

Ürümqi

QINGHAI

TIBETANS

Lhasa

Kucha

XINJIANG

Yutian (Khotan)

XIZANG

Kashgar

Balit Fort

Hunza
Valley

Bamiyan

Kabul

Tang Empire

Under temporary Tang control

Area of Five Dynasties

Tibetan Empire

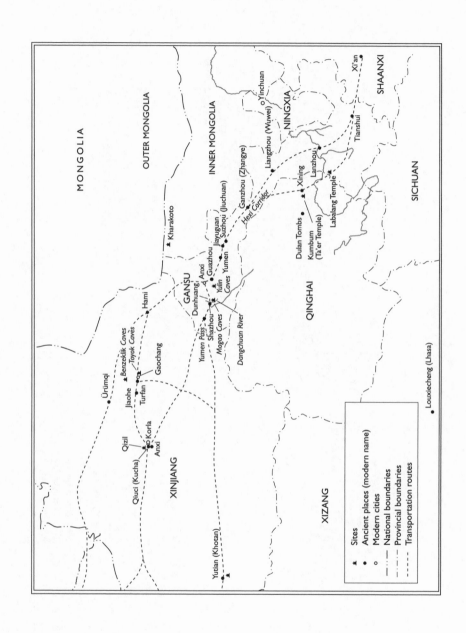

INTRODUCTION

The Sketch: Historical, Thematic, and Stylistic Issues

This book takes as its subject the status of the pictorial sketch in Tang dynasty China. At the center of our inquiry into the medieval artist's practice is a rare, virtually unpublished collection of preparatory drawings or sketches from China's largest Buddhist site, Dunhuang. This cave-temple site is located in the multiethnic region of western China in Gansu Province that borders present-day Qinghai Province (traditionally a part of Tibet) to its south and Xinjiang Uygur Autonomous Region (the center of Uighur culture) to its west. The sketches are part of a hidden cache of manuscripts documenting the diverse population of Central Asia's Silk Road kingdoms. A primary concern of this study is the relationship between the artist's drafts and the finished works located in the oasis cave temples. Discussion of artistic production and the physical sketch also allows us to address fundamental questions about cognition and the nature of creativity posed by both practitioners and theorists in ninth-century China. Of fundamental concern to ninth-century critics was what constitutes art: does it rest in the process of making a work or in its completed, final form? In evaluating works of art, the authors of Tang art histories placed the highest value on spontaneity during the preliminary stages of painting. The physical sketch itself received little or no attention in art-historical writing by collectors during the Tang and subsequent dynasties. Instead, a great deal of attention was paid to the *process* or *act of drawing*; the connoisseur's interest was with a work's inception. Never collected or prized as evidence of the process of creation, sketches themselves attracted little attention in critical and biographical responses. But the act of sketching did. In celebrating spontaneous feats with brush and ink, claims for unmediated expres-

sion relied on the notion that sketching, inflected with ideals associated with Daoism and Chan (Zen) Buddhism, was the moment that a composition was closest to nature through the mediating force of the artist. Elevating sketching to an aesthetic object independent of actual sketches or artistic practice, ninth-century critics invoked myth and magic, legend, and proto-scientific explanations to describe painting practice. The last portion of this book is concerned with what was at stake for critics who described practice so at odds with workshop evidence.

In order to address these larger issues, this study at the outset first defines the identity of the workshop painter and, second, describes the range of artistic activities associated with the sketch. The preparatory process shifted according to format and surface. The sketches reveal the artist's cognitive process during production, particularly in the spatially complex environment of monastic murals. The wall painter was one of many specialists in a nexus that included other artistic laborers and practitioners such as scribes, sculptors, cartouche inscribers, and storytellers, all of whom were organized into guilds or workshops. In this study, the "sketch" and "sketching" both point to an object and a process in the preliminary or preparatory stage of the artist's practice. Both the process and the physical document are germane to our discussion. As we shall see, many of the practices performed by the artist are coexistent but not intersecting with the biographical and critical discussions of the painter in contemporary texts. My interpretation explores the tensions between the perspective on the atelier offered by literate medieval observers and that presented in the artists' preparatory sketches. Without trying to resolve the two, together these differing sources provide an animated view of this transitional moment in Chinese painting.

Physical evidence left by medieval painters indicates that artists active in Buddhist temples during the Tang and Five Dynasties (618–960) depended on sketches in two important stages of the painting process: one on paper, the other on the wall. Beneath the polished, meticulous overdrawing that showcased the colorful articulation of form populating Buddhist wall painting, artists executed underdrawing in a free, loose hand by applying pale black ink on a dry surface. It was with this preliminary underdrawing that artists established the general contours of the composition; while approximate, these lines secured the proportion and the precision critical to compositions in Buddhist temples. I will explore this underdrawing stage in Chapter 2. Paintings covered vast surfaces and were positioned in dialogue with each other across interiors. The artist worked actively rendering images in these spaces.

At the Mogao cliff facade near the modern town of Dunhuang, grotto temples were hewn by artists and laborers out of a mountain scarp on the edge of the Lop Nor and Gobi deserts. The Sanwei mountain range separates Mogao from a sister cave site, Yulin, to the east. The paintings embellish hollowed

spaces in this desert mountain scarp, their architecture formed from the living rock. The Dunhuang wall paintings are an important record of medieval Chinese painting, both Buddhist and secular. The cliff facade, stretching one mile north to south just to the west of the Dangchuan River, contains 492 cave temples decorated with Buddhist iconographic programs and portraits of their donors constructed between ca. 366 and 1250. Today, the earliest extant mural dates to the first half of the fifth century. The largest of these later, more elaborate cave temples penetrates as much as 75 feet (23 meters) into the mountain scarp, which is composed of a precarious mixture of loose stones and sandy soil. The cave temples contain four colossal Buddha images that extend as high as 122 feet (32 meters). Three, and in some places four, tiers of cave temples populate the relatively flat facade, which made it the ideal place in which to construct temples for local elites. Hewn from the northern section of this mountain scarp are another 200 grottoes once used as monastic living quarters. Crude beds, stoves, and storage ledges are evidence of the simple life led by those in residence. Once, freestanding temples almost certainly occupied the area at the base of the facade; three late Qing dynasty (ca. early nineteenth century) temples still stand.[1]

The mural painter's practice was improvisational in both freestanding buildings and cave temples. The activities and decisions of the wall painter in these spaces are the central concern of this study. To accompany or precede the preparatory work directly on the walls, another stage of preliminary sketching occurred. Sketches of key figures and schematic diagrams of mural compositions were made on paper, analogous to practices of Renaissance Italian muralists. Yet in China, artists' preparatory materials were not collected systematically by later connoisseurs, and few survived the premodern period. Our ability to characterize how medieval workshops functioned at all is owed to a rare collection of medieval ink-monochrome studies for Buddhist wall painting discovered at the site in 1900. The sketches were among the 42,000 manuscripts, finished silk paintings, and other sacred objects deposited in a sūtra cave at Mogaoku (that is, the Mogao caves). Dunhuang is arguably the best-preserved Buddhist temple complex remaining in Asia; in breadth and range of objects it rivals the Potala Palace in Tibet. Approximately 45,000 square meters of extant wall painting document the development of Buddhist painting from ca. 480 to 1250. The contents of the hidden library, which include the artists' sketches, also date to the medieval period, with the bulk datable to the ninth and tenth centuries.

The Sūtra Cave

Sixty-five artists' preparatory works remain, representing great variety in artistic production, including ritual diagrams of altars and texts; reference draw-

ings for commonly produced murals; pounces used to produce identical figures on grotto ceilings; close studies of key figures in murals along the main walls of cave temples; practice drawings executed in a random style; and precise, unmodulated drawings for tracing figures on silk. Most commonly, these appear on the backs of damaged or discarded scrolls of sūtras (sacred Buddhist canonical texts). They are also found on single sheets of paper or long rolls or uneven rectangles and squares of joined sheets. The range of quality and type indicates that this collection once formed the working papers of long-standing ateliers active in the region and may have belonged to the government-supported painting academy or bureau. This institution was launched by the regional kings of Dunhuang sometime between 921 and 947 under the rule of Cao Yijin (r. 914–35) and his son, Cao Yuanzhong (r. 944/945–74), who, as military commissioners (*jiedushi*), governed the prefectures of Gua and Sha (Guazhou, lit. Melon Prefecture; and Shazhou, lit. Desert Prefecture), where the Dunhuang and Yulin caves stand. The Cao family established an independent kingdom after the collapse of the Tang dynasty and imperial authority in 907. All evidence indicates that these two rulers were responsible for founding and supporting the painting bureau that played a part in systematizing iconography and compositions and embellishing the cave-shrine programs and restoration works sponsored by the Cao kings.

The sketches were among thousands of manuscripts on paper and hundreds of paintings on silk included in the sūtra cave. A stele inside relates that the space was originally created as a memorial chapel for the Abbot Hongbian in 862. His portrait sculpture occupies the chapel now; but, at some point in the past, it was moved to the cave above to make room for the overflowing library (Plate 1). Hongbian assumed the position of the chief of monks or "general controller of the clergy" (*dusengtong*) when Zhang Yichao, a member of the local elite, overthrew Tibetan control in 848.[2] The stele, which records Hong Bian's investiture in 851, was moved to his memorial chapel upon his death. The imperial court awarded Hongbian with gifts of silk, sūtra wrappers, and a purple robe, the latter indicating that he had attained the highest honor for a Buddhist in the Tang realm.[3] Sometime after the chapel was appropriated as a monastic library, it was sealed and hidden behind a false wall and covered with murals datable to the early eleventh century. There the contents remained unnoticed until June 22, 1900, when the local caretaker, Wang Yuanlu, and his assistant discovered a break in a wall in the corridor leading into the main assembly cave temple (now labeled cave 16). The bulk of the manuscripts was removed in 1906–7 when the Hungarian Aurel Stein and the French explorer Paul Pelliot selected thousands of manuscripts and shipped them to Europe.

Dunhuang arts are exceptional for two reasons in regard to this study. First,

a great deal of Tang dynasty wall painting remains at this site, documenting pictorial arts largely damaged in the central plains and less remote parts of diasporic China.[4] The dismantling of Tang architecture and destruction of the capital of Chang'an in 881, when it was occupied by the warlord Huang Chao, is lamented in a famous poem by Wei Zhuang.[5] Persecutions of Buddhism, such as the xenophobic attack on Buddhist practice and its related material culture from 842 to 845 during the reign of Emperor Wuzong, meant the loss of many other wall paintings in the capital.[6] Zhang Yanyuan notes this temple destruction in his final chapter of the *Lidai minghua ji* (Record of Famous Painters Throughout the Ages), written ca. 845–47. Zhang nostalgically surveys the wall paintings lost during the Buddhist persecution, a clear indication that a significant number of murals in flagship capital temples was no longer extant. And a millennium later, no trace of temple wall painting in Chang'an remains, leaving Dunhuang painting, with its idiosyncratic qualities and regional features, the best index of three centuries of mural history when the mural was still the primary form of painting.[7] Second, the contents of this hidden medieval library, a preserved cache of otherwise neglected artist's materials, may be linked to the large repository of extant wall painting remaining in situ. Combined, the drafts and finished murals make the Dunhuang remains the only complete artistic environment of premodern China to have survived intact. Their discovery continues to challenge and change Chinese, European, and American perceptions of Tang art since the first publications on Dunhuang arts appeared in the 1920s.[8]

It is now believed that the contents of one major monastic library, Sanjie si, formed the bulk of the Mogaoku collection.[9] The manuscripts and paintings were sealed behind the cave-shrine wall sometime between 1002 and 1006, most likely propelled by the changing conditions of Silk Road communities such as Khotan and Dunhuang.[10] Some event prompted temple librarians to hide their extensive collections of sūtras along with a wide range of administrative documents written in Chinese, Tibetan, Sanskrit, Tocharian, Sogdian, Khotanese, Uighur, and other languages of the Silk Road. The latest securely dated manuscript is 1002, providing a *terminus ante quem* for dating.[11] During the early eleventh century, Karakhanid Muslims from Kashgar attacked Khotan, an important Buddhist center to the west of Dunhuang on the southern transportation loop around the Taklamakan desert. As noted in a 970 plea from the Khotan king to his uncle Cao Yuanzhong for help, these events may have been enough reason to board temple libraries, as the Islamic Karakhanid armies long threatened Khotan.[12] These Buddhist relatives of the Dunhuang leaders may have precipitated the library's closure when they carried news of the destruction upon fleeing the region. Khotanese paintings datable to the late tenth century and other sacred objects from that region are found in the

Dunhuang library, indicating that they may have brought these materials directly to Dunhuang when they fled.

The exact circumstances of the cell's sealing are still not known, leaving us to speculate upon other possibilities for the closure. Throughout the history of Buddhism, notions associated with *mofa*, or the end of the Buddhist law, have induced the burial of hundreds of objects with the belief that, in Buddhist time, the world was destined for destruction. In recent years, hidden medieval libraries in Tibet and Nepal, and whole caches of exquisite Northern Zhou dynasty (556–81) sculpture in Shandong, have been uncovered.[13] In the twentieth century, the Dunhuang caretaker, Wang Yuanlu, was prompted to bury hundreds of simple, local sculpture in front of the cave site as an act of devotion when replacing older sculptures with newer ones. Undoubtedly, spiritual piety was the motivation for the sealing of the sūtra cave.

Nowhere else in China does such a complete group of sketches survive. The Dunhuang preparatory materials are the only significant collection of artists' drafts to predate the eighteenth century, providing a body of original works to assess both the practice and the theories of art. On a practical level, they demonstrate the way in which over a period of one hundred years from the late ninth to the late tenth centuries medieval Chinese artists organized projects according to well-established, professionally driven production techniques. Complementing these rare drafts and the thousands of completed murals, administrative documents also from the sūtra cave provide explanations of the economic structure that gave support to the extensive painting and scribal workshops that produced this great mass of text and image. The economic infrastructure and the institutional framework surrounding the practice of art, and more specifically the collaborative, time-demanding work done by painting ateliers, has been little documented in the Chinese tradition. Performances of art and religious devotion by patrons, artists, and monks may be assessed with the aid of this extremely detailed documentation. The truly remarkable collection of materials from all facets of the artist's practice means that we may also assess contemporary responses to wall painting during the Tang.

Monochrome Drawing

In this study, the sketch denotes the preliminary stage of painting either on paper or as underdrawing on the surface of a soon-to-be finished work. This practice of sketching and underdrawing (*baihua*) is distinct from the later tradition of monochrome ink in a fine-line drawing style called *baimiao*. After the tenth century, works executed in fine-line, unmodulated baimiao were considered to be finished paintings, indicating that by the eleventh and

twelfth centuries, monochrome ink drawing had become accepted as a style in its own right.[14] What was preparatory drawing in the Tang had become a finished visual statement in the Song dynasty (960–1279). By and large, in the Tang and Five Dynasties, monochrome drawing was used exclusively in the initial stages of painting and hidden beneath layers of opaque color and dense overdrawing.

The value of the Dunhuang ink sketches is that they preceded this revolutionary change in painting style in the eleventh century, when monochrome drawing became a style in its own right. There had been some admiration in the Tang for paintings executed in a strong linear style with faint touches of light color, and the occasional example was unusual enough to warrant comment.[15] The style of drawing in these Dunhuang sketches could be called proto-baihua, a nascent monochrome painting, belonging to the stage in Chinese art history before painters and patrons widely recognized monochrome style as finished work.[16] Drawing is a general term applied in this study to the whole range of monochrome brushwork including sketching, but typically referring to more polished execution of the brush.

Manuals and Drafts

Without the polished details of finished paintings, the sketches expose "insider" features of artistic production. These notations of praxis—encompassing gesture, context, and cognitive activity—reveal habits of mind, providing a glimpse into the subjective experience of seeing and creating. Art practice is best understood as a range of activities. The great value of the Dunhuang sketches, in their randomness and haphazard states of completion, is that they provide clues about how these activities were accomplished. With an interest in behavior, cognitive anthropologists investigate how people think in the process of doing. This mode of inquiry focuses on cognitive behavior. Methodologically, I have been interested in the kinds of questions that will produce a full picture of the range of activities and movements associated with wall painting production. In the case of medieval Dunhuang, to investigate the implications of action and response, we may turn to the unfinished works where these traces of gesture, performance, and cognition are imbedded. Uncompleted objects may suggest more about artistic process than finished pieces; decisions are lain bare and vulnerabilities are apparent.

Analyzing documents in relation to the three-dimensional spaces with which they originally were connected allows us to determine how those objects were used in context. For instance, Dell Upton, in his investigations of architecture of the southern United States, analyzes the probate wills of home owners to determine the social function and status of interior spaces

that, because of slavery, functioned differently than spaces in American residences today.[17] In our analysis here, three elements are interrelated: verbal documents, architectural context, and artistic works or material culture. By bringing these three together a great deal of activity and cognitive behavior may be reinstated into an artistic or social space. This approach may be fruitfully applied to the Dunhuang case, for which we have thousands of verbal and pictorial drafts, finished works, and administrative documents. Ethnoarchaeology, which uses the present to reconstruct the past, is useful to investigate modern Buddhist art workshops, involving as it does observing and collecting data on artistic behavior that has long since vanished. For this, I have relied on painting workshops in Qinghai Province, adjacent to Gansu Province, where Dunhuang is located. Artists there worked with the same level of technology as did painters in medieval Dunhuang. Behavioral context might be the most difficult feature of artistic practice to locate and define because materials that identify themselves as how-to manuals are the least likely to provide primary information on practice.

In *The Practice of Everyday Life*, Michel de Certeau advocates an investigative procedure that interrogates the unpolished and unprepared. For example, a recipe book is a cooking guide made with an audience in mind, but it does not really tell one how to cook. That is, vocabulary to describe desired activities such as "whip" and "chop" already assumes a certain amount of knowledge. These kinds of texts provide a retrospective view on the process composed only after a meal has been prepared. They are backward looking and are a schematic version of the production process. Similarly, painting manuals such as Han Zhuo's *Shanshui chunquan ji* (Chunquan's Compilation on Landscape; d. 1121) and *Zhaoxiang liangdu jingjie* (A Commentary on the Sūtra of Measurements in the Making of Icons; ca. 1742–43), which provides details on icon measuring, indicate well-established conventions for painting and sculpture.[18] The manuals do not tell how to actually make icons or landscape paintings; rather, they are comprised of a list of activities an artist would have considered in the production process. Yet they are not guides to actually executing those steps. Instead, Han Zhuo, for example, gives clues to conventions and artistic tropes of production and discussion, such as brushwork labeled with fanciful terms including "orchid-leaf line" and "beard-wispy mountains." The Sūtra of Measurements in the Making of Icons provides ratios of proportion. Zhang Yanyuan's *Record of Famous Painters Throughout the Ages* would be a third example; it presents an ideal of practice. Therefore, a painting manual is similar to a cookbook in that it is a post-production document. The type of casual draft sketches remaining from Dunhuang are of a completely different order. To continue the cooking analogy, the draft sketches are similar to the notes a cook scribbles on a scrap of paper or as marginalia in a cook-

book. In both cases, these notes provide references closer to the work process in which artisans engaged.

New Directions in the Ninth Century

Most of the Dunhuang documents are drafts and preliminary studies dating to a period of independence, ca. 890–980, when the region broke off from the rest of China and formed close cultural connections with its neighbors to the south and west: the Uighur kingdom based in Turfan, the Khotanese kingdom to its west, and the state of Shu in present-day Sichuan Province. During this period, Dunhuang artists made the most discernible changes in their art. Most significant was the emergence of a standardized stylistic and programmatic repertoire. Painters developed efficient production regimes, settled on iconographic schemes, and introduced a range of techniques to solve problems encountered while embellishing enormous cave temples and intricate silk banners. This standardization was due, in part, to increased patronage by lay devotees.

In the preceding centuries, the most influential source of patronage of the arts had been the imperial court, but this declined when the Chinese Tang dynasty fell in 907. For the next half century, cultural development gravitated to a number of regional poles where the arts industries developed rapidly, responding to new consumption demands. One of those centers was the Dunhuang court, commanded by a military government that maintained strategic alliances with other kingdoms throughout western China and Central Asia. The increased local demand for paintings and sculpture quickly professionalized the artist's practice—a key development that constitutes one of the primary topics of this study. The history of workshops and ateliers in China has yet to be written; this book is the first in-depth study of a group of painting ateliers productive in the same region over a century. Since guild history is an underexplored area of the field, this book will also have implications for the larger history of labor.

The sketches from Dunhuang are from a period that could be called "post–Wu Daozi." Wu (active 710–60) was an artist in the capital of Chang'an and celebrated in ninth-century texts as the ideal wall painter of his time. Descriptions of his practice contain all the paradigmatic qualities associated with spontaneity admired in ninth-century texts and in aesthetic theory dating back to the third century B.C.E. The authors of the *Record of Famous Painters Throughout the Ages* and the *Tangchao minghua lu* (Celebrated Painters of the Tang Dynasty; ca. 842) emphasize the importance of the initial, preparatory stages of painting; and, particularly in Wu's case, of performances of underdrawing sketching. It is evident that Tang art criticism was

inflected with Daoist values promoting spontaneous expression. Minimal work yielding maximum results had long been advocated in popular tales and folklore. In the Tang, these values were again promoted, but in the context of wall painting and sketching. Tang writers attribute realism to magical intervention; realism is achieved according to these writers in the preparatory stages of painting when the artist should be directly aligned with nature and serve as its conduit. These fantastic claims underscore the need for an independent study of texts that address creativity and its connection to sketching in both its visual and textual dimensions.

Wu Daozi marked a new direction in painting because his naturalistic results were achieved in the monochromatic sketching stage with an economy of line, the texts report. His mid-eighth-century career seems to genuinely coincide with an increase in monochrome painting and an appreciation for it. Several factors during this period may have spurred the development of monochrome painting before it became a fully realized style in the eleventh century. Increased sketch production and the open-air, visible spectacle of the wall painter making approximate, preparatory contour lines in black ink were by-products of extensive mural production in thousands of temples during the Tang dynasty. This seems to have engendered an increase of an appreciation of monochrome drawing and sketching and led to its popularity even in the Tang. Sources on early painting mention only three artists known for their ink painting.[19] By the ninth century, seven artists are noted in Zhang Yanyuan's *Record of Famous Painters Throughout the Ages*; Wu Daozi is among them.[20] By the following century, during the Five Dynasties, monochrome figure painting emerged into a style that featured strong ink lines reminiscent of the definitive overdrawing used to finish brightly colored murals. Evidence is supplied by a handscroll attributed to Zhou Wenju, who served as a painter-in-attendance for Li Houzhu, ruler of the Southern Tang (r. 961–75), located in present-day Nanjing.[21] Executed in plain, fluctuating line with occasional small dabs of color, the scroll presents the viewer privileged glimpses of court ladies at leisure—an old theme traditionally executed in fine line and color, as for example in *Ladies Drinking Tea and Tuning the Lute*, attributed to Zhou Fang (ca. 730–800). The Five Dynasties use of the new technique represents a significant shift in aesthetics that emerged from the workshop practices. The techniques developed in one area of expertise—wall painting production— appear to have influenced all other workshop painters. Muralists had to cultivate freehand drawing to make paintings from smaller drawings, and this skill spread broadly in ateliers.[22] Freehand drawing was absolutely essential in the Buddhist atelier. Its prevalence in the preparatory stages spurred a growing interest in quick brushwork and an aestheticization of spontaneous, unfettered expression associated with it. Whatever actually happened in later paint-

ing styles, it is clear that by the ninth century the spectacle of the wall painter engendered a fascination with the sketch.

Process and Cultural Response

Critical fascination with Wu Daozi's contribution as a seminal figure in this shift may be assessed against the extant remains of a contemporaneous working atelier at Dunhuang. This type of comparative analysis is desirable despite the geographical distance between the texts' authors based in Chang'an, in what is now Shaanxi Province, and Luoyang, in Henan Province, and the Dunhuang-area workshops to the west, in Gansu. When William Acker published a translation of *Record of Famous Painters Throughout the Ages* in 1954, capping three decades of research, the critical mass of the Dunhuang sketches, workshop financial documents, and finished paintings were not available for systematic analysis.[23] Small photos without interpretation or explanation of the sūtra-cave materials now in British collections were published in 1921 by Aurel Stein; a *catalogue raisonné* of the Dunhuang sketches in French collections was published in 1974 after the posthumous publication of the end of Acker's translation.[24] With these artists' materials today being more accessible, it is possible to assess the ninth-century claims about artistic practice with actual artists' working papers. The results are surprising. Comparing discussions of workshops and the archaeological evidence left by workshops reveals a coextensive, but not necessarily intersecting, relationship. That is, as I demonstrate in Chapters 5 and 6, the enterprise of analyzing discursive and object-based evidence is more complex than one of equating the written record with extant paintings.

The last chapter centers on a discussion of Wu Daozi because, in texts, he is cited as the renowned muralist who comes to symbolize new directions in Tang-dynasty wall painting. Wu's biography allows us to uncover much of the author's agenda, particularly about sketching and theories of creativity. By viewing his biography as paradigmatic, we may ascertain shifts in aesthetic theory at the time by interrogating the ways in which broad claims are advanced according to moral types—an interpretative strategy that has been widely accepted in the field—in order to advance those claims.[25] It is necessary to pose crucial questions about the texts themselves and challenge their usefulness as factual, historical resources. How were writers compiling their information? Were writers observing painting production directly? If not, what was their historically bound agenda? Why were claims made about artists that were inconsistent with practice? What was at stake for writers who described painting in a way that was clearly at odds with the evidence?

These questions point to the necessity of deploying interpretive models

other than those supplied by the texts of the period.[26] This is in recognition that all accounts of acts are fundamentally different, as Bakhtin argues, from the acts that are actually performed.[27] Deploying theoretical tools may signal a novel approach, but the point is that the historical evidence from the Tang period warrants a thorough analysis given the recent finds in the last century. In this comprehensive study on ninth-century painting practices and their contemporaneous discursive rhetoric in the central texts addressing wall painting, it is evident that these are two "non-communicating worlds"; that is, the world of culture in which acts are objectified and interpreted and the world of action as experienced.[28] While in some way Bakhtin's distinction between the worlds of culture and action is problematic in its artificial dialecticism, it provides a useful framework for our understanding of verbal descriptions of behavior and the other traces of behavior and gesture such as unfinished, preparatory artists' materials. Because text occupies a place of supremacy over the visual in Chinese cultural critique, and modern art historians have come to rely on art histories written in the Tang as evidence of workshop activities, a study of ninth-century art that cannot manage to juggle the difference between the written and visual record would be incomplete.

In these texts, the ambivalence about sketches is noteworthy. In Tang-dynasty China artists regularly copied from their own and others' work, but in aesthetic theory these acts were denied value. Unmediated expression was idealized because it was rarely practiced. The texts emphasize and privilege intuitive creativity over learned artistic behavior and conventions. What was at stake for these writers who advanced claims of expression so clearly at odds with the way in which most painting was produced during this period? For Chinese theorists, these questions were heavily inflected by issues of class. Unmediated expression was constructed as an experience closer to nature and hence more naturalistic. Later, these class-bound values impacted many positions in Chinese art criticism. Although all types of artists produced copies, in later theory the educated literatus was viewed as an original practitioner who creatively transformed (copied) old masters, whereas the professional (uneducated) artist reproduced images without personal inspiration. Critiquing the written record permits exploration of the moment in Chinese painting praxis and theory when these critical positions came into being. It probes fundamental issues concerning the nature of artistic creativity, representation, and resemblance for the subsequent eight centuries of traditional Chinese painting.

Performance

The theme of performance crops up in several key areas in relation to behavior, action, and practice. The ninth-century art historians Zhang Yanyuan and

Zhu Jingxuan fuse the performed act of sketching with the product—the sketch as a seminal moment in artistic production when the painting, if not finished, is essentially complete. This sense of achievement is linked with Daoist-inflected ideals about work and labor that focus on the status of the body in artistic production. Performativity may be oversimplified in regard to abstract expressionism ("painting is an index of the artist's engagement with surface") and particularly in regard to the ways that these same modernist interpretations are applied directly to Chinese painting.[29] And yet Zhang and Zhu themselves conflate gesture and product to the extent that painting is a record of an artist's brush movement. What is at stake for these critics is not an indexical recording of individuality and an unrecoverable temporal moment of creativity, but the mimetic imprint of natural forces spontaneously acting through the artist's body. Behavior and gesture are linked to realism and presage latter notions of resemblance of a different kind.[30] Therefore, because performativity is invoked by ninth-century critics in their understanding of painting production, behavior and gesture elbow their way to the table for discussion.

Performance is also an important issue addressed in four other critical dimensions of this book. Of a different sort altogether is the routine replication of a composition by a workshop that uses techniques and methods passed down in traditional atelier practices. Chapters 2 and 5 consider the ways in which one theme (The Magic Competition Between Raudrāksha and Śāriputra) is executed sixteen times over roughly a century in cave temples at Dunhuang. They are variations on this one theme, executed according to a set of rules that are inherently flexible in mural production. The way that wall paintings are executed in the space of cave temples and freestanding temples is linked to behavior in this study. On the other hand, in discussions of banner production, the close detail work of tracing and copying is juxtaposed with the set of skills and artistic behavior of the muralist who employs freehand sketching to cover the large surfaces of the interiors. The spaces of practice are as different as the results. The banner painter works at a close distance to the silk or paper on a flat or angled surface near a window or in sunlight. The wall painter is working in a darkened space moving around to painting surfaces at great distance from each other. A third distinct method engages the monk-artist in a highly literate practice of combining sūtra text with ritual diagrams that engages him in copying from texts in precise, minute characters or script with abstract drawings of ritual worlds.

The discussion of artistic practice shifting according to format draws our attention to a consideration of the social performances required of the artist in the course of production. The painter and sculptor participate in ritual performances of patronage recognition and submit to the supervision of the temple officials. The ritual feasting and informal modes of evaluation by local

officials during which wine (*mijiu*, a fermented grain brew closer to beer than grape wine) was shared during work critiques and elaborate banquets given at the dedication of colossal images, permit a distinction between formal and informal artistic rituals in secular Buddhist art production.[31] And, finally, the theme of performance in painting itself directs attention to the intersection of oral and visual cultures of production. Tumbling and stage-like drama are depicted in murals in which magical discourse is featured in highly animated, motion-filled tableaux. The bodies are overly muscular, defined by heavy accents of shading to emphasize the figures' corporeality. The audience is consulted in these exchanges by meta-narrators or clowns who gesture and grimace at the viewer in a shared conceit that the picture plane is indeed a representational fiction performed by both the artist and the audience.

1. THE ECONOMICS OF BUDDHIST ART

Compensation and Organization

Class and status are central to the history of later Chinese painting. No issue in the production of art may be more fraught than how artists were compensated. For the literati (amateur) painters beginning in the eleventh century, artistic expression was, at least in discursive practices, not about earning financial reward but instead about creating a vehicle to convey personality, mood, and thought.[1] This aversion to linking art with commerce, already mentioned in the ninth century by Zhang Yanyuan in his art history *Record of Famous Painters Throughout the Ages*, may in fact explain why so few transactions are recorded in the art production environment.[2] Therefore, it is no surprise that such records would be kept in a sphere unconnected to the critic's rhetorical world. To illuminate the environment of the medieval workshop artisan, a fortunate stash of Dunhuang records made by monastic accountants records the receiving and disbursement of goods and foodstuffs at the temple storehouse. Artists are mentioned as the recipients of several of these transactions in account books of the Jingtu si (Pure Land Monastery), one of the wealthiest Dunhuang-area monastic complexes.[3] From these matter-of-fact accounts, we may ascertain how the professional workshop painter interacted with institutions and donors who supervised, approved, and compensated the production of art.

This chapter, concentrating on the economic history of a workshop tradition active in Dunhuang during the tenth century, will illuminate the workings of a professional painting environment. One of the key issues in exploring the efforts of these artists is linking this workshop tradition to the development of a painting academy in the small independent kingdom. The

painting academy (or bureau at this nascent stage) would remain the primary avenue for imperial governments to realize painted mural, scroll, and calligraphy projects. The institution went virtually unchanged through the late imperial period when the court disintegrated in 1911; it is, therefore, a key to the history of Chinese painting. Payments to the workshop or academy artists were made largely in foodstuffs, with the temple mediating between patron and artist (serving the traditional function as a "go-between"). And, indeed, in the monastic accounts, it is the foodstuff transactions and the sharing of food among temple, government, and artists that receive the most attention. Further, this chapter advances a crucial distinction in artistic identities. Professional workshop artisans were distinct from monks who were literate members of the monastic community and responsible for text copying and ritual of diagrams but not the bulk of artistic production.

By the time the first Song emperors had established a painting academy in the capital of Kaifeng in 965, the Shazhou government of the Cao family was operating its own painting academy at Dunhuang.[4] Crucial evidence for the existence of this academy is found at the two sites, Mogao and Yulin. Cave-temple inscriptions reveal that professional artists during this period improved their social status to the extent that their court ranking allowed them to become patrons alongside the highest political officials.[5] Their full titles, specifying rank and painting duties, leave no doubt that, during the early to mid-tenth century, a full-scale painting academy or bureau was active in the Dunhuang region, encompassing Shazhou and Guazhou. These circumstances correspond to what we know about the increasing status of the artist in other regional painting academies during this same period. Similar painting bureaus were also founded in two other parts of China when Tang central authority dissolved in 907 and regional centers flourished. One was established under King Meng of the Kingdom of Shu, located in Chengdu, Sichuan, in 935; the second was established in 943 in what is now Nanjing and went on to operate under a succession of emperors of the Later Tang dynasty.[6] Dunhuang's academy was established earlier, sometime in the 930s. The merits of painters who served in both the Shu and Later Tang courts are chronicled in two important art histories, one by Huang Xiufu, the *Yizhou minghua lu* (Record of Famous Painters of Yizhou [Sichuan]; ca. 1005–6), and the other by Guo Ruoxu, *Tuhua jianwen zhi* (The Record of Things Seen and Heard about Paintings and Drawings; ca. 1080–85).[7] These texts continue the formal art narratives written in the ninth century by two art historians in the Tang capital, Zhu Jingxuan and Zhang Yanyuan, discussed in detail in Chapter 6. The evidence that survives from Dunhuang—"undigested" information in the form of mural inscriptions that list artists' names and titles, and financial documents that chronicle how artists were compensated—is less formal but equally valu-

able in allowing us to assess the workshop's economic structure, a theme the other chronicles omit.

The three new petty kingdoms, Shazhou, Shu, and Later Tang in Nanjing, emerged in the first quarter of the tenth century in the northwest, southwest, and southeast respectively and enjoyed a certain degree of prosperity. A burgeoning arts industry developed in each as a result of their independence. A clear index of artistic practice during this period comes from Dunhuang's court. The extant working papers and administrative documents, such as sketches, unfinished works, completed paintings, and financial accounts, allow us to triangulate the interactions between patrons, artists, and the temple (the latter functioning as an intermediary between maker and consumer).[8] Under the support of the Cao family, painting workshops developed into a government-sponsored painting bureau or academy in the Shazhou court. This bureau, albeit on a smaller scale, had a structure similar to the institution that eventually became the painting academy in the Northern Song court in the eleventh and twelfth centuries, blossoming under the patronage of Emperor Hui Zong from 1101 to 1125.

The nascent academy at Dunhuang flourished under government support, and local folk guilds from which it emerged also continued after the formal organization was founded. This expansion of the painting atelier's role coincides with the increase in cave excavation and production of monumental silk paintings during the late ninth and tenth centuries. The bulk of the Dunhuang preparatory materials dates to this period. They may have been personal notations rooted in the preparatory stages of painting, but their use at Dunhuang points to a larger, systematized production of murals and banners. These sketches are of particular interest in this chapter because they are an index of professionalized painting activity. They can be linked to the advent of guilds and a burgeoning arts industry during this period of loose central authority and regional strength in China, known as the Five Dynasties (907–60).

The Dunhuang sūtra cave offers resources beyond the artist's sketches. In addition it contains drafts of regional financial documents that list daily expenditures, including funds for art projects. These records complement other documents of economic history, including corvée labor registers, land and irrigation contracts, and individual labor contracts in which the buying and selling of familial labor was exchanged for annual food supplies and other subsistence-level support. Laborers were not slaves; they contracted their services to others and paid taxes, but they were poor nonetheless. Individuals devastated by a poor harvest, for example, were at the mercy of richer landholders and the wealthy temples that were exempt from taxation. The rich written record also clarifies how this type of worker differed from local craftsmen,

Figure 1.1

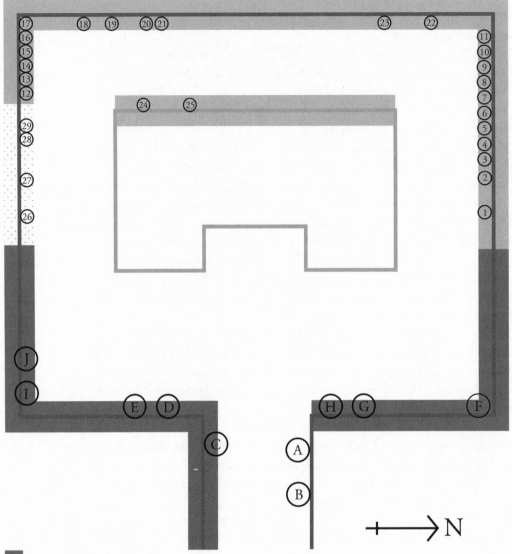

Cao Yijin's family

Buddhist monks

Military and civil officers

Important donors

(A) Zhang Yichao, deceased at time of construction

(B) Suo Xun, deceased at time of construction

(C) Cao Yijin, Primary Donor

(D) King of Khotan, Cao Yijin's son-in-law
Sponsor of Later Restoration (940–45)

(E) Lady Cao, Queen of Khotan, Cao Yijin's
eldest daughter (later restoration donor)

(F) Lady Li, Cao Yijin's wife

(G) Lady Suo, Cao Yijin's wife, Suo Xun's daughter

(H) Lady Song, Cao Yijin's wife

(I) Lady Fan, Cao Yijin's grandmother

(J) Lady Yin, Cao Yijin's mother

DONORS WITH OFFICIAL TITLES (ABBREVIATED)

1. Supervising Controller-General of Vice Commissioners in Five Sections, Returning Allegiance Commandery Army

2. Administrator of Waterways in the Southern Border [Jurisdiction], Returning Allegiance Commandery Army

3. Administrator of Shachi Town, Returning Allegiance Commandery Army

4. Inspector of Right Wing of the Mobile Brigade, Returning Allegiance Commandery Army

5. Commander of Second Right Army, Returning Allegiance Commandery Army

6. Administrator of Cihui Town, Returning Allegiance Commandery Army

7. Administrator of Affairs in the Sixth District, Returning Allegiance Commandery Army

8. Commander of Fourth Right Army, Returning Allegiance Commandery Army

9. Commissioner . . . (title incomplete), Returning Allegiance Commandery Army

10. Commander of Fifth Right Army, Returning Allegiance Commandery Army

11. Administrator of Waterways in the Southern Border [Jurisdiction], Returning Allegiance Commandery Army

12. Inspector of Left Wing of the Mobile Brigade, Returning Allegiance Commandery Army

13. Grand Inspector of the Mobile Brigade, Returning Allegiance Commandery Army

14. Patrolling Commissioner, Third Frontier Area Command, Returning Allegiance Commandery Army

15. Grand Inspector of Right Wing of the Mobile Brigade, Returning Allegiance Commandery Army

16. Chief Commissioner for Horse Pastures, Returning Allegiance Commandery Army

17. Administrator of Chixin Town, Returning Allegiance Commandery Army

18. Commissioner of West Circuit Patrol, Returning Allegiance Commandery Army

19. Administrator of the Imperial Residence, Returning Allegiance Commandery Army

20. Army Counselor, Returning Allegiance Commandery Army

21. Administrator of Waterways in the Four Borders Jurisdiction, Returning Allegiance Commandery Army

22. Administrator of Waterways in the Northern Border [Jurisdiction], Returning Allegiance Commandery Army

23. Grand Inspector of Left Wing of the Mobile Brigade, Returning Allegiance Commandery Army

24. Patrolling Commissioner, Northern Area Command, Returning Allegiance Commandery Army

25. Visiting General, Area Command Administration, Returning Allegiance Commandery Army

Buddhist monks with official titles (abbreviated)

26. Administrator of the Offices of Monastic Residential Affairs

27. Supervisor of Various Offices of the Army Command

28. Supervisor of Futian Temple

29. Supervisor of Wuni Temple

Figure 1.1. Placement of donors in cave 98 (ca. 923–25). Design by Limin Teh.

members of trade guilds, and workers who were managed by temples to execute the merit-seeking works commissioned by individuals and the local government. Financial accounts prepared in 925, 931, and 939 for the prosperous Jingtu si are the basis of the analysis of the economic factors connected to the artist's practice in this chapter. Jingtu si was patronized by the Cao family, who ruled the Returning Allegiance Commandery Government (*Guiyijun jiedu*) in the capacity of military commissioners from 921 to 1006. The government's patronage of this temple, support of a painting bureau, and participation as a donor in many of the cave temples from which extant sketches were constructed allow us to scrutinize in a tangible way how the political and monastic community shaped artistic production. A diagram of donors assembled in cave 98 indicates the complex economic, political, familial, and artistic relationships implicated in any act of patronage in the Cao court (Figure 1.1). Cave 98 was dedicated by Cao Yijin, who ruled Dunhuang 914–35. In the main corridor, opposite a portrait of himself, Cao includes commemorative portraits of deceased leaders of the Dunhuang Commandery government. Zhang Yichao, who reclaimed Dunhuang from Tibetan forces in 848, is depicted opposite Cao Yijin. Cao married Zhang's granddaughter (one of his several wives). He also strategically married his eldest daughter to the king of Khotan, who is depicted on the east wall (see Figure 1.2). Both these marriages established a temporal and geographical network of alliances between past and present and local and foreign rulers who were situated to secure the Cao's Dunhuang kingdom. By creating a map of those alliances in the cave, the social and political network is brought to bear on the Buddhist merit-making activities of the court. Other family members are also near the place of honor on the east wall and corridor, the saṅgha or community of monks and nuns are positioned farther back in the cave on the south wall, and the military and political figures in the government, in the cave's deeper recesses, are located in the northwest and southwest corners and on back of the altar screen. All three groups are in dialogue with each other, assembled in symbolic pictorial form by the artisans who brought these figures together in the cave-temple's interior.

The most tangible manifestations of the triangle of art workshops, monastic establishment, and government organizations were the exchanges of commodities that connected them. Payments in the form of raw food served as the primary compensation to artists. In cooked form, grain was transformed into meals and wine that eased evaluative discussions of art projects and

Figure 1.2. King of Khotan with bride (*right*). Wall painting. Cave 98, Dunhuang. East wall, south section. Ca. 923–25. Section of wall: 4.44 m × 3.54 m. Wenwu chubanshe.

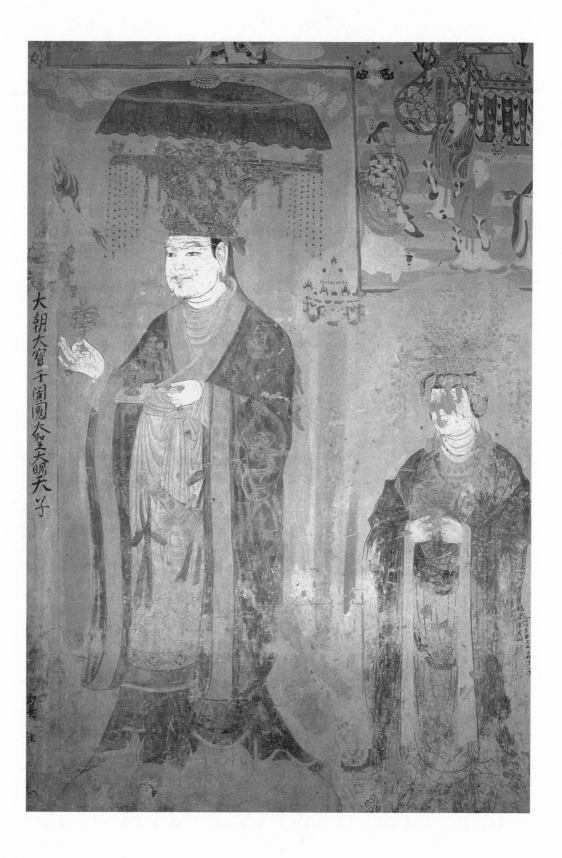

大朝大寶于闐國大聖大明天子

supplied the staple for vegetarian feasts that marked the completion of projects. Food was the means through which the activities of art production and evaluation were mediated. The circulation of objects in the temple, the exchange of food for work, and the cycle of gift giving and merit making that generated the need for such work and objects demonstrate the continuous transformation of commodities of all types in the temple. Donations of grain to the temple became the food and wine around which government officials, monastic evaluation teams, and artists discussed the production of images. First, we turn to the structure of the painting guild and academy.

From Guild to Academy: Evidence in Yulin Cave Temples for a Painting Academy

In the late-tenth-century temple that is cave 35 at Yulin near Dunhuang, one of the donors depicted in a mural is Zhu Bao; an inscription accompanying his generic portrait identifies him as a "Shazhou chief craftsman working as the Commissioner of the Painting Bureau" (Shazhou dugongjiang goudang huayuanshi). Zhu Bao's high rank in the Returning Allegiance Commandery Government also earned him the prestigious title of Acting Advisor to the Heir Apparent (Jianjiao taizi binke). The "heir apparent" refers to Cao Yanlu, the military commissioner and king of the Dunhuang region from 976 until 1002, whom Zhu served. Cao's other prestigious titles, noted in the cave's inscriptions, are the Grandmaster of Imperial Entertainments with Silver Seal and Blue Ribbon (Yinqingguanglu dafu) and Grand Preceptor (Taishi), conferred in 984; the latter gives us a *terminus post quem* for the date of the cave.[9] Noteworthy is how Zhu and other artisans had gained enough status within the government to be considered patrons worthy of enhancing the image of the military commissioner who ruled the Dunhuang regional government. In earlier, mid-Tang caves at Mogaoku, one sees clandestine inscriptions by artists noting the completion of a project or an occasional signature tucked away in a sculpture niche, but these are largely hidden from view. Here in a Yulin cave temple dated to the late tenth century, artists assume a proud position as copatrons alongside the rulers whom they served.

Wall-painting production, cave construction, and the regional Dunhuang government are linked in demonstrative ways in this grouping of donors in the late tenth century. Cao and the Commissioner of the Painting Bureau are accompanied by other high-ranking artists in the pictorial donor procession of cave 35, including Wu Baolin, "chief painting hand" (*zhi huashou*). In the same section of the cliff facade at Yulin, we find further evidence of the artist's new role as patron. The donors' inscriptions in nearby cave temple 32, which contains a mural of The Magic Competition Between Raudrākṣa and

Śāriputra, confirm the existence of the painting academy and hint at its complex structure. Below their portraits on the west wall, four apprentices (*huajiang dizi*) give their titles and names (now damaged).[10] This one inscription tells us a great deal, particularly when considered alongside cave 35. First, it establishes the existence of a hierarchy of masters and apprentices, which is just what one would expect in an academy. These artists, I argue, determined the compositional programs in the scores of cave temples dedicated by the Cao family. The standardization of themes and figures in The Magic Competition, The Debate Between Vimalakīrti and Mañjuśrī, Amitābha's Paradise, the Sūtra of Golden Light, and Maitreya's Paradise could only be achieved with this kind of organization in place. The opportunities for craftsmen in the expanding regional art industries are manifested in their inclusion as donors in these late-tenth-century caves. In cave 34, the "skilled chief of materials" or head designer (*duliao*) of the gold and silver guild, Yu Chibao, is also depicted with official titles that place him in Cao's court. Another man of similar rank, the chief of materials in the bow and arrow guild, Zhao Anding, stands next to him.

In cave 33 another inscription suggests the existence of an institutional corollary to the painting academy. Its patron was Cao Yuanzhong, military commissioner of Shazhou ca. 944–74. In a cartouche accompanying his generic portrait, Bai Ban[?] (character now obscured) is identified as the chief artisan of the Painting Workshop in the Left Hall of the Frontier government (*duhuajiang zuo jiedu yaya* []*zuoxiang*).[11] The *zuo* refers to a *fang* or workshop type of structure, distinct from a *yuan*, an academy or bureau. The former is more informal and is project based; the latter is a standing institution. This evidence indicates that two different but parallel types of painting organizations existed at the same time, both connected to the government. This inscription also establishes a continuity in the painting organization of two successive regional kings (Cao Yuanzhong and Cao Yanlu). Painting workshop artists appear in four neighboring caves at Yulin: Bai's donor portrait is in cave 33; in cave, 34 Yu Chibao and Zhao Anding are included as donors; in cave 32, the four painting apprentices appear alongside Wu Baolin, the Chief Painting hand; and in cave 35, Zhu Bao, the Commissioner of the Painting Bureau of the Shazhou government, stands with other donors. These four cave temples were the last grottoes excavated on the far cliff facade during Yulin's most important construction phase in the tenth century.[12] All of these caves (32, 33, 34, and 35) contain significant inscriptions relating to artisans and indicate that they played a considerable role in cave construction and exerted a discernible influence over the artistic programs executed by the regional kings.

The workshop (*zuofang*) mentioned in cave 33 is probably closer to what Chinese scholars call a folk (*minjian*) workshop. A *minjian fang* was more

informally arranged for a specific event or project, even though, in this case, it had some form of high-level support. This is not a contradiction. Cartouches on printed sūtras from the Southern Song indicate that there were at least two forms of printing guilds. One was close to the folk type. Members often had the same surnames, indicating clan ties. When a project was completed, the workers were dismissed. Frequently they gravitated to longer-term projects sponsored by the government, which resembled the ongoing institution of the academy (yuan). For example, publications such as the carving and printing of the Buddhist canon during the Southern Song dynasty (1127–1268) took many years, and a printing workshop was formalized for the completion of this and other similarly extensive endeavors.[13] A government bureau is a different type of organization in which artists are permanently available and ranked in an intricate structure. In ad hoc workshops, it was the project, not the structure of the painters' work, that was paramount.

While it is certain that the Dunhuang region had a painting academy at the beginning of the Northern Song (ca. 960), other documents suggest that as early as the 930s some type of academy or bureau already existed. In Pelliot document no. 2032, dated 939, the bookkeeper records the visit of a temple representative to an academy member (*huasheng*) who painted the door of a grotto (Figure 1.3).[14] Another entry from the same document mentions payment to another academy member of three *shi* (or *shuo*) of millet, a substantial amount, equivalent to over 1.8 hectoliters. These textual examples augment the visual evidence of a painting bureau in cave temple and banner production discussed in Chapters 2 and 4.

We may gain a sense of the structure of the painting academy through its relation to another institution, the Jishuyuan or Rites (and Skills) Academy. The Rites Academy addressed a range of ritual responsibilities. While its extent is not entirely known, its members had expertise in musical, social, and ceremonial rites. Pelliot document no. 3716 is a collection of sample letters to be used in circumstances governed by etiquette, such as thanking the local government for providing medicine during an illness. The document also includes advice for proper conduct during courtships, weddings, and funerals, and courtesies to be followed in polo matches. The rituals described are Confucian in character.[15] The author advises on bowing prior to polo games, the burning of wheat and placing of flowers on family graves, and the presentation of a prospective daughter-in-law to the home into which she will be married.[16] The text is signed by Zhang Rutong, a master of ritual (*lisheng*) of the Dunhuang Rites (and Skills) Academy (Jishuyuan). Zhang's title as ritual master or member is consistent in type with the title of the "academy member" (*yuansheng*) mentioned in the financial accounts of Jingtu si. The ritual master and painting master did not perform the same tasks, but their titles

Figure 1.3. Account of revenue and expenditure. Draft print from the office of the West Granary. Prepared by Yuansheng and Guangjin. Detail, verso. Jingtu temple. P2032. Ink on paper. D. 939. Length of entire scroll: 25.9–30.2 cm × 2335.0 cm. Cliché Bibliothèque nationale de France, BnF.

suggest their work units were organized along similar lines. The parallel titles also confirm the general claim that there were academies or bureaus (yuan) in the early Five Dynasties in the Dunhuang region.[17]

Other evidence of workshops comes from the paintings themselves. As established, Dunhuang paintings are made in sets, possibly copies from each other—a practice typical of workshop production in this period. It has been suggested that paintings on the theme of The Scripture on the Ten Kings of Hell exported from Ningbo in the Southern Song dynasty also contain a homogeneous style, suggesting efficient copying techniques. In Dunhuang, banners containing certain figures, such as vajrapāni (door guardians), are boldly treated by the artist using thick black lines or excessive amounts of shading to exaggerate minor differences in identical iconography (Figures 1.4 and 1.5). In finished images, artists employed clever techniques for varying details of design although the figures are identical in height and linear structure.[18] With a standard draft sketch for reference, many minor details in paintings could be changed to suggest a workshop's expansive repertoire based on a core, but small, range of standard figural types.

Scores of other pairs of like paintings on silk may be identified in the Dunhuang collections. A set worth noting are five bodhisattvas wearing either

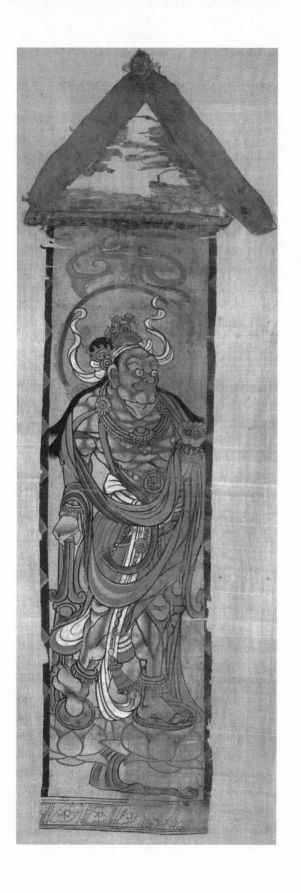
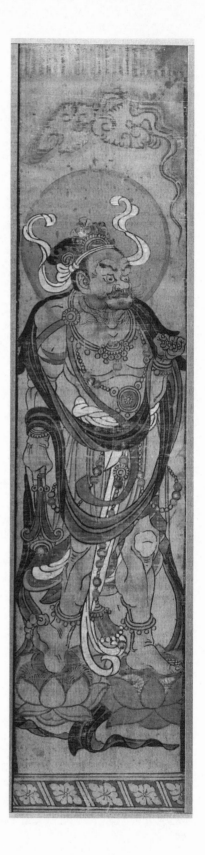

monastic dress or typical bodhisattva robes (two of which are produced here, in Figures 1.6a–b). Here again, the size and position of the figure is the same. Without the decorative triangular piece on top, the five banners respectively measure 76.0 cm, 73.5 cm, 71.0 cm, 71.4 cm, and 70.0 cm in length and 18.0 cm, 18.3 cm, 17.4 cm, 17.0 cm, and 17.3 cm in width. In a third example, the bodhisattvas reproduced in Plates 20a and 20b, as discussed in Chapter 4, exhibit qualities of being traced from the same model. These correspondences are not just a matter of iconographic similarities. They suggest a method of production that efficiently and accurately reproduced figures in sets that are nearly identical.[19] The economics of art making in Dunhuang required that artists be hired to work on specific projects in which a certain number of paintings were commissioned for a set price. Therefore, if paintings were executed at the same time, it is logical that they would have similar features, proportions, and palette. Fifteen caves with like iconography, dating from ca. 860 to 980 at Dunhuang and Yulin, exhibit similar painting techniques and painting formulas. The sketches are further evidence that mural painting also was produced using specific production rules to allow for duplication.

The institutions that preceded the yuan in Dunhuang are mentioned in various inscriptions and documents. The *huahang*, or painting guild, reflected an increasingly organized production of painting. Many of the duties of those in charge of the guild may be understood as relevant to the bureau or academy. Stein document no. 3929, a record of merit, provides an invaluable profile of a painting guild manager (*huahang duliao*) in the Frontier Commandery Government (*Jiedu yaya*) named Dong Baode.[20] The second character (liao) in his title—duliao—means "materials"; the first (du) means "superintend." Therefore, this position evidently involved the control and deployment of painting resources. These duties, according to the implications of the title, also included management of entire projects, including aspects of design programs and production.[21] In another Stein manuscript, the title "materials manager of the Painting Academy" (*huayuan duliao*) is given.[22] The Painting Academy commissioner (*huayuanshi*), a position held in the late tenth century by Zhu Bao, also presumably had control over materials. It was this level of artists, either the materials manager or commissioner, who kept the draft sketches used in the execution of each project. The preparatory materials stored in the sūtra cave may therefore be read as instruments of hier-

Figure 1.4. (left) Vajrapāni. Stein painting 123. Ink and colors on silk. Dunhuang. Late ninth or early tenth century. 64.0 cm × 18.5 cm. Copyright British Museum.

Figure 1.5. (right) Vajrapāni. EO1172b. Ink and colors on silk. Dunhuang. Ninth century. 72.0 cm × 17.0 cm. Réunion des Musées Nationaux / Art Resource, NY.

archy and status among artists. The drawings are the most tangible record of the academy or guild's presence at Dunhuang.

The text also praises Dong's reconstruction of an old temple and his embellishment of its interior and provides his stylistic lineage. Dong was skilled at portraits and is listed as a follower of the Central Asian painter Zhang Sengyou (active 500–50), known for his heavy shading and waterfall drapery, and of Cao Zhongda, another artist of the Northern Dynasties (386–581). The author indicates that Dong was literate; but nonetheless, we may infer that his educational level was not high. The text indicates Dong's commissions were numerous, and the salary he received from them was so great that his family was financially secure, with a surplus of grain—the primary form of payment for artistic work in tenth-century Shazhou. The artist also had gifts bestowed upon him, indicating a status above that of the average artist who simply received meals in exchange for work. We may assume these gifts came in part from the military commissioners for whom he executed compositions and under whom he held a position. Dong had been named a *yaya* or official in the government. During the Five Dynasties, there were many yaya in the military governor's office who had no connection to artistic projects. The term was a general appellation for an official. Jiang Boqin suggests that Dong Baode probably bought his title (the yaya portion),[23] which supports the conclusion that the Five Dynasties was a time of upward mobility for artists, who received many commissions and lucrative payments. This assertion is based on the wealth of the artist described in his biography and the irrelevance of a military title to his role as head painter. Jiang may be right that the title was purchased, but his own article also provides evidence of a government-supported painting bureau, which would make an official government title for a painter reasonable and plausible. From all indications in the document, Dong Baode did not possess substantially high government status. His standing came from his expertise as an artist and a materials manager in the painting guild.

Painters were joined by artisans in their formal affiliation with the government. Woodblock carvers also had regular commissions. In two woodblock prints found at Dunhuang, dated to the years 947 and 949, the texts include information on how they were commissioned. The military commissioner of Shazhou and Guazhou, Cao Yuanzhong, ordered (*qing*, literally "invited") an

Figure 1.6a. (left) Bodhisattva in monastic dress. EO1414. Ink and colors on silk. Ninth century. Total banner height: 195 cm; composition: 76.0 cm × 18.0 cm. Réunion des Musées Nationaux / Art Resource, NY.

Figure 1.6b. (right) Bodhisattva in princely robes. EO1399.153. Ink and colors on silk. Ninth century. 81.4 cm × 17.0 cm. Réunion des Musées Nationaux / Art Resource, NY.

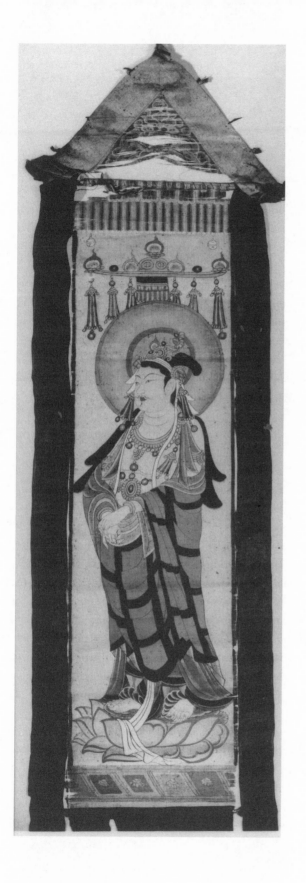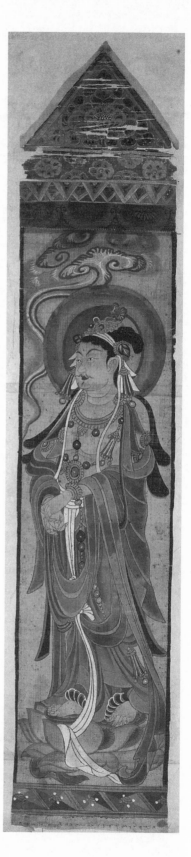

Figure 1.7. Woodblock-printed booklet of Diamond Sūtra. Lei Yanmei identified as woodblock printing official in final line. P4515. D. June 14, 949, or June 3, 950. Booklet: 14 cm × 13.5 cm; image: 13.5 cm × 10.2 cm. Cliché Bibliothèque nationale de France, BnF.

artisan to make the prints for the well-being of the people.[24] The same engraver, Lei Yanmei, was responsible for both; according to his titles, he was promoted in the time between the first print, made on August 4, 947, when he was just an artisan (*jiangren*), and the second print, in 949, when he already held the position of Woodblock Official (*diaoban yaya*), connecting him to the Frontier Commandery government (Figure 1.7).[25]

Government Control: The Artisan and the Corvée Laborer

Manuscripts discovered at the Turfan oasis also provide extremely valuable information about the structure of the arts industries and the legal status of the artist. These documents help clarify the identities and relationship of workers to the government. Three references indicate artists worked professionally in organized units during the period of Tang imperial control

(640–803). As with so much of the Turfan textual tradition, these references appear out of context, turning up in modern times by chance in piecemeal fragments of refashioned official papers made into substitute grave goods. A paper shoe found in tomb 153 (72TAM153: 29, 30) was formed from a discarded draft of a work register (or household register) of artisans and painters.[26] This document was authored by the commandery government—a political entity used by frontier governments such as Dunhuang. Governing bodies in both locales were established in the early Tang as regional administrative units for the imperial court in Chang'an.[27] Record keeping was essential to maintaining the standards of Tang society. It was the practice to reuse government manuscript drafts and fashion the waste into substitute mortuary goods, such as shoes, which were believed to serve the dead in the afterlife. The household register that survives gives us two important pieces of information. Artists are listed by name in two sections of the manuscript.[28] On the fifth month, twenty-ninth day, as many as thirty-five artisans (*ruzuoren*) were in the employ of the local government.[29] Second, in the same document, several days later in the sixth month, second day, another list of artisans (jiangren) includes a *huashi* (painting master). The latter title confirms that painters were part of a workshop tradition in which skill was a distinguishing factor. That is, a hierarchy existed for painting production in Turfan much as it did in ninth- and tenth-century Dunhuang. If there were painting masters, there were those who assisted them. The verb associated with these masters—to manage (*jiang*)—further indicates they were in charge of other workers and responsible for the many facets of projects. The importance of this document cannot be overstated as it predates the Dunhuang financial registers (P2032; P2049) by two centuries. Because much of Turfan government practices reflect central Chinese traditions during the seventh to eighth centuries (for example, the *juntian* land-management system), this text also provides some idea of how artists were managed in central Chinese government organizations.

A second Turfan document (73TAM210: 12–1 [2]) provides information of the government's procurement of forced or corvée labor, possibly as a form of tax.[30] Specific individuals are listed by name and by expertise, including painters (*huajiang*), bronze and archery artisans, carpenters, iron workers, leather crafters, and *youjiang* (oil pressers; lit., oil artisans). These separate categories point to a guild system in which one's craft becomes one's identity. All artisans grouped together by occupation in this manner appear to have the same social status. That is, the record suggests that painters and other craftsmen had the same legal status as oil makers and workers who produced domestic goods. Painters, carpenters, and tradesmen were regarded as producers or makers of products for the elite, as were oil pressers. This is a strong

indication that art was still conceived of as a service to be performed and not yet a leisurely pursuit for personal expression, as it would begin to be in the late tenth and eleventh centuries. Nor was pictorial accomplishment in painting an indicator of education and literacy, as was already the case for calligraphy, for which a brush was also used.[31] Finally, Otani document 3774, excavated at Tuyugou (Toyok, approximately 50 kilometers outside of Turfan), provides additional evidence that the Turfan-area government requisitioned labor.[32] The question of labor given as a tax payment is an interesting and complex problem in the context of artists.

Household registers, kept for tax purposes, suggest that artists, along with other skilled workers, were taxed by local officials who requisitioned their services for government projects. For example, in document fragments from Karakhoja tomb no. 1 (dated to ca. 639–40) of the Chu Gaochang period, sewers (artisans who stitched clothes or shoes), leather workers, painters, carpenters, painters, oil producers, and butchers are listed according to craft category rather than by personal name.[33] This registry indicates that skilled labor was specialized and was organized according to *hang* or workshops. Those that produced oil, made wine, butchered pigs, specialized in leather production and embroidery, and cultivated tea are identified specifically by trade.[34] This kind of government tax list, categorizing the population according to trade, was most likely used by the Gaochang government to tax its residents according to skill. That is, leather workers and painters had to fulfill their fiduciary obligation to successive Turfan governments by providing services to the state in their area of expertise. A document dated to three decades later, after Taizong's forces brought Turfan under Tang control, excavated from Astana tomb no. 61 contains another name-registry of local artisans (66TAM61: 16 a; 66TAM61: 27[5] a).[35] Additional types mentioned are masons, armorers, sculptors, and ironsmiths. These artisan lists from two tombs span the Chu Gaochang period (439–640) and the Xizhou period (640–803), suggesting that artists were organized in similar institutions and taxed in the same fashion throughout the last three quarters of the seventh century, despite a change in government. The system of administrative control under Taizong in the Xizhou period would be structurally the same as that in Dunhuang. During the early to mid-Tang, the imperial government exerted the most overt cultural, political, financial, and artistic control over Silk Road commanderies.[36]

The question arises as to how much these artisans were organized by and regulated by the government. Since one type of artisan (listed in 64TAM1) made armor (*jiajiang*), which the private populace was forbidden to own, we can conclude that no independent craftsman and his family would be making the armor without the support, resources, and direct participation of the government.[37] Thus, at least some of the artists listed in the registry were, in

effect, in the exclusive employ of the ruling commandery. Therefore, the notion of a hang (specialized artisans or guild) as a system of independent agents such as we find in thirteenth- to sixteenth-century Europe, for example, does not quite fit the Tang or Chu Gaochang system.[38]

Artists may have been taxed according to skill and required to render their obligation using the skills of their trade, but this should be distinguished from the related, but altogether different, practice of taxing other elements of the population to perform corvée labor and contribute to mass public works. Abundant evidence exists in Turfan documents that prior to the seventh century some workers functioned more like slaves or forced laborers engaged in general public works.[39] We may surmise that any corvée laborer could be assigned work related to craft endeavors such as building city walls, tomb digging, and cave excavation. However, this kind of labor (which was also performed as part of the tax burden) is unskilled and should be distinguished from the work of painters and sculptors who were responsible for Turfan-area temples such as the cave temples at Tuyuguo, the Xiku si grottoes above the early capital of Yarkhoto (Jiaohe), and the painting inside a freestanding earthen temple in the Tang Gaochang administrative complex.

Similarly, forced or corvée laborers who were engaged in public works in the Dunhuang region should be distinguished from the artists who embellished the Dunhuang cave temples. In Dunhuang documents of the late eighth and early ninth centuries, work groups (*tuantou*) were drawn from the able-bodied populace of villages to fix temple properties, such as the storehouse at Longxing Temple, presumably to fulfill a tax obligation to the local government, which at that time was controlled by the Tibetans.[40] The Tibetan rulers ran the temple system as an extension of government following a theocratic model. We learn from the text that men skilled in managing carts and water buffalo were among the workers organized into the work unit to restore this temple. Presumably, they were drafted to haul supplies. Therefore, we cannot conclude that all laborers were skilled; large-scale projects required many hands, and the government appeared to take advantage of available labor to conduct public works. However, the legal status of these corvée laborers, who as commoners were commandeered for public works projects, was the same as that of artists. The Turfan household registers place all kinds of laborers, regardless of their artistic skill (oil makers are equal to painters) in the same low social and tax status. But in terms of skill and profession, the two are different. That is, painting projects are not simply executed by a mass of unskilled laborers. It was the skilled folk workshops, each of which specialized in a particular craft, that were the prolific and productive force behind the rise of a government-supported painting academy at Dunhuang in the mid-tenth century.

By the tenth century, this distinction became manifest in government positions that recognized the skill of painters. As officials, their tax and social status was raised above that of commoners who remained a ready source of labor for the government's large public works projects. In ninth- and tenth-century Dunhuang, artists who held the higher positions in the workshop were increasingly noteworthy in political positions and their social status changed accordingly. Three specific individuals demonstrate this development. First is Lei Yanmei, who was listed as "woodblock official" on a 949 official print for Dunhuang's military commissioner Cao Yuanzhong after being promoted from the title "artisan" just two years earlier. Second is Dong Baode, who was the painting guild manager during the late tenth century. Like Lei Yanmei, Dong held the title of official (yaya) in the commandery government. The third prominent artist is Zhu Bao, commissioner of the Painting Academy, who is pictured in Yulin cave 35 alongside the ruler Cao Yanlu in ca. 984. These three examples demonstrate that artists rose from their association with common laborers in the seventh and eighth centuries to positions of prominence; it was now possible for a professional artist to hold a rank of some distinction.

The Structure of the Painting Academy

The hierarchy applied to painters allows us to venture a structural overview of the tenth-century Painting Academy at Dunhuang. Two top positions for painters were the painting bureau commissioner (huayuanshi) and the painting guild manager (*huahang duliaoshi*). Other leading posts were occupied by the materials manager (duliao) and the head of artisans (*dugongjiang*). Under them were especially skilled or valued painters (huashi). Below them, the specialist (*boshi*) or master fell into the upper half of the bureaucratic scale but did not enjoy a particularly high status. Other painters were described as painting artisans (*huajiang*), painters (*huaren*), painting bureau members (*huasheng*), painting artisan apprentices (*huajiang dizi*), and artisans (*jiang*), the last being the lowest position. These eleven different titles used to describe pictorial artists indicate a complex system of ranking based on skill and experience. The hierarchy betrays a highly organized environment for the production of wall paintings and banners from the late ninth century through the tenth.

In addition to the artists affiliated with temples and the government, there seems to have been artist positions outside this structure. There are several examples of painters (huaren) in the financial accounts, including the entry in P2049. The title is generic, indicating no status in a hierarchy. These artists may have been part of a looser guild structure in which workers were hired temporarily for specific projects, perhaps by the temple itself (for small-scale

works), recalling the minjian guild structure. Evidence that the huaren may have been hired outside the formal guild or academy structure is provided by the fact that in this transaction of the Jingtu si, the painter (huaren) is given a payment of goods for services instead of the typical meals as wages. This huaren received nine shi of millet, equivalent to 3,060 cash (copper coins), which may suggest that huaren were sufficiently valued to be given payment directly or were outside the regular bureaucracy.

Entries in Five Dynasties monastic accounts demonstrate that the temples in the Dunhuang area needed many types of artisans to complete the vast array of objects that were hand-produced. Masters (boshi) existed for separate crafts that today seem quite similar. Yet their division indicates that bureaucrats and artists of this period distinguished carefully between the skills required to produce objects with particular materials. The emergence of the wage-earning boshi during the late eighth to mid-ninth centuries provides further evidence of an overall professionalization of technical services in the arts and crafts industries during the period to which the sketches and copybooks date.[41]

In the earlier part of the Tang dynasty (seventh–eighth centuries), the term *boshi* actually meant something else; it referred to high-status officials.[42] In the eighth and ninth centuries, the term came to refer to someone with expertise. In addition to painting and sculpture boshi, there were specialists in construction with wood, mud, or plaster, including those who plastered ceilings, used sand and hemp, built stoves, and also made sculpture with mud and dried plant material. Other craftsmen constructed rampart beams, trued wheels, made pulleys for carpentering, built bell towers, and carved wine dippers.[43] Skilled metalworkers included gold casters, cauldron makers, silversmiths, and joiners of sheets of metal. A fourth category was the artisan dealing in fabrics, including those who dyed and repaired coarse and fine fabrics.

Other evidence from Dunhuang offers a broader picture of the operations of various types of guilds since the mid-Tang. Guilds often made joint contributions to temples to honor their organization. The gold and silver traders' guilds formed a society to dedicate cave temple no. 34 at Yulin.[44] A similar group on the other side of China also made a contribution to a temple through their own guild. At Fangshan, near the southwest corner of present-day Beijing, the butcher's guild society donated stone-inscribed sūtras that were part of the massive project to duplicate the Buddhist canon and organize it underground, beneath a pagoda, in order to preserve the Buddhist dharma in uncertain times.[45] In addition to the gold and silver guild, wine, music, and tea guilds existed in the Dunhuang area; some of the records mention organizations similar to those in the metropolitan centers, pointing to a shared institutional structure in many parts of the empire.[46] From these

materials it is evident that, in both the capital and the provinces, guilds were thriving in the eighth century and beyond. The Tang legal code only had six directives for commercial activities and few details on business and trade organizations; it did not outline the origins and control of guilds either, but the expanding markets of the Tang empire point to important roles for these concerns. The word for guild (hang) is etymologically related to alley, reflecting the practice of separating sellers of like wares in markets.[47] In the case of the painting and other art guilds that moved around to different project sites, the term is used to indicate workers with the same expertise or specialization. These specializations were recognized by the temples that employed artisans, and which noted their status, function, and form of payment in their records. Archaeological remains from Turfan indicate that the textile workers there, who worked in a growing trade that benefited from Silk Road exchange, were physically positioned together within the town of Gaochang.[48] This evidence supports the idea that, in smaller, noncosmopolitan areas, the division by trade in the town center was maintained. Now let us turn to the ways officials interacted with artists and methods for compensating their work.

Supervision

Artists who worked in this hierarchy of production were supervised and visited by officials who assessed their work. Temple records noting the expenditure of grain and wine for these official visits give some clue as to how artists were supervised. In Jingtu si's financial accounts, entries describe intertemple officials (*panguan*) calls to artists. While the purpose of their visits is not explained in detail, in one case two pecks of millet were exchanged for wine when a group of panguan visited. These supervisors visited (*kan*, literally "to see," probably best understood as "to inspect") a painting master in a grotto, which would have been in a cave temple where a project was being executed. Of importance here is the status of both parties. The panguan were mid-level temple officials who participated in the monastic supervisory board.[49] Their immediate superior was the *dusengtong* (chief of monks or general controller of the clergy), the highest administrator for all the regional temples, who worked closely with the local government.[50] If the panguan participated in an administrative structure of the temple that maintained relations with the government, it is possible that the painting master (huashi) they visited also belonged to an organization such as a guild or workshop that had formal relations with the intertemple bureau. In one case we have direct evidence that the dusengtong managed the restoration of the colossal Buddha in cave 96 for the regional king and military commissioner, Cao Yuanzhong (ruled 944/945–74).

Eulogy of Cao Yuanzhong and Lady Zhai: Reconstruction of Cave 96

The draft of a eulogy praising this restoration project, funded by Cao Yuanzhong and his wife, Lady Zhai, reveals how a renovation of this magnitude was organized and how artists, the temple, and the local government worked in tandem (Figure 1.8). In 966, the couple arranged for the repair of the Daxiang si (The Temple of the Great Image), also known as the Beixiang si (The Temple of the Northern Image)—that is, cave 96—at Dunhuang (Figure 1.9). Inside the nine-story pagoda-facade is a colossal image of Maitreya, first dedicated during the reign of Empress Wu Zitian in 695. The eulogy meticulously outlines each stage of the project and its participants. Cao Yuanzhong and Lady Zhai, observing the month of fasting (the fifth month of the lunar calendar), retired to the Dunhuang caves. There they performed pious acts such as lighting lamps, burning incense, chanting prayers, and ordering sūtra copies; these texts were to be distributed to seventeen local temples.[51] These monasteries, incidentally, are frequently mentioned in sūtra cave documents and must have been the regular beneficiaries of government largess (revealed in the great number of sūtras, paintings, and other documents with their names). Cao and Zhai searched for an area of the caves that needed attention. They settled on the colossal statue of Maitreya, now one of four large statues at Dunhuang. According to the text, two tiers of wooden frames were rotting and broken. Even today, one can see the vestige of the labyrinth wooden stairs wrapping around the colossal sculpture. It is probably this intricate wooden staircase that Cao and Zhai pledged their efforts to restore. The text explains work began on the nineteenth day of the fifth month.

> Accordingly, they gave instructions to the . . . chief of monks (*dusengtong*) and to relevant officials, both clerical and lay. One and all expressed delight at the scheme, and before ten days were over, the repairs were already complete. Wood suitable for beams and rafters could not be found in the valley, for at this early season in the year the timber is all too dry . . . [hiatus in text] he sent to the city for timber, and workmen were also brought, who piously offered their services, being faithful believers. These [i.e., the artisans] were provided for in the most ample fashion; food was heaped high as the hills; wine flowed like the sea.[52]

This first section of the draft text, written on the back of a random collection of sketches of tribute horses and camels, which also bears the inscriptions of Cao Yuanzhong, confirms many of the social and economic circumstances gleaned from reading the financial accounts of the Jingtu si of the 920s and 930s. Despite the usual claim in this text, dated to 966, that artists worked for free as pious believers, "food heaped high as hills" should be understood as a part of their compensation. Food was exchanged for work. The temple facil-

Figure 1.8. Draft eulogy for Cao Yuanzhong and Lady Zhai's restoration of the Daxiang temple (Cave 96), Dunhuang. Stein painting 77. Detail, verso. Ink on paper. D. 966. Entire scroll: 30.5 cm × 84.5 cm. Copyright British Museum.

itated the projects, probably distributing meals to the artisans. The project facilitator, mentioned at the beginning of the eulogy, is the chief of monks Ganghui. Given that his position as monk and administrator gave him access to resources in both the temple and the government, these workers may have been part of the government-supported guild system. According to the text, they were hired from another location, indicating that the Dunhuang cave-temple administration did not maintain an in-house workshop of artists to execute projects but facilitated their work in the temple. When needed, the materials also had to be procured from outside the temple. Cao and Zhai had to have donated the appropriate amount of dry goods or other items to the temple so that the restoration timber could be purchased. What the text does not spell out is how much they donated, but the large scope of the project indicates that the local king and his family took care of the timber purchase and other expenses. This places the monk-officials who were involved in the Daxiang si (cave 96) restoration in the position of go-betweens acting as social and economic facilitators.

A painting attributed to Zhou Jichang (active ca. 1160–80) best illustrates the relationship of administrative monks to patrons, artists, and the finished work (Figure 1.10). The painting is part of a set pictures of lohan (or arhat, close followers of the historical Buddha); the right half is given over to a depiction of a lohan transforming into an eleven-headed Guanyin (bodhisattva of

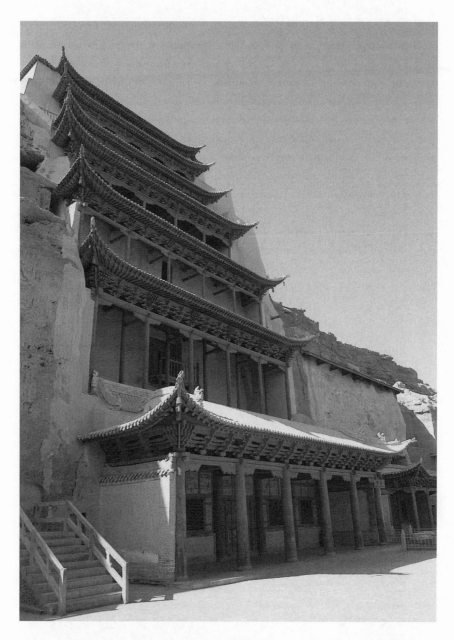

Figure 1.9. Facade, Daxiang temple. Cave 96, Dunhuang. Originally constructed 695. Renovated by Cao Yuanzhong and Lady Zhai, 966. Exterior: H 45.0 m. Photo by H. Wallach.

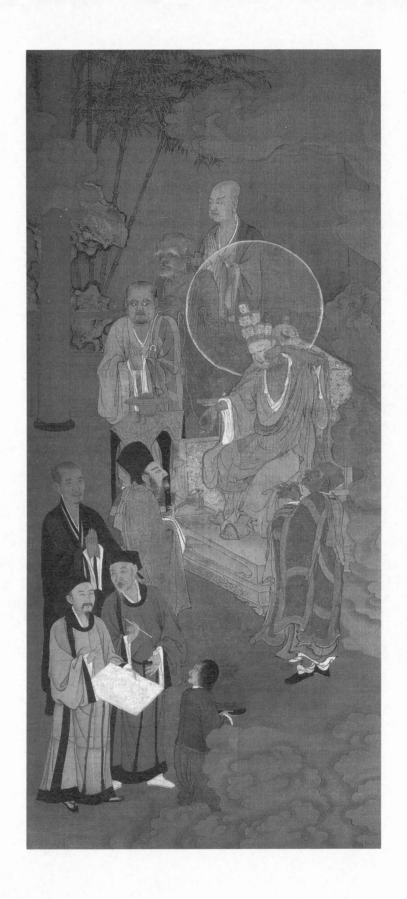

compassion). The manifestation takes the form of a mask, which he appears to take away from his face. This magical aspect of the painting is balanced by a secular commentary on the other side. In the left corner, an artist (presumably Zhou Jichang) is poised with a sketchbook in hand. Another man in secular dress—a donor—looks on; literally positioned between them is a monk who visually embodies the role of mediator standing between both parties, gesturing to one and looking at the other. The painter's self-portrait, rare in the entire history of Chinese painting but almost nonexistent until the Ming (1368–1644), indicates the increased status of the artist noted in both the Yulin inscriptions and the eulogy for the Dunhuang painting guild materials manager, Dong Baode. This twelfth-century picture puts in explicit form the tripartite and interconnected relationship between patron, artist, and the temple monk, with the last as facilitator between the first two. This is important here because while the monk performed the role of go-between in art projects, for the most part he was not an artist or craftsman himself. The auxiliary role of the monk in the artistic sphere is confirmed by the separate group of sketches of maṇḍalas that contain characters and therefore require a high degree of literacy to create. While they may have been involved in the production of specialized visual culture in the temple, the majority of art was made by specialists in the crafts.

After explaining how the artisans were fed in the 966 restoration at Dunhuang, the text continues with a discussion of further contributions by the military commissioner and his wife. The work was completed, an inscription praising both Cao and Zhai was prepared, according to this same text, and then "the princess of the Liang Kingdom, of the Zhai family [Cao's wife], prepared food with her own hands and gave it to the workmen." Although the understanding was that the restoration was complete, the work begun on the nineteenth day of the fifth month was discovered to be insufficient just a few days later; on the twenty-first and twenty-second days, more rotted timbers were found. The couple had left the site but returned, apparently agreeing to fund the second stage of restoration. These repairs were completed by fifty-six carpenters and ten plasterers. The text notes the final feast that brought the project to a close: "These workmen and officials were provided with a banquet (*shifan*). The teachers and pupils made offerings of food (to the Buddha) for three days and afterwards distributed it to various temples."

Figure 1.10. Zhou Jichang (fl. second half of twelfth century), *Lohan Manifesting Himself as Eleven-Headed Guanyin.* Museum of Fine Arts, Boston (06.289). Ink and colors on silk. Southern Song dynasty, ca. 1178. 111.5 cm × 53.1 cm. Courtesy Museum of Fine Arts, Boston. Reproduced with permission. 2001 Museum of Fine Arts, Boston. All Rights Reserved.

Three moments are described when food is distributed: the two banquets that punctuated the end of both stages of repair and the food "heaped as high as the hills" that was provided in the interim. The former may be interpreted as ritual feasting necessary in the dedication of projects and monuments, not only for the artists but for the patrons, saṇgha, and perhaps other members of the community as well. These events help us determine the roles of the patrons, artists, and monks. First, we learn that the majority of professional artists in these types of projects were not monks. The monks did play a role in art production, but although artists and monks had interdependent roles, they were distinct. As we have noted, the chief of monks, Ganghui, was called in to oversee the project and facilitate relations between the government and the temple. When the text discusses obtaining workers for the job, monks are not mentioned; instead, carpenters and plasterers were brought in. When the work was completed, monk disciples helped to celebrate the project, were present at the banquet for the workers, and then made offerings to the statue for three days, after which they distributed the food to other temples. It is evident, however, that their role is separate from that of the artist.

It appears that one of the roles of the dusengtong was to facilitate large-scale projects. Holders of this office, in addition to Ganghui, are found leading cave constructions.[53] Other duties of the chief of monks included overseeing sūtra lectures, such as on November 28, 944, when the chief of monks presided over a lecture on the *Pomo bian yijuan* (Subduing Demons [The Magic Competition] transformation text, P2187) at Jingtu si.[54] Since the chief of monks was responsible for all seventeen temples in the Dunhuang area, one of his duties was to establish the direction of the Dunhuang saṇgha and temples. A famous example of a man who held this position is Wu Hongbian, who was selected by the imperial court in Chang'an to be the chief of monks in the Dunhuang area after the Zhang family ousted the Tibetan rulers in 848. Hongbian, who held office 851–ca. 862, constructed cave 16 for large public ceremonies; after his death his memorial chapel was excavated from the north wall of the corridor in cave 16. The chapel was to become the sūtra cave where the 42,000 medieval documents and paintings were discovered in 1900 (Plate 1). The chief of monks held considerable power and played a prominent role in the history of Dunhuang.[55]

Food and Feasting: Payments in Cooked and Uncooked Food

We now consider additional methods and means of paying artists in tenth-century Dunhuang. Temple financial accounts do not tell us how paintings and sculpture were made, but they do give significant clues about compensation. As we know, hundreds of caves containing over 45,000 square meters of

murals, hundreds of portable banners on silk, and scores of sketches on paper survive from the Mogao cave temples. This prolific output suggests a highly structured organization for painting production at the site. Yet there is precious little information on how the murals were constructed or what techniques were employed to make the hundreds of paintings eventually stored in the sūtra cave. Fortunately, temple accounting procedures required notation of each expenditure and type of revenue handled by temple accountants. As established, payments to artists were primarily in grain; it was one of the regions' commodities of exchange, and temple accounts carefully noted each transaction in daily ledgers.

First, let us consider the nature of these monastic accounts.[56] Temple accountants kept draft records during the course of the year and rewrote them during the first month of the following year. As established, two scrolls in the Pelliot collection detail the accounts of the Jingtu si for the years 925, 931, and 939.[57] This temple, as it turns out, was one of the richest temples in the Dunhuang region, and the survival of its books confirms the largess of a prominent, government-supported temple and the activities its donors pursued to accrue and perpetuate economic and spiritual wealth.[58] Jingtu si was a regular recipient of Cao Yuanzhong's gifts and attention. Jingtu si and other big temples were effectively the nexus of much of the area's economic activity. They provided loans in dry goods to the local population who then returned the amount borrowed with interest. The source of these goods was merit donations made to the monastery. The temples also ran mills that made grain into wine, wheat into flour, and tea leaves into compressed cakes for storage; a price was exacted by the temple for the milling services. Each time something entered or left the storehouse, it was noted. Of particular interest in this study are artistic projects that required resources held in the temple's storehouse.

The exact location of Jingtu si is still unclear. The annual accounts were approved by monk-officials, but they fail to note the temple's specific geographic location. Several possibilities exist. First, the documents were held in Dunhuang's sūtra cave. While that does not prove Jingtu si was located in the area, archaeological finds at the base of Mogaoku reveal that there was once a substantial number of buildings in front of the caves, most likely constructed from mud bricks and timber beams. This is supported by several Jingtu si account entries describing "going up to and coming down from a cave" (shangxia ku) in order to conduct business. One entry for 925 reads, "2 dou [12 liters] of millet used upon the return of monk-officials' trip to and from the caves, in order to buy wine for the community of monks."[59] In another entry, wine was also exchanged for millet for the day the intertemple supervisory officials went "up to a cave temple" to check on the painting master. The frequency of entries mentioning travels between the home base and caves indicate that the

si (temple) was close to, but not in, the grottoes. It is possible that administrative affairs, such as finances, were handled in ground-level structures and auxiliary chapels maintained in the cliff facade above.

The names of at least fifteen, or possibly sixteen, other temples like Jingtu si are mentioned in the Dunhuang documents, attesting to the network of temples in the region.[60] Exactly how these temples interacted and ran their administrations must still be left to speculation, but it is clear that in medieval times an active exchange existed between area temples. These monasteries were quite possibly positioned at the base of the cliff facade below the cave temples. In other words, we have to imagine a cliff facade decorated with wooden architecture, freestanding buildings at its base, and frequent exchanges between cave temples, detached structures, and other monasteries in the region.

PAYMENTS TO ARTISTS: COOKED FOOD

The most basic and typical form of payment to painters was some form of meal or cooked food. An example is found in Jingtu si's accounts for 925, where seven dou (equivalent to 42 liters) of millet are made into wine (*wojiu*) so that the monk official can host (*qu*) a banquet or meal (*juxi*) for a painter (huajiang). In the same document, one-and-a-half *sheng* of oil (about 900 ml) is used by the monk official to host a meal (*tiedun*) for the painter.[61] This withdrawal of oil from the temple storehouse by the monk could indicate that he shared a meal with the artist, essentially rendering a meal as an exchange for services. An alternative interpretation is that the oil was directly given to the artist—a commodity in payment for the painting rendered.

An additional entry in the monastic account, dated to 930, highlights the connection between grain expenditures from the storehouse for artistic projects and feeding workers. One shi and four dou of millet, approximately 0.84 hectoliters, were removed from the temple coffers for a banquet to dedicate an umbrella, probably a parasol for a statue of the Buddha.[62] Since this is such a large sum of grain, we might infer that in addition to its use for the banquet that is mentioned in the text, the artisans received some dry grain as an additional form of compensation. The banquet included the collective artisans (*zhugongjiang*) and the temple's acolytes. Other entries also relate the temple's role as banquet host during the consecration of objects. Four pecks of millet were used to prepare (*shi*) a Buddhist vegetarian feast (*suzhai*) for the gold and silver workers (*jinyin gong*).

In the first payment type (cooked food), three verbs are typically joined with three nouns related to meals. To supplement (*tie*), bestow (*shi*), and host (*qu*) are commonly combined with vegetarian feast (*zhaijie*), meal (*dun*), and banquet (*juxi*). The verb *tie* (to supplement) also implies that the meal was a

supplement to something else, possibly an additional payment not listed. This could have been rendered in a separate transaction that did not go through the temple coffers. If, indeed, artists were largely paid in food, then possibly the regular meals were not provided by the temple, but instead by the patron. Jingtu si appears to have been merely in charge of overseeing the artisans, facilitating the relationship between artists and those who commissioned the work, without assuming financial responsibility. That is, the donations from patrons passed through its coffers, and then were distributed in coordination with the projects funded by the donations. Although quite wealthy, temples were administratively not-for-profit entities; they functioned as conduits for merit-making donations. In this vein, the banquets were essentially some version of *qingke*, literally "invitation of hospitality," a role that would suit a project's facilitators. Qingke is still the primary form of conducting business in China today. Meals are the site of negotiating relationships and work arrangements. In medieval times, temples and their agents acted as go-betweens, a common device used throughout the history of patron-artist relations in China.[63] Go-betweens eased a transaction without the embarrassment of direct negotiation. Accepting donations from patrons, the temple staged the celebratory banquets or meals at the beginning and end of a project and also paid for the wine for hosting visits from supervising monks. Essentially, then, the banquets augmented other regular meals that would presumably be provided for the duration of the project.

PAYMENTS TO ARTISTS: UNCOOKED FOOD

A variant of meals in exchange for services rendered is the payment of uncooked food. Examples of this kind are much rarer; only three conclusive recorded instances are available. Two indicate payment in millet: "nine shi of millet used for the painters and hand laborers." First, the quantity is very large, equivalent to almost 1,200 pounds.[64] This large amount of grain essentially represents a currency transaction, as coin or paper currency were rare in Dunhuang and in large areas throughout China in the tenth century. Officials in the employ of the imperial government in traditional China were typically paid in grain, usually rice, thus it seems reasonable to assume its currency status in this case.

To put this transaction of nine shi into perspective, one dou of millet in mid-eighth-century Dunhuang was worth about thirty-four cash (copper coins). Each shi is comprised of 10 dou, bringing the total dou in this transaction to 90. If the grain were converted to copper currency, it would be worth 3,060 cash, or slightly more than three strings. It appears that this grain was destined for several people. In addition to the painter or painters (*huaren* can be interpreted as a singular or plural noun), *shougong* (artisans) were probably

also given this millet for their own use. Another example of a wage transaction in millet is also located in Jingtu si's storehouse accounts. The relatively substantial amount (1 shi, 60 liters) was first given to the laborer or artisan (shougong) named Shanhui and then to "the gentleman who paints lacquerware." In summary, large amounts of grain were withdrawn from the temple coffers and given to painters and artisans who performed the hired services. The temple distributed the dry goods to the proper parties. These payments provide evidence of an organized management of professional artists. That is, the higher the artist's status, the larger the payments in grain and food. In all the cases of food supplementation (*tie*), the worker listed is not higher than a jiang or artisan, revealing that the artists who were offered a meal were of low status.

While grain functioned as the primary currency in the arts industry, there is one case of an actual currency transaction. A painting master (huashi) was given five dou (30 liters) of millet to buy coins (*ke*, small ingots of silver). In the inscriptions, as in other Chinese sources on painting, records of actual payments in hard cash to painters are rare. Payments in coins, though, may actually have been more prevalent than the records suggest, at least in the metropolitan areas of China.[65] For example, Ennin, the Japanese monk who made a pilgrimage to China in the ninth century and traveled extensively in the central plains, recorded the price of various paintings in currency.[66]

The documents, despite their rather succinct references to the business at hand and matter-of-fact language, provide the earliest extant records of payments to Chinese artists. They give a broad framework of the cycle of merit and exchange in the Buddhist temple. Serving as a mediator between the lay community and the hired labor that executed the merit-making projects, the monastic system transformed every commodity easily into an object or entity with another meaning. If grain or cash coins were accepted at the Meditation Gate in town after a sūtra lecture, they were brought back to the temple and entered into the storehouse of goods and commodities belonging to the sangha. With the entry into the financial books, the gift became a commodity that could serve another purpose; once calibrated into a numerical figure and properly stored, it could be combined with other resources in the future to serve a new event that kept the merit cycle in perpetual motion. Temple granaries supplied the foodstuffs for meals on festival days; the grain from which to make ale to facilitate discussions between temple monks and monastic officials from the central administration; and the symbolic banquet fare at dedication ceremonies. At each moment in this process the status of cooked and uncooked food shifted meaning. First as a gift, then as a commodity within the storehouse, and then as a gift again to the lay community, the grain's physical and symbolic state constantly was in the process of becoming

something else.[67] The impossibility of the gift and the expectations of the gift giver seeking merit was a tension that surrounded the contributions of the lay to the ordained community. No gift was given without the understanding that something else would be provided in return.

In the next chapter we look at how these artists functioned in the workshop itself and consider the central role of the preparatory process in a collaborative production environment. The relationships between the finished wall paintings and draft sketches on paper reveal important information about the cognitive structure established around Buddhist wall painting and allow us to assess the artist's practice and questions of labor from another perspective. The artisan described in this chapter will in subsequent chapters be contrasted with the scribe and performer to further define the world of the medieval professional painter.

2. THE COGNITIVE PRACTICES
OF THE WALL PAINTER

This chapter analyzes artist's preparatory sketches and associated murals in fifteen Buddhist cave temples at Mogao near Dunhuang and at Yulin (see Appendix 1). The iconographic program of these cave temples, constructed by local painting and sculpture workshops from ca. 862 to 980, is similar; their content overlaps by 66 percent, suggesting a planned, organized method of mural production over a century. As discussed in Chapter 1, the workshops served the local court and a closely knit group of devotees who shared an affiliation with the local ruling elite. The key to understanding the standardization of content in the ninth and tenth centuries at the site is the artist's sketches found in the site's sūtra cave. The preparatory drawings provide crucial information about the entire practice of wall painting production. The purpose of the ensuing discussion is to triangulate the relationship between the sketches, the finished murals, and the artistic practice that links these two ends of the creative process.

The cave temples share a standard floor plan. Each is comprised of a main chamber, and, depending on the state of preservation of the damaged facade, an antechamber, corridor, and side chambers. The cave temples were dug from the living rock out of a mountain scarp or cliff facade; after the initial excavation was completed, the dark, black holes dug from the rock were transformed into square chambers, and a raised, sloped ceiling was created with layers of plaster of mud and dried plant material. These rough layers were smoothed with a ground of white that served as the painting base. Every surface inside the cave was, in turn, decorated with wall painting. These compositions contain iconic groupings with narrative details that are linked to Bud-

dhist sūtras. Sculpture is positioned at the back portion of the cave either on open platform altars, in niches carved into the back wall, or on the face of a central pillar. Around this sculpture, assemblies of ordained Buddhists and lay worshippers circumambulated clockwise, reciting sūtras to commemorate the passing of ancestors, mark periods of retreat and fasting as laity took bodhisattva vows, and celebrate festivals days such as the Buddha's birthday. The embellishment of the cave temples was a complex process involving many artisans working collaboratively over a period of several months; the larger caves may have taken a year to complete (Figure 2.1).

This chapter considers the entire spectrum of muralist's cognitive and technical processes. An unusual archaeological find makes the large scope of this study possible. Sixty-five preparatory sketches by ninth- and tenth-century painters were sealed along with thousands of documents sometime in the eleventh century in the sūtra cell in Dunhuang's cliff facade until the year 1900 when they were discovered. They are in remarkably pristine condition, well preserved by the desert climate despite their nine-hundred-year burial. Their survival, along with the 42,000 manuscripts, is truly one of the remarkable aspects of medieval Buddhist art and culture. Art historically, the sketches provide information simply unavailable any other place. They are, as we shall see, linked to the murals at the site and also provide important information relevant to the medieval professional atelier across China and Central Asia. In no other collection do sketches survive from any artist's workshop until the early modern period in China. As established in the Introduction, logistical, technical information is imbedded in their designs, recording the artist's creative and physical activity during the production process—information not preserved in any other materials extant from medieval China. This is the first complete study of their function and meaning.

The painters' preparatory materials typically fall into three basic types for murals and two basic types for works on silk (works on silk are discussed in Chapter 4). For wall painting production, the sketch types include schematic and abbreviated studies for a wall region, detailed studies of specific figure groups in a mural, and pounces for repetitive ceiling designs. For works on silk, sketches were produced in order to make careful copies for tracing and duplicating banners. The final, fifth type of sketch is the diagram used in ritual practice by monks and nuns. The generous and relatively all-inclusive approach of monastic librarians, such as Daozhen of the Sanjie si, whose collections formed the bulk of the hidden sūtra cave at Dunhuang, suggests that we have an invaluable cache of drawing documents typical of medieval workshops.[1]

That these extraordinary draft sketches are the only ones to survive from China's middle period leads us to several important observations about the sta-

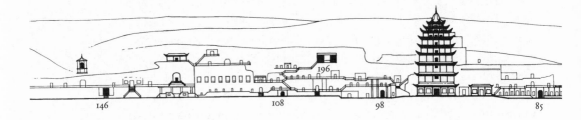

Figure 2.1. Mogao cave cliff facade. Caves highlighted in black, dated to ca. 862–980, are the focus of this study. These include caves 6, 9, 25, 53, 55, 72, 85, 98, 108, 146, 196, and 454, and (not pictured) Yulin caves 16, 19, and 32, located east of Dunhuang.

tus of drawings on paper: sketches were not systematically collected or treasured; and during this period, artistic practices in China did not require a fixed set of drawings in order to complete a work. By contrast, the traditions of Italian Renaissance murals and French manuscripts of the fifteenth century included elaborate studies in dry point and charcoal cartoons. The term "sketch" in the art historical study of these traditions, but especially for the Italian practice, signals the presence of a unique, creative energy based on insight and individual talent. Sketches in the Chinese and Central Asian traditions during all periods do not conform to these practices or standards, nor were they invested with the same status by arbiters of cultural taste in China. It is not just a question of survival. A meticulous collecting culture existed in China in which the value of tradition, lineage, and precedent equaled, if not exceeded, that in European cultures. Portions of rubbings, calligraphy, painting, prints, and books were savored, recorded, noted, and copied for posterity. In the Introduction, I speculate that the notion of class and the artisanal associations related to sketches and copying contributed to the lack of appreciation for and collecting of "old master sketches" in China. This is a major reason for the lack of interest; on the whole, painters were socially and economically ranked very low, although as Chapter 1 discussed, during the tenth century artists improved their social status.

Mural Sketches

Murals were the primary form of painting at Dunhuang, and a rich sampling of types and themes of sketches connected to their production is available for analysis. Each exhibits its own specialized features and suggests distinct production protocols for finishing the ceilings and executing the narratives of the

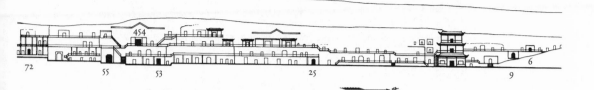

lower walls in each chamber, and making close, detailed studies of primary figures. While some drawings suggest multiple uses accessible to a number of skilled artists for copying purposes, unlike later examples of perfected sketches, many of the Dunhuang drawings are notations and jottings in which the organization, but not the details, of a composition is provided. On the whole, the sketches for murals have a random quality consistent with the freehand drawing technique used in the underdrawing stage of wall painting. They appear to be executed quickly and contain no readily apparent guide to the user indicating compositional relationship to final paintings. Their loose brushwork, layout, and figural detail lend a personal, subjective quality that has little to do with a process of oversight, review, or pedagogical instruction for potential students. In fact, in some cases it is hard to imagine the criteria for keeping these scraps.

Freehand sketching does indeed serve as the key to understanding the random quality of the sketches. It is with the more detailed sketch studies that wall painters executed compelling parts of the murals that would receive attention from an audience in their completed form. The issue of freehand drawing will be a major theme throughout the book. We will see how it was also invoked by medieval critics and deployed discursively as a measure of the skill set of the artist. Of course, freehand sketching was essential to muralists working in all temples, tombs, and grottoes in the Tang dynasty. This skill was disseminated widely in workshops, where it was popularized, and eventually drew the interest of critics who were impressed with the improvisational methods of the muralist—a subject we take up in the last section of the book.[2]

Since the size of the cave temples and freestanding temples changed from one project to the next, freehand sketching was a valuable skill in a wall painting atelier. The muralist combined both drawing techniques and measuring skills to adapt an image to different conditions. The sketches on separate pieces of paper were preliminary drafts, preceding the artist's execution of the underdrawing directly onto the painting surface. At this stage, monochrome

sketches represent one of many necessary preparatory stages in silk and wall painting. And, as such, they indicate the pictorial features of the underdrawing that lies beneath each finished work of wall painting produced at Dunhuang and at freestanding temples that existed in towns and villages all over China during the ninth and tenth centuries.[3] Both sketches and underdrawing are efforts of the preparatory process; their brushwork shares common, abbreviated features.

Out of necessity, artists developed many different stages of ink drawing. The wall painter's technique matured into a range of highly specialized skills. In this chapter we will identify several types of sketch connected to the underdrawing phases of production. Several issues are crucial to keep in mind. Each cave temple at Dunhuang is a different size. Models of fifteen caves produced from 862 to 980 with similar thematic programs are reproduced in Appendix 1. The different floor sizes of each cave are apparent in the drawings in the Appendix. Wall size also changed from cave to cave. Regardless, the number of figures in the narratives of sacred themes ranges from 2,000 to 3,500 per wall, with the size and number of figures decreasing or increasing proportionally. In addition, during the late ninth and tenth centuries, the ceilings were articulated with the simple Thousand Buddha design that required a technique completely different from that used in painting the lower walls. That artists could not count on each cave to be the same shape meant that they managed many factors to insure consistency in iconography, harmony in design, and stability in mathematical precision despite the challenge of changing proportions. The rules or protocols of production are the key to this sameness. If, in fact, no two cave temples are exactly the same size or contain exactly the same program, we have to look to both artistic behavior and cognitive process for a system of continuity. We will not only track thematic content but artistic behavior and practice as a key to understanding the most prolific period in wall painting production in China's history.

Before we turn to an examination of the various types of sketches recovered at Dunhuang, a review of the historical circumstances of local artistic production in the ninth and tenth centuries will help further situate Dunhuang practices.

Historical Background

From the Sui dynasty to the middle of the Tang dynasty (581–780), Dunhuang had close cultural connections with metropolitan centers of China. Cultural models and compositions from the capital, Chang'an, were popular at Dunhuang in the seventh and eighth centuries (caves 328, 45, 220). The

inherent mobility of designs and sketches is suggested by a ubiquitous motif at Dunhuang—the arrival of the king to the debate between Mañjuśrī and Vimalakīrti. Its repetition in different caves indicates how sketches were used over long periods of time. The procession scene in cave 220 at Mogaoku is identical to a figure group handscroll on silk (now in the collection of the Boston Museum of Fine Arts) entitled *Twelve Emperors* that is attributed to Yan Liben (d. 673), a famous court painter who served the emperor in Chang' an. The motif is also found in other caves in Dunhuang, such as cave 154. The primary figure is a king. The bulky, imperial stature, outstretched arms, and regalia are similar enough in all three cases to suggest a shared source for the design. Most likely in the early eighth century, when communication between Dunhuang and the central plains reached its height, some version of the composition in cave 220 was brought from metropolitan China to Dunhuang, along with many other designs. The theme's imperial flavor suggests the design proliferated from China's cultural center.[4]

The dissemination of design via copy sketches from region to region, capital to outlying areas, may explain why, in a time of regular communication and open roads such as the early and mid-Tang, there is a similarity in figural types and motifs in places as distant from each other as the Uighur oasis of Turfan, located to the west of Dunhuang, and Nara, Japan. Scholars have long termed this the "Tang international style," an appellation that attempts to capture the geographical inclusiveness of the metropolitan court style of China that appeared in many workshops across East Asia. The corpulent, hip-shot (s-curve) bodhisattvas and mathematically precise Buddhas, more or less identical in thousands of examples, attest to the endurance of copying and tracing techniques. Other ubiquitous motifs include the paired dragon and phoenix design on sarcophagi, stelae, ceramics, and the ceiling apex of cave temples and freestanding temples. However, this pan–East Asian consistency in iconography breaks down during the period to which these Dunhuang sketches date, ca. 862–980.

At Dunhuang the shift from the metropolitan style was already beginning during the years 781–848, which witnessed the introduction of Tibetan cultural models. Tibetan theocrats held power in Dunhuang after their armies occupied Gansu and parts of Ningxia using what is present-day Qinghai, south of Gansu, as a base. Qinghai remains culturally Tibetan to the present day. In the absence of metropolitan cultural paradigms, a local, indigenous style emerged dominant, consistent with Inner Asia models of the mid-Tang period; by this time, western regions once linked to the empire were separated culturally and politically from the central plains. Artistic programs with Dunhuang origins became the standard as guilds secured regular patronage from

local temples and regional governments. A style of cave embellishment that features prominently placed portraits of local donors emerged at Dunhuang and Yulin, a Buddhist cave site nearby also supported by the local governors. In the tenth century, regional artistic identity grew in western China, linking Dunhuang with the traditions of Sichuan in the southwest, to neighboring Qinghai province to the south, and the region that is now Inner Mongolia, to the north. As discussed in Chapter 1, a painting academy was established in Shazhou during this period, and artists' sketches found at Dunhuang are linked to the advent of workshops, the professionalization of the artisan, and a growing patronage of temple arts that expanded the types of material goods and facilitated their penetration into markets.

The mix of different types of artist's drafts from Dunhuang comprise the remnants of a prolific group of highly organized painters. Were these materials merely random, unconnected survivals? It is possible that the drafts were made after completed paintings by a few, unrelated artists and that these works on paper are just the notes of an unorganized group of painters. The drawings, however, can be firmly linked to the hundreds of finished paintings at the site, suggesting that they are an index to organized workshop procedures. The remainder of the chapter will be an exploration of the many preparatory techniques artists deployed in orchestrated production used to complete those murals. These sketches belonged to the painting workshops or bureau that served the Dunhuang court. In other words, much more than a group of random, unconnected drawings, these works on paper are the product of the professionalized painter's practice developed in association with affiliated regional courts in the tenth century.

Cognitive Mapping

We turn now to the completion of murals and the role of schematic sketches and detailed drawings in the freehand painting process. Five of the six themes we will discuss are identifiable compositions and connected to subject matter for wall paintings frequently reproduced in the fifteen ninth- to tenth-century cave temples under consideration. Thus there is a direct link between the drawings and sustained production at the site. The themes are: Sukhāvatī-vyūha Sūtra (Amitābha's Paradise), Suvarnaprabhāsa Sūtra (Jinguangming zuishengwang jing, Sūtra of Golden Light), Maitreya-vyākaraṇa (Mile xia-sheng jingbian, Maitreya's Paradise), Xiangmobian (Subjugation of the Demons, also referred to as The Magic Competition), and The Debate Between Vimalakīrti and Mañjuśrī.[5] A sixth sketch is a compendium of narrative vignettes associated with several tales; the identification of its motifs is not entirely clear, but the organization of the sketch reveals important informa-

tion about the cognitive processes of the wall painter and is for this reason included despite subject ambiguity. The drafts for each of these six sketches share a common feature. The large expanse that the picture will occupy in the wall painting is referred to only in the most abbreviated, cursory manner in the sketch. The artist notes narrative or pictorial details but ignores their placement in the final composition and eliminates references to the iconic centers that anchor the painting's center.

The highly mnemonic, abbreviated quality of the sketches in this category indicates that they guide the artist in conceptualizing the painting process. Despite their often loose, unconnected features, the drawings reflect a set of cognitive practices that mirror the process of perception in which objects are visually acquired in successive intervals not wholly constituted until the sequence of acquisition is completed. In this way they are cognitive maps—keys to a range of processes and procedures of the artist omitting crucial pictorial features. The organization of the sketches suggests how one might "acquire" or experience a painting, and, by extension, imagine and plan its production. This type of sketch is an index to visualizing artistic activity rather than supplying information for pictorial details. In addition to these highly schematic, condensed maps of a large area, smaller, more focused studies of one vignette in which the artist explores the details of face, body, and action are placed on separate areas of the paper. These individual studies of specific characters concentrate solely on individual figures and omit reference to the larger context in which they appear. Together they suggest the whole process of planning and underdrawing.

Let us turn to an example of these two types of mural sketches to establish the pictorial problem with which we engage in this chapter. In a drawing probably used in connection with Amitābha's Paradise, the artist radically collapses the distance between the main components of the composition (Figures 2.2 and 2.3). The artist also abbreviates the haloes, mandorlas (body haloes), and daises for various deities. These elements are reduced to a series of circles functioning as placeholders for the figures positioned on the stages and elaborately constructed backdrops of the mural of Amitābha's jeweled paradise (Plate 2). In the sketch, the succession of spaces where these figures will appear are blocked out with the bridges and corridors that connect the series of platforms. These spaces are largely left blank. A tree emerges from the recess between two balustrades. Its foliage is reduced to circles that indicate spaces where more detailed forms will appear. In the upper center, the same circles serve to indicate the positions of celestial beings that complement the main icons, such as Buddhas and attending bodhisattvas. Two figures dancing on stages in the lower and center right of the drawing (Figure 2.2) stand out amid

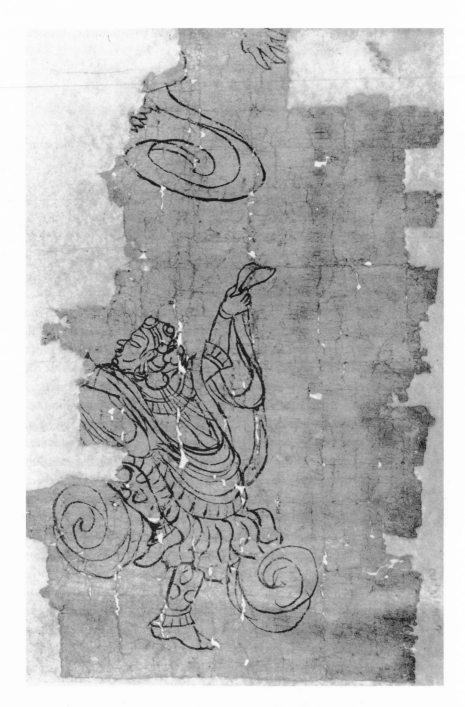

Figure 2.2. (Opposite) Sketch for Amitābha's Paradise, recto. P4514.16.2. Ink on paper. Late ninth or tenth century. 31.0 cm × 19.0 cm. Cliché Bibliothèque nationale de France, BnF.

Figure 2.3. Sketch for dancer on platform in Amitābha's Paradise, verso. P4514.16.2. Ink on paper. Late ninth or tenth century. 31.0 cm × 19.0 cm. Cliché Bibliothèque nationale de France, BnF.

icated to Bhaiṣajyaguru, Amitābha, and the bodhisattva Avalokiteśvara and could therefore belong to any one of them.

Several thematic possibilities may be entertained for the identification of these scenes. The easiest and most compelling explanation is that the first twelve are Queen Vaidehī's (Weitixi) visualizations of the Western Paradise. In the sūtras and pictorial renditions of Amitābha's Paradise, the queen visualizes thirteen objects that will lead to a rebirth into paradise and that are followed by depictions of the three realms of rebirth. The sketch is just one number shy of the thirteen meditations. Further, in the assortment of figures on the right half of the page, a figure kneeling in prayer opposite an icon—the standard format for depicting Vaidehī in meditation as seen in cave 217 and scores of other depictions (Figure 2.5)—is a persistent motif in the messy, hard-to-parse sketch.

Just below the twelfth scene, at the midpoint, another cluster of scenes commences. A figure with attendants appears to be eating; other traveling figures are outside the walls. While one cannot be sure of the identification given the shaky brushwork, the artist has clearly marked the division by assigning a number; for instance, the number "1" appears in the upper left next to a flying banner. If this section is part of the Amitābha narratives, it could portray the scenes of betrayal when Vaidehī visits her imprisoned husband with gruel and honey hidden beneath her robes in order to provide him sustenance. The figures assembled below could be Candraprabha and Jīva, two ministers who appeal to Ajātaśatru, Queen Vaidehī's evil son, who imprisons his mother after she hid the food beneath her robes.

Abruptly, a vertical line divides the scene from another cluster of vignettes; the number "4," written in a variant form, appears on the top of this column; the number "2" appears near the bottom. The numbering continues with the fifth scene in a final column. If we posit that all the scenes on this page are connected to the Western Paradise stories, the other scenes may be identified as the narrative leading to rebirth in paradise. From the bottom right of the sketch, the scenes are the death of the hermit; chase of the queen by Ajātaśatru with sword; continuing from bottom left, the vignettes are the appearance of a divine figure; and Ajātaśatru on his horse as he approaches his imprisoned mother. An alternative possibility is that the two final columns depict the seven perils encountered while traveling from which Avalokiteśvara acts as savior. The figure on the lower bottom, next to the number "5," appears to be enveloped in fire—one of the perils commonly depicted.[10]

In this example, the artist completely segments the auxiliary anecdotes from the iconic center of the composition to which they will eventually be attached, omitting any reference to the larger composition. Their final appearance in a painting complete with icons as reproduced in the section from cave

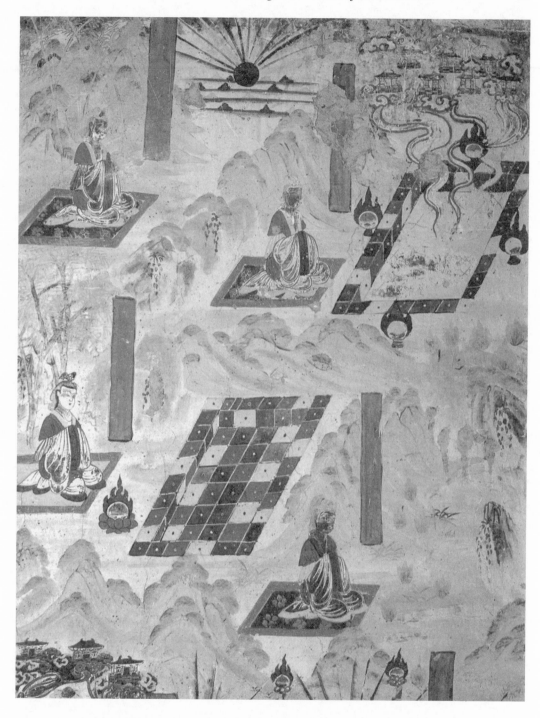

Figure 2.5. Visualizations of Queen Vaidehī. Amitābha's Paradise, Detail. Wall painting. Cave 217, Dunhuang. North wall. Eighth century. 3.91 m × 2.42 m. Wenwu chubanshe.

146 (Plate 2) is radically different. They assume a minor position in a large, intricate, and complex tableau of shapes, tales, and colors. In the sketching stage the artist fractures scenes into independent units, pursuing pictorial elements separately because during the larger process of wall painting production he will attend to each scene as a distinct pictorial unit. These drawing documents clearly belong to an internal creative process; they do not provide the non-painter a guide to the murals. They reflect the randomness and "insider's disorganization" of the working process. The cursory attention given to the narrative order indicates the documents were not intended for dissemination within the atelier. As a template for mural production, they provide insufficient information. The personal quality of the sketches suggests that the head artist responsible for the underdrawing relied on personal notations and did not make drawings for general use and circulation.

The Process of Sketching in Vignettes: Maitreya's Paradise

In a group of drawings associated with Maitreya's Paradise in cave 196, the artist concentrates on ten figure groupings that are central to the meaning and visual force of the painting (Figures 2.6a–d). In this example, instead of a scattered, numerical order of narrative vignettes, each of the scenes occupies a large space on the preparatory paper. Nonetheless, as in the other drawings the identification and ultimate destination of the scenes is not entirely clear. On paper they are spread across the back of a damaged sūtra that extends 7.95 feet (2.42 m) long by 9.84 inches (25 cm) wide (Plate 3). The completed wall composition contains not only the narrative motifs but also a vast Buddhist pantheon encompassing approximately 240 figures and extending 10.75 feet (3.28 m) wide.[11] This sketch suggests that artists had to develop practical techniques of sketching massive compositions because of the considerable size of the murals in cave temples. By 893–94, the beginning date of this cave, these techniques were well developed. In fact, the cave's construction appears to be a pivotal moment in the artist's practice at Dunhuang; in addition to the Maitreya sketches, three long, very important scrolls for The Magic Competition on the west wall and the three drawings for the Sūtra of Golden Light on the south are also extant, evidence that by 893 workshop techniques were already well developed and mature.

As in other wall painting drafts, the artist focuses on pictorial details rather than the relationship of the details to the whole composition. Eleven figure

Figures 2.6a–d. Portion of handscroll with sketches of Maitreya's Paradise, verso. (Text of Diamond Sūtra, damaged, recto.) Stein painting 259. Ink on paper. Late ninth or tenth century. Entire scroll: 24.5 cm × 240.7 cm. By permission of the British Library.

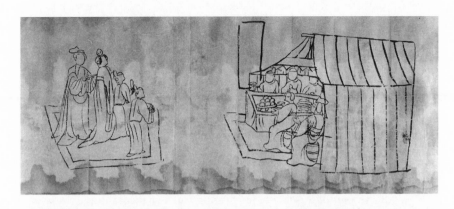

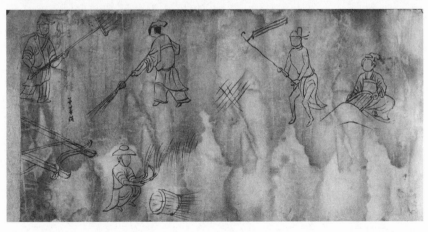

groupings of Maitreya's Paradise are placed at fairly regular intervals on paper. These episodes correspond to the areas to the right beyond the central paradise terraces in the mural where Maitreya holds court as the Buddha of the future (Plate 3). In earlier representations at Dunhuang and other sites, Maitreya usually appears in sculpture, as a bodhisattva in the garb of a crown prince prior to his becoming a Buddha, rather than in wall painting.[12] In later periods at Dunhuang, these early sculptural installations became less popular; and by the eighth to tenth centuries, Maitreya is usually portrayed as a Buddha in complex, schematic paintings such as this example. In later iterations, Maitreya holds court on the large imperial terraces similar to those used for Amitābha in his Western Paradise. Around this grand display are narrative scenes highlighting the joys of life in Maitreya's soon-to-be-realized realm. It is to these sections that the sketches on paper correspond.[13]

The Maitreya's Paradise wall paintings are part of very complex grotto programs with many tableaux placed side by side on both the north and south (left and right) walls. Palette and style make each of these six compositions almost indistinguishable.[14] Therefore, another possible reason artists chose to sketch only the narrative scenes on paper is that these are the only elements that changed significantly and are the important motifs that distinguished one composition from another. The four uniform-sized paintings on each of the north and south walls in cave 146 are typical of the streamlined approach to representation in the late Tang and Five Dynasties, in which a uniform palette and design extends across an entire wall and throughout the entire cave (Plates 4a–b). Across the two wall surfaces eight compositions are delineated; five of these contain a grand terrace supporting the court of a Buddha including the Maitreya's Paradise, Avataṃsaka Sūtra, Bhaiṣajyaguru's [the Buddha of Medicine] Paradise, Lotus Sūtra, Amitābha's Paradise, and Sūtra of Golden Light.[15] Unlike the new narrative conception of a physical brawl between Buddhists and nonbelievers in The Magic Competition on the cave's west wall, these iconic-centered *jingbian* (sūtra tales) or *bianxiang* (storytelling tableaux) feature scenes that draw on a schematic formula for devotional imagery devised in the seventh century. The paradises feature a central icon, bodhisattvas, and attendant monks, encircled by vignettes subsidiary to the Buddha.[16] Little action is included, but the compositions contain busy, closely packed imagery. Much of this could be duplicated from one composition to the next.[17]

The difference in compositional style, however, seems not to affect the artist's sketch notations. Although the vignettes around Maitreya's paradise are small and blend into the seamless program of grand iconic displays, narrative details in each paradise remain important. Judging from these sketches, artists worked diligently to perfect details. The most impressive example of a late

Tang dynasty version of Maitreya's future arrival is in cave 25 at Yulin, dated to ca. 825, but little of it is directly related to the sketches in question. Instead, cave 196 corresponds more closely in style and content to the sketches on paper than any finished extant painting of Maitreya's Paradise.[18] The scenes in the sketch correspond directly to a circle of vignettes on the upper and lower right side of the mural in cave 196.

The upper section is devoted to auspicious events after Maitreya's coming.[19] The lower third is devoted to preparation for this coming. In general, the painting is organized chronologically between events in the immediate future and those that will occur in the distant future. In the lower section, men and women prepare for the arrival by taking the tonsure; the investiture of nuns takes place in enclosures marked by a canvas cloth and poles. Nearby, in another enclosure in the right corner, faithful women gather for a wedding that takes place in future time.[20] In the sketch, the wedding and other scenes are placed separately, side by side across a long scroll, but in the wall painting the artist places them together to form clusters of activity.[21]

It is with the scene of a large wedding banquet that the sketch scroll begins. A group of women is gathered around a large table inside a tent while two men and women present themselves outside on a mat. In cave 196 the wedding scene corresponds exactly to that found in the sketch, including the angle of the mat placement, the tent stripes, the number of figures (five in the tent, four outside), and the costumes. Even the cartouche to the left of the food-laden table is located in the same position. Although cave 33 at Mogaoku also includes this scene, details differ. The tent and mat are enclosed by a cloth-type fence rather than being left unfenced. This banquet scene is also depicted in the Maitreya composition on the north wall of cave 25 at Yulin, but the detail of four figures (two men flanking women) presenting themselves at the tent's opening is omitted. Instead, the enclosed group of women awaiting tonsure is pushed against the wedding scene. In a silk painting of Maitreya's Paradise (Figure 2.7), the tonsuring is included while the wedding banquet is omitted (not reproduced). There are at least five other scenes (plowing, transmission of the robe, threshing wheat, sorting the grain, and loading it into the cart) that appear consistently in the wall paintings but not the silk version, which is dated to the same period (late ninth or early tenth century) as the mural. Therefore, we may conclude that while the portable and wall versions of the theme are related, the sketches were used to produce murals, not banners.

The next scene in the sketch is another vignette connected with the ease of life under Maitreya's reign. With a wooden switch, a farmer urges his two oxen to plow a plot of land. This scene signifies that agricultural work is easy and produces great bounty under Maitreya.[22] In the upper right section of the

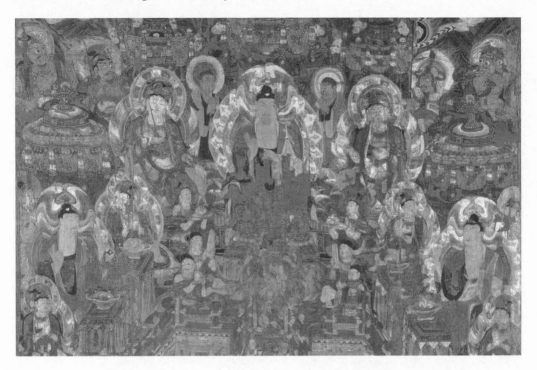

Figure 2.7. Maitreya's Paradise: iconic configuration. Detail, center. Stein painting 11. Ink and colors on silk. Late ninth or early tenth century. Entire banner: 1.39 m × 1.16 m. Copyright British Museum.

mural in cave 196, this plot has a pink ground offsetting the peasant's hand-held plow; the scene is identical to the sketch. Above the plowing scene are the harvesting activities that follow the seed sowing and planting. Again, the postures and relationship between the figures are almost identical, with corresponding scenes of harvesting in the drawing placed at the end of the scroll—a woman harvests wheat with a sickle; a man threshes stalks of grain (represented by crosshatch marks). A pair sweep and toss the grain to separate the wheat from the chaff; another figure sorts the harvest in bushels. The scroll appears to continue, although it is cut or damaged at the edge of a mule harness. In the finished painting, this section depicts the cart bringing the harvested grain to market; the right edge of a wooden frame in the sketch may be the market cart.

Most significantly, the organization of the sketch is consistent with the two drawings of Amitābha's Paradise and the sheet of scenes numbered "1–12." In each, the artist's focus is on individual vignettes or parts of the composition only. Here, in this example, Maitreya does not appear in any significant form in the sketch. The order of the vignettes is not provided, although the cartouche boxes indicate where the verbal explanation will be placed in the final

version. In addition to omitting the main actor, the artist made further abbreviations by eliminating from the drawing facial features, color references, and architectural details. These lacunae make it difficult to identify completely all the motifs that lie between the wedding scene in the beginning and the harvesting scene at the end.

Almost as an afterthought, Maitreya is depicted in the sketch as emanating a powerful radiant light to demonstrate the promise of his realm (in a schematic triad just left of the oxen).[23] The other cluster of scenes in the immediate vicinity includes a heavenly king with flag and shield, a monk seated on a dais with two adoring figures, and a tree with a monk's bag below. All are found in the mural except the last. It is possible that this final figure is located in the damaged section of the upper left half of the mural. Perhaps the latter scene is a reference to the transmission of the robe from the Buddha to Mahākāśyapa, a related tale spun into Maitreya's Paradise lore. In cave 25 at Yulin (upper left), the scene is still extant in perfect condition. Mahākāśyapa on Mt. Kukkuṭapāda waits in a grotto for the Buddha, who then transmits the robe in a nearby scene.[24]

In the scrolls' middle section, the scenes are connected to the section of the Maitreya lore explaining the ease of death in the future realm.[25] At the onset of death, each person will go willingly to his or her tomb and die. In the sketch in front of the pagoda-shaped structure, a figure is prostrate, wailing. A couple stands respectfully in prayer at the structure's left side. In the preceding hut-like structure, two elderly figures pay their respects outside a walled compound. These events appear to correspond to the voluntary removal to one's tomb upon impending death.[26] Afterward, relatives visit the grave site to bid farewell to the dying; later they pay respects at a family shrine. Both the hut compound and the pagoda attended by worshippers are found in the mural's upper right section in cave 196. The preferred shortcut for making sketches for the wall paintings involves omitting the iconic centerpieces of compositions that, in their final form, tend to feature space-crowding thrones of Buddhas and bodhisattvas. These observations are applicable to another set of drawings for Amitābha's Paradise crowded on the recto next to the draft drawings of Vimalakīrti. No iconic reference is included to clarify the order of these vignettes. Oriented in the opposite direction from the other sketches on the scroll, the scenes are roughly arranged in two halves (Figure 2.8; see also Figure 3.8b). The right half deals with the events leading up to Vaidehī's visualizations of Sukhāvatī and the left, the actual visualizations.[27] The chaotic compression of scenes is further confused by a lack of reference to the Buddha and his retinue of heavenly attendants positioned on courtly terraces.

Beginning at the top midpoint of the page and working downward, Vaidehī meditates on the sun, water, ice, and a lotus pond.[28] Although the

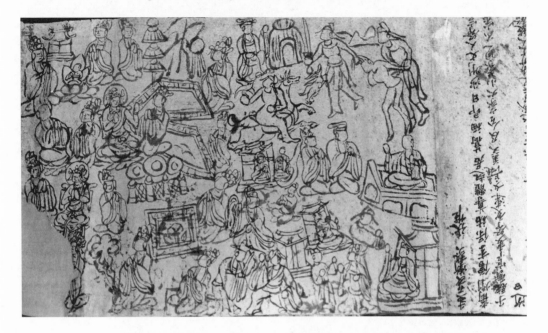

Figure 2.8. Sketches for Amitābha's Paradise, Visualizations of Queen Vaidehī (next to draft letter and Vimalakīrti sketch). Detail, recto. Stein painting 76. Ink on paper. D. 917 or 974. Entire composition: 31.0 cm × 127.0 cm. Photo by author. Permission to photograph courtesy of British Museum.

order is not entirely clear, the artist seems to begin again at the top, just to the left of the sun. Vaidehī meditates on a decorated stand—the treasures of paradise. Moving to the middle of the page, she visualizes a pavilion and an arbor. The vignettes are arranged in a switchback pattern that effects variety in the design when they are placed in vertical narrative strips around the iconic paradise.[29] The last group of meditations appears in the far left with Vaidehī engaging a series of divine figures (probably Avalokiteśvara and Mahāsthāmaprāpta). Finally, she meditates on the lowest form of rebirth—a lotus bud, here anthropomorphized as a newborn infant. This type of sketch contains little in the way of easily recognizable imagery, pointing to a sketch tradition in which compositional guides are kept distinct from pictorially true drawings. The former are less concerned with the picture and more concerned with its comprehensiveness—a guide to the sum of its parts.

Sūtra of Golden Light

The practice of isolating clusters of figures and executing them in sketches without reference to the iconic context or their thematic identity is evident in

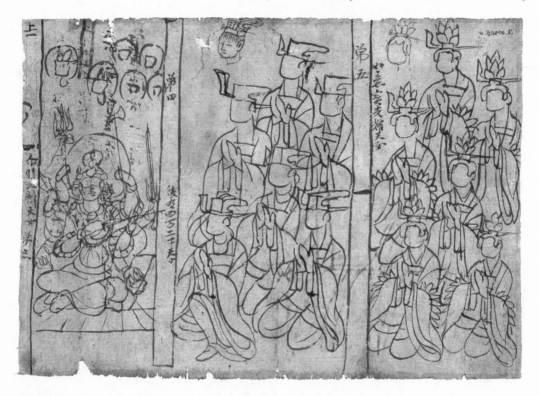

Figure 2.9a. Sketch for Sūtra of Golden Light: Sarasvatī and groups of worshippers, recto. Stein painting 83(1). Ink on paper. Late ninth or tenth century. 29.7 cm × 43.0 cm. Copyright British Museum.

another group of sketches for the Sūtra of Golden Light (Figures 2.9a–b). Each of the three sheets of drawings features abbreviated groups of figures, hands pressed together in attentive worship. Next to each of the groups are cartouches or long strips, each with an identification of the figures to its right; they include worshipping kings, princes, women, heavenly kings, and yaksha, powerful earth deities whose energy has been marshaled to protect the dharma.[30] The artist has again used a shorthand to indicate their placement within a larger composition. Their order in the mural is indicated by region and numerical order specified within each section; the artist writes: "middle section, number three," "middle section, number four," "upper [section], one," and so on. This provides a simple guide to their final placement in lieu of making an entire sketch of the whole composition.[31]

Sarasvatī, the goddess of music and poetry, other female and male worshippers, and a bodhisattva are reproduced here in this manner; a bridge is on the verso along with an unrelated list of sūtras.[32] In wall paintings with the sūtra's theme, clusters of devout male officials, high-ranking women, earth

Figure 2.9b. Sketch for Sūtra of Golden Light: detail of a bridge, verso. Stein painting 83(1). Ink on paper. Late ninth or tenth century. Entire composition: 29.7 cm × 43.0 cm. Copyright British Museum.

deities, armored guardians of the four directions, and other heavenly beings are similarly broken into clusters of like figures, identified by colophons on the far left edge of each grouping (Plate 5). Each group faces Śākyamuni at the painting's center. A small bridge, also depicted on the drawing's reverse, leads down to the waters with newborn souls emerging from flowers. The angle, size, and arc of the architecture in both the sketch and finished painting are nearly identical.

The artist's practice of separating scenes into discrete sections appears to replicate the viewer's sensory apprehension of the subscenes or plots within these larger, complex tableaux of Maitreya's Paradise and the Sūtra of Golden Light. The artist works in a manner consistent with how the viewer sees and comprehends the painting; the processes of production and reception are well matched. In theories of visual cognition, scholars argue that the human eye processes information in relatively small sections.[33] Similarly, scanning the painting surface, we assimilate information successively, our short-term memory engaging images for only a matter of ten to twenty seconds. It is in long-

term memory that these successive impressions coalesce to comprehend the visual field and produce meaning, yet we experience no sensation other than simultaneous acquisition of information arrayed across a surface.[34]

The artist's practice in wall painting production appears to replicate the process of seeing and acquiring information consistent with the physical function of image acquisition. The production process is conditioned by sensory perception; ultimately this process impacts the viewer, who is presented with an arrangement of visual information in discrete, small sections. In composite sketches the artist divides pictorial information into distinct units; when these are applied to walls, the viewer must connect the disparate scenes and combine them to produce narrative substance. The artist's process of working in segments embodies the way space and figures are perceived by the human eye. As storyteller, the viewer actively searches the cartouches that signal the location of each new moment.

The Magic Competition and the Transposition of Shapes

The greatest range of draft sketches extant for one composition are scenes for the Laoducha dousheng jingbian (The Magic Competition Between Raudrāksha and Śāriputra), also known as the Xiangmobian (Subjugation of Demons).[35] The theme is depicted in fifteen different caves dating from ca. 862–980 at Dunhuang's Mogaoku and nearby Yulin (see Table 2.1). Interiors of two of these cave temples (196 and 146) are reproduced here in Figure 2.10; Appendix 1 contains the elevations and ground plans for all fifteen.[36] Typically, this theme occupies the entire back (west) wall of the grotto and is positioned on one's left during circumambulation in the dark path behind the altar of sculpture (Plate 6 and Figure 2.11). These back walls are enormous; they range from 17 feet to 41 feet in length. Predictably, artists found it most useful to use both the conceptual diagrams and the close studies of individual figures to complete murals on these large surfaces. The size of compositions made it impractical to make regular, miniature studies of whole compositions.

The large size of the walls is one of two issues that affects the size of the figures in each composition. No two caves are exactly the same size, and artists altered the figures in The Magic Competition murals to fit each new space.[37] Cave sizes changed for several reasons. The geological structure of the cliff meant that artists had to work around the unpredictable results of excavating a space with large boulders nestled in sandy soil that could often collapse if disturbed. Cave size was further affected by the patron's resources and whether the grotto was created for assembly or as a small memorial shrine. For example, cave 55 (962) and cave 25 (974) were produced for the same patron, the regional commander Cao Yuanzhong; cave 55 is more than two-and-one-half

TABLE 2.1

Cave-Shrines with The Magic Competition and their Donors

	Date	Managing Patron (*Kuzhu* 窟主)	Donor/Family (*Gongyangren* 供養人)
Cave 85	862–67	Zhai Farong 翟法榮	Cave of Monastic Controller Zhai 翟僧統窟
Cave 9	892–93	Unknown	Suo Xun 索勳, r. 892–94 Zhang Chengfeng 張承奉, r. 904–20 Cave of Zhang Chengfeng 張承奉窟
Cave 196	893–94	Dharma Master He 何法師	Suo Xun 索勳 Cave of Dharma Master He 何法師窟
Cave 72	before 907	damaged	
Cave 146	920–40	Covered with Xi Xia mural	Song Family Cave 宋家窟
Cave 98	923–25 940–45	Cao Yijin 曹議金 Restored by King of Khotan	King's Great Cave 大王窟 Li Shengtian 李聖天
Yulin 19	924–40 962	Cao Yijin 曹議金 Restored by Cao Yuanzhong 曹元忠	r. 921–35 r. 944/45–74
Yulin 16	936–40	Cao Yuande 曹元德	r. 935–39 Deceased Cao Yijin 曹議金
Cave 108	935–39	Zhang Huaiqing 張懷慶 Cao Yijin's younger sister's husband	Cave of Official Zhang 張都衙窟
Cave 454	939–44 976	Cao Yuanshen 曹元深 Restored by Cao Yangong 曹延恭	r. 939–44 r. 974–76 The Cave of the Grand Protector 太保窟
Cave 53	953	Cao Yuanzhong 曹元忠	Cao family
Cave 55	962	Cao Yuanzhong 曹元忠	Cao family
Cave 25	974	Cao Yuanzhong 曹元忠	Cao family
Cave 6	980+	damaged	
Yulin 32	980–1002	Cao Yanlu 曹延錄	r. 976–1002

NOTE: Cave 44, a Tang cave renovated in the Five Dynasties, may once have included a porch that contained a tenth-century Magic Competition composition, but no remnant is extant.

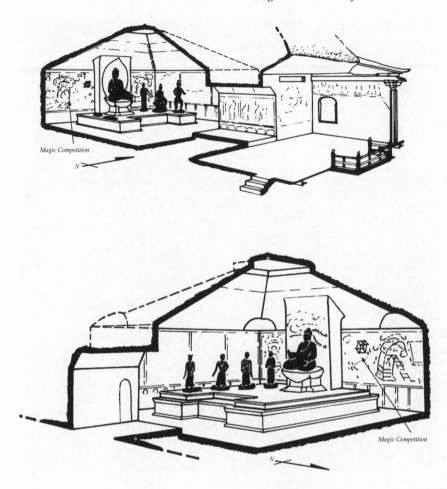

Figure 2.10. Three-dimensional view of caves 196 (top) and 146. Position of The Magic Competition indicated. Design by the author.

times the size of cave 25.[38] From one grotto to the next, the wall space may increase or decrease, but iconography demands that the figures and compositional features be consistent from painting to painting. This is clear in these two examples executed within several decades of each other.[39] Artists standardized and maintained the same ingredients regardless of the cave temple's size. Only proportion required adjustment; the size of the figures had to be adjusted to the size of the wall, eliminating the decision of which figures to include.

These transformations are possible with a flexible painting program based on preparatory drawings that segment figures into discrete, transposable parts. Freehand drawing that readily adapts to changing wall sizes helps the process. This skill is one that ninth-century critics often remarked upon in connection

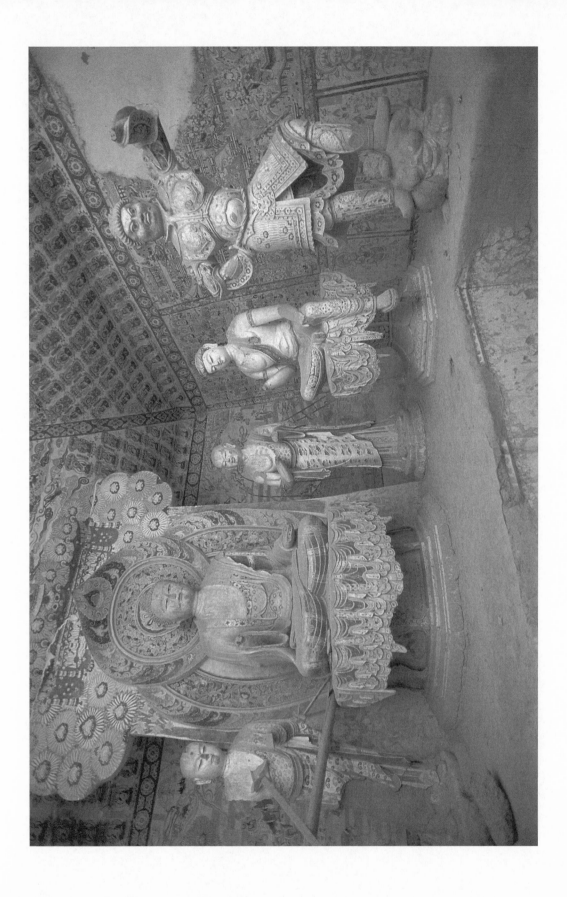

with the legendary, mythologized wall painter Wu Daozi because the ability to transpose figures into new spaces in freehand drawing was a noteworthy but necessary talent. No examples of drawings made to scale are known to exist from any mural workshop. This flexible sketching regime allows for the figures to remain fixed while the size is reduced. Consider the changing size of the wall paintings of The Magic Competition in these fifteen caves. They range from 7.81 to 12.25 feet (2.38 to 3.73 m) in height (not including the ceiling spaces, which can increase the height by as much as 50 percent in some cases) and from 18.25 to 40.78 feet (5.57 to 12.43 m) in length.[40] Two examples, from caves 196 (d. 893–94) and 146 (ca. 920–40), are reproduced in their entirety in Figure 2.12. The reproductions of the murals are adjusted to approximate their relative sizes, indicating that while the length of cave 146 is 8.5 percent smaller, the height of the composition is 21 percent smaller than the same composition in cave 196.[41] Despite the change in size, the thirty-one central vignettes of the tale are included in both murals and identified by cartouches that explain each scene in the text.[42] These thirty-one narrative moments are occupied by 113 to 215 figures in caves 196 and 146, respectively. In cave 146, the space has shrunk, but the number of subsidiary figures has increased, making for a more crowded, overpopulated composition. The artist has not altered the essential iconography, but expanded the number of details.

If the iconography remains consistent, the adjustment must occur in the proportion of the figures, which expand or contract according to the increasing or decreasing size of the wall space. For example, the main protagonists, Raudrākṣa on the viewer's right and Śāriputra on the left, are considerably smaller in cave 146—what one would expect given the reduced scale of the cave temple.[43] In cave 196, the figure of Raudrākṣa is ca. 8 feet (2.44 m) tall and 3.1 feet (0.95 m) wide; in cave 146 the height is 6.75 feet (2.05 m), but the width is considerably smaller, at 2.1 feet (0.65 m). (See Plates 7 and 8.) The reproduction according to scale makes these differences clear (Figure 2.12). Artists are obviously employing a system of transposition—much like changing key while playing the piano. The song or theme remains the same. As the key shifts, the sound changes but the relative relationship between elements (keys or figures) remains constant.[44]

This statistical analysis tells us a great deal about copying, reproduction, and artistic practice in the mural atelier. While the consistent iconography might lead us to presume that each of these caves, versions, or iterations of each other are nearly identical, they are not. The features determining "sameness" need to be examined further. One might suspect that if cave size is not

Figure 2.11. View of sculpture and sculptural platform, west wall obscured. Cave 196, Dunhuang. West wall: H 5.30 m. Dunhuang Research Academy.

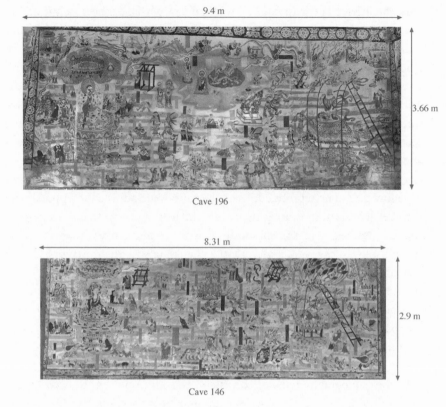

Figure 2.12. Comparison of west wall size, caves 196 and 146. Design by H. Wallach and the author. Dunhuang Research Academy.

identical, figure size will increase or decrease proportionally in a manner similar to the enlargement feature on a Xerox machine (to use an anachronistic analogy). However, no discernible pattern exists. The area of composition is not proportionally consistent in larger and smaller caves. But the effect of symmetry and order is real; the paintings appear consistent with the other compositions, and the frames' widths are nearly the same size. This framing technique contributes greatly to the impression that the entire cave is not only ordered but a replica of another cave with similar contents produced during the same period. Yet the figures inside, executed freehand, are not measured to scale. The artists spent a great deal of time in order to convey the impression of mathematical precision, but in reality no such exactness exists. And in caves that appear similar, the sense of proportionality is false because there is no ratio of expanding size of cave to expanding size of figures; each composition is different.

Instead, the crucial factor linking caves from the same period is the prac-

tice of painting surrounding their production. This involves the artist's inter-
action with the cave-temple space and the cognitive process of applying pic-
torial elements to its architectural frame. Freehand drawing directly on the
cave's surfaces demanded an active engagement with material and form. Given
the changing size of each cave temple, the artist's performance of each theme
required him to adapt the artistic content. Assessing the space of an unem-
bellished cavern or an empty freestanding temple and formulating an artistic
plan of action were the responsibility of the head artist (*duliao*). Using the
fifteen caves dated to ca. 862–980 paradigmatically for understanding artistic
practice during this period, it is clear that the workshop manager had to have
the ability to judge a space in its raw, inarticulated state, assess the production
of compositions and the thousands of figures to be located in each new space,
and deploy the pictorial form according to traditional expectations of icono-
graphic recognition. By isolating each scene as a separate unit in the prepara-
tion and execution stages, the artist is able to treat each section as an inde-
pendent entity and adjust it as needed. The inherent mobility of figures as dis-
tinct scene clusters is an effective way to manifest the complex scenes in an
adaptable system. Wall painting, as this summary of management skills sug-
gests, was an extraordinarily complex and multistaged process.

The cartouches, intended for explanatory captions, also provide a visual
demarcation signaling each scene as a separate unit in both the artist's pro-
duction and the viewer's reception of the mural. The boxes are outlined in the
process of painting and initially left blank by the painter for scribes. These
boxes allowed the scribes, who filled in the text after the painting was com-
plete, a specific environment in which to include the text in an easily con-
tained and identifiable manner. Crib sheets used by cartouche inscribers to
complete Dunhuang wall paintings (further discussed in Chapter 5) are
among the manuscripts found in the sūtra cave. These documents do not con-
tain any pictures or references to the pictorial contents of the wall paintings,
indicating these separate drafts were made for the express purpose of writing
the text. As accomplished professionals, the scribes, too, appear not to have
needed any reference to the compositional whole when executing their por-
tion of the murals. This system was flexible and transposable enough to be
useful from cave to cave.

Let us look more closely at the sketches themselves.[45] Two of the scrolls are
only single sheets with sketches on both the front and back (Figure 2.13).[46]
The third is much longer, containing a series of five roughly equal-sized pages
(Figures 2.14, 2.15, 2.16, and 2.17), joined together after being used by the
artist; an inscription is added at the end.[47] All the drawings that survive are
related to the right side of the finished murals, which is concerned primarily
with the last and most prominent of six contests, all tests of spiritual might

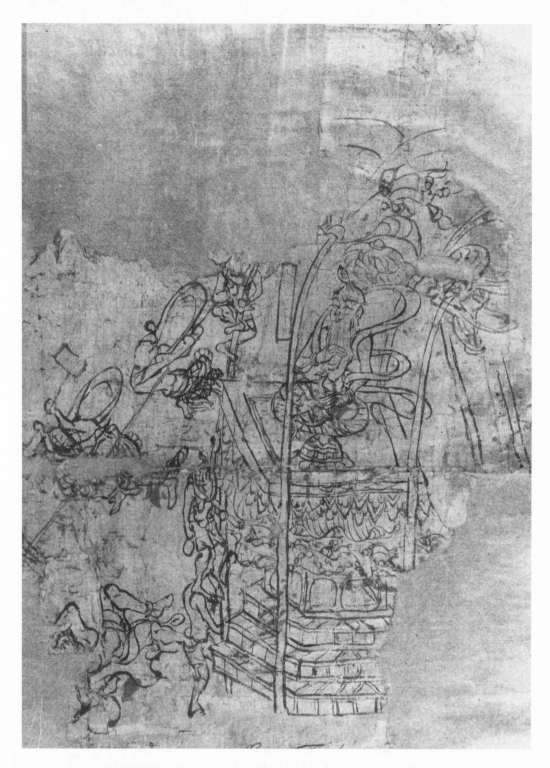

Figure 2.13. The Magic Competition: Raudrākṣa, seated on throne, and fellow heretics. Sketch for mural composition, recto. P. tib. 1293(1). Ink on paper, one sheet. Late ninth or early tenth century. 57.0 cm × 36.0 cm. Cliché Bibliothèque nationale de France, BnF.

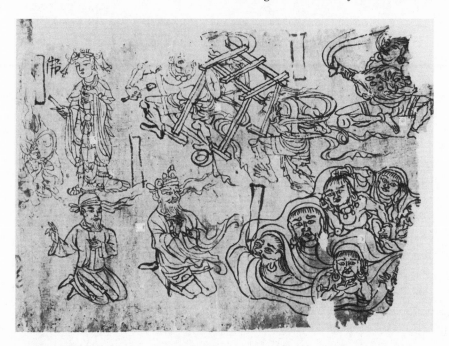

Figure 2.14. The Magic Competition. Composite sketch of five important scenes placed around the throne of Raudrāksha, recto. P. tib. 1293(2). Handscroll, ink on paper. Late ninth or early tenth century. Entire scroll: approx. 29.0–35.0 cm × 176.0 cm. Cliché Bibliothèque nationale de France, BnF.

between Buddhists and non-Buddhists (heretics) that the murals depict. The last contest culminates in the crushing of the heretics in a gale wind; in the right half of the mural they are shown in their final moment of defeat. They buckle under the Buddhists' wind, tangled within their own tent canopy that has blown from Raudrākshaʼs dais. As the hurricane envelops their bodies, they scream in anguish and block their ears in pain. The painting's figures are exaggerated; they are part of the fantastic realm and perform their activities as part of a highly ritualistic performance of magical powers between the Brahmans and the Buddhists.

The magical contests are part of a more elaborate story involving a minister of Śravastī who, impressed with the spiritual fortitude of Śāriputra, converts to Buddhism. He then attempts to find a park in which to build a temple to demonstrate his piety, reproduced in the upper right (Figure 2.18). After selecting the land of a local prince who challenges the compensation for his property, the matter is referred to the king; the heretics seize this opportunity to obstruct the pious acts of the Buddhists. The local king proposes that their leader, Raudrāksha, confront the monk Śāriputra in a test of magical power

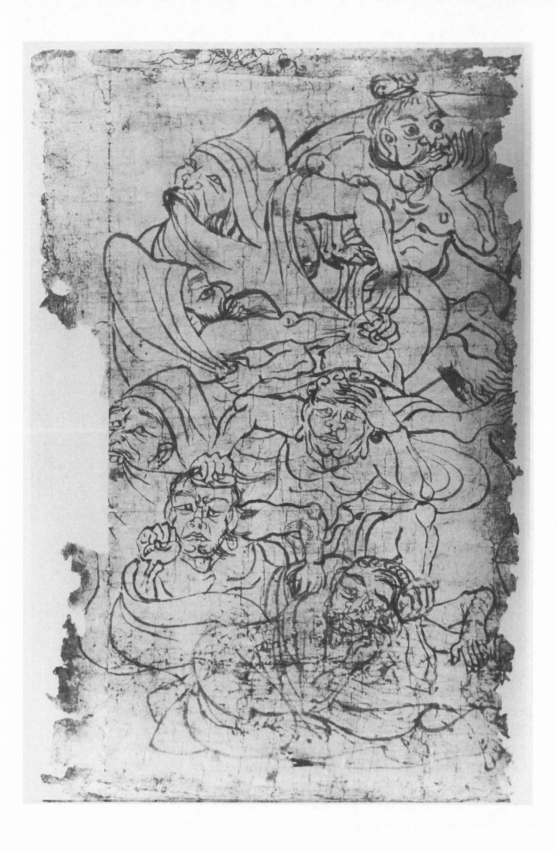

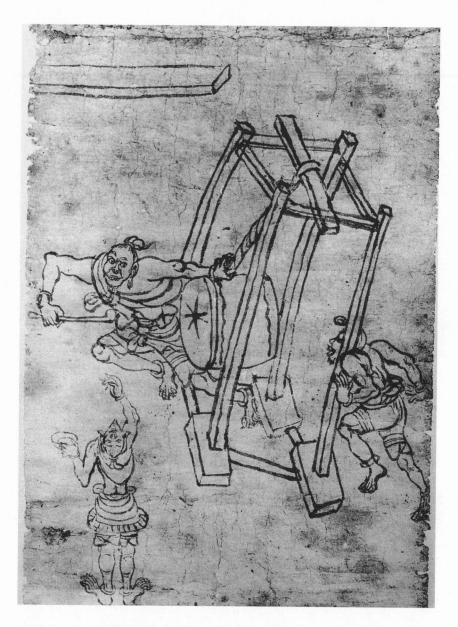

Figure 2.15. (left) Sketch for The Magic Competition. The seven heretics tousled in the tent canopy below Raudrāksha's throne, recto. P. tib. 1293(2). Handscroll, ink on paper. Late ninth or early tenth century. Entire scroll: approx. 29.0–35.0 cm × 176.0 cm. Cliché Bibliothèque nationale de France, BnF.

Figure 2.16. (above) The Magic Competition. Sketch of the heretics about to sound the victory drum, recto. P. tib. 1293(2). Handscroll, ink on paper. Late ninth or early tenth century. Entire scroll: approx. 29.0–35.0 cm × 176.0 cm. Cliché Bibliothèque nationale de France, BnF.

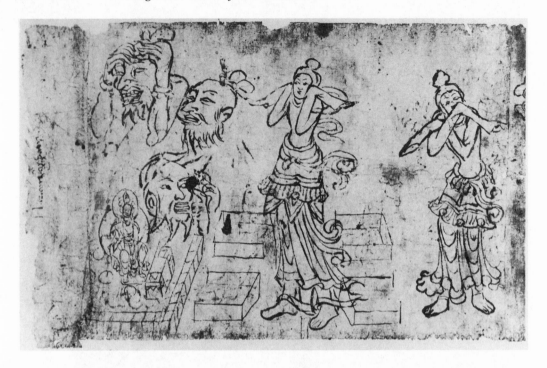

Figure 2.17. Assorted sketches for The Magic Competition, Heretics in anguish, women and men protecting their ears, mouths, and heads as the gale crushes their camp. Buddha lecturing in the Jetavana garden, lower left, recto. P. tib. 1293(2). Handscroll, ink on paper. Late ninth or early tenth century. Entire scroll: approx. 29.0–35.0 cm × 176.0 cm. Cliché Bibliothèque nationale de France, BnF.

in six contests, depicted in Figure 2.19. First, Raudrāksha manifests a jeweled mountain; it is crushed by a vajra power brought forth by Śāriputra. In the next test of magical skill, Raudrāksha's bull is devoured by Śāriputra's lion, a symbol of the Buddhist dharma. Following that defeat, the heretics' pond is consumed by an elephant (also a symbol of the law) called forth by Śāriputra. Next, a mythical, golden-winged bird is manifested to devour Raudrāksha's powerful dragon. And Vaiśravaṇa, the guardian of the north, overwhelms evil demons. In each case the winner is Śāriputra, who relies on superior power channeled to him by Śākyamuni. These first five contests will again become important when we consider the storyteller's performance scroll of the same theme in Chapter 5.

Śāriputra's moment of triumph comes in the sixth battle. Raudrāksha desperately manifests a large tree hoping to overpower the Buddhists' camp. In the murals the tree has already shrunk in size. This occurs when Śāriputra answers the colossal tree with a gale that pummels the heretics. The chaotic

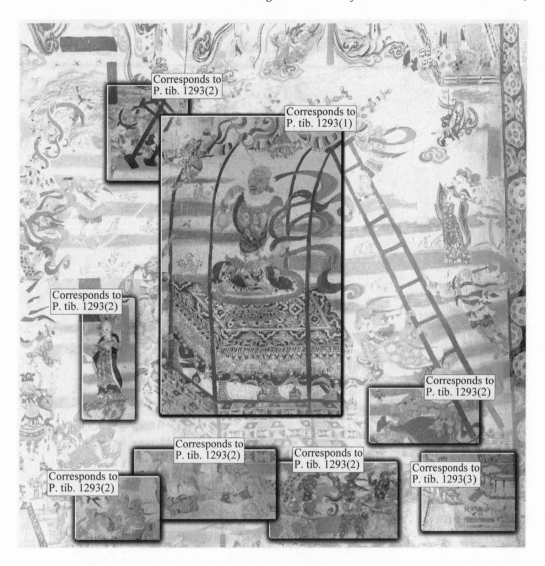

Figure 2.18. Magic Competition sketch corresponds to P. tib. 1293(1), P. tib. 1293(2), and P. tib. 1293(3) (29.0 cm × 43.0 cm). Wall painting in cave 196, Dunhuang. West wall, right (northwestern) section. Detail: approx. 3.19 m × 3.16 m. Photo © Dunhuang Research Academy. Design by H. Wallach and the author.

curvilinear, wind-bent forms on the right contrast with the rectilinear stasis of the calm, Buddhist camp. The heretics become frenetic. As the Buddhists' gale overturns everything, snakes appear and devour Raudrākṣa's once towering but increasingly feeble tree. Because the weight of the mural composition rests on the final moments of defeat, it makes sense that in the practice sketches, too, the artist explores the most exceptional and active parts of the story's cli-

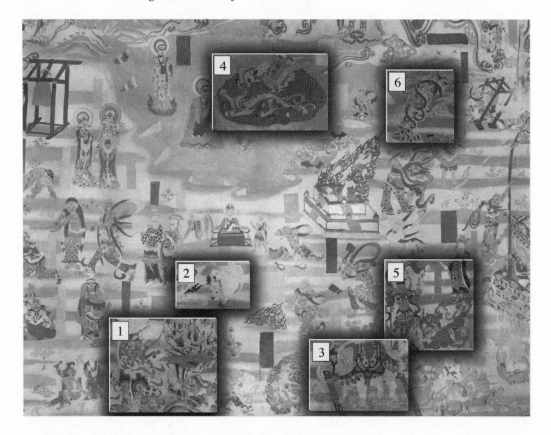

Figure 2.19. The Magic Competition: details of the six competitions fought by the Buddhists and heretics. 1) Jeweled mountain / Vajrapāni; 2) Buffalo / Snow-haired lion; 3) Pond/Elephant; 4) Golden-winged bird / Dragon; 5) Evil Demons / Vaiśravaṇa; 6) Tree/Gale. Wall painting. Cave 196, Dunhuang. West wall. Entire composition: 3.66 m × 9.41 m; detail: approx. 3.40 m × 4.34 m. Photo © Dunhuang Research Academy. Design by H. Wallach and the author.

max in detail. In the draft and the completed work, the emphasis is on the different emotions and facial expressions of characters experiencing physical pain and mental anguish. The correspondence of the sketches to the wall painting is indicated in the graphics of Figure 2.18.

The leader of the heretics, Raudrāksha, who is at the center of this final flurry of activity, dominates the right half of the wall paintings (Plates 9 and 10). He is the subject of one of the detailed sketches, which depicts him grimacing on his throne with helpers trying to secure his tent stakes and grasp onto its poles for safety. There is no sketch for the victorious Śāriputra, who is a visually static counterpart in battle. The only exhibition of tension on this side of the composition comes from the defeated heretics who prepare for the

tonsure and other rites associated with conversion. They moan as their heads are washed in preparation for the ritual shave, clean their face and teeth, and grimace in their unenlightened ignorance (further discussed in Chapter 5). The artist contrasts their excessive display of emotion with the stoicism of the Buddhists, who dominate the left side of the mural. On the whole, the Buddhist figures are dignified and devoid of expression, articulating the belief that superior beings are free from the ignorance that causes emotional pain. The comical heretics, who prepare for conversion to Buddhism after their defeat in the competitions, are analogous to the grimacing heretics who brace themselves as the gale wind descends (see Plates 25 and 26) on the mural's right side. It may be that sketches simply do not survive from the left (Buddhist) half of the painting. It is also possible that an artist made sketches after an existing painting for subsequent use and deemed their stoic countenances and predictable positions not important enough for independent drawings.

This wall composition, repeated at least fifteen times from 862 to 980 in the cave chapels of the local ruling families, hovers between the two states of the Buddhists' stoicism and the heretics' expressiveness. It is also simultaneously frozen in the suspenseful wind contest that instills an atemporal stasis or ambiguity; and yet, it includes many narrative details that insist on a temporal sequence. Examples of these cause-and-effect details include the disagreement over where to place the Buddhist temple and the encounters with the king that appear along the right margin of the mural. These are the cause of the competition, yet they are clustered in miniature form on the edges. The composition remains lodged somewhere between iconic stasis and meanings associated with narrative development. The large figures of Raudrāksha and Śāriputra are anchors around which narrative meanings accrue, yet they also function on their own as symbols of good and evil. This symbolism must have been appealing to both patrons and artists because of the persistent, recurring interest in the concept of opposing forces portrayed in Chinese Buddhist paintings. Secular and religious, good and evil, Buddhist and non-Buddhist are paired as if the presence of one implies the other. Within the mural this dualism, embodied in Raudrāksha and Śāriputra, is made more emphatic by the structural tension resulting from the competitors' depiction in colossal form. This tension is characterized by the temporal discontinuity (the thirty-plus scenes that occur at different times in the tale that surround the two figures) and visual simultaneity (the display of these different moments all at once in the mural tableau appears without clear delineation between the scenes). The artist's use of two easily identifiable opposing forces also becomes an effective organizing principle for the visual delivery of material. In other words, the artist depended on reliable formulae, that is, the dominance of the largest figure in the composition and the notion of dualities that permeates

Chinese Buddhist tales, both of which are formulas sufficiently flexible to meet the changing artistic environment of the monastery and cave temple. Moreover, the manipulation of the formulas within the story conveys the artist's role as storyteller. Similarly, the visual presentation of the tale forces the viewer to construct a narrative around the images, thereby placing the viewer in the role of storyteller. In this way, artist and viewer participate in the rich history of storytelling and contribute to the circulation of The Magic Competition tale.

Production Protocols: Measuring and Dividing

In the production of The Magic Competition, the transition from preparatory sketch to finished wall painting is consistent with the primary rules governing the artistic process of other themes. As we have mentioned, artists made two kinds of sketches. One was a cognitive map of a large region of wall painting locating figures who, in this case, surround the heretic master's dais. The others were close studies of individual figures or scenes. In this composition, these include the drawing of the heretic drummer and the seven heretics who have been jumbled in Raudrāksha's tent canopy. In the latter, the cloth enshrouds their faces with a humorous touch, emphasizing their foolishness and ineffectual control over their circumstances (Figures 2.16 and 2.17).

These two close studies elaborate upon figures in the composite sketch. In the latter, the figures are abbreviated; positioned in a circle, their placement mimics the circular arrangement of registers that expand from the colossal image. Whether drawn before the painting was complete or made as a copy after a finished painting, they establish the compositional layout. Since clarifying the layout is the artist's goal, the figures are abbreviated. Conversely, the other studies of central, active, or humorous features make no reference to the larger composition or to Raudrāksha. Rather, the artist isolates the essential features of the scene including countenance, emotion, and musculature.

The two types of preparatory sketch feature very different qualities of drawing, yet each makes reference to either a region or single scene. Similarly, the sketches for the depictions of Maitreya, Suvarnaprāvbhasa, Vimalakīrti and Mañjuśrī, and Amitābha's Paradise contain only segments of the composition. Much of the artist's practice relies on an ad hoc assessment of space and transposition of figures to the changing environment. These sketches reflect the ever-shifting artistic process of production in which the artist actively worked to make the thousands of figures in each cave conform to a symmetrical and consistent design. What other organizing principles in addition to sketches of small sections of the mural allow for flexibility? What other elements of the work process are important to the atelier?

The key to these questions is understanding the principles of relative pro-
portion and symmetry operative in each cave. In fifteen caves containing
murals of The Magic Competition, artists maintained thematic consistency
in approximately 66 percent of the rest of the cave. As depicted in Appendix
2, ten compositions are consistently included in two-thirds of the caves. These
include the five with identifiable compositions under discussion in this chap-
ter as well as pictorial depictions of Bhaiṣajyaguru's Paradise, the Lotus Sūtra,
the Flower Garland Sūtra, the Requiting Parental Kindness Sūtra, and the
Requesting Heavenly Favor Sūtra (Beseeching Heaven). This stability indi-
cates a tradition or pattern of embellishment that artists excelled at and could
perform when commissioned. A repertoire consistent with the Three Realms
Buddhism, a doctrinal formulation that may be the key to the eclectic inclu-
sion of sūtras in late Tang and Five Dynasties Buddhist caves, is a possible
source of compositional standardization. The prevalence of this doctrine
might also account for the multisect affiliation of many of these consistent
themes in cave temples during this period. This stable, reproducible range of
compositions, developed during the mid- to late ninth century, was refined
and repeated through the effective end of the Guiyijun period in 1006. With
the contents standardized, the challenge pictorially was making each version
appear similar to and as resplendent as the others, even though the changing
size of each cave and the resulting differences in the proportion of the figures
make no identical likeness possible. This was achieved by strict standards of
measurement for the compositional spaces. Within each cave, the widths of
each of the individual compositions arrayed along a wall are nearly identical,
varying only by a few centimeters. The width of the registers between these
tableaux are also nearly the same size. Thus, in each cave, each component has
a relationship consistent with the relationship of parts in the other fifteen
caves. A series of examples will demonstrate the working principles of the wall
painters.

A sampling of five caves (55, 98, 108, 146, and 196) clarifies how the mea-
suring schemes are maintained. On the north and south walls of each cave,
four compositions are evenly divided on each side (with the exception of three
compositions per wall in cave 196). The width of each composition is very
nearly the same. Where they are not of identical length across the wall, they
are of similar width in the same position across the other side of the cave. In
cave 196, the first composition near the west corner is 10.75 feet (3.27 m) on
the north and 10.3 feet (3.14 m) on the south. In the middle position, the
composition is considerably larger, measuring 12 feet and 12.08 feet (3.66 and
3.68 m), respectively, on the north and south walls. The third composition is
yet again a different size (9.25 feet and 9.6 feet / 2.82 m and 2.93 m). In cave
146 the compositions are nearly identical in width on each wall and on the

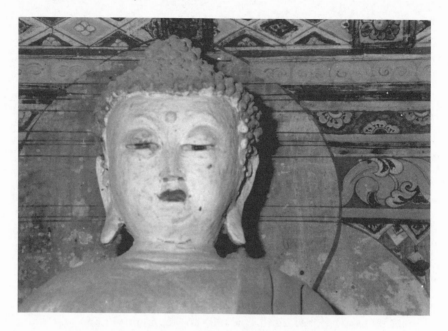

Figure 2.20. Painter's red guidelines visible behind icon. Cave 18, Dunhuang. West wall. Late Tang dynasty. Photo by Song Liliang. Dunhuang Research Academy.

opposite wall; proceeding from the west corner, the measurements for the corresponding painting on the north and south are (in feet): 7.3 × 7.3; 7.25 × 7.3; 7.25 × 7.41; and 7.25 × 7.41.[48] These nearly identical dimensions reflect a system of laying out the cave with a measuring device. A technique such as *tanxian* (marking lines) must have been employed. This involves dipping a rope in red powder and then snapping it across the prepared painting surfaces, leaving a prominent but erasable line for guidance. In one cave temple (18), marking lines are visible behind a sculpture of the Buddha where the wall painting is left unfinished (Figure 2.20). In this case, they were incorporated into decorative wall design.[49]

Grotto Donors and the Case for Court Art

Because many of the cave temples under discussion were commissioned by members of the ruling elite, we must imagine that artists participated in an ongoing artistic legacy with links to the local government. Artists working at the sites were no doubt cognizant of other grottoes supported by the same families, such as the complex relationships suggested in the patronage of cave 98 and the other fourteen Magic Competition cave temples (see Figure 1.1 and Table 2.1). In fact, the close connections between each of the caves' patrons

and their prominent local positions indicates we should consider the murals of The Magic Competition as a type of frontier court art. Although written documents confirming the activities of a government-sponsored atelier and academy date no earlier than the 930s, it appears that a highly organized atelier existed at Dunhuang by the 890s, which would establish a link between the earlier and later Magic Competition paintings.[50] The organizational and textual evidence for such an academy is explored in Chapter 1. Here we will concern ourselves with the art historical features of this frontier court art.

Cave 196, dated to 893–94, is pivotal to understanding the increasing professionalization of painting under the emerging Dunhuang kingdom. The sketches of Maitreya's Paradise, the Sūtra of the Golden Light, The Magic Competition, and Amitābha's Paradise contain pictorial features directly related to the murals in this cave temple, suggesting a highly professional level of production was already well in place at the time of its making. In the cave, artists standardized The Magic Competition. The figures in cave 196 are drawn with a new confidence and fresh approach to the iconography; in the same mural in cave 146, which dates to 920–40, the figures by comparison are schematic and the composition flat. It is as if the notion of a fantastic, magical world of wizardry became a matter of rote reproduction after the development of the primary iconography in the 890s. Caves 196 and 9 (completed one year before cave 196) are linked in this development. Two patrons depicted in caves 9 and 196 are Suo Xun and Zhang Chengfeng. In the early 890s, until Suo was murdered in 894, these two vied for the post of military commissioner, the highest political position in the region.[51] Factoring in the time it took to complete a cave, only a few months' hiatus in construction exists between the two caves. This tight time frame strongly suggests that the same artists were involved in painting caves 9 and 196. While the forms in cave 146, made some thirty to fifty years later, are more schematic than those in cave 196, the figures in cave 9 are overly large and more carefully delineated than those in 196. This suggests that artists developed the major features of the iconography in cave 9 and repeated them several months later in cave 196, codifying the composition for future productions.[52]

The popularity of this complex, but apparently deeply satisfying, format of The Magic Competition held the interest of both painters and patrons for over a century at Dunhuang.[53] Each cave was built by the Cao family, the Zhang family, or their relatives; both families ruled Dunhuang from 848 to 1006. In cave 98, for example, 246 donors are depicted, their identities and titles inscribed alongside (Figure 1.1). Many of those included held positions in the government or were spouses of government officials. First, consider the primary patrons of the fifteen caves under discussion, namely, Suo Xun (r. 892–94), Zhang Chengfeng (r. 894–910), Cao Yijin (r. 914–35), Cao Yuan-

zhong (r. 944/45–74), Cao Yangong (r. 974–76), and Cao Yanlu (r. 976–1002). Each was the military commissioner of the Gua and Sha Commanderies. After the Tang dynasty collapsed in 907, the commissioners began to act as independent kings.

During the Five Dynasties (907–60) and the early Northern Song dynasty, these officials maintained regular contacts with the Sogdian and Uighur courts and the Han regimes in the central plains. From 1006 to 1038 a hiatus in leadership left the region open to outside domination, which was fully realized in 1038 when Dunhuang came under the control of the Xi Xia (Tanguts). During their century-long control over the region, the Caos actively patronized Dunhuang-area temples and supported the painting bureau from the 920s through at least the end of the tenth century. Government and temple papers, such as financial accounts and donor inscriptions kept by the secretaries of these families, document the artists who worked with the temples to carry out their commissions. I believe these government-supported artists were responsible for the painting of The Magic Competition murals.

The Measured Space: Wooden Temples as Prototypes for Cave Temples

In the previous section we explored the practice and process of freehand sketching: the use of both composite and close studies, their flexible deployment according to guidelines of a prolific, robust workshop system serving the temples, and the sophistication of production in a professionalized environment supported by the regional court. The artistic environments of cave temples also had longstanding links to architectural forms beyond the region and sacred spaces associated with local Daoist practice. The next section will address the importance of these antecedents. A disciplined production environment, necessary to execute references to freestanding buildings, indicates a systematic approach to the articulation of space. Direct quotes from other structures also point to the strong likelihood that artists working in these Buddhist cave temples also embellished tombs and freestanding buildings, making use of motifs from those environments to artificially recreate the monastic complex in the grottoes. Scholars have long emphasized that the earliest dated Dunhuang grottoes reflect the artistic programs of other cave sites to the west, in present day Xinjiang, particularly those of the Turkic cultures of Qiuci (Kucha). The argument is that Dunhuang cave temples draw heavily from tomb imagery and freestanding wooden architecture within China's borders as well as in what is now Pakistan and Afghanistan, incorporating these references by imitating elements of freestanding architecture in the decorative program of the cliff facade.

This influence is evident in the incorporation of antecedents from wooden architecture of the gabled ceiling in Northern Wei (439–534) and Northern

Zhou (557–81) cave temples 254 and 251. By the late Tang dynasty, ca. 850, the grotto design imitated the layout of temple grounds. Buddhist spaces drawing on wooden prototypes were not a new phenomenon. The cave temples at Bhājā, Sāñcī, Ajaṇṭā, and Ellora in central and western India (ca. first c. B.C.E.–C.E. eighth c.) all contain elements that imitate wooden structures. This is particularly evident in the porticos and antechambers of Ajaṇṭā, where nonfunctional pillars symbolically "support" the porches. Early Indian chaitya halls, too, contain vaulting and ribbing that, while unnecessary for supporting the living rock of the cave temples, imitate enclosed stūpa buildings and wooden structures.[54] The chaitya ("window") itself is a replica of a wooden architectural form.

The most prominent example of these explicit wooden references on the Mogao facade is the multistoried pagoda that is cave 96.[55] The entire front of this section of the mountain scarp was removed in order to carve a colossal image. On the face, carpenters and sculptors created a seven-storied facade (see Figure 1.9). The eaves, railings, and rafters all suggest a wooden pagoda. The square shape of the levels recalls the pagoda at the Dayan si (Great Gander Temple, in Xi'an), which housed the sūtras and translations of Xuanzang (602–64), who returned in 645 from India and Central Asia with Buddhist treatises. Caves 16 and 17, 365, and 366 above it—the home of the sūtra cave built originally as an assembly hall and chapel for Abbot Hongbian—are also adorned with a pagoda-like facade.

The appearance of medieval Dunhuang as a whole was quite different than it is now, with its modern museum doors. Each cave temple was embellished in the front with wooden beams and a porch. In the early 1960s, when the facade needed consolidating and a concrete face to prevent further erosion, an extensive archaeological survey was performed by Ma Shichang, professor of archaeology at Peking University, and others.[56] The elements of real architectural references that had eroded with time were carefully noted, including the holes used to support the wooden facades on all caves, the metal hooks that held banners hung for specific occasions, and the tiles that paved the ground in front of the wooden entrances.

Photographs taken by Paul Pelliot in 1908 and James and Lucy Lo in 1943 show the archaeological remnants of the wooden exterior (holes in the facade, and so on) (see Figure 2.21).[57] Many of the larger ground-level caves, such as 96, 130, 98, 55, and 61, had large pillared entryways that are no longer evident, elements of the prominent wooden additions to the facade that were an integral part of the site. A prominent example of a remaining wooden facade is in cave 196 (Figure 2.22). It is located on the upper section of the cliff face and has survived damage over the centuries. The facade did not need a buttressing layer of concrete during the modern reconstruction because of its good condition. Thus, a model of a wooden temple—such temples were once

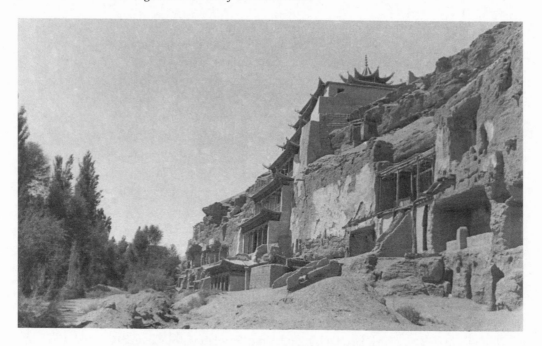

Figure 2.21. Facade, Mogao grottoes, Dunhuang, 1943. Photo by James and Lucy Lo. The Lo Archive.

prevalent—has been preserved. Carpenters constructed a weight-bearing pillared portico filling in the roof with wooden beams extending the cave upward and outward from the rock matrix. These wooden members reference explicitly the weight-bearing properties of wooden architecture incorporating the mortise and tenon technique, in which wooden beams and levers are interlocked to distribute the weight evenly in freestanding buildings. Here, in grotto architecture of course, the use of wooden supports is largely for show.

Given the importance of referencing the well-established spatial and pictorial configurations of tomb and temple, the first order of business in making a cave was effecting a sense of regularity and mathematical precision, suggesting with paint a whole range of components of freestanding buildings and their wall paintings with two-dimensional pictorial features. In freestanding architecture, the width of the bays was determined by regularly spaced wooden pillars. This was visible during the reconstruction of the tenth-century temple Dayun si (Great Cloud Temple) in southeastern Shanxi Province. In 1992, with the walls of this Five Dynasties temple safely removed to another compound building, the wooden elements were repaired piece by piece. The skeleton revealed the symmetry in bay width and height on each opposing side (Figure 2.23). The plaster walls, on which the murals were painted, were also built in the interstices between pillars and would naturally

Fig. 2.22. Cave antechamber, detail. Mortise and tenon structure supports plaster walls; living rock foundation. Cave 196, Dunhuang. Wall: L 10.2 m. Dunhuang Research Academy.

conform to the sizes imposed by the wooden infrastructure in freestanding buildings. In the case of cave temples, the appearance of precision and symmetry had to be achieved regardless of their irregular shape. The north and south walls of 146, reproduced here as two-dimensional textures, demonstrate the way in which the regular intervals in murals reference or imitate the bays created by pillars in buildings (see Plates 4a–b). The irregularities of rock, sand, and geological imperfections dictated creative solutions when workers could only approximate rectangular temple spaces; they effected the sense of architectural supports (wooden posts) without their actual presence. In many cases, as in cave 196, the walls curve near the top where the sloped ceiling meets the rectangular walls; but this curvature is concealed through decorative detailing creatively deployed to fill in the irregular spaces. The artist does everything possible to make the compositional spaces evoke the measured spaces of bays in wooden temples. The north and south walls contain regularly spaced wall paintings (*bianxiang*, or transformation tableaux) that suggest they are governed by wooden partitions of bays. Each section, complete in and of itself, is separated from its neighbor by an intricate floral pattern.[58]

Reference to the temple is extended to the spatial layout of the cave. In the east wall of the antechamber to cave 196, two of the four guardians of the four directions, painted directly on the walls, flank the corridor; typically, in temple complexes, these protectors are sculptures and are on the exterior since

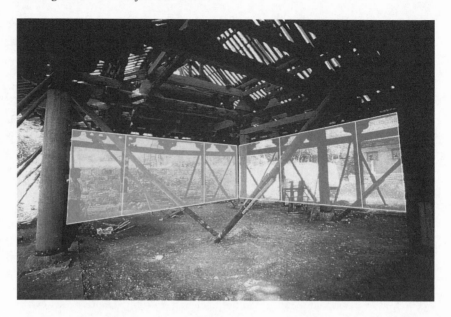

Figure 2.23. Five Dynasties temple under reconstruction in 1992. Dayun si, Shanxi Province. Photo by author; design by H. Wallach.

their role is to protect the grounds from evil forces. In cave 146, the four Loka-pāla (guardians of the four directions) are depicted in four corner squinches in the main room (Plate 6). In other caves, such as 130, the sculpture of door guardians (vajrapāni) occupy similar apotropaic positions. Typically, as is still the case at Tōdaiji, in Nara, Japan, these door guardians (albeit Kamakura-period reconstructions) appear close to the main door. In the condensed cave-temple environment, other spaces of the freestanding temple complex are referred to and abbreviated. The side buildings off the main axis are suggested by smaller cave temples to the right and left. In cave 9, before the gate-like corridor that leads to the main image room, two lesser side chapels contain auxiliary imagery (the drawing in Appendix 1 does not include the side chambers). In the grotto, the combination of the antechamber, side shrines (which would flank the entrance before the corridor), corridor, and main room suggests the succession of gates, spaces, and buildings that are found in a typical freestanding temple complex arranged symmetrically around a central axis. In other extant eighth- and ninth-century temples, such as the Foguang si at Mt. Wutai and the Tōdaiji and Hōryuji, both in Nara, the sūtra repository, long covered corridors, gates, and sūtra recitation halls were carefully arrayed around the main image hall. The interior room of the caves, for example, in 196 and 146, functions much in the same way as the *jintang* (kondō) or image hall does where the primary images for worship are kept in a space that is large enough to accommodate devotees.

Knowledge of the look and feel of the freestanding temple is, of course, abundantly displayed in the architectural backdrops in which the Buddhist worlds unfold pictorially. In wall paintings, the buildings painted around the Buddha, bodhisattvas, and heavenly beings are comprised of a great array of wooden structures such as found in Tang-period temples (Plate 11).[59] In some cases these detailed structures are part of fantastic Buddhist worlds, the pictorial models of which were conventions handed down from artist to artist. But in constructing these realms, it is clear from the range and consistency of the representations of wooden architecture that freestanding buildings were the main referent. Of course, the function of the cave temple is different from that of the wooden prototypes. Some grottoes were lived in by caretakers such as monks or nuns; worshippers occupied their spaces for rituals and ceremonial functions. But caves were not part of the mainstream, residential architectural system of the peoples of western China or eastern Central Asia.[60] Therefore, in creating the fantastic world of paradise and related narrative tales, painters naturally drew from the well-respected architectural forms of residences, courtly compounds, and palaces of imperial or elite life. These structures were fantastic enough a setting for the imagined worlds of the Buddhas. And in picturing the fantastic, as Todorov and others have pointed out, a combination of the known and the unknown, the real and imagined must coexist in order for the fantastic to be convincing.[61]

Wooden prototypes were a part of pictorial references in Dunhuang painting from its inception. The cavern-style ceiling, used in Chinese tombs but generally thought to originate in West Asian architecture, is also a feature of Northern Dynasties ceilings at Dunhuang. Repeated in large blocks in caves such as 251 and 288, squares with horizontal, plank-like registers are rotated to suggested recessed ceilings with beams (Figure 2.24). At Bāmiyān, the Buddhist cave site in modern-day Afghanistan, artists incorporated this type of beam architecture into a cave shrine dating to the fifth century (Figure 2.25a). The wooden armature served no functional purpose in a cave carved from living rock, but nonetheless artists there, too, clearly recalled shapes used in wooden buildings. Squares of flat beams are rotated so the edge of two joining horizontals meet, effecting the sensation of a turning or twisting kaleidoscope of shapes. Other wooden members extend from these in close, parallel lines. Something like this type of ceiling articulation at Bāmiyān may have been behind the Dunhuang cavern-ceiling squares and simplified when the transition to purely painted shapes was effected (Figure 2.25b). In residential architecture in the same region, the use of a square opening in an extant fort dated to the ninth century makes abundantly clear the need for openings in functional architecture. At the Baltit fort in the Hunza Valley, Pakistan, near the Chinese border, where a granary and living quarters dating to the ninth century still stand, the hearth required ventilation to prevent the house from

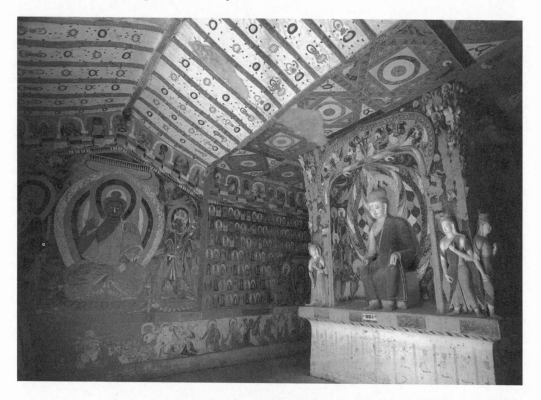

Figure 2.24. Front room, detail. Cave 251, Dunhuang. Southeastern section. Western Wei, ca. sixth century. Wenwu chubanshe.

filling with smoke (Plate 12). This opening is decorated on the interior with carved beams and the room's vertical beams are also intricately carved, and perhaps were once painted as well. The interior view of the Baltit fort makes visible the wooden prototypes that are recalled in the lavishly painted Dunhuang cavern ceilings. Two layers of wooden beams rotated at an angle interlock to form a diamond-shaped pattern (Figure 2.25c).

The lively cavern-ceiling designs of Dunhuang were augmented by suggestions of other wooden prototypes that, with their references to pillars and crossbeams, evoked the symmetry and stability of freestanding architecture. In cave 251, the artists and diggers who excavated the cave have referred to the gable and rafters of a wooden roof by making an angled front room and painting red "beams" to suggest a wooden structure. In this and in other similar Northern Wei (439–534) (namely, numbers 248 and 428) and Western Wei (535–56) caves, the ridge pole of a wooden building is suggested by a thick application of paint along the crease of a sloped ceiling, punctuated with lotus flowers. Parallel red lines follow the form of this slope to simulate the rafters of a hip roof. Actually, in cave 251, as well as in caves 254, 431, 435, and 437,

Figure 2.25a. (top left) Recessed ceiling constructed with wooden beams. Cave 20, Bāmiyan, Afghanistan. Ca. fifth century. Réunion des Musées Nationaux / Art Resource, NY.

Figure 2.25b. (top right) Detail of Xiwangmu (center). Wall painting. Cave 249, Dunhuang. South ceiling. Western Wei dynasty. Ca. second quarter sixth century. Wenwu chubanshe.

Figure 2.25c. (right) Baltit fort, Hunza Valley, Pakistan (north of former Gandhara region). View of roof opening from exterior and interior. Photos by author; design by H. Wallach and the author.

these beams are more than imitations. Real lumber is used, although it has no structural function. Wood is used instead of the imitation, painted red "beam" in cave 288; for example, both the painted version and nonfunctional wooden slabs at the gable's top serve as "ridge poles." Painters and artisans also concretized the association of wooden prototypes in other ways, such as incorporating wooden brackets on the top of two-dimensional, painted, vertical pillars to suggest the weight-bearing properties of traditional wooden architecture. These flourishes leave little doubt that traditional Han mortise and tenon architecture served as the model for some of the imitation wooden architecture in cave temples. Later conventions for articulating ceilings reproduce the references to freestanding architecture pictorially. In both early and late caves, with their intricate layers of square registers nested within each other, the cave shrine ceilings can be thought of as a compression of designs on wooden beams in the flat ceilings of freestanding buildings.

The three-dimensional treatment of the cave temples' upper reaches includes a profusion of sculptural ornament around architectural pieces. Caves of the Northern and Western Wei periods are the most notable in this regard. In cave 288 (and many others,) qianfo (Thousand Buddhas) occupy the space near the "hip" of the roof, filling out the triangular region near the ceiling's apex. These Buddhas, typically pounced in later periods (see below), are actually three-dimensional, low-relief sculpture made from press molds. In most cases only half of the press-molded sculpture still remain on the walls, while the other half have fallen off. The low-relief tiles are affixed with a mud plaster mixture and could easily loosen. Molds brought back from Central Asian expeditions by Koslov or Oldenberg now in the Hermitage Museum indicate that the process of making sculpture in Dunhuang and the Qizil area cave shrine, located in the ancient kingdom of Qiuci (Kucha) to the west of Turfan, was consistent with the piecemeal approach of the wall painter.[62] Arms, legs, bird, and other motifs rest in one large mold as separate entities (Figure 2.26). Artists pressed mud plaster into the cavities and, when it dried, affixed the component pieces for the sculpture to a niche or wall. Additional mud plaster and paint were applied to fill out the physique of larger figures, making them seem rotund and convincing as three-dimensional objects.

The sense of a constructed ceiling of beams and sculpture—common in Buddhist architecture—is referenced in the later ceilings in a dense layering of square registers, such as in cave 320, which collapses the normal space of a ceiling in a freestanding building (Plate 13). It is clear that in the upper reaches of the cave temples, artists wanted to refer to the roofing structure of bona fide architecture. Although the apex designs are condensed, they occupy space in the same way as brackets and beams in wooden temple rooms.[63] They recall the wooden beams of the cave's apex in Bāmiyān, in which large wooden pieces were affixed to the natural rock (Figure 2.25a). At Dunhuang, the lotus

Figure 2.26. Mold for hands, feet, bird, and other motifs for Buddhist sculpture. Qizil. Fifth or sixth century. Hermitage 1386–29a. Photo by author. State Hermitage Museum, St. Petersburg.

design at the center of the ceiling of cave 320 and the horizontal elements arranged in successive squares around it are an imitation of the embellished ceilings of freestanding buildings. In cave 320 only a few inches are left between the central roundel and the brackets; but in freestanding structures, several feet separate the flower from the brackets.[64] In freestanding temples, horizontal designs articulate long, horizontal beams, but the grotto's interior is carved from porous rock that does not permit precise edges. The four sloped walls of the grotto ceilings recall the four quadrants of ceilings in wooden structures.

The floral design in cave 320 is made up of a series of like shapes that are rough microcosms of the whole. At the center, a multipetal floral design is surrounded by eight horseshoe shapes executed in rings of varying shades of blue, and attached to scalloped green arcs. These motifs are also nestled within larger pointed brackets of green and then finally surrounded by eight blue-tipped petals. The whole design is enclosed by four brackets that are a com-

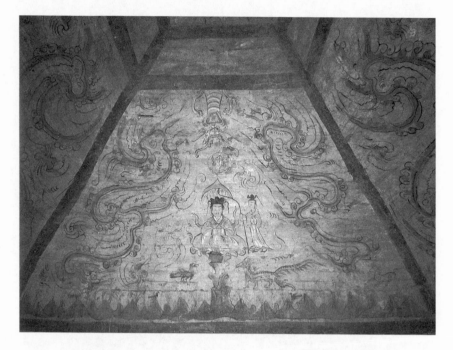

Figure 2.27. Detail of Xiwangmu, tomb ceiling. Wall painting. Jiuquan, Gansu Province. Fifth century. Wenwu chubanshe.

bination of the petals and the horseshoe arcs used in the center. The components are flipped or inverted in the corners so that the blue arc is on the outside and the green-tipped petal appears on the inside. Similar tightly knit patterns dominate Tang painting, metalwork, and textile designs.

The artists are concerned with three things: achieving symmetry, reusing core motifs throughout a composition in slightly different combinations, and layering darker and lighter colors. Clearly, we are dealing with at least two different types of architectural structures—a cave shrine and a freestanding building that is the implied referent in the design. Consider that the multilayered squares of the sixth to eighth centuries contain very explicit references to different types of wooden ceiling structures. In each case they are a block of form and color, yet each register retains the look and feel of a beam or pillar.

We have established how Dunhuang artists drew from architectural Buddhist cave temples in Pakistan and Afghanistan, but they also drew from the deeply symmetrical and symbolic world of tombs closer to home. The importance of tomb imagery in understanding the symmetrical features of cave temples and their symbolic references should not be overlooked. Wu Hung has shown that the earliest Buddhist temples in China, dating to the Han dynasty (206 B.C.E.–C.E. 220), borrowed heavily from Daoist concepts of immortal-

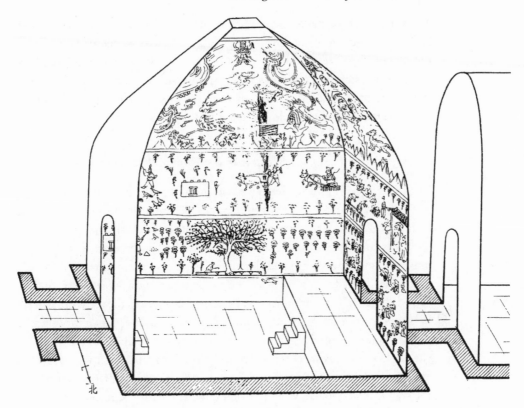

Figure 2.28. Tomb at Jiuquan, Gansu Province. Fifth century. Wenwu chubanshe.

ity to explain and picture Mahāyāna Buddhist principles; Xiwangmu (Queen Mother of the West), one of the primary Daoist gods, is often interchangeable with the Buddha in this early stage.[65] In tombs around Dunhuang, we see striking resemblances to and direct borrowing of Daoist figures. This similarity may even suggest that the artists painting in tombs and temples were the same, drawing from a common storehouse of familiar imagery to embellish both Daoist and Buddhist cosmic spaces. For example, in Jiuquan, an important town in the string of military commandaries established during the Han dynasty in Gansu Province and a commandery with a significant population during the Northern Dynasties (386–581 C.E.), a tomb contains the dramatic Daoist images of Xiwangmu, Fu Xi and Nü Wa, and the Lord of the East (Figure 2.27). Cave 249 at Dunhuang, dated to the second quarter of the sixth century, features the same deities, positioned similarly in a heaven of Daoist immortals (Figure 2.25b).[66] The wind-powered energy of the numinous figures depicted in swirling clouds and decor encompasses them. Further, in terms of layout, tombs contained antechambers and symmetrical layouts, often with side chambers for foodstuffs and auxiliary items (Figure 2.28).

These architectural designs were important conceptual as well as artistic models for the cave temples at Dunhuang. Artists drew from the rules governing the design of well-established cosmic spaces underground and the measured spaces of freestanding buildings. Now, after having described the structure of the cave temples and murals on the lower walls, we turn to the use of pounces and the artist's practice deployed in decorating ceilings.

Ceiling Decor: Further Partitions in the Approach to Mural Production

The earliest terms for the sketch were connected to reproduction and copying and are relevant to the layout of the cave temple and its connection to wooden architecture. The term *fenben* designates a preparatory sketch and was used with this meaning in texts that date to the mid-ninth century, roughly the same period to which the Dunhuang sketches under examination belong.[67] Translated literally, "fenben" may be rendered as "powder version" or even "powder sketch" if *ben* is understood as a stage or piece in the artist's practice.[68] Whereas the term in the textual context seems to mean "preparatory sketch," the characters themselves appear to point toward a pounce, a design pricked with holes. Pounces are designs formed by pricking a paper surface with a pin at uniform intervals (Plate 14 and Figure 2.29). The artist places a pattern on the wall in successive rows and applies powder over the surface. The application of powder to the pricked surface leaves a dotted design. This allows the artist to control the form's size, creating a tableau of like figures that are executed as separate entities and painted to appear as one composition. Around the skeleton of pounced lines, the artist improvises the surface details, expanding slightly its overall size with the freehand application of color. Pounces were used at Dunhuang in cave temples that reference wooden architecture.

Historically, the meaning of the word "fenben" seems to have broadened from the designation of a concrete practice (i.e., pouncing) in its earliest stage to a later stage in the Tang when the word acquired the more general meaning of preparatory (or copy) sketch. That is, a literal reading of one of the general terms used for sketches in the ninth century—fenben (powdered version)—suggests that while it once must have referred explicitly to pounces and to the special procedures involved in their use, it came to have general connotations. Xia Wenyan, writing in 1365, offers the closest gloss of fenben consistent with its Tang-dynasty meaning when he states that "fenben are to earlier generations what is meant [now] by *huagao* (painting draft)."[69]

Another term, *xiuhua*, appears to be close to what we have come to understand "fenben" to mean—"underdrawing." Liu Daoshun uses it in his *Shengchao minghua ping* (Critique of Famous Painters of the Present Dynasty), ca. 1059, when he remarks that the muralist Zhang Fang did not need to

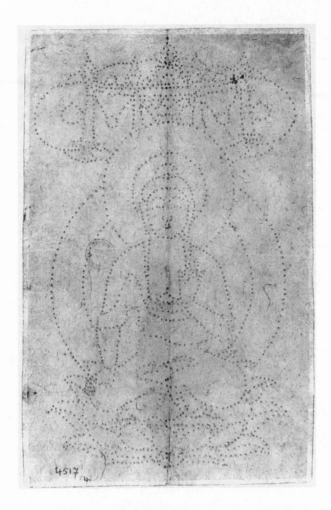

Figure 2.29. Pounce, recto. P4517.4. Ink on paper with perfo-
rations. Ninth or tenth century. 33.0 cm × 21.6 cm. Cliché
Bibliothèque nationale de France, BnF.

employ xiuhua; he simply applied brushstrokes.[70] It has been suggested that
the term "xiuhua" (see Character List), which may be creatively rendered as
the "bones of the painting," should be translated as "charcoal sketch"; but no
evidence suggests that in the ninth and tenth centuries (or even in the Song
dynasty) artists used a charcoal stick or black powder in either pouncing or
underdrawing.[71] Instead, the "bones of the painting" most likely point to the
moist, pale gray or light black ink applied as underdrawing in both murals and
portable paintings, such as revealed by the brushwork visible in a damaged
section of the west wall in cave 55 (Plate 15).

The powder employed in pouncing was not black, but red. The pounces
found at Dunhuang are still stained a pale red, even a millennium after their
use.[72] After the powder was applied, the artist used the red dots as a guide to

execute the black contour lines of figures. Whereas pouncing in China was red, close examination of mural underdrawing at Dunhuang and the imperial tomb murals of Princes Zhanghuai and Yide near Xi'an confirms that preliminary sketching in China was in moist black ink.[73] For Chinese muralists, red was probably the most effective color for pouncing because it contrasted sharply with the black ink typically used in freehand underdrawing. Workshops in the Italian, Chinese, and Central Asian traditions used pounces somewhat differently. In Italy pouncing was always executed with a charcoal powder. The pricked cartoons surviving from the workshops of Michelangelo, Leonardo, and Raphael are stained a fuzzy gray from the frequent application of black powder.[74]

Pounces were an important tool in Tibetan workshops. Their emergence in replication during the ninth century, when Tibetans took control of Dunhuang (781–848), may indicate that the technique was developed by Tibetan artists. Before this period, the Thousand Buddha design was applied by drawing a linear grid on the wall's surface. These features are evident in the early Western Caves of the Thousand Buddhas (about 40 kilometers west of Dunhuang) and at Dunhuang itself. This observation is supported by evidence that the pounce technique enjoyed widespread use in Tibetan-influenced artistic projects in the region, such as the iconic painting of Kharakhoto (Heicheng), one of the seats of the Xi Xia kingdom from the eleventh to thirteenth centuries, where Tibetan cultural models predominated.[75] Pounces were widely used in Central Asia from the ninth to the thirteenth centuries and are still in prevalent in modern Tibetan workshops near Dunhuang.

When artists moved away from the Daoist themes inspired by tomb decor in the ceilings of late Tang and Five Dynasties cave temples, the Thousand Buddha design became the preferred, if not exclusive, motif to embellish ceiling slopes. Whereas figures in the lower walls were executed freehand and vary in height and width, the ceiling figures are virtually identical. This was achieved through the use of pounces. In each sheet the Buddha sits on a lotus under a jeweled, floral canopy; the same scene is repeated again and again. Variations in palette and decorative schema in the canopy and Buddha's drapery effect much-needed variety. Within the limited palette of malachite, red, black, and white, the artist creates the impression of variety by changing the patterns of the mandorlas, haloes, and daises. These variations could be decided on the spot; after all, any given composition contained one thousand replicas of the design.

Further variety is achieved with the mudrā (or hand positions) of the Buddhas, which alternate between two or three common gestures, as demonstrated in the section of cave 196 (893–94) reproduced here in Figure 2.30 and Cave 146 (920–40) in Plate 16. In one form the Buddha is depicted in the

dhyāna (meditation) mudrā with hands folded, palm up on the lap. A second features the right hand, palm up, in a gesture of presentation; sometimes it holds a lotus. In the opposite hand, complementing these gestures is the mudrā of discussion (*vitarka*) made by the left hand; the tips of the forefinger and thumb touch to form a circle. A pounce from the sūtra cave has a gesture identical to the figures in this detail from cave 196. The *bhūmisparśa* hand position, right hand pointed down calling the earth to witness, is a third type depicted in extant pounces.

The extant pounces from the sūtra-cave hoard are consistent in size with the qianfo (Thousand Buddha) design on the ceiling of caves 146 and 196. Seven of these extant pounces, which belong to the later period of artistic practice at Dunhuang, average 25–41.6 cm in height.[76] Although some cave temples (199, 427, and 197) have smaller versions of the motif, measuring 9–16 cm, a majority of caves in the late ninth and tenth centuries have a larger version, ranging from 30 to 45 cm.[77] The difference between the finished average size of the murals and the size of the pounces is due to the addition of color. After the skeleton of red dots is on the wall, the artist completes the figures by applying heavy color. These additions add four to five centimeters to the size of the Buddha. In the second half of the tenth century and into the Xi Xia period in the eleventh century, the design decorates the lower walls, once a popular place for the motif in its nascent form during the late sixth century. When found on these lower walls during the later period, the Buddha figure becomes the largest in its history.

In another example of this technique, a large pounce (Stein 73 [2], measuring 54.4 cm, considerably larger than the others) was probably used for a cluster of figures during this later period. In cave 61 (d. 947–51), where the Thousand Buddha design meets the imitation altar valance at the bottom edge of the recessed ceiling, a series of five iconic units is repeated around the whole length of the interior. This pounce was probably used to execute the ceiling decor in this cave commissioned by Lady Zhai (wife of Cao Yuanzhong, reigned ca. 944–74). The four heavenly kings are grouped to the sides; these figures are not in the pounce and must have been added freehand along the vertical cartouche boxes (colored rectangles containing text). The same design is similarly re-created in an identical position in cave 146.[78]

Later, in the eleventh century, when the Thousand Buddha design migrates again to the lower walls, the pounce was still preferred to other techniques because it was the most efficient solution to the design's inherent, uncompromising redundancy.[79] The identical size of the qianfo figures puts them in direct contrast with the other figures on the cave walls, which varied in proportion according to narrative or iconic importance within each cave and varied in scale from one cave temple to the next. As established, the variation

Figure 2.30. Thousand Buddha design: detail. Wall painting. Cave 196, Dunhuang. Ceiling. Wenwu chubanshe.

was made possible by adapting a freehand painting technique that, unlike the pounces, allowed sizes to change. The ceilings posed a different problem in cave-temple production and the pounce solved this unique painting problem. It supplied fixed contour lines on the sloped surfaces where it would be hard to gauge dimensions. In this environment the artist would also be at an uncomfortable angle to the painting surface with neck bent back and head tilted up. Insuring accurate sizes would be nearly impossible without an instrument for standardization.

The identical images produced with a pounce were useful in furthering the impression of the Buddha's perfection, stability, and omnipotence. Ink marks at the center of the pounce were one method used to line up each application evenly with the figure above. Other pounces (for example, P4517.2, reproduced in Plate 14) have the additional feature of a square boundary line pricked with holes that would produce a definitive rectangular grid around each motif. In addition to the perforated boundary line, another pounce has tabs attached to all four corners to facilitate its use during the application of powder (P4517.3). The reproduction possible with the pounce allowed for a smoother, more efficient finish to the ceilings.

Indeed, the pounces allow the core parts of the composition to become essentially "moveable parts."[80] Scholars have speculated that the frequent repetition of iconographic elements in Buddhist visual culture meant that many smaller paintings on silk and paper were made with pounces.[81] Yet extant specimens and the physical conditions of ninth- and tenth-century painting all point to a process limited to the large spaces of mural ceilings. Pouncing may be more mechanical than the freehand articulation used in the lower registers, but we should not imagine that it required no skill. After the powder was applied to the pounces, the entire ceiling would be covered with a web of red dots. Without a professional artist at work who understood the design and how to effect variegated coloring, the pounce's dots would be rendered useless. The pounce indicates the presence of a professional, highly trained atelier. Tools, methods, and procedures were put in place by artists who developed appropriate procedures and solutions for painting production over several decades. These preparatory materials were the possession of the ateliers regularly serving the local court.

Another pounce that predates the Dunhuang Thousand Buddha is from Turfan; its features also point to professional use. It was discovered in the old city of Karakhoja, or Gaochang as it was called during the Han Chinese phase in the early Tang dynasty.[82] Two different floral motifs appear on the front and back of a single sheet; one is a lotus flower with a large stamen emerging from the center curl of a twisted vine tied with a tassel. A ruled line demarcates the right edge of the design and would be used to position the pounce on surfaces to facilitate ease and frequency of use. Comparing it to the significant body

of floral motifs in Turfan textiles, it is possible that this pounce was a guide for establishing a frequently applied motif.[83] The repetitive designs of textiles make the pounce an ideal tool for ensuring consistency in design. The works appear to have been the property of the professional textile atelier whose products were one of the driving forces in the economy of the Silk Road. In archaeological sites of western China and eastern Central Asia, pounces indicate the presence of professional artistic production.

Vision and Artistic Practice

That wall painters used a range of preparatory materials for mural production is evidence of an organized, highly evolved painting tradition, one responsible for the immense output at Dunhuang in the ninth and tenth centuries. These achievements are exemplified by the fifteen caves included in the preceding case study. The tools employed in all fifteen included pounces and two types of sketch. As we have mentioned, pounces were used to strictly control the embellishment of the ceilings. Unlike the ceiling, the freehand drawing used to establish the design on the lower walls called for a flexible program involving two types of painting sketches. As previously noted, these contrast with the identical motifs in the ceilings. The sketches deployed to execute the main parts of the room reflect a freehand drawing process. Within this larger category of freehand drawing, the two types of guides or sketches involve very different cognitive processes. The compositional map is an abbreviated guide to large areas of the murals; detailed studies, on the other hand, were needed to embellish elements of key figures in a narrative. Both permitted the painter to partition the work into discrete units and this, in turn, contributed to the cumulative, piecemeal process of production of Buddhist wall painting. The large size of the murals made it impossible to make full-scale or detailed studies on paper; the changing size of each cave, which contributed to this aspect of practice, made necessary a general cognitive awareness of which images belonged where, while maintaining a flexible format. These technical practices remained consistent throughout the Guiyijin period (Returning Allegiance government, 848–1006). Although the size of figures and the selection and arrangement of compositions within each cave temple are not identical, the practices governing the embellishment of the caves were stable. Similarly, some of the wall paintings may appear to have little in common, but the principles governing their production are consistent. Therefore, the notion of resemblance is not based on a visual interpretation so much as the artistic practice that underlies mural production. This type of standardization in production confirms the increasing professionalization of artistic practice in the Dunhuang court during this period and suggests the expansion of support for and the promotion of painting in the Northern Song dynasty.

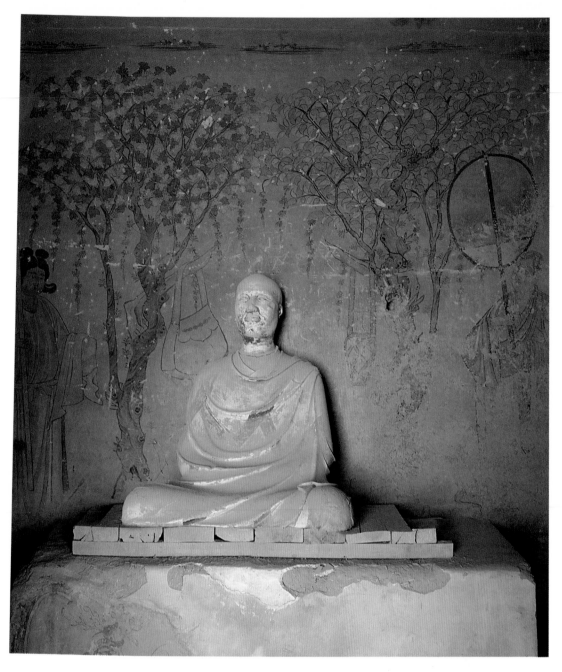

Plate 1. Sūtra cave. Originally memorial chapel for Abbot Hongbian. Wall painting and sculpture. Cave 17, Dunhuang. D. 862. Sculpture: H approx. 117.08 cm. © Dunhuang Research Academy.

Plate 16. Thousand Buddhas, detail. Cave 146, Dunhuang. Ceiling. Upper slopes: 4.08–5.22 m; lower slopes: 3.70–4.28 m. ©Dunhuang Research Academy.

3. THE INFLUENCE OF THE DUNHUANG SKETCHES: *FENBEN* AND MONOCHROME DRAWING

The sketches from Dunhuang shed light on several other important categories of monochrome drawing and artists' preparatory materials. This chapter addresses the relationship between the Dunhuang sketches and printed painting manuals and connoisseurship guides developed in the late Northern Song dynasty (ca. 1050–1125). Printed didactic manuals developed after the tenth century grew out of the workshop practices of earlier ateliers; but these practices and their associated drawings are not widely documented except in the Dunhuang context. Therefore, any study of sketches from the site serves to clarify issues applicable to early stages of Chinese painting. The rich deposit of Dunhuang sketches also sheds light on narrative painting of Buddhist themes dating to the late Southern Song and Yuan dynasties (mid-thirteenth century to the third quarter of the fourteenth century). Moreover, when the market for Buddhist art shifted to China's east coast in the late eleventh century, ink drawing techniques used in these workshops developed out of ninth- and tenth-century practices. Hence, the work of these later artists is better understood when compared to the art of its Dunhuang predecessors. This chapter will address three broad topics: *fenben* and copybooks, miniature copy sketches of post-Tang wall paintings, and the literati uses of styles associated with the spontaneity of sketching, the development of which begins with the proto-*baihua* practices widely evident in the Dunhuang ateliers.

Painting Manuals, Late Copybooks, and the Earliest Artist's Sketch

The eighteenth-century Commentary on the Sūtra of Measurements in the Making of Icons (Zhaoxiang liangdu jingjie), in the Taishō Buddhist canon

Figure 3.2. Sketches of mudrās. Stein painting 83*. Ink on paper. Late ninth century. 15.4 cm × 143.5 cm. Copyright British Museum.

workshop practices that matured in the painting academy in later imperial China.

The appearance and function of pre-ninth-century sketches is unclear since only one is known to art historians (Figure 3.3). This sketch, found in a tomb in the Kharakhoja graveyard of Turfan, is datable to the Northern Liang dynasty (421–39) and is the earliest known extant example of a copy sketch or *fenben* used by workshop artisans. It was found in a tomb that, curiously, contains no wall paintings. On paper the artist, sketching in ink with light colors, drew conventional scenes of estate life separated into six sections. In two nearby tombs at Kharakhoja, the same scenes are depicted in wall paintings. In each tomb the individual elements—male head of household with spouse(s), field plowing, livestock, and food preparation—are arrayed in slightly different order; in some cases the number of spouses and horses and the amount of agricultural land increases or decreases. It seems clear that topics such as bountiful harvests and productive families are standard for Northern Dynasties tomb murals. Indeed, the theme of prosperous family life is so ubiquitous in tombs in the Turfan area that a draft sketch such as this could be brought to each tomb by the artist when under commission to execute the mural for the deceased.[8] Therefore, it is probable that a sketch detailing these important scenes was the valued property of an artist's workshop. Tomb decor tends toward conservative and repetitive subject matter in China and localities dominated by Chinese cultural models. For example, tombs in Nanjing, Sichuan, and Shanxi share motifs that are particular to each region and persist over long periods of time.[9] While no other examples survive from this early period, this tomb sketch provides important information about the mechanisms for iconographic repetition in an active artistic environment.

Dunhuang Sketches and the Problem of Full-Scale Miniature Copies

The preceding chapter reviewed the unique methods of sketching for murals at Dunhuang: ninth-century Dunhuang artists did not sketch entire compositions for reference, nor did they, as the mural sketches show, at this early date regularly make detailed notations on paper for a whole mural composition. Neither did they make a design of a whole mural composition on paper after the completion of a mural. As we have argued, this is probably because of the large size of finished grottoes, whose compositions could measure more than 40 feet (12.19 m) in length and 20 feet (6.1 m) in height. From the considerable number of Dunhuang sketches kept in the equivalent of a temple archive, it appears that artists executed the sketches with no audience in mind but rather to their own satisfaction and just to the point where they could be used in the atelier. The approximation of shape, elimination of facial features, and

Figure 3.3. Drawing of *Prosperous Family Life*. Ink and colors on paper. Kharakhoja graveyard, Turfan. Chushi period, ca. 505–55. 47.0 cm × 106.5 cm.

collapse of space, particularly in the sketches for wall painting, are qualities that would preclude their presentation to donors for discussion or approval but not their usefulness in the atelier.

A well-known painting, Wu Zongyuan's *Chaoyuan xianzhang tu* (The Star Gods Procession), datable to 1050, gives every indication of being a complete, miniature sketch or copy of a wall painting (Figure 3.4). According to Xu Bangda, a prominent scholar and former curator at the Palace Beijing Museum in Beijing, the scroll is part of the tradition of miniature, supplementary versions (*fuben xiaoyang*) made when a mural is newly finished in the event that it should sustain damage and require repair.[10] Both Xu and Huang Miaozi, an important historian of the twentieth century, speculate that the *Chaoyuan xianzhang tu* is a copy of a nonextant temple mural.[11] The question is whether there is any evidence from Dunhuang to clarify this practice and shed light on this one surviving "miniature" copy. Perhaps Dunhuang artists neglected to make proper archival copies of their wall paintings; but more likely, artists or temple officials in the late ninth and tenth centuries were not in the habit of keeping miniature versions of their mural designs. Given that the archives of at least seventeen temples form the contents of the sūtra cave, an excellent cross section of late ninth-, tenth-, and early eleventh-century temple records, it is inconceivable that, if crafted, precise miniature copies were not kept in the library. How can we reconcile this observation with a Northern Song scroll that resembles a miniature but comprehensive copy of a mural?[12]

The scroll, executed in thick contour lines that imitate the overdrawing in wall paintings, retains the air of an unfinished work; the thick lines suggest that color will be added.[13] Yet the regular, thick application of line suggests it was fashioned after a complete wall painting. Indeed, more random, less orderly sketches were typically used in the working process by wall-painting ateliers in the ninth and tenth centuries. Other stylistic indicators point to this

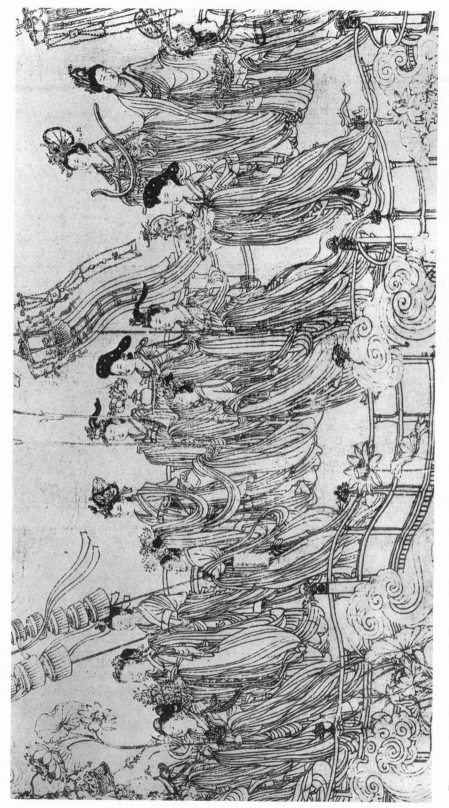

Figure 3.4. Wu Zongyuan, *The Star Gods Procession*, detail. Ink on paper. Ca. 1050. H 40.6 cm. Collection of C. C. Wang, New York.

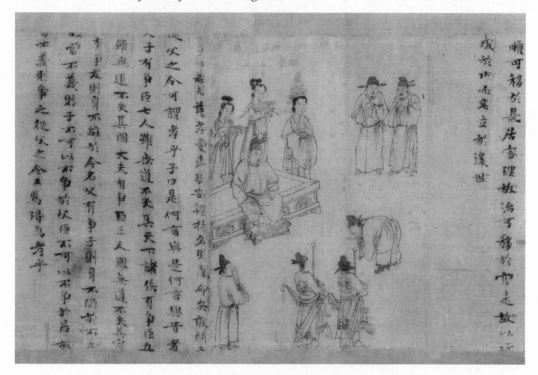

Figure 3.5. Attr. Li Gonglin (1049–ca. 1105), *The Classic of Filial Piety*, chapter 15: Filial Piety in Relation to Reproof and Remonstrance. Handscroll. Ink on silk. 21.5 cm × 475.5 cm. All rights reserved. The Metropolitan Museum of Art, Ex Coll.: C. C. Wang Family, from the P. Y. and Kinmay W. Tang Family Collection, gift of Oscar L. Tang family, 1996. (1996.479a–c)

scroll's production following completion of a mural. The pictorial evidence to support this claim is found in the disjunctive brushwork that suggests two different functions for the scroll. This leads to the conclusion that Wu Zong-yuan's *The Star Gods Procession* may be a literati response to an artisan's practice rather than a direct indication of it. Thus, this painting may not simply be an archival copy as Huang and Xu speculate.

Two radically different types of drawing are juxtaposed side by side. In the flower stems at the bottom of the scroll, the artist uses dashed lines to indicate the approximate shape and position of boundaries. Yet the elaborate coiffures are completed with fine wash and details describing the textures of the headdresses and soft hair of the goddesses that gracefully move leftward in a long procession of Daoist star gods. One type of line abbreviates form; the other defines it with the care and attention given to final compositions. These are two very distinct techniques of drawing that typically appear in very

different types of works—atelier drafts and finished paintings inviting a public audience are typically at opposite ends of the creative spectrum.

This contradiction in the quality of finish and the expectation that these thick lines anticipate a stage of copious coloring indicates the scroll lies outside the self-conscious, monochrome fine-drawing tradition (*baimiao*) exhibited in the *Filial Piety* illustrations by Li Gonglin (1049–1105/6) (Figure 3.5), the handscroll of *The Debate Between Vimalakīrti and Mañjuśrī* by Ma Yunqing (fl. 1230) (Figure 3.6a–c), and the anonymous *One Hundred Flowers* from the Southern Song dynasty (1127–1278) (Figure 3.7).[14] The delicate, monochrome brush of these Song and Yuan dynasty works differs entirely from Wu Zongyuan's heavier hand. The elegance of the fine lines in *One Hundred Flowers* displays the sophistication of monochrome painting during the late twelfth–early thirteenth centuries, when artists explored possibilities of plainness and precision in ink drawing.[15] The polish and finish of these three very different kinds of fine-line drawings—all considered finished paintings—is not present in *The Star Gods Procession*. The *Filial Piety* scroll deploys a careful hand intentionally awkward and insipid. Details in the *Vimalakīrti and Mañjuśrī* scroll are drawn carefully and with a delicacy typical of the genre and period. *The Star Gods Procession* contains some of this precision in the faces and coiffures, yet for the most part it suggests an unfinished state.

How does one explain the unfinished, preparatory quality of *The Star Gods Procession* in the light of these other materials? It seems to be neither a sketch in the vein of the Dunhuang examples, nor a finished work in the Yuan dynasty fine-line tradition of baimiao. One answer is that a function of miniature mural compositions was to obtain a patron's approval; in the Song, as Xu Bangda and Huang Miaozi suggest, artists may have produced miniature copies for temple archives. One can imagine that these paintings could circulate as independent objects.[16] This would explain a whole genre of handscroll painting featuring compositions typically found in earlier murals. *The Star Gods Procession* may be a chance survival of the intermediary stage documenting how mural themes become scroll compositions. While the original purpose of works such as these may have been the documentation of wall compositions, their subsequent circulation in studios rather than in mural workshops explains in some part the appearance of monochrome Buddhist themes in handscroll format in the Yuan dynasty (1271–1368), when Buddhist murals ceased to be painted in such great numbers.[17] These later compositions feature once-large-scale mural themes in a condensed scroll format.[18] Created in the spirit of preparatory sketches, they have an appeal to connoisseurs beyond the temple and artisanal production. Indeed, it may be that imitation of Tang-style sketches in the Northern Song gave rise to baimiao as a style in

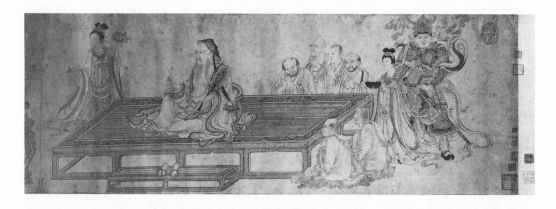

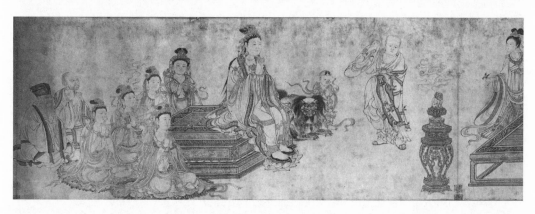

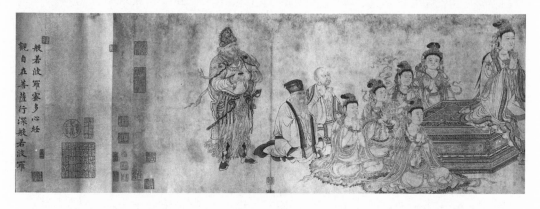

Figures 3.6a–c. Ma Yunqing (fl. 1230), *Debate Between Vimalakīrti and Mañjuśrī*. Ink on paper. 34.8 cm × 207.1 cm. National Palace Museum, Beijing.

Figure 3.7. Anon., *One Hundred Flowers.* Ink on paper. Southern Song dynasty, thirteenth century. Palace Museum, Beijing.

its own right in the eleventh century. In this way, baimiao drawing served a completely different purpose than the ninth-century Dunhuang sketches as they left the confines of the atelier.

Sketches of The Debate Between Vimalakīrti and Mañjuśrī

Although most extant sketches for Dunhuang murals fall into the categories discussed in Chapter 2, several do not. The latter are more complete compositions than the former, but I argue that they still serve the purpose of the artist, not connoisseurs, as did later finished monochrome paintings. Two Dunhuang sketches resemble complete compositions. Despite this resemblance, they provide a conceptual map rather than exact records of a mural composition: they omit crucial details, leave large portions of the compositions unexecuted, and use a casual style that contains personal forms of notation. A drawing depicting the philosophical encounter between Mañjuśrī and Vimalakīrti (*Weimo jing bianxiang*) is a rather free rendition of the key elements of

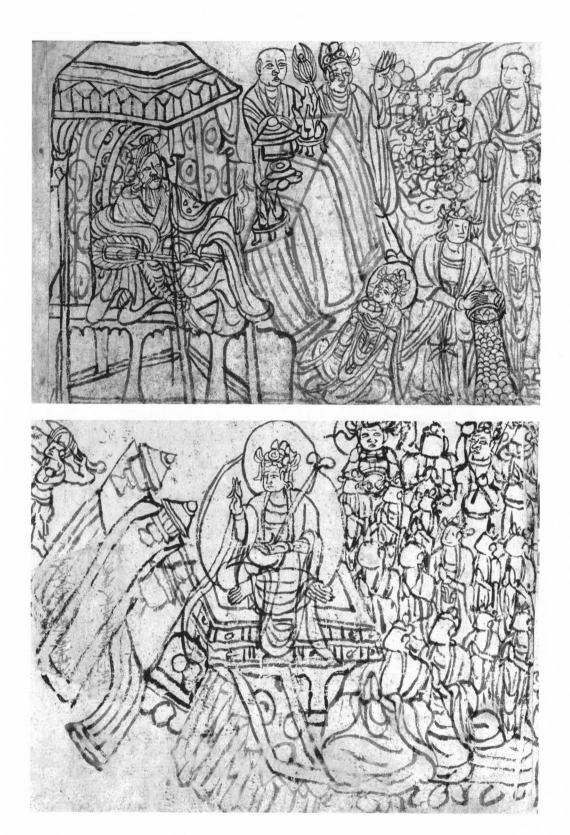

displays from the story is included in the sketch. In these cases, artists often preferred to omit the ubiquitous, recurring iconic centers in the sketches and focus instead on the anecdotes (as discussed in Chapter 2). But in this composition, because the focus is on the protagonists and often narrative detail is downplayed, auxiliary scenes are not stressed.

The drawing of Mañjuśrī and his cohorts, positioned on the right and gazing left at his opponent, suggests an all-inclusive grouping with attendants standing dutifully behind. But it is a mass of featureless faces executed to approximate their positions. The altar with ritual vessels and streaming valance is oddly tipped out and upward. The altar of goods near Vimalakīrti is more stable. Supplicants in front of Vimalakīrti's dais, including the bodhisattva releasing a pot of gold coins, are clearly articulated. The group of devotees at the top is executed only in contour lines with little more than headdresses denoting their presence.[24] Compared to the precise brushwork of *The Star Gods Procession*, this sketch contains relatively no order. Thus this type of sketch is analogous to the type of conceptual map in which the artist notes the order of scenes in sequential numbers. The general features of the composition are randomly organized on opposite sides of a handscroll. In its reduced, approximated form, this type of sketch is understood only as a guide in the preparatory stages in the atelier; it would not aid atelier apprentices to finish a mural, nor would not help a later artist repair a wall painting if it sustained damage. The artist has made rather complete pictorial notes about the layout, but splits the sections onto two sides of the same scroll. In other words, the composition was conceived in parts rather than as an integrated whole.

Migrating Motifs and Styles: The Influence of the Tang Sketch on Later Painting

Aspects of Tang painting inspired the work of later artists, particularly in draft sketching. There are several compelling examples to suggest the migration of Tang sketches into later ateliers. Although it is not clear how these transformations took place, the reappearance of Tang styles and themes suggests sketches were admired and copied by later artists. Motifs could be lifted from Tang drawings and placed in Song paintings, drastically shifting their original meanings. An example is the scene of men huddled in a forest in a handscroll of the *Nine Songs* (Figure 3.10), an adaptation of popular verses about a

Figure 3.9a. (top) Vimalakīrti: detail, verso. Stein painting 76. Scroll: 31.0 cm × 127.0 cm. Copyright British Museum.

Figure 3.9b. (bottom) Mañjuśrī: detail, recto. Stein painting 76. Scroll: 31.0 cm × 127.0 cm. Copyright British Museum.

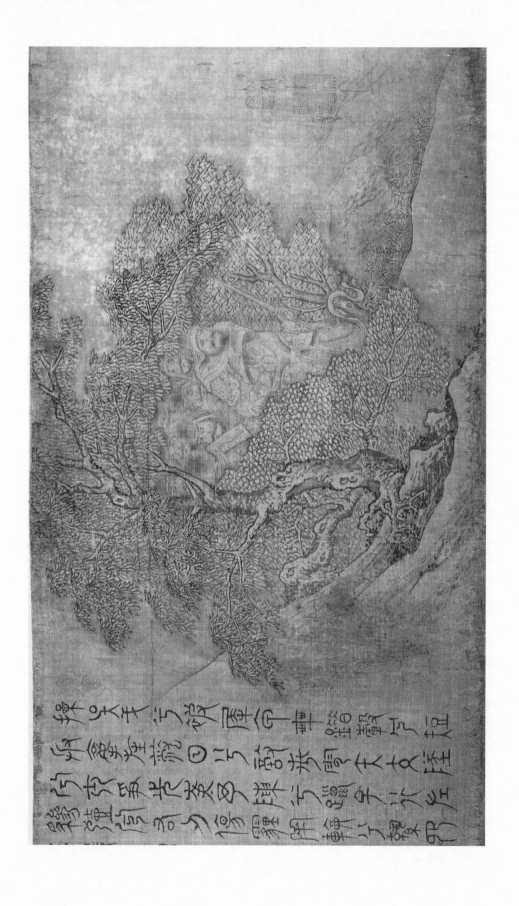

shamanistic ritual.[25] Consider the example of the intentionally agitated line in this cluster of figures huddled in the forest. These men take refuge as a group in the primitive and wild frontier.[26] Their poses, countenances, and the group's total effect are very similar to those of the group of figures in a sketch for The Magic Competition (Figure 2.15). The latter, ninth-century monochrome sketch depicts heretics defeated by a Buddhist gale of conversion in that tale. They are pictured tangled hopelessly in their tent canopy that frames their grimacing faces. The brushwork, executed in a modulated, casual style, contributes to the effect of movement; the figures are captured at a specific moment in time. The finished twelfth-century *Nine Songs* vignette and the ninth-century preparatory draft, with its spontaneity, are close enough to suggest that at some point the artist for the *Nine Songs* borrowed a motif from Tang or Five Dynasties sketches. The later painting seems spontaneous, but it is realized only in style rather than in descriptive brushwork.

Another example that deploys the impression of spontaneity is a detail from the *Daoist Divinity of Water*, a Ming-dynasty work that narrates the folktales of the frenetic pace of the wind and water deities accompanied by their retinue of demons. Enlisted to aid the deities in their quest to order nature's chaos, one of the "good" demons is bent over at the waist (Figure 3.11). This comical, playfully rude position is similar to the pose of a heretic in a ninth-century wall painting of The Magic Competition in cave 196 (d. 893–94). In the cave, we see his face peeking at us through his legs (Plate 29c). Although we do not have the sketch for this section of the painting, there is a Dunhuang sketch of the wind god (Figure 2.14 and Plates 9 and 10) also found in later, Ming-dynasty painting. In the latter handscroll, the wind god is positioned behind the cart (not reproduced); in the Dunhuang mural he is in the far right, releasing a bag of wind. It is with the portable sketch that we can imagine the later artist executing the motif, which functions as a stock vignette in later works. Later fenben, such as Gu Jianlong's compilation of motifs from older paintings, demonstrate how this process took place.

The transposition of a motif for a new purpose is also prevalent during the Yuan period (thirteenth–fourteenth c.). The vignette of Yang Pu Moving His House appears in paintings of the imperial-guard-turned-ghost, Zhong Kui, escorting his sister in a palanquin to her wedding in which the band is depicted en route to her betrothed's home; the same palanquin appears in paintings depicting Zhong Kui on his way to the Lantern Festival.[27] Thus, in these three examples, the same motif is used for three different purposes.

Figure 3.10. Attr. Li Gonglin (1049–ca. 1105), *Nine Songs*: detail section e. SH-137-e. Ink on silk. 27.3 cm × 654.6 cm. Collection of the National Palace Museum, Taipei, Taiwan.

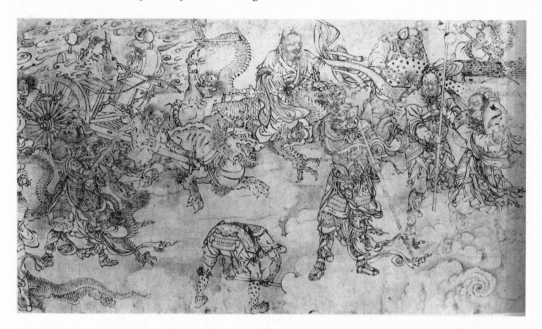

Figure 3.11. Formerly attr. Li Gonglin, *Daoist Divinity of Water*: section 2. Handscroll. Monochrome ink on paper. Ming dynasty, 1368–1644. 263.5 cm × 49.9 cm. Freer Gallery of Art, Smithsonian Institution, Washington, D.C.: Gift of Charles Lang Freer, F1917.185.

What mechanism explains the deployment of the same motif in different compositions? Sketches provide the most reliable means of design circulation and communication among artists across time or space. A collection of compositions in a copybook for an atelier could be used in a variety of venues within the workshop and in the hands of later artists. The most interesting example of sketches being applied to a new context is the Topkapi Serai sketch album currently held in the Tehran National Library.[28] This is a Persian collection of designs that appears Chinese in origin. During the Yuan dynasty, when the Mongols controlled much of Asia and established a khanate in the Middle East, Chinese designs were copied and transferred to the Persian world, where they were reused in a different context.

In addition to narrative paintings with Buddhist and Daoist themes, the Dunhuang sketches clarify how the sketch-like, intentionally awkward features of literati painting are self-conscious efforts to capture, in finished form, the unfinished, preparatory stages of painting. This is the biggest shift that occurs in monochrome drawing in medieval China. One of the ambitions of awkward drawing is to evoke a record of the initial process of working with the brush using abbreviated brushwork. The workshop drafts from the Tang

and Five Dynasties, which are truly preparatory and casual, help us to appreciate the polished hand of Song-dynasty artists employing the plain, baimiao style in figure painting and the studied awkwardness of early literati monochrome landscape painting. The former is studied execution of finessed drawing in a vernacular hand, while the latter is experimental ink play that made it possible for amateurs (without well-developed technical skills) to paint or to enhance the nonrepresentational aspects of personal style.

When amateur literati painters formulated an aesthetic alternative to the dominant line and color tradition of the eleventh century, Tang painting styles were appropriated and transformed. In this period, monochrome sketching takes on new associations and is no longer used exclusively for draft drawings during the preliminary stages of painting. Amateur artists such as the scholar-officials Su Shi (1037–1101) and Mi Fu (1052–1107) focused on landscape subjects such as bamboo, rocks, and trees using plain ink; they invested these subjects with scholarly significance in their painting theories. When trying to evoke both antiquity and immediacy, these Song-dynasty artists drew partially on the preparatory style of the atelier wall painter who routinely executed underdrawing in quick freehand.[29] Yet, in relying stylistically on workshop brushwork, these literati painters distinguished their application of spontaneous drawing from artisanal practice. Many issues were at stake in setting themselves apart from the working professional, but much of their disdain for fine-line and color painting was class driven. Figure painters in the Song dynasty, such as Li Gonglin, who participated in the new painting milieu formed by amateur artists of higher social status than working artists, also produced paintings in monochrome ink in the fine-line drawing style called baimiao (Figure 3.5). These personal, sometimes idiosyncratic drawings were considered to be finished paintings, indicating that by the eleventh–twelfth centuries, monochrome ink drawing had become accepted as a style in its own right.[30] The value of the Dunhuang ink sketches is that they preceded this revolutionary change in painting style.

A comparison of the sketch from Dunhuang to a scene from the *Filial Piety* handscroll by Li Gonglin, Su Shi's *Bamboo and Rock by River*, or Qiao Zhongchang's *Later Red Cliff Ode* demonstrates that monochromatic Song painting is not "sketchy" and off-hand.[31] In the "Filial Piety in Relation to Reproof and Remonstrance" and other scenes in the *Filial Piety*, Li Gonglin accentuates the effect of plainness by introducing archaizing elements such as the figures' childlike quality and the slightly askew placement of the compositions. These examples of intentionally awkward drawing demonstrate the great appeal of the spontaneous look among artists of later periods, particularly the Northern Song. Ultimately, the artist betrays his artifice in other passages with an economy of line and shrewd design. Similarly, Su Shi's *Rock, Bamboo, and Old*

Figure 3.12. Attr. Su Shi, *Bamboo and Rock by a River*. Handscroll. Ink on silk. Possibly a Jin dynasty work after Su Shi. Later inscription d. 1334.

Tree and similar works, such as *Bamboo and Rock by a River*, emphasize how style mediates subject matter by featuring scratchy brushwork, awkwardly shaped objects, and an unfinished quality as if they were dashed off (Figure 3.12).[32] That may have been the case in this example of truly amateur painting, but the effect of an everyday quality is highly constructed; the bamboo and rock are understood as finished motifs, even with abbreviated line and sparse description. The Dunhuang sketches share this plainness, but are preparatory rather than final works. What began as a shorthand method for marking the contours of a wall painting is adopted later for its suggestions of spontaneity. Unadorned and unpolished qualities appealed to artists for ideological and aesthetic reasons. The Dunhuang sketches help us understand better the formal qualities of new monochrome figure painting and the beginnings of literati painting in the eleventh century, which transformed aesthetic ideals that went unchallenged until the twentieth century.

They put into perspective artists' changing interests, and shed light on important shifts in perceptions of the creative process that took place from the tenth to thirteenth centuries. Until the early eleventh century, monochrome sketching was used almost exclusively for the underdrawing stage of painting, as the Dunhuang sketches make clear. The spontaneity in style of the underdrawing was a by-product of this initial stage of Buddhist painting in the workshop. The artist's touch with the brush was erased by finishing with ornate colors and motifs. It was the polish of the finish that mattered rather

than a particular individual's experience of perception and record making. After the application of color, artists augmented and emphasized key contour lines, adding overdrawing in black. In the most expensive paintings, the final layer was executed in fine, gold detailing. In modern Qinghai Province, where artists still produce thousands of thangkas annually for domestic and international consumption, the price of a painting is calculated according to the time spent on it; one to three months is typical for one painting. What distinguishes a painting executed for the longest period of time is the amount of detail in the overdrawing, which may consume vast numbers of hours.[33] For Song dynasty amateur literati painters who worked outside the collaborative atelier, the act of painting was the most important; the qualities described above were rejected.

Further evidence of the transition between the Dunhuang early sketches and the later baimiao style is exhibited by professional works of the late Song and Yuan dynasties (thirteenth–fourteenth centuries), such as in two versions of The Debate Between Vimalakīrti and Mañjuśrī, one by the Jin-dynasty painter Ma Yunqing (active ca. 1230) (Figure 3.6 a–c) and the other by Wang Zhenpeng (active ca. 1280–1329). The baimiao painting style in post-Tang art begins with artists such as Li Gonglin in the eleventh century, but becomes pristine and highly ornate in the hands of thirteenth-century professionals. In the Dunhuang example (Figures 3.9a–b), the figures are cluttered and executed in a cursory fashion. In their reduced, approximate shape these sketches were used only as a guide in the preparatory stages in the atelier. The difference between the tenth-century sketch for a mural and the Yuan handscroll is that the latter, while depicted in a monochrome hand, is a finished painting. The baimiao style of the eleventh to thirteenth centuries is a transformation of the brushwork used only in the sketching stages in earlier painting. What was once a spontaneous draft style became a finished style in its own right.

Other themes that most likely followed this same history are Yuan and Ming paintings of *Buddha Receiving a Foreign King, Clearing out the Mountain* (Shoushan tu), and *Buddha Placing Hārītī's Child Under a Glass Bowl*.[34] Although no sketches remain of these paintings, the compositions suggest a similar pictorial path.

In summary, in the ninth century, sketching in black line still represented one of many stages needed to complete a wall painting. In the Tang, monochrome drawing (baihua) was still understood as unfinished painting rather than completed work; several damaged wall paintings in Dunhuang reveal the original, black underdrawing. Painting without color was new and experimental.[35] It was not until the Song dynasty that monochrome drawing was appreciated as a style in its own right.[36] Therefore, Tang sketchwork should not be mistaken for finished monochrome painting styles of a later date.[37] In

the Northern Song, the style of Tang sketches came to represent the best qualities of the earlier painting; artists elevated the sketch to the status of painting.[38] In the eleventh century, literati painters such as Li Gonglin were perhaps directly inspired by Tang sketches when they developed their own monochromatic figure style of painting known as baimiao. Later, in the Yuan dynasty, superb fine-line drawing in finished works builds on the Song dynasty interpretations of the earlier Tang sketching tradition. Periodically, we find an indication that these sketches were treasured by later connoisseurs such as Xia Wenyan and Tang Hou, both of whom in the fourteenth century praised the beauty of ancient drawings.[39] Tang painting endured in later imperial China. Next, we will examine practices of the painting workshops in Dunhuang further, exemplified by two additional types of sketches: those for banners and those used in ritual practice.

4. BANNERS AND RITUAL-PRACTICE DIAGRAMS: TWO ADDITIONAL TYPES OF SKETCHES

Sketches found in the Dunhuang sūtra cave are important for the history of wall painting because they clarify how, during this period of substantial mural production, painters practiced their art. In this chapter we turn to two additional types of monochrome drawings discovered at Dunhuang. Murals formed the bulk of painting output, but silk banners were produced in great numbers as well. They were stored rolled or folded and displayed on specific occasions. Fundamental differences between the two painting practices for each type of format influenced the painter's preparatory materials. Muralists were responsible for large spaces. They worked with many collaborators and executed thousands of motifs in the temple chambers and their wall surfaces. They worked largely in freehand, and their sketches reflect this. Their pictorial notations are often segmented, ad hoc, and sufficiently broad to allow them to quickly assume control of large spaces. Artists who made portable paintings on textiles used sketches in a very different way, relying on them to trace or fix the size of figures typically depicted as single figures on a blank ground. A third type of artist, using drawing as a form of religious expression, produced diagrams that served as guides to visualization and recitation of sūtras. In this chapter we will explore these two alternative types of sketching—for banners and ritual diagrams. Following this discussion, we will isolate the distinct qualities of line in both of these two forms of sketch and distinguish between the professional artisan painter and amateur monk artist. We begin by distinguishing the diverging production methods of the mural and banner.

The Sketch as Preparatory to Silk Banners

Drawings for portable paintings on silk or paper generally feature only one icon. In contrast to mural sketches, the brushwork is quite fine and precise; details of costume, position, and setting are relatively complete. And, similarly, although the many scenes intended for a wall painting are typically condensed into a page or several attached pages, the drawings used to make banners are comparatively simple and orderly. Banner sketches were either traced onto clean painting surfaces or used to make direct copies. In the preparatory sketch and underdrawing stage, the brushwork is fine and detailed. This has a great deal to do with the artist's physical connection and cognitive relationship to the production materials during the preparatory stage. The artist painting silk banners engaged in close copy work. Working by a window or another source of light, artists traced and made sets of like banners, paying careful attention to line. The wall painter, however, actively moved around in the cave shrine or temple, covering a large territory. Because cave temples varied in size, the sketches were only partial; the painter was required to improvise in freehand drawing. On the other hand, the final products of the banner maker were typically the same size as the sketch, as opposed to the figures of cave shrines and temples, which shifted according to the size of the interior space. While many banners are nearly identical in size and shape, no two murals in grotto architecture were ever alike.

Sketches for paintings on silk, in contrast to random arrangements of figures in wall painting drafts, are usually more or less complete compositions with the figures true to size. Within this category of banner materials, there are several types; the primary difference between them lies in the quality of line, which ranges from unmodulated brushwork to fluctuating ink line. The best-known example is a late ninth-century drawing of Vaiśravaṇa, the Devarājā (heavenly king) who protects the northern realm (Figure 4.1a). His frame fills the vertical and most of the horizontal expanse of the paper, with his metal-tipped halberd defining the diagonal axis. The figure and his costume are executed in fine, precise lines, describing in great detail the ferocious beast on his belt buckle, the medallion-encrusted suit of armor, and the floral patterns on his crown. The collection of human attendants and menacing animal cohorts (not visible in Figure 4.1a) assembled to his left are drawn in a looser, fluctuating line and lack the detailed work devoted to the costume. The most impressive aspect of this sketch is its closeness to the composition of a painting in the Stein collection finished in a brilliant panoply of color and gold (Figure 4.1b).[1] Many of the details of the costume in this painting are identical to those in the sketch, suggesting advanced techniques for transferring designs by a workshop. The twirl of the scarves that cascade from Vaiśravaṇa's crown and the three-quarter view of his right hand holding the

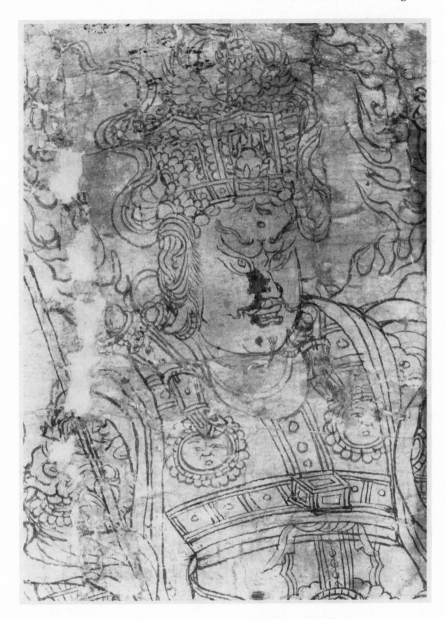

Figure 4.1a. Sketch of Vaiśravaṇa: detail. P5018, right side of scroll. Ink on paper. Late ninth century. Entire sketch: 28.5 cm × 75.3 cm. Cliché Bibliothèque nationale de France, BnF.

billowing clouds on which the pagoda rests are just two examples of correspondence. The faces are nearly identical. Interestingly, however, the sketch is much larger than the banner, although their contents are nearly the same.

According to the connoisseurship manual by Zhao Xigu (active 1195–ca. 1242), the *Dongtian qinglu* (Record of Pure Earnings in the Realm of Immor-

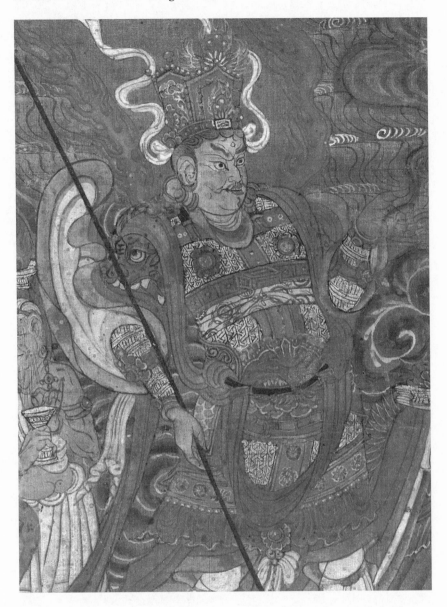

Figure 4.1b. Vaiśravaṇa. Stein painting 45. Ink, colors, and gold on silk. Ninth century.
Entire composition: 37.6 cm × 26.6 cm. Copyright British Museum.

tals; ca. 1242), two techniques, *lin* and *mo*, are typically used to copy paint-
ings.[2] Lin involved setting a clean piece of paper next to a work and copying
it alongside. Mo, on the other hand, was tracing a painting's contour lines by
placing a clean sheet of paper directly over it and following each line. A third
technique, which involved melting wax over paper with a flatiron to transfer

the design, was also used in the premodern period.[3] The two techniques, lin
and mo, would produce different kinds of lines. In the lin technique, the posi-
tion of the original figures might be modified in the copy, and the lines will
be looser than if they had been traced. The attendants in the Vaiśravaṇa
sketch, drawn with a looser hand than the main figure, might be an example
of this freehand copying technique. Their positions are not the same as those
in the finished painting. A traced drawing, on the other hand, will be nearly
identical, but the linear execution might exhibit a flatness that comes from the
tracing of the lines. While it is unclear whether this sketch of the Northern
Devarāja was made before or after the finished painting, the identical features
of Vaiśravaṇa in the sketch and painting suggest that one was produced after
the other in the same atelier. In a third painting, in the Musée Guimet
(MG17666), of Vaiśravaṇa crossing the waters with his retinue, many of the
details are the same, such as the trailing back foot balanced on the toes; the
long halberd; and the forward, impending movement of the body.[4] Although
it could have been produced in the same workshop as a loose copy, this sketch
was not used as a direct model for the second painting.

The wall painter could not trace or copy in the same fashion as the artist
of the banner atelier because murals, painted on rock, were immovable. The
sketches for murals indicate that drawing and copying for wall painters was
more random and approximate, as established in Chapter 2. The difference in
working methods for grotto painting is apparent in a comparison of a cogni-
tive map for a mural executed cursorily with an assortment of narrative details
(as in Figure 2.4) and the Vaiśravaṇa sketch executed in a precise, linear style.
The dissimilar brushwork was dictated by different painting surfaces and for-
mats. While one provides a loose approximation of physique, expression, and
space, the other defines these firmly. In the silk banners, one finds little change
in physique and costume. Space is also rendered consistent with the function
of both sketches. Given the large expanses of a mural, the wall painter relied
more on a free approximation of shape, estimating the space and adapting the
great number of figures. Numbering scenes in a sketch is a pragmatic solution
to producing a large number of figures on a wall. On silk paintings of the
Mahāyāna tradition (Vajrayāna is considered below), which includes many
sets of single-figure banners, the artist worked in a more precise mode very
close to the surface, effecting exacting detail. For this reason, making connec-
tions between monochrome ink sketches on paper and finished silk paintings
on silk is easier than connections to wall paintings because the first two share
a similar compositional layout. In size, sketches and silk banners are much
closer to each other than preparatory drawings are to murals.

A sketch of a bodhisattva depicted in an unusual three-quarter back profile
(Figure 4.2) may be connected to a finished painting despite its damage. The

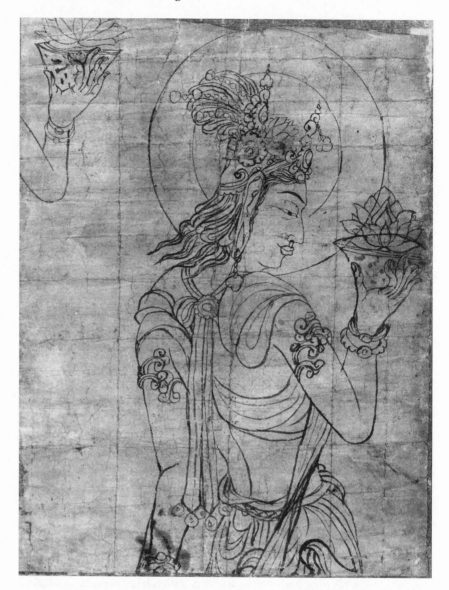

Figure 4.2. Bodhisattva depicted in three-quarter rear profile with spotted glass bowl. Fragment. P3050. Ink on paper. Ninth or tenth century. 32.6 cm × 25.1 cm. Cliché Bibliothèque nationale de France, BnF.

sketch is cut just below the waist so we cannot assess the lower half of the body. Everything in the torso, face, and headdress, though, is nearly identical to a painting in the Stein collection (Figure 4.3). A quick sketch of the hand and spotted-glass bowl with a lotus was attempted first on the left side; subsequently, it is incorporated into a drawing of the complete figure. This same

position, with the right shoulder thrust forward and left arm somewhat awkwardly shifted back, is duplicated in the silk painting. The bands that embrace the upper arms are slightly different, but there are few other discrepancies in costume. The drapery on the right shoulder, or down the back, falls in the same fashion. The coiffure and headdress diverge, but the similar tilt of the head, gaze fixed on the bowl, majestic nose, and full lips suggest that the sketch preceded the painting. The figure has features associated with conservative Gupta artistic programs used throughout Indian and Himalayan workshops. The artist elected not to transfer some elements, such as the turn of the scarf below the right elbow, but in view of all the other elements shared with the sketch, and given that the two are of nearly identical size, we can conclude they are linked.[5]

The hard, schematic lines in two other paintings of the same figure indicate how tracing techniques could flatten figures, especially if the copyist did not fully understand the lines of the original painting or the sketch. In a ninth- or tenth-century painting (Stein painting 104, not reproduced here), the copyist appears to have misunderstood the spotted glass bowl with lotus for a scalloped, schematic version of a flower that is usually found as a hair ornament.[6] The hair is also strangely carved so that where the lotus touches it, big chunks are missing. Also, more drapery has been added to the back to avoid having to depict the torso from an unusual angle. This tactic has been taken to an extreme in another three-quarter view version of this bodhisattva (Stein painting 120, reproduced in Figure 4.4). The entire back is covered with a flatly rendered piece of cloth to avoid an awkward rendering of the back torso. The face and oddly bent left elbow are flush against the picture plane, indicating that the contour lines were traced from another source and that the artist may have not understood how to effectively translate the original design.

When sketches for paintings on silk diverge from finished works, it is usually in minor details of drapery or variations in a figure's iconography. A ninth- or tenth-century sketch of Avalokiteśvara indicates how the artist could change a figure in the drawing stage (Figure 4.5). The artist switches the attribute from a bamboo branch to a lotus flower. Both types exist in extant paintings on silk (for example, Stein painting 117, reproduced in Figure 4.6). The difference between this finished painting and the sketch can be explained in several ways. First, the essential elements are the same: the hair, topped with a scalloped-shaped knot, cascades down the shoulders; the body jewelry hangs down to the abdomen; the cloth of the headdresses falls from the face to the chest in the same triangular patterns; and both have a moustache. The painting and sketch could have been executed at different times; possibly, the sketch was made after the painting in order to execute a new copy. Sketches demonstrate the great number of possibilities for transmitting ideas and for

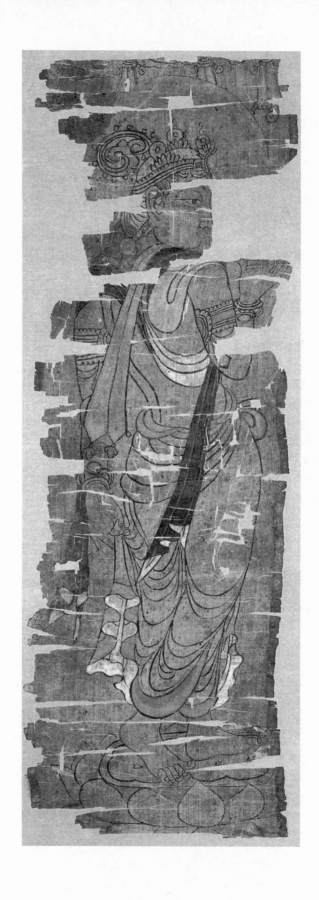

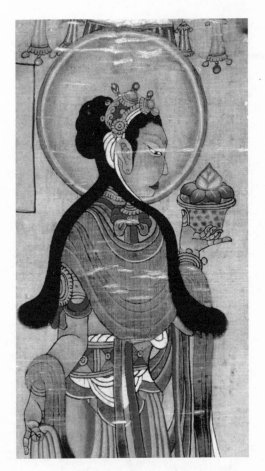

Figure 4.3. (left) Bodhisattva depicted in three-quarter rear profile with spotted glass bowl. Stein painting 113. Ink and colors on silk. Ninth or tenth century. 52.0 cm × 17.5 cm. Copyright British Museum.

Figure 4.4. (above) Bodhisattva depicted in three-quarter rear profile with spotted glass bowl. Stein painting 120. Ink and colors on silk. Ninth or tenth century. Entire composition: 58.0 cm × 18.0 cm. Copyright British Museum.

experimenting in designs. Any indecision about the status of a motif and its inherent mobility sometimes carries through to the underdrawing stage directly on the silk. In the earliest of all the dated banners (d. 729) from Dunhuang (Plate 18), damage to the top layer reveals a remarkable change.[7] It appears the artist first planned a frontal view of the monk, but changed to a three-quarter profile orientation of the face for the final version. Generally, the artist rearranged details of costume, iconography, and countenance but made few substantive changes to the design in banner paintings. A survey of two

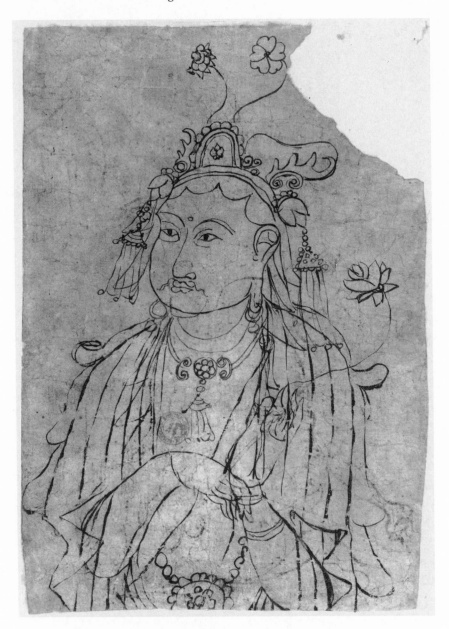

Figure 4.5. Avalokiteśvara: fragment, recto. P4082. Ink on paper. Ninth or tenth century. 39.4 cm × 28.1 cm. Cliché Bibliothèque nationale de France, BnF.

sets of nearly identical bodhisattvas demonstrates that minor changes could be made to give figures a markedly different appearance.

Two paintings of bodhisattvas from the Stein collection (paintings 125* and 136, reproduced here in Plates 20a–b) are mirror images of each other. Unlike other works where the figures are identical in pose (Figures 1.6a and 1.6b),

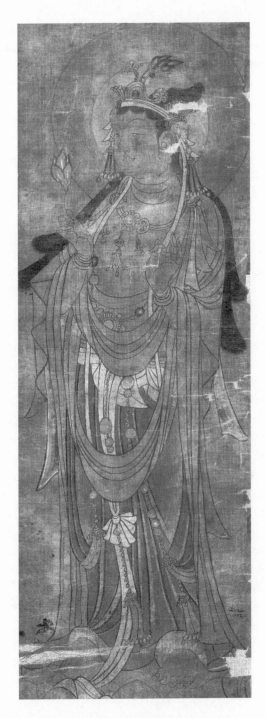

Figure 4.6. Bodhisattva with lotus. Stein painting 117. Ink and colors on silk. Ninth century. 70.5 cm × 17.5 cm. Copyright British Museum.

these two figures do not face the same direction. The bodhisattva reproduced in Plate 20a faces the viewer's right; the other figure faces left. Both turn away from the hand that holds an attribute (*cintāmaṇi*, or censer), accentuated by the foreshortened, white sacred thread emphasizing the turn in the body. The bodhisattvas are almost the same size: from the top of the halo to the bottom of the lotus bases, they measure 52.7 cm (Plate 20a) and 52.3 cm (Plate 20b). Every other detail suggests a common model as well. The thrust of the hip, the turn of the drapery below the bow in the front, and the jewelry correspond. The way the artist has changed the appearance despite their identical shapes is to vary the drapery. On the left, stripes of colors alternate; on the right, the bodhisattva's robes are partially decorated with a circular pattern set against a fabric dyed a solid hue. Their mirror-image postures and changes in attributes and drapery indicate that the artist invested production time in varying their appearance. We may assume they were traced from a common model, either by placing the silk over the sketch on a clean ground or by placing the sketch behind a silk or hemp canvas on a frame, and, in the sunlight, tracing the drawing onto the new, blank surface.[8]

Many pairs of similar paintings on silk can be identified in the Dunhuang collections (Figures 1.4 and 1.5). Two in the Musée Guimet (Figures 1.6a and 1.6b) are particularly noteworthy for the use of different attributes in the same bodhisattva figure. Here again, the sizes and positions of the figures are the same, but the artist manipulates details in the costume to effect variation. The differences lie mainly in small changes in dress. One bodhisattva wears monastic robes; vertical and horizontal bands divide the fabric into sections. The other is adorned with the princely dress typical of this class of deities. In all, five examples of both types are extant. The measurements for all five paintings are nearly identical as well: only two centimeters in both height and length separate identical proportions in each case. Further evidence of the widespread practice of tracing banners is clear in that at least ten sets, encompassing twenty-four paintings, found in the sūtra cave, are virtually the same (Appendix 4).[9]

These near-identical paintings, in which same-size images are changed slightly by altering colors, costume, and attributes, demonstrate that artists worked on painting in sets—production units of at least two works. Attention to the artist's practice and habits of this production regime reveals that in the economics of banner making it was most effective to reuse designs. Artists appear to have been hired to work on specific projects and to make a certain number of paintings for an agreed-upon price. Paintings with these identical features must have been produced at the same time. Clues indicating how tracing occurred are suggestive in earlier texts but not wholly definitive. Gu

Kaizhi (ca. 345–406), an important Eastern Jin painter, writes of tracing by copying; others refer to grids on paper, although this was probably a later practice.[10] Liu Daoshun, in his *Shengchao minghua ping* (Critique of Famous Painters of the Present Dynasty; d. 1056), refers to copying murals with this technique.[11] The sketches in a Qing dynasty collection have a wax-like translucency that may have been used to transfer designs in printmaking.[12] The most direct tracing method may have been simply to put the design behind or under the new, untouched surface, as mentioned above. In bright sunlight the details are easily visible underneath after the painting surface has been properly burnished and prepared.[13]

Some sketches with extremely precise, thick lines were perhaps used as reference drawings in the atelier to produce painting in multiples. This type of sketch may have been responsible for instituting efficient production of silk banners. A large drawing of Avalokiteśvara in the British Library (Figure 4.7) is analogous to Stein painting 14 (Plate 19). The drawing appears to be a core sketch around which infinite changes could be made based on the commission. Thus, for example, in Stein painting 14 inscriptions were added as well as additional jewelry and robes. The iconography is the same in both sketch and banner; both are given the name "Great merciful, great compassionate savior from hardship" (Daci dabei qiuruo guanshiyin pusa). More importantly, the artistic spirit of the figure is identical. The face is a wide oval and the crown is overly large; in fact, both are top-heavy and slightly tilted to the arm with the flask. There are minor differences in the drapery; it encircles the body in the painting, but hangs straight in the sketch. This discrepancy demonstrates that the sketch was not traced directly from the painting; the sketch could have been a first draft or used as a reference in the course of making the silk painting's fine lines. In the end, the artist could have decided to change the position of the arms. In fact, the circumstances of this painting's commission support the assumption that the sketch was kept as a reference in the atelier, which allowed for minor changes. It could be referenced to make this composition each time it was ordered by donors. The donors are omitted in the sketch, making it more versatile; the number and gender of the donors would change each time the painting was commissioned.

This painting was dedicated by a Mr. Zhang in honor of four deceased family members (his older sister, a nun pictured on the left; his older brother, Chamberlain Zhang Youcheng; and his parents) on the fifteenth day of the seventh month, the *Yulanpen hui* or Ghost Festival (Ullambanapātra), in the year equivalent to 910.[14] One of the inscriptions mentions his wish that his parents be reborn into the Western Paradise, a sentiment closely connected with the spirit of the festival. Therefore, we may surmise that sketches such as

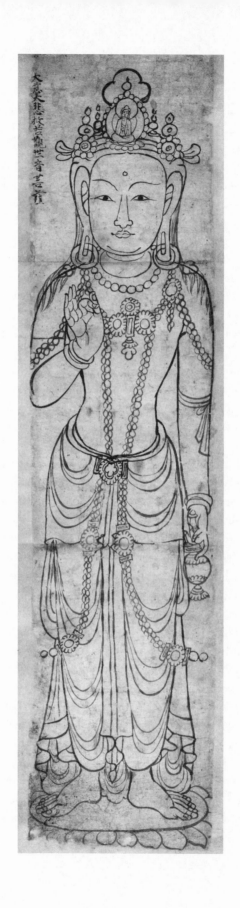

this one of Avalokiteśvara, who responds to pleas for help, were kept in the atelier for reference and adapted for occasions that arose, such as this commission from Zhang.

In some cases, sketches cannot be linked directly to identical extant paintings but may be connected, instead, to those with similar subject matter. An example is a fine, precise drawing of a youthful Vaiśravaṇa (P4518.34).[15] Details of the costume, such as the cloth helmet and the jewel at the base of the throat in the armor, are also found in paintings of the Eastern King dating to the second half of the ninth century. The stylistic correspondence in body type, costume, and countenance between this sketch and the finished paintings of the Eastern King suggests, too, that the sketch and painting may be linked to the same moment of production.[16] The point is that the Devarājas associated with the cardinal directions were probably executed in sets of four because the figures are displayed as an iconographic unit. A sketch such as this one of Vaiśravaṇa could be kept in the atelier with sketches of the three other Devarājas. When an order was commissioned, the iconography would be clearly laid out in reference drafts, and they could be copied to execute the order, which at a minimum would require four paintings.

An iconic drawing of the Buddha flanked by two monks and two bodhisattvas was probably kept in the atelier as reference for drawing the central portion of paradise scenes on silk, which required an iconic grouping at the center (Figure 4.8). Some erasure of lines in the Buddha's body indicates that the artist desired precision in every line. The painting epitomizes the kind of unmodulated drawing commonly used for the contour lines of most iconic figures in Dunhuang painting. We do not see the precise lines often because they are covered with color and overdrawing, but they are ubiquitous underneath the brilliant colors of the banners.[17] An example is the painting of Maitreya's Paradise rendered on silk (Figure 2.7); the precise drawings used in its central iconic grouping suggest the type of careful drawing used in the sketch. A rare example of an unfinished silk painting of Kṣitigarbha and a scene from the Scripture on the Ten Kings of Hell reveals the blunt drawing used for banners.[18] All the primary contour lines are sketched in dark ink. Based on what we know of other, similar compositions, the next stage was to add a layer of color; and, finally, another layer of fine overdrawing, also in black ink (and often touches of red for the flesh).[19]

In certain figures such as the apotropaic vajrapāni, the artist boldly uses the thick black line of underdrawing to emphasize the brawn of the subject, which the artist does not attempt to conceal, but exaggerates for dramatic effect. Two

Figure 4.7. Avalokiteśvara. S9137. Ink on paper. Tenth century. 27.1 cm × 126.4 cm. By permission of the British Library.

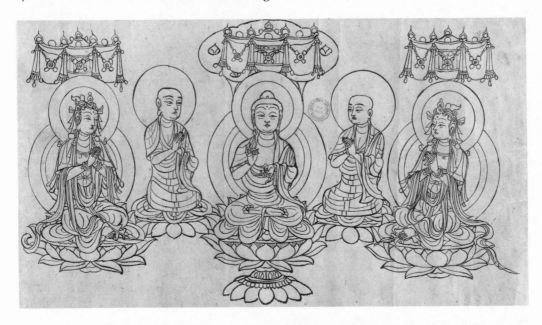

Figure 4.8. (above) Iconic grouping of the Buddha flanked by two monks and two bodhisattvas. P3939. Ink on paper. Tenth century. 29.4 cm × 50.8 cm. Cliché Bibliothèque nationale de France, BnF.

Figure 4.9. (right) Assorted sketches of Vajrapāni on back of a damaged sūtra. Detail, verso. P2002. Ink on paper. Figure d. 861 or 921. 23.1–23.4 cm × 446.0 cm. Cliché Bibliothèque nationale de France, BnF.

banners now in the British Museum and in the Musée Guimet feature a style of drawing with extra thick lines of the kind usually reserved for underdrawing and preparatory sketches, such as the vajra holders in the practice sketches reproduced in Figures 4.9 and 4.10.[20] What makes the three silk paintings (reproduced in Plate 21 and Figures 1.4 and 1.5) of interest are the techniques for varying details of design on figures that are otherwise identical in height and linear structure.[21] First, shading is liberally applied to the physique in Stein painting 123 in an armature of brown cinnabar color that enhances the black contour lines. It has the effect of making the figure seem more imposing; the musculature defined by the web of brown shading, for instance, gives the impression of great bulk. Other details enliven the figure. In the other two paintings (Musée Guimet EO 1172b, Figure 1.5, and MG 17774a), the artist basically uses the same body but changes small motifs to vary the imagery. These include the sprightly, pointed big toe on the left foot and flying headscarves whose tips point outwards. In the second Musée Guimet banner, the toe is curled under and the scarves curve inward. Now we turn to another type

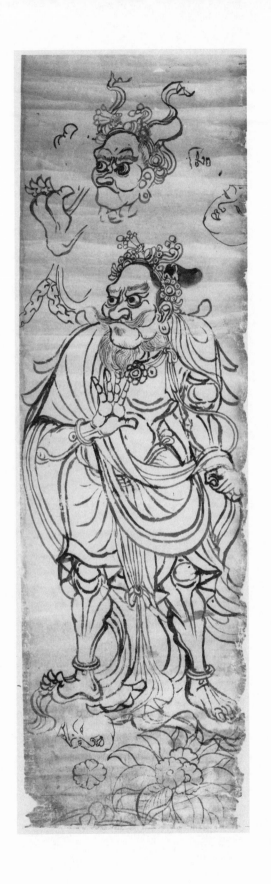

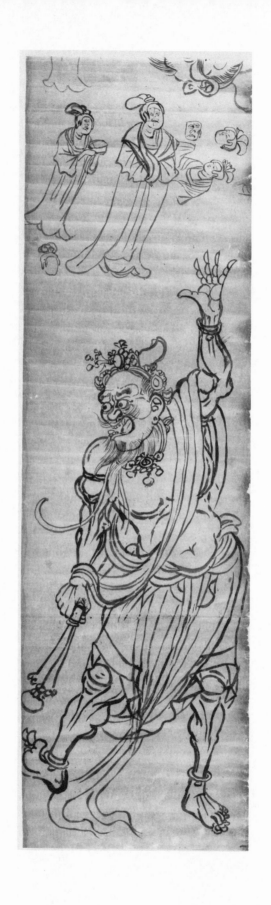

of sketch that functioned beyond the preparatory practice of the artist and in religious ritual.

Sketching as Religious Performance: Ritual Diagrams

Monks may have worked with artists to insure proper representation of figures. It is clear, however, that the majority of artists were not reading sūtras to compose paintings (a subject discussed in Chapter 5), but instead were using the range of pictorial aids considered in this book. There is, however, a class of drawings that clearly served a different function beyond artists' preparatory tools. These sketches in either black monochrome or red ink were finished diagrams; they were used directly as religious aids. That is to say, they were a visual aid to be used when a text was recited. This class of painting, used only in ritual, was an exception to the practice in Chinese art of the ninth and tenth centuries that limited monochrome drawing to the preparatory stage. In these examples the performance of art and its production are joined. Most of these drawings—as tools in religious practice—are of Tantric or Vajrayāna Buddhist subjects and have qualities that distinguish them from the sketches artists used in the painting process. Diagrams for maṇḍalas and dhāraṇī are the most common. They contain complex and intricate prayers and ritual notes that surround the monochromatic images. The presence of extensive calligraphic notations sets them apart from the other artists' materials. But there is also a type of preparatory drawing for Tantric paintings distinct from the ritual practice materials. These two types of Tantric drawings may be distinguished in the Dunhuang artifacts. In this second type, textual notations sometimes indicate color; and in other instances, dabs of color added by the brush indicate hue. These features are unique and not found in other monochrome drawings at Dunhuang. They suggest a link between complex textual notions on sketches, Vajrayāna practice, and the special demands of Tantric iconography. That is, the sketches for banners are limited to one figure in a size similar to the final painting; the lines are precise and the composition is clearly delineated. Sketches for Tantric material require many more stages for an artist to transfer the notations into a completed work. They contain more detailed notations and many figures and parts. Below are discussions of these two types: sketches used in the production of silk painting with Tantric subjects, and monochrome drawings used in ritual practice.

Figure 4.10. Vajrapāni. Assorted sketches on back of a damaged sūtra. Detail, verso. P2002. Ink on paper. Figure d. 861 or 921. 23.1–23.4 cm × 446.0 cm. Cliché Bibliothèque nationale de France, BnF.

First, some maṇḍala sketches were clearly used in the production of paintings. These may be distinguished from the other Tantric materials in that they were primary aids to make pictures by artists who were largely concerned with visual, not textual content. In this regard, the sketches are no different from other silk banner sketches. For instance, in a maṇḍala of the five Dhyāni Buddhas of the Diamond World (Vajradhātu), pictorial features are emphasized in the careful drawing of figures (Stein painting 173, reproduced in Figure 4.11). Lines precisely define Vairocana in the center and the deities in eight triangular enclosures that emanate from the figure. One large, square register is left blank, leaving a suitable space for additional figures. Around the outer edges, ritual implements occupy the spaces between the wrathful guardians at the doors marking the four directions. Two aspects of this sketch attest to its preparatory function in the artist's atelier. The first is a patch of paper that has been pasted on the sketch in center left (below and to the left of Vairocana). The addition of pasted paper with a deity offering flowers is not visible in a photograph except for a break in the first ink line encircling the inner core. The artist has replaced what was probably a mistake underneath with a better version of the figure. Gluing a piece of paper over part of a drawing to correct a minor mistake in a draft indicates that a highly skilled artist had a hand in the drawing. The artist clearly was concerned with details of pictorial finesse and was fastidious enough to want the surface to appear unified, perhaps in order to trace it. Pasting a correction on a draft was common in Chinese painting academies. An example is the sketch of the *Emperor Kangxi's Visit to the South* in the Palace Museum, Beijing, dated to ca. 1689. Near the end of the preparatory work, the artist has corrected a mistake in one of the scroll's minor personages by pasting a clean a piece of paper over it and executing a new, acceptable figure. These practices indicate that both, although separated by 800 years, were produced in a similar art workshop. This example is very different from the other maṇḍala sketches I will review.

The second piece of evidence that connects this sketch of Vairocana to pictorial rather than ritual practice is its similarity to a finished colored maṇḍala on silk (Plate 22). In the finished painting, the main deity, Avalokiteśvara, is in the center with subsidiary deities occupying the vajra-pointed triangles that radiate around the four-armed bodhisattva. But in the court at the top of the painting, the five Dhyāni Buddhas form another maṇḍala accompanied by the Cintāmaṇi and sixteen-armed form of Avalokiteśvara on either side. These figures, without the two additional forms of the bodhisattva, are comparable in layout to the center of the sketch. Although the figures are somewhat displaced in the silk maṇḍala, the composition is consistent with the sketch. Fierce guardians with an elephant, a lion, and other powerful beasts are placed in the rectangular gateways. Four apsaras with garlands fill the spaces where

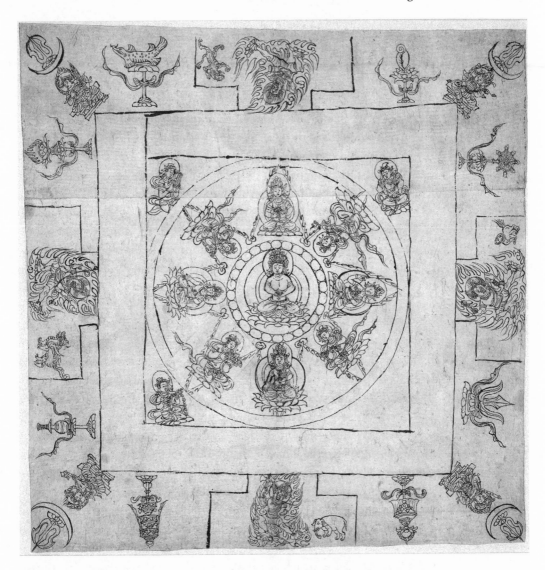

Figure 4.11. Maṇḍala of the five Dhyāni Buddhas. Dhāraṇī for Amitābha or Vairocana. Stein painting 173. Ink on paper. Late ninth century. 44.8 cm × 43.2 cm. Copyright British Museum.

the circle meets a square. Vajras, fish-laden stands with flying draperies, and crescent-moon-shaped cups holding three-pronged vajras punctuate the four corners. Donors typically fill the lower section of the finished maṇḍala; there are no donors in the sketch. Drawings such as Stein painting 173 were probably kept in the atelier for reference, as argued previously, for the long, thin sketch of Avalokiteśvara. In that instance, I linked the sketch to a finished silk

banner dated 910, in which inscriptions and donor portraits of the Zhang family had been added. The additions that supplied details about what motivated the commission could supplement the main design.

Because of this inherent complexity, maṇḍalas may have necessitated a different, perhaps fully literate, class of painters. The demands of this type of painting are clear in drafts on a long roll. Four maṇḍala sketches are interspersed on the recto with drafts of unrelated texts, including a portion of a rhyming dictionary (P2012, reproduced in Figure 4.12).[22] These diagrams were used in ritual practice in confession rituals.[23] Full attention is given to iconography, including the requisite number of deities, with their attributes and postures; in comparison, the compositional layout and artistic qualities are a minor concern. Unlike the maṇḍala of the five Dhyāni Buddhas, in which all the figures are placed in their final position, figures are drawn separately at the sides where they are identified by cartouches. The main body of the maṇḍala is roughly outlined. The flowers, vajras, and attributes to be delineated in meticulous detail in a finished painting are rendered as flat shapes. Rather than indicating the structure of the painting pictorially, written notations provide details about the placement of dharma wheels, which should appear in the four gateways. In another section, the artist uses characters to indicate color; "yellow ground" (*dihuang*), "blue-green ground" (*diqing*), and "multicolored ground" (*diwuse*) are written amidst the abbreviated Tantric figures and attributes. These sketching practices, unlike those in the banner, mural, and ceiling drawings reviewed previously, reflect a set of rules applied for religious practice diagrams. These instructions are for visualization, not painting production.[24] The artist uses verbal rather than pictorial means to convey information.

This approach to visual material may be compared to another example of a maṇḍala used for an entirely different purpose. In a drawing of the Diamond World (Vajradhātu) maṇḍala, instead of using written notations for figure placement and color, which as we mentioned are used in confession rituals, actual dabs of color were added as visual cues for hue (Plate 23). This maṇḍala and another, of a wrathful, Tantric figure, possibly a Vidyārāja (Ch., *mingwang*), have dots of blue, red, green, yellow, and brown placed intermittently across the surface of the monochrome drawing to guide the artist or colorist in the atelier. Color schemes were especially important in Vajrayāna painting, in which hues convey important iconographic information; also, in meditation, specific colors had to be visualized. Thus, in producing maṇḍalas, each section had to be executed according to specification.[25] Presumably, the dabbing of different hues would ensure this correct coloring in copies without the presence of the master painter. These unusual indications of color may also have been used to make paintings in sand, a common but ephemeral form of

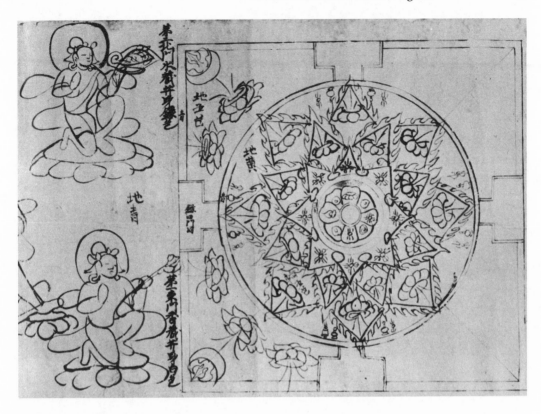

Figure 4.12. Maṇḍalas; confessional drawings. P2012. Ink on paper. Entire drawing: 29.4–30.0 cm × 513.7 cm. Cliché Bibliothèque nationale de France, BnF.

painting in the Tibetan Buddhist tradition. In any case, what is clear is that these directions are employed in the artistic production of objects that will later be used in ritual.

One other type of maṇḍala involves yet another set of visual, ritual practices. In an example of this type (Stein painting 172), a lotus pod is placed at the center and petals are abstracted into a dharma wheel (Plate 24 and Figure 4.13). On the sketch, a supervisor has written instructions to an apprentice suggesting changes in pictorial motifs. In the left (labeled "south") section of the sketch, the artist has written, "Put the deity in the center and move the mudrā to the left." Just to the left of the deity, the artist has noted that the ritual implement should be eliminated to make room for the mudrā, which will be moved to accommodate the deity. These same instructions are repeated in the three other entrance ways at the cardinal points. The verb "to use" (*yong*) suggests a physical activity other than painting, which would be referred to as *hua*, or "to paint." Possibly, this type of sketch was a guide for making paintings in sand, a ritual practice typically executed by monks.

Figure 4.13. Lotus-centered maṇḍala: detail left section (south). Stein painting 172. Ink on paper. Tenth century. Entire composition: 58.5 cm × 57.5 cm. Photo by author. Permission to photograph courtesy of the British Museum.

Other maṇḍala sketches, as we have noted, were not prepared for use in the atelier, but were intended for use in ritual practice. A red-ink drawing—one of the rare examples of a drawing in this color ink from Dunhuang—held in the British Museum (Stein painting 173) was probably used in the recitation of the dhāraṇī written in the center (see additional example S5656).[26] The figures, vajras, and lotus stands are simply drawn, but the precision of the execution indicates that the diagram is a finished piece. Other examples of ritual documents that played a role in religious activities rather than artistic practice are those connected to actual meditation practices. Stein painting 6348 (reproduced in Figure 4.14) contains the entire text of a mantra written in miniature characters crowded along the edges and open spaces of a maṇḍala; the text's comprehensive nature, which draws from twelve distinct prayers and sūtras, suggests a spiritual function for a literate user. The invocation of the powers of Vairocana through these texts and images was a powerful tool in the protective functions that Buddhism played in the lives of medieval Chinese, Tibetans, Uighurs, and Khotanese. Another diagram, of an altar in ink monochrome (Figure 4.15), was used to set up a ritual space for the Uṣṇīṣa-vijaya dhāraṇī. Next to two-dimensional depictions of basins and vases, Chinese characters indicate what should be placed inside the containers, such as water,

Figure 4.14. Maṇḍala drawing with the texts of eleven sūtras, recto. S6348. Black and red ink on paper. 654.0 cm × 76.2 cm. By permission of the British Library.

incense, or light (lamp oil). The four directions are indicated in addition to the placement of the ritual master's seat and the stove or burner.

Ritual texts were also printed. The printing of dhāraṇī pictures with text caused them to become votives; they could be reproduced very quickly. In a Mahāpratisarā dhāraṇī dated to 980 (Stein painting 249, reproduced in Figure 4.16), the text provided around the Sanskrit seed syllables is so stylized, small, and inaccessible in its circular format that it would be difficult to read in ritual practice. This printed dhāraṇī and others like it were made in large numbers for an expanding lay clientele; several impressions were found in the Dunhuang sūtra cave.[27] These objects were probably not used in monastic

Figure 4.15. Uṣṇīṣa-vijaya dhāraṇī. Altar diagram. Stein painting 174. Black ink on paper. Tenth century. 44.0 cm × 30.5 cm. Copyright British Museum.

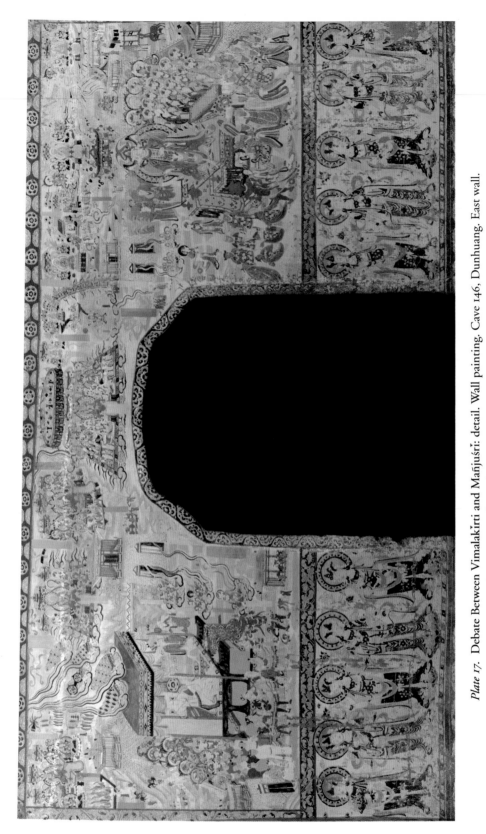

Plate 17. Debate Between Vimalakīrti and Mañjuśrī: detail. Wall painting. Cave 146, Dunhuang. East wall.
5.09 m x 8.51 m. © Dunhuang Research Academy

Plate 33. Ten worlds of the Avataṃsaka Sūtra. Detail of Buddha, bodhisattvas, and other heavenly beings. Wall painting. Cave 196, Dunhuang. North wall, northwest corner. Entire wall: 5.13 m X 10.23 m; detail: 1.57 m X 2.20 m. ©Dunhuang Research Academy.

Figure 4.16. Mahāpratisarā dhāraṇī. Avalokiteśvara with eight arms as wish bestower. Dhāraṇī prayer in Sanskrit, center and corners; Chinese text interspersed. Stein painting 249. Woodblock print on paper. D. 980. Printed area: 41.7 cm × 30.3 cm. Copyright British Museum.

ritual but disseminated to a range of practitioners and had a talismanic function for the owner. The production of this type of printed dhāraṇī in Dunhuang expanded in the tenth and early eleventh centuries.[28] Nonetheless, at the most accomplished levels of spiritual practice we could expect monks to have used complex texts and diagrams that were handwritten to their specifications rather than popular expressions of prayers that were printed in multiple copies. Instead, these prints could have been given to devotees in exchange for contributions to the monasteries consisting of textiles, food, and so on. In the next chapter we turn our focus to the intersection of oral, textual, and visual cultures.

5. PERFORMANCE:
ORALITY AND VISUALITY

Performances of the artist in the ephemeral realm of freehand drawing are central to understanding the wall painter's cognitive process during production. Using the sketches as an index of the artist's engagement with artistic space and methods, a material-based perspective on artistic action was explored in the first several chapters. This chapter will address performance as depicted in painting. Certain features of a new Tang vernacular style emerged during the eighth and ninth centuries. The ability to portray observable phenomena, such as emotion, movement, and popular customs, coincided with the increase in temple wall painting production during this time. The prevalence of sketching techniques that abbreviated pictorial form with a vigor that suggests verisimilitude heightened the sense of immediacy in representation. These qualities were accomplished by the painter's own strong interest in themes that showcased movement of pictorial characters. The mobility of the wall painter and his cognitive adaptation to the changing environment of the cave shrine parallels the themes of performance, drama, and action featured in the compositions.

These themes of ritual, stylistic, and technical performance are brought together in this chapter to consider how oral narratives and popular storytelling themes found their way into wall painting. During this stage in Chinese and Central Asian painting, art was most closely linked to performance. Compositional themes, literary observations, sketches recording traces of the artist's decision-making process, and storytelling narratives popular in temples and towns all suggest an appreciation of dramatic elements in real and imagined worlds. These elements are best portrayed in The Magic Competition

wall paintings. Fifteen examples framed our inquiry into production in Chapter 2; now we turn to their thematic substance.

One of the primary points of discussion will concern the origins or milieu from which this tale emerged. Sūtra production and other scribal activities were separate from painting in medieval China and eastern Central Asia. Scribes and painters had different titles and were responsible for producing distinct materials; sūtras and paintings required related skills of the brush, but all evidence points to a division of labor that kept writing and painting separate.[1] The exception is the drawings made by monks used in religious practice, in which both talents were deployed with equal skill and finesse. For the most part, the painter's tools were confined to sketches transmitted through the atelier. Applying this logic to the production of The Magic Competition, it is relatively easy to dismiss the possibility that artists were reading sūtras to compose these paintings. Artists quite naturally referenced their sketches. But what about the less clear-cut case of vernacular literature? Inscriptions in painting cartouches often share similar language with a type of performance literature called *bianwen* ("transformation tales")—a new kind of colloquial-based genre that matured during the eighth century. It contains antecedents to the novel. Is it possible to connect the worlds of writing and painting through bianwen? How can performance literature and painting contain similar content if the practitioners were not sharing sources? This chapter will address the artist's practice in an oral environment and demonstrate how artists were members of an oral culture shared by performers, sūtra lecturers, and text copyists. The popular theme of The Magic Competition—which survives in sūtras, vernacular literature, preparatory sketches, and finished wall paintings—allows us to assess the role of the artist in Buddhist storytelling (see Plates 9 and 10).

Historiography and Sources of Narrative

The richness of three sketch scrolls and fifteen large wall paintings of The Magic Competition dated to ca. 860–980 is augmented and complicated by surviving versions of the tale in popular literature and more formally written sūtras. Three kinds of written text that tell all or parts of the tale are extant—sūtras, popular literature, and the inscriptions accompanying the wall paintings. The popular literature, known as bianwen, is particularly relevant for two reasons. First, bianwen on The Magic Competition were written some time in the latter half of the ninth century to the tenth century, the same period to which all fifteen murals date.[2] Considered to be the genesis of popular literature in China, bianwen reflects vernacular patterns of speech that were associated with performances of the tale. Second, like the paintings, these

vernacular bianwen have links to an oral narrative tradition, which itself could be considered a fourth kind of text. This fourth kind is the spoken (verbal) form delivered in storytelling performances and sūtra lectures (*jiangjingwen*). (The latter could be considered a fifth type of text, given its more formal nature.) Naturally, we do not have access to these transitory forms of the narrative in direct physical ways, but their presence is seen throughout the visual representations.

How written forms of the tale overlap has been the subject of major studies by at least ten scholars. The conclusions they reached are contradictory.[3] This makes a summary of the major research findings over the last century all the more vital at this juncture: the study of this tale has not only raised many fundamental questions about popular culture and expression, it has also revealed, on some level, the current state of thinking on early popular culture in China. I use this overview as a way of framing the problems with respect to the tale's pictures, focusing on the links between visuality and oral context—a topic that in Chinese painting deserves a new look. At the center of discussion are the ways oral transmission of culture impacts the visual worlds of painting and spectacle. I am not arguing, however, that these murals were used in monks' sūtra lectures as didactic props.

The earliest modern studies of the tale were broad deliberations on the Central Asian origins of the fifth-century sūtra Xianyu jing (Sūtra of the Wise and Foolish), which contains the story "Sudatta Erects a Temple." This story is still widely regarded as the textual source of The Magic Competition.[4] The newly assembled and massive Buddhist Tripiṭaka (*Taishō daizōkyō*, 1912–25) made possible Takakusu Junjiro's and Sylvain Lévi's intricate studies in the 1920s on fifth- to thirteenth-century recensions of the Sūtra of the Wise and Foolish. Their studies compared these newly organized, canonical variants that had been passed down through repeated temple printings over a millennium.[5] Yet, Paul Pelliot and Aurel Stein's on-site investigations at Dunhuang and the removal of thousands of its texts to Europe changed the course of studies of The Magic Competition simply because these rare documents and paintings were the largest body of medieval culture that had been preserved completely in a nearly undisturbed medieval context.[6] Many, if not most, of the texts were handwritten, meaning that a good percentage were unique, individual renditions that contained variations; they were not products of continual reprinting, as was the homogenized Taishō compilation of the accepted sūtras in the canon. The discovery and distribution of the Dunhuang materials made possible new areas of study by providing texts with previously unknown variant readings of the Sūtra of the Wise and Foolish, along with compelling, later vernacular versions that revealed dissemination on the popular level and names of monks and patrons.[7] All this gave the Dunhuang texts

an unprecedented historical relevance. In particular, the popular materials from the sealed library in cave 17 at Dunhuang have made it clear that it is no longer possible to think of a single Buddhist tradition and canon; instead, we must envision many kinds of popular Buddhisms that flourished away from India and the imperially supported temples in metropolitan China.[8]

Thousands of photographs of murals taken during the Stein and Pelliot expeditions, including six of the Dunhuang and Yulin caves embellished with The Magic Competition theme, provided new pictorial material, as well. Comparative visual studies of the caves became possible. Matsumoto Eichii, the first scholar to assemble a study of The Magic Competition using the newly available photographs, pioneered a modern Buddhist art history that emphasized firm links between pictures and textual iconography.[9]

An early monograph on the vernacular origins of The Magic Competition tale, published in 1954 by the French scholar Nicole Vandier-Nicolas, was the first to suggest that the tale, and its pictorial versions, were connected with the colloquial literature found at the site. Her study helped establish the parameters of the debate on The Magic Competition as it remains today. Vandier-Nicolas focused on one long portable scroll (P4524) possibly once owned by a storyteller-performer of The Magic Competition. The scroll features sung verses of the text on the scroll's recto and pictures of Raudrāksha and Śāriputra's contests on its front. The pictures were most likely made for performance and are possibly the only verifiable extant example of a storyteller's scroll from China. The text, however, seems to be a written record of the ephemeral oral performance that accompanied the pictures.[10] Her analysis of the text, along with a more recent study of the scroll's features by Victor Mair, gives solid proof that vernacular versions of the tale emerged from a storytelling tradition that incorporated pictures.[11] Mair, who has devoted himself to studying the roots and formulas of this storyteller's literature (bianwen), has speculated that storytelling with pictures was ubiquitous in Tang China and Central Asia, reflecting Indian traditions, and has stressed their secular manifestations.[12] Wu Hung has studied the meaning of the term *bianxiang* (transformation tableau) and determined that the wall paintings were not used in storytelling. One could conclude, as I do in this chapter, that the murals are an index to storytelling activities, tales, and practices that occur outside the cave temple.

The story's plot is very involved, as indicated in Chapter 2. Briefly, to repeat the general contours of the story, a minister of Śrāvastī converts to Buddhism. His piety, though, causes conflict since the garden on which he proposes to build a temple belongs to a local prince, and the latter feels he has not been given a fair price. Local troublemakers seize the opportunity to challenge the Buddhists' clout; they are classified as *waidao*, outside the "way." This term denotes religious sectarian dissent; it also carries connotations of nonconfor-

mity and deviation from a cultural orthodoxy. These infidels are political lia-
bilities, as well. When they bring the matter before the king, he orders six con-
tests of the heretics' and Buddhists' magical powers, the outcome of which
will settle the matter of the garden and the proposed temple. As important as
these first scenes are to establishing the narrative momentum of the story, the
artist had placed the garden, attempted temple construction, and the king's
judgment along the right side of the mural, on the painting's edges. Their aux-
iliary status is underscored by their diminished size suggesting, also, different
temporal moments for the preceding events (see Figure 2.12). The Buddhists
search for Śāriputra to prepare himself for the battle (bottom center); he is
located in Buddha's heavenly realm (upper left). When he finally converts
Raudrākṣa, the heretics' leader, with a dose of holy water, he flies across the
painting's upper edges to make the journey, completing a full circle back to
the narrative's beginning. With the auxiliary scenes relegated to the edges, the
center becomes the battleground, with the king arbitrating at the center (Plate
25). Further, the two masters of the camps are enlarged at either end of the
space enclosing the six contests at the center. The center becomes encircled by
the events leading up to the battles and the enlarged combatants who, on their
daises, frame the right and left sides of the six magical jousts (Figure 2.19).

The importance of this type of rich story to the development of popular
literature captivated Chinese scholars in the early revolutionary period in the
1920s who wanted to locate the origins of vernacular culture and *baihua* (col-
loquial spoken language) in collective experience common to all Chinese.[13]
Wang Zhongmin's edition of Dunhuang bianwen stories in 1957 represented
a culmination of decades-long research into Tang literature as the roots of
Chinese popular culture.[14] The question was whether the texts with Buddhist
subjects were, in effect, sūtra lectures. These lectures are considered to have
been a simplification of Buddhist concepts for lay audiences.[15] Magic Com-
petition texts that generally fit this category, however, have been labeled or
presented in three distinct ways; this creates problems if we are to understand
their relationship to colloquial performance. These three types are: 1) a scroll
with verses positioned so that they could be read while pictures were viewed
(P4524), labeled a *bian*, 2) bianwen with no pictures and unclear circum-
stances of production, and, finally, 3) other Magic Competition texts clearly
used in sūtra lectures (such as P2187), labeled a *yazuowen* (literally "seat-
settling text," apparently an introduction to a much longer sūtra lecture).[16]
What position did bian, bianwen, and yazuowen literature occupy in the
instruction of the laity, or were they strictly entertainment?[17] Which tradition
best reflects the oral locus of vernacular literature? This question is further
complicated by the close correspondence between bianwen text scrolls and
cartouches in Magic Competition murals.

Disagreement on the relationship, or lack of relationship, between the murals and this oral/written tradition exists on several key points. Akiyama Terukazu, the first to link the performance scroll, independent bianwen literature, the cartouches that identify each key scene, and wall paintings in a substantial study, finds a close connection between bianwen and wall painting. He demonstrates this by matching lines of the bianwen with the cartouche phrases from caves 55 and 146.[18] Chinese scholars, supplementing this same evidence with the transcription of all The Magic Competition cartouches, stress, instead, the divergence between the bianwen and the mural cartouches.[19] But by using a larger sample of cartouches, Cai Weitang and Li Yongning have provided solid evidence that the contents of The Magic Competition cartouches were not directly copied from bianwen texts.[20] They also have confirmed that the murals were not used by storytellers to entertain or instruct the laity within the cave temples.[21] The narrative disjunction of the wall paintings, they maintain, would make it impossible for a lecturer to convey the plot effectively to an audience in the caves. For example, the first scene appears in the lower center; the second scene occurs in the upper right of the wall painting. The thirty-some-odd scenes are scattered around the mural in a seemingly ad hoc, random manner. Li and Cai numbered the scenes to indicate the narrative complexity of the tale and the infeasibility of using the murals as some kind of narrative prop for a storyteller. Following the textual order, the scattered incoherence of the visual narrative leaves little doubt that artists did not use the texts (bianwen) as a model for the paintings during production; otherwise, they would have organized the painting in a coherent linear format with distinct divisions. Largely following the thrust of their argument, Wu Hung maintains that The Magic Competition cartouches are so unlike the bianwen texts that it is more likely the paintings inspired later literature. Thus he turns around the question of "influence" and sees the paintings as the creative source for texts and credits the artist with textual creation.[22]

These studies raise several key questions: 1) Did writers and artists interact as coproducers of this tale (in various venues), and if so, how? 2) Why would artists create largely unreadable paintings, their narrative disjunction so pronounced that they have no visual logic analogous to the verbal logic of the texts? 3) How do the paintings convey meaning? 4) Must we hold paintings to the same narrative standards as verbal texts? 5) Can we still understand the paintings as artifacts of oral performance if we deny a direct relationship between bianwen and wall painting cartouches?

Akiyama's study of artists' sketches of The Magic Competition is an exception to the intensive focus in scholarship on the bianwen, sūtras, and cartouches.[23] However, his study does not attempt to directly link the artist's

mural production to The Magic Competition sketches. Still unresolved is how and why the popularity of the theme led to a standardization of the wall compositions.

A great deal is at stake in these problems, not the least of which are the pictures; as is clear from this brief review of the literature, the murals have received little treatment in their own right. In general, although various scholars have stressed different aspects of The Magic Competition literature, the thrust of research has been to reconstruct the linguistic logic of the written texts, which include cartouches imbedded in the wall paintings. The criteria used to analyze all the materials are textual; for instance, the latest studies assume that the logic and order of the texts is inherent to all renditions in the tale including those in the pictorial arena. Even though Li Yongning and Cai Weitang demonstrate that the wall paintings do not follow a verbal textual logic, in effect they render the paintings meaningless by not suggesting a picture-based order. In fact, the paintings may be of great importance in establishing the foundations of popular literature in early Buddhist writing.

Instead of looking at texts as a closed system independent of social and historical factors, if we consider how the transformation in vernacular culture took place in the visual realm, we may establish features central to the tale's emergence. The Magic Competition integrates both text and image in a radically new way that combines both aural, oral, and pictorial traditions—one that forces us to dislodge the written text from its privileged position in previous scholarship.[24] In Chapter 6, I argue that a shift in aesthetics takes place in the late ninth and tenth centuries favoring naturalized expression such as genre scenes invoking the everyday. Colloquial phrases in the new genre of literature (bianwen) are analogous to these developments in painting.

Performative movement conveyed through dramatic poses of the body signaled the arrival of vernacular expression embodied in The Magic Competition. The bodily response of the figures to the unfolding drama distinguishes these paintings from earlier works. These pictorial actors inhabit a new "vernacular body" that encompasses an internal reception of unfolding events. The mythological is presented as the everyday, and the figures lend a credibility to the painted magical world by assuming credible poses; often these postures are overdetermined and exaggerated in their animated enthusiasm. All the noncanonical texts devoted to this tale were performed before a live audience (or written after such an oral exchange). Something of that quality is embodied in the painting. The delivery of the tale with pictures during successive moments in real time (as opposed to the time of the *discours*, the story itself) helps to explain the partitioning of the visual space into distinct, segmented sections, such as the separation of the six matches (Figure 2.19) from each other. The events are distinct and individually animated. Moreover, the

setting of the doctrinal battle between Raudrāksha and Śāriputra suggests a stage-like venue; the six contests are arrayed between them like performances. By paying attention to the origins of the story in oral discourse—both in monastic and secular settings—the genesis of its pictorial protocol may be linked to the textual tradition without necessarily viewing one as taking precedence over the other. In other words, by highlighting how oral discourse and the performance tradition bear on artistic invention, the verbal forms may be seen as complementing rather than determining the paintings' structure. A homology or a semantics of expression exists between visual and textual programs. The use of language in situated action in earlier, ephemeral performances of the tale is an important factor when analyzing this composition.[25] The figures, as we shall see, are themselves assuming poses as if they were acrobats and actors on a stage captured in the midst of performance. The power of this composition lies in the artist's depiction of many events unfolding in different narrative moments but revealed simultaneously in one large composition.

Locating aspects of oral narrative culture within the structural logic of the pictures will involve extensive discussion of both the nature of production methods and the significance of key scenes in the paintings. An exploration of these two areas—production and thematic significance—will emphasize the importance of the artist's practice for the paintings as distinct from the writer's practice.

Oral Context and the Emergence of the Tale

By all indications, the story of The Magic Competition took shape in an oral, storytelling and lecture context. This may be the single most important aspect of its history for the study of paintings. These roots hold true even for the oldest parts of the tale preserved in sūtra literature, such as the Sūtra of the Wise and Foolish, a text we might expect to be purely an artifact of a literary author. According to a sixth-century catalog, this sūtra is a collection of Khotanese tales, an assertion supported by its format and the detailed lore surrounding its transmission.[26] In 455 C.E., the Gansu monk Huijue is believed to have traveled to Khotan for an important religious festival that included sūtra debate and lectures. Before returning to his native Liangzhou (Wuwei, Gansu Province, to the east of Shazhou, where Dunhuang is located), he is said to have stopped in Gaochang (modern day Turfan) to translate into Chinese the Sūtra of the Wise and Foolish that he had just heard in a Serindian language at the festival. He was helped by an accompanying group of seven monks.[27] Whatever the actual circumstances of the text's production, the text is comprised of sixty-nine short stories in thirteen fascicles, stories that very much

have the character of separately told tales that might have been compiled from various sources. The loosely grouped stories, which include jātaka tales and other didactic literature (*avadāna*, *vinaya*), are not woven into any narrative structure.[28] Rather, their connection is thematic; they discourse on the cause and effect of good and bad deeds, hence the title Sūtra of the Wise and Foolish. Yet a title such as "Collected Stories of the Deeds of Wise and Foolish Beings" would more accurately reflect the contents. Each tale begins with the phrase, "Such I have heard," emphasizing their oral transmission even though this is a widely observed Buddhist scriptural convention.[29] This introductory phrase, of course, starts every sūtra in the Buddhist Tripiṭaka, but its frequency in this particular text lends a disjunctive tone to the story line. The forty-eighth story is particularly relevant to this inquiry. Entitled "Sudatta Erects a Temple" (*Xuda qi qingshe*), it later reemerges in painting and performance literature as the *Subjugation of the Demons* (The Magic Competition). True to the independent quality of each tale in the larger text, it is preceded and followed by unrelated stories.[30]

"Sudatta Erects a Temple" in the fifth-century Sūtra of the Wise and Foolish combines two tales that may have existed independently in oral and written literature up to that point.[31] The authors gave equal weight to the search and the contests. That they existed separately is supported by the persistence of one as an independent tale that often finds its way into other texts, such as the Lotus Sūtra.[32] The search for the temple site for the Buddha's lecture has a separate life as a tale independent from the contests. Pinning down the tale's precise textual permutations is almost futile because of its constant change in the oral and written arenas. Simply put, "Sudatta Erects a Temple," as it is found in Sūtra of the Wise and Foolish, is merely a record of its fifth-century state; versions of the garden tale and the six contests probably circulated in many forms prior to and after this document, and most of these existed in the unrecoverable, ephemeral oral realm. Yet it is possible to say that "Sudatta Erects a Temple," and the larger text in which it is embedded, is not a Chinese reworking of a single foreign text that had a literary pedigree. There is no evidence that a single Indic-language written text containing all aspects of the story preexisted this Chinese version. The sūtra is not a translation in the most literal sense, but rather an indigenous product of the Hexi corridor, the western Gansu region encompassing Dunhuang. The area was a buffer between China's central plains and Turkic regions (now Xinjiang) to the west. The sūtra's format suggests that the text including "Sudatta Erects a Temple" is a joining together of tales circulating in a temple performance tradition with a strong oral component.

Consider, again, the circumstances of the text's transmission. One would be justified in doubting the accuracy of the sixth-century catalog's account of

Huijue's trip to Khotan for a quinquennial dharma fest. Frequently, Central Asian circumstances were invented for the "transmission" of an indigenous or apocryphal Chinese text in order to give it credible origins.[33] That is, if multilingual Central Asians were present to mediate between a Sanskrit (Indian) "original" and the Chinese version, authenticity was unquestioned. In the case of Sūtra of the Wise and Foolish, these conditions are fulfilled in the apocryphal tale of the monk's translation; two Central Asian sites included animated, multilinguistic exchanges between interethnic dharma masters. Khotan, a region that exerted a fair amount of cultural weight in Dunhuang, is the site of the original encounter; Turfan, also in Central Asia, serves an intervening role as the place of translation. Yet, we might even question whether the trip was made at all; the sūtra could just as easily have been composed in Gansu and merely given a respectable Khotan-Turfan provenance with "high religious" associations like so many other popular Chinese texts. Based on the transmission legend and syntax that is wholly Chinese and not indicative of a translation, it is clear that western Gansu monks were the primary authors or compilers of the Sūtra of the Wise and Foolish.[34] Although no scholarly studies mention this, the writers' local identity gives the text a relevance intrinsic to the Dunhuang area and may help to explain the tale's continued popularity and endurance in the written, oral, and pictorial traditions there.[35]

In this respect, this sūtra joins a whole class of cultic texts that had no origin beyond western China but were given a foreign provenance to qualify for inclusion in the canon.[36] These indigenous sūtras, which often address particularly Chinese concerns such as the cult of ancestors, contain the bulk of stories found in the vernacular literature (bianwen) and wall paintings of Dunhuang.[37] The vernacular literature emerges from and alongside the monastic sūtras but is aimed at a broader, mostly lay audience. It seems clear that in Chinese Buddhism, traditions contrived in local practice and sustained in folk narratives are the most meaningful and vibrant. That they are often articulated in the guise of formally transmitted teachings does not mean the written text enjoyed a wide reading audience; rather, the continued reemergence of a tale is more likely a result of its circulation in the oral realm, complemented by written renditions.

The transmission lore of The Magic Competition supports exchange of information in this manner. The coalesced narratives in the sūtra, each signaled with an aural marker—"Such I have *heard*"—are consistent with an oral origin of the tales because even though this sort of marker is a convention in Sanskrit, ultimately, an oral version preceded written ones. The Gansu monks were to have collectively interpreted the tales after having witnessed and heard the lively debate at the Khotan meetings, absorbing them over sev-

eral months in various Serindian languages.[38] Consider the sixth-century account of their journey.

> [At such assemblies,] the various scholars of the Tripiṭaka would each expound upon the jewels of the Law. They would preach the sūtras and lecture on the *vinaya*, teaching according to their own profession. Tanxue (var. Huijue) and the other monks . . . divided up to listen. Then they practiced the Iranian sounds with enthusiasm and broke (analyzed) them into Chinese meanings. They thought carefully as they translated and each wrote down what he had heard. When they returned to Gaochang (Turfan), they assembled (it all) into a single work.[39]

As John R. McRae notes in his study of encounter dialogues (*jilu jianda*) between Chan master and student, dialogue-based literary texts are not necessarily journalistic accounts of events, but are imitations of like events— recreations of how they might have transpired.[40] Although the Sūtra of the Wise and Foolish uses a conversational pretext for a literary enterprise, it preserves the *notion* of a vernacular discussion—a kind of nascent oral narrative in written form. The sense of a dialogue or exchange between monks meant that it possessed a direct and vivid power. That is to say, as Buddhism developed in China, a preference emerged for "natural" expression. Whereas texts continued to be written and copied, the idea of mind-to-mind or word-of-mouth transmission gained support, becoming a standard formula for narrative structure in sūtras regardless of their origins.[41]

Performance, Spiritual Debates, and Tibetan Cultural Models

Although the colloquial pretense became a standard formula in texts, the oral exchange of Buddhist philosophy was also a genuine mainstay in the transmission of Buddhist teachings. The idea that the monks responsible for authoring the Sūtra of the Wise and Foolish witnessed a series of lively doctrinal discussions in Khotan is consistent with historical accounts of great doctrinal debates held in monasteries and imperial courts during Buddhism's long history in the region.[42] In this sense, the theme of The Magic Competition tale—an encounter between two groups, one of which asserts the superiority of its Buddhist tradition and the other of which denies it—evokes these dynamic debates over religious practice. Therefore, the sūtra's form (the quasi-conversational structure) and content (the confrontation of two masters) embodies aspects of the religious oral arena. One such famous eighth-century debate, styled the Concile de Lhasa (or the Lhasa Debate) by Paul Demiéville, is particularly germane to my argument for the thematic connection between oral debate and this tale.

Sometime late in the eighth century, the Tibetan theocracy arranged for a

debate between the Chinese monk Moheyan and the Indian monk Kamalaśīla to determine the merits of their respective traditions.[43] The future of Tibetan Buddhism was at stake. The two monks, representing radically opposing approaches to religious practice, were asked to characterize their mind-cultivation methods by responding to the same question. On the one hand was the unmediated, spontaneous enlightenment of Chinese Chan (Zen) school; on the other hand, the highly scholastic (gradualist) school of India.[44] A tenth-century Dunhuang text characterizes this encounter using the dialogue model; imbedding the doctrinal tension in a colloquial context puts the reader into the role of direct witness. A freshness is achieved by listing the monks' responses after each query. Here, the oral circumstances of transmission have been preserved or simulated in written form.[45]

The hallmark of oral narrative, worth noting here because it will figure in discussions of painting below, is the segmentation of the exchange into parts listed separately in the text: 1) question, 2) first response, and 3) second response. One could imagine a more synthetic, processed account that clearly places the writer and the reader in post-narrative time, but the "natural" encounter of a dialogue-debate was a preferred structure in the Tang dynasty for highlighting and exposing spiritual, political, and aesthetic tension. Debates were staged between groups that had inherently strained relations, often for the entertainment value to audiences. Buddhists and Daoists, Buddhists and anti-Buddhists, and the proponents of the Three Teachings were routinely invited to face off or debate their traditions in the post–An Lushan imperial court (after 756).[46] The frequency of oppositional constructs in paintings indicates that their dynamism was well received by viewers. Readers of texts that employed these clearly drawn paradigms and audiences that witnessed sectarian confrontations between Buddhist schools also participated in the inherent tension of the oppositional formula.[47]

The late-eighth-century debate in Lhasa mentioned previously may shed light on the significance and popularity of The Magic Competition theme at Dunhuang during the ninth and tenth centuries. Around the time of this religious debate in the Tibetan capital, the Tibetan army occupied most of western Gansu, including Dunhuang. Their military dominance of the Hexi corridor was nothing new.[48] Tibetan armies had occupied the Chinese capital, Chang'an, for a brief time in 763; after withdrawing to western Shaanxi, they continued to invade the region every autumn until 777, cutting off access to imperial grazing and pasture lands. A 783–84 treaty recognized the Tibetans as equals of the Chinese and effectively gave them control over what is today Ningxia and Gansu Provinces until ca. 847–49. Although the Tibetans dominated a large area, the Tibetan presence in the region is best documented at the Dunhuang site, where thousands of financial and political papers were stored. From these we know that Tibetan financial support of the Buddhist

temples in Gansu may have facilitated their military presence at Dunhuang, but it was the emergence of a mixed ethnic population through systematic intermarriage that insured their social control.[49] When the military leader Zhang Yichao reasserted Chinese control over the Dunhuang area in 848, he returned allegiance to the imperial government. In this new pro-Chinese environment, an anti-Tibetan attitude surfaced. Under the new command, many other ethnic groups (Uighur, Tibetans, Qiang, Long, Wenmo, and 'A-zha) came under Zhang Yichao's control and were accorded a status below the Han Chinese.[50] The title of his post-Tibetan government, Military Commission(er) of the Returning Allegiance Commandery Army (*Guiyijun jiedushi*), reflected the local stance of militarized opposition to a Tibetan government.[51] The Zhangs and the Cao clan, who took over in 914 and ruled until 1006, self-identified as ethnically Chinese (although they married with Khotanese and Uighurs); the official language, political dynamics, and social models were all self-consciously Han. An important paradigm was established in Zhang Yichao's political organization, casting the Han (Chinese) as insiders (normative) and others as foreigners.

It was these ruling families who were the primary patrons of The Magic Competition murals. Some have suggested that the theme's popularity may have had political overtones to the extent that the themes pitted one group against the other in a physical, rather than a doctrinal, duel.[52] The implications of the Cao family's control of an ethnically mixed population, including a large number of Tibetans, are significant. Even after the collapse of the imperial government in China's heartland in 907, the Cao family kings maintained a strong Chinese identity. As China split into regional kingdoms, Dunhuang became an independent state and was increasingly pervaded by a frontier mentality. References to threats and uneasy alliances are found throughout the art the rulers of Dunhuang patronized, particularly in the woodblock prints of the bodhisattvas Mañjuśrī and Avalokiteśvara, and the guardian king Vaiśravaṇa made by the printing office of Cao Yuanzhong (ruled ca. 944–74).[53] The pervasive sense of the realm's interior, defined by an indeterminate but strong awareness of its exterior, or enemies, is explicit in a series of printed icons (P4514.6[1], date August 4, 947). In the prayers accompanying the print of Avalokiteśvara, Cao's role is defined as the "Commissioner for the distribution of military land allotments *within* the sphere of his jurisdiction and for the suppression of Tibetan tribes."[54] Surprisingly, "suppression of Tibetan tribes" was still a stock phrase used to indicate outside threat a century after the defeat of the Tibetans by Dunhuang armies. The actual continued presence of a large Tibetan population meant that metaphors of interior versus exterior were used all the more frequently in cultural representations precisely because the interior was in fact compromised.

Also in the caves we find donor portraits of brides sent in strategic marriage

alliances between Dunhuang clans and the Khotanese who ruled the southern silk route to the west of Dunhuang and often threatened to attack Dunhuang (Figure 1.2).[55] The Khotanese women are prominently featured in their own costumes in the procession of donors that line the entrance to later caves, as if to will the union's efficacy by picturing it.[56] These themes charted clear boundaries and delineated distinct cultural identities that possessed a clarity appealing in a climate of mutable boundaries and categories. The Magic Competition first appeared in the Later Tang in cave 85, datable to 862–67, after the departure of Tibetan officials, and continued through the 980s. Although no records make clear what this theme meant to the Zhang and Cao rulers, its prominence in so many of their caves suggests a personal significance for the donors. The metaphor of vanquished heretics, who are referred to in the bianwen as the "broken demon army" that gives up their campaign, is easily understood in terms of the Zhang and Cao family rulers' situation as military governors during unstable times.[57] The theme addressed issues of power and control in cultural terms as well as resonated with local concerns for dominance during a period when Chinese cultural traditions could not be taken for granted. The alliance with Chinese cultural traditions would have been especially important, if, as it has been suggested, the Cao family was not of Han Chinese but of Sogdian descent.

The battle between Śāriputra and Raudrākṣa, a Brahman with Himalayan features, has clear ethnic dimensions with a local Dunhuang significance (Plates 7 and 8). The confrontation between Dunhuang residents and Tibetans was resolved in 848, but the local Chinese victory was metaphorically reenacted for another 120 years in 15 cave-temple murals at the Dunhuang and Yulin grottoes. The habit of distinguishing Chinese from the "other" in painting themes was a common Tang way of addressing diversity. Consider a mid-ninth-century mural in cave 158 at Dunhuang in which a vast number of earthly rulers are assembled to witness the *parinirvāṇa* (death) of the Buddha; wailing as (unenlightened) mortals who cannot appreciate the beauty of the event, they are overly expressive and emotional.[58] All but one of these grotesque figures are foreigners, their ethnicities made especially distinct by outrageous costumes. The assortment is meant to represent how all humanity is affected by the Buddha's passing, but the Chinese are notably depicted as the serene and calm initiated while some of the most distraught and emotional figures are stereotypically depicted foreigners. Indeed, the Buddha himself is Chinese in the cave's large reclining sculpture. What is equally compelling about this painting is its production during the period of Tibetan control. The Tibetan king, unfortunately now removed from the wall painting, is depicted as the leader of this Central Asian retinue. That Han Chinese notions of the spiritual "other" were still dominant when the cave was pro-

duced from ca. 790 to 820, that is, during the Tibetan period, suggests that local artists maintained artistic conventions despite the change in patrons.

The *Hua-Hu* (Chinese-foreigner; *Hu* is literally "barbarian") distinction was rampant in metropolitan China. It is most evident in the anti-Buddhist campaign (ca. 819) of Han Yu (786–824), the brilliant, xenophobic writer, which culminated in the violent Buddhist persecution of 842–45. This persecution was as much an antiforeign movement as it was an antireligious campaign. Cultures that had mediated the transmission of Buddhism from India were conflated in the swelling political and economic hatred. In Han Yu's case, it is clear that his disdain of Buddhism centered on China's subservient position vis-à-vis a foreign deity. It galled Han Yu that protocol placed the Chinese emperor beneath a "barbarian"; the Buddha, after all, was the paradigmatic Hu.[59] Han Yu's beliefs epitomized those of many Han Chinese, who saw themselves as culturally superior to foreigners or national minorities, whom they viewed as inherently uncivilized. Where the cultural distinction was more neutral (not bound with the political and economic concerns of the 845 persecution), the ethnic division was still clearly delineated. For example, in Tang tomb figurines aiming to recreate a moment in daily life for the deceased, Central Asian musicians appear lively, bearded, costumed, and anatomically exaggerated. These naturalized features are meant to appear "barbaric" in comparison with the figurines of female court dancers who assume imperially recognized Chinese features (corpulent physique clothed in voluminous robes and eyes with the epithelial fold).[60] Not only did the vast number of peoples such as the Tajiks, Uighurs, and Sogdians in China's western regions and other parts of Central Asia look different; the Han perceived them as fundamentally distinct. The Hua-Hu paradigm signified a cultural perspective that infiltrated aesthetics and politics on every level. No circumstance makes that clearer than the characterization of the heretics in The Magic Competition as people possessing "doltish minds" (*chixin*) who were fools (literally, "mules and asses," *lüluo*).[61] Even though the heretics' stupidity is largely attributed to their status as nonbelievers, the ethnic or racial reference was the distinction really at issue.

The situation was even more complicated at Dunhuang. In the court of this northwestern kingdom, there were no anti-Buddhist factions that made Buddhism into a cultural enemy. But several things are clear from pictorial language of The Magic Competition. The winner of the competition of fantastic tricks is the Buddhist monk Śāriputra, who is clearly given Chinese features as he surveys the battleground from his raised dais (Plate 26). Raudrākṣa and his cohorts, who make extreme, unseemly displays of emotion, are given very prominent noses, high foreheads, and overdeveloped physiques, all features routinely assigned to foreigners, Indian or otherwise (Plates 7 and 8). The loser

in this case is clearly foreign and non-Chinese. In an ethnically mixed region, where residents no doubt were sensitive about physical differences and attendant political power, it was important to make aesthetic or linguistic statements about those minor distinctions. The Dunhuang patrons who selected this theme for a majority of their caves had enormous political clout at stake, and that power was negotiated through the painting. The political and social implications of The Magic Competition theme at Dunhuang are abundantly clear when the audience is identified. In The Magic Competition mural, and, incidentally, in the text that describes the great debate in Lhasa, the king presides as final arbiter of the encounter—real or imagined (Plates 9 and 10, center).[62] The confrontation happens in full view of the assembly. While the debate may concern spiritual matters, the ramifications of the outcome are decidedly this-worldly. The reward of supporting the Buddhists is explicit in the bianwen text of The Magic Competition. As payment for the land, the minister paves the ground with gold coins and depletes the realm's resources on Buddhist temples. His merit-making activity, and by extension the meritorious deeds of patrons who provide the funding for The Magic Competition murals, in turn ensures the cultural superiority and spiritual well-being of the kingdom.[63]

The Raudrākṣa and Śāriputra theme found in the early Sūtra of the Wise and Foolish is linked to religious lecture-debates in monastic settings and political circumstances of ninth- to tenth-century Dunhuang donors through a coherent continuum in western Gansu where the story endured for over five centuries. It was there, after all, that the tale originated or at least gained its most enthusiastic tellers. Pictorial, oral, and written versions of The Magic Competition occupy parallel positions in the storytelling tradition. The social and political circumstances fueled its popularity and ensured its survival in oral culture. As a result of this popular support, The Magic Competition found its way into three new genres that emerged in the ninth century.

Emergence of New Genres in The Magic Competition

When The Magic Competition tale (what was entitled "Sudatta Erects a Temple" in its fifth-century form) reappears in ninth-century written and visual texts, it is detached from all the other sixty-eight stories in the Sūtra of the Wise and Foolish. The earlier forms in various sūtras help us understand its origins; but during the four centuries after its inception, the tale of The Magic Competition changed considerably.[64] What is even more significant than the changes in content is the emergence of new genres in which the theme is explored. The sūtra formulas are jettisoned for a narrative that is meant to be spoken and, in some circumstances, shown with pictures. The

tale's oral roots were noted in its origins. Whereas the earlier text was written as if it was heard yet meant to be read, the new vernacular tales in their written form are meant to be memories of the spoken narrative. And the dynamic, bold wall paintings are a permanent version of the pictures shown during an oral rendition that was now utterly transformed by the introduction of visual information. During this later period, exciting shifts happen because of structural demands made by the new genres. To some extent these new formats—performance handscrolls, expanded wall paintings, and vernacular texts—form a coherent unit. Yet, vast structural differences isolate the visual and written narrative into independent entities.

Scholars of bianwen generally agree that the vernacular performances were written around 800, but no versions of the written tale are extant from that date. In fact, the earliest Magic Competition bianwen consists of two fragments dated to ca. 900; this corresponds roughly to the period when the theme became popular in wall paintings, linking both verbal and pictorial versions chronologically.[65] Information about the tale's connection to performance is provided unwittingly in several colophons that give the copyist's name and brief personal circumstances. In a Magic Competition lecture scroll (P2187) dated to (the equivalent of) November 28, 944, the monk Yuanrong reveals in two colophons that he is both the writer and the performer.[66] The scroll is a kind of notebook filled with texts used in various ceremonies. The first colophon reads: "It was freezing so I had to breathe on the brush in order to write this.[67] Written by the *falü* (administrative monk) Yuanrong at the Jingtu si (Pure Land Temple)." The second reads: "The *[du]sengtong* (monastic controller) of our city prayed that we may long continue to receive imperial blessings."[68]

Yuanrong, an administrator at one of the richest Dunhuang temples, probably recorded The Magic Competition bianwen after the oral performance. The practice of making a written version after an oral recitation is reflected in other performers' comments. One monk, age 48, noted some personal distress after copying the text as night fell; lamenting the difficulty of returning home, he recounts how awfully hot it was during his recitation of the Vimalakīrti Sūtra lecture (P2292).[69] Yet another bianwen, of the Mulian tale (P3107), has blanks for the honored deceased and the name of the host monk, indicating that sometimes these vernacular tales were written in advance and reused in a liturgy.[70] This text was also copied by a writer at the Jingtu temple.

These are examples of sūtra lectures. Other examples of The Magic Competition tale, labeled bian or bianwen, indicate that audiences may have heard them outside the temple in a quasi-religious setting or as entertainment. Because of the occasional nature of the texts (their link to festivals and ceremonies honoring the dead or for gaining merit), no two are exactly alike. For

example, there are differences between three main sources: BJ1589 and S5511; S4398; and P4515. These Magic Competition bianwen are in a literary style, indicating they were written by performers or literate listeners and are perhaps one step removed from a prompt book or lecture notes (aide-mémoire).

One of the biggest debates in the study of this literature is its relative distance from oral performance. Specialists seem to agree that the bian (a transformation) were more colloquial versions of tales than the bianwen (transformation texts).[71] Bianwen are probably more formal versions of performances since, in at least the case of the monk Yuanrong, the performer reveals he wrote The Magic Competition tale in the extreme cold after it was delivered (P2187). For our purposes, what matters is that these vernacular texts reflect some degree of oral discourse and genuine colloquial speech patterns because of the conditions of their presentation and reception. The introduction of an audience-cognizant interrogative—"how is it?" *ruowei*—links the prose and verse (sung) sections typically found in the bianwen chantefables.[72] The interpretive meaning of this phrase is something like "in what way do we know this fact?" or "how is this situation manifested into a concrete image in the mind's eye?" This phrase may occur at the end of the prose section, just before the verses, to signal a shift in style and perhaps also as a transition to pictorial accompaniment.

The other indication that The Magic Competition bianwen are close to an oral context is the constant repetition of the story. The storyteller reiterates information in alternating sections of verse and prose, thereby revealing that the stories were largely meant to be heard rather than read. Repetitive sections served as reminders of key scenes to an audience of listeners. The repetition may be related to the display of pictures. Only one extant portable scroll combines both text and pictures of The Magic Competition (P4524). The text, which as we noted earlier appears only on the back, is not a complete verbal rendition of the story; it only contains the verses that would be sung in a performance. The prose sections would presumably be supplied by the performer from memory during the show or lecture. While not written on this performance scroll, the prose sections are preserved in other examples of performance texts without pictures; and it is in those examples that the textual repetition may be noted. For example, in a complete Magic Competition bianwen (S5511 and BJ1589), the storyteller/writer describes every contest twice—once in prose and once in verse—so that in reading this narrative, the repetition seems amateurish and unnecessary.[73] The written tale's structure makes sense only when the text's close relationship with oral performance and pictures is recognized.

The scroll P4524 includes pictures on the front; the text on the back remains hidden from the audience's view. Yet the illustrations are linked spa-

tially with the text. Presumably, the verses, spaced along the back every foot
or so, served as a signal to the storyteller or as references to practices that would
combine oral presentation with pictures.[74] During a performance, the appear-
ance of the verses as the scroll was unfurled would indicate it was unrolled far
enough. Once the storyteller reached a verse, he could sing it with one picto-
rial episode in full view.[75] Therefore, the text and pictures correspond, even
though they are found on different sides of the scroll. No tableau would have
characters on the back of pictures unless it was intended to have viewers or
receivers on both sides. During the performance, it may be that the scroll was
only displayed during the recitation of the verses.[76] A well-timed unrolling of
the scroll could suggest the passage of time, while the verbal repetition of key
details in fixed sung verse, with a picture of the essential contest scene on dis-
play, would serve as a reminder to the audience of crucial details.[77]

Whatever outstanding questions may remain about the scroll's use, it
demonstrates clearly that visual and oral narratives became inextricably linked
in certain settings. Although no other materials like it survive, the scroll nev-
ertheless suggests the popularity of joining Buddhist tales and pictures in oral
telling during the ninth and tenth centuries, perhaps at a level never again
duplicated in China. Picture storytelling may have emerged, as Victor Mair
argues, from the proselytizing demands made by Buddhism; the dynamic nar-
ratives of India, which served as prototypes, could have given rise to the tra-
dition of telling vernacular tales with pictures, strengthening the argument
that the oral life of The Magic Competition was its sustaining feature.[78]

Visual Response to Orality

We have seen how the verbal narrative adapted itself to the visual in the car-
touches. What about the pictures' response to the oral context? The structural
coherence of picture episodes to blocks of text produced a certain amount of
repetition in the paintings as well. For example, in P4524 the main characters
are repeated every eight inches or so in each section. The duplicated compo-
nents are the heretics clustered under a tent, the Buddhist contingent stand-
ing around Śāriputra's dais, and the king at their center. The only composi-
tional change occurs between these fixed elements. For instance, the bull and
lion in one of the contests wrap themselves around each other, teeth gnashing
flesh, while Śāriputra looks from the right (Figure 5.1); the heretics consider
the spectacle from the viewer's left; the king is located just after Raudrākṣa's
tent (small section visible). A single tree divides the simple reenactment from
the next where the same configuration is repeated; a pool of water being con-
sumed by an elephant replaces the lion and bull. The artist chooses an episodic
narrative structure for the performer's scroll since it was to be unrolled and

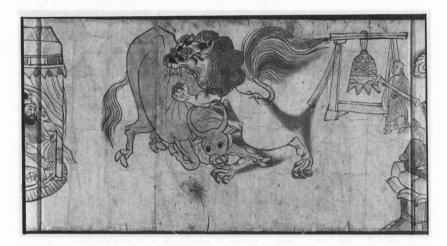

Figure 5.1. The Magic Competition Scene 3, recto: Lion overcoming the heretics' bull. Scene 3, verso: text verse of a bianwen (performance text) (not visible in picture). P4524. Ink and colors on paper. Ca. early to mid-ninth century. Entire scroll: 27.5 cm × 571.3 cm. Cliché Bibliothèque nationale de France, BnF.

shown in successive parts to an audience. In other words, the new genre was invented or adapted in order to incorporate the visual in oral storytelling. Other pictorial options such as continuous narrative were open to the artist, but would be unworkable because the audience had to see the main actors frequently. From P4524 we may surmise that the storyteller's pictures depicted only the crucial scenes. If the scroll was only shown at intervals with sung verse, then the pictures punctuated moments of summary (when the verses repeat information already given in the prose descriptions) and served as a visual ground onto which the audience could project key contours of the story.[79]

The appeal of these contests to an audience and their suitability to visual form rests in the repetition of the protagonists in each scene and the drama between the two. Imagine the confluence of visual and oral narrative in a performance of the tale. The dragon is called forth; it is vanquished by a large bird that devours it. (Compare this with the mural depicted in Plate 9, and Figure 2.19 scene 4). A monster quivers at the sight of the guardian of the north who is tougher and stronger (Figure 2.19 scene 5). A vajra-wielding strongman smashes a mountain, breaking it into slivers with obvious ease (Figure 2.19 scene 1). These images work well in either form of narrative, but together they form a powerful union.

The emphasis on dramatic action is consistent with the general trend away from static Buddhist icons toward themes that could entertain and excite the

viewer without knowledge of the tale. The dynamism of the physical encounters becomes compelling in itself. The artists could have chosen to highlight the Buddha's lecture in the garden once the contests had been fought.[80] This is precisely how the famous printed version of the Diamond Sūtra, dated 868, begins—a monumental but static enactment of the Buddha's lecture in the Jetavana garden with the faithful assembled.[81] That picture is merely a frontispiece to the Diamond Sūtra canonical text, most likely meant for a monastic audience, or at least a product of a strong readers' reception of the sūtra. The audience for The Magic Competition was more interested in the dramatic possibilities of Buddhist tales. In the sūtra frontispiece, the Buddha is positioned at a three-quarter frontal view behind an altar of offerings, below the valance of honor, and surrounded by the usual cast of characters—monks, bodhisattvas, and guardian kings. This focus on the Buddha as he lectures on the three treasures, rather than on events around him, is typical of illustrations to canonical sūtras, reflecting older modes of pictorialization. In some sense the static lecture scenes are a visual reminder that the following printed text is an embodiment of the Buddha's explication of the dharma. On the contrary, The Magic Competition murals and the performance scroll under consideration do not include a lecture scene at all, which is just one of many moments in the narrative, but instead focus on the juicy drama of the competitions. In fact, one is hard-pressed to find the Buddha anywhere in the murals; and he does not figure in the performance scroll at all. Pictures related directly to text and narratives that sprang from the oral realm were two distinct traditions in Chinese Buddhist art. The dynamism of The Magic Competition is an innovation in Buddhist art in the late ninth century when an emphasis on animated physical competition (which The Magic Competition wall paintings selectively depict) emerged.[82] Newly conceived compositions for wall and silk paintings moved away from iconic scenes toward action scenes that often downplayed monastic content. While the contemporaneous Diamond Sūtra frontispiece print represents a new, expedient approach to production through multiple printings, it nonetheless reflects older pictorial traditions.

Even if we take into account the long history of The Magic Competition since the fifth century, several conditions point to radically new directions at this moment in the late ninth century. The artist and storyteller at some point agreed (no information is available to ascertain priority) to focus almost exclusively on the contests in the performance or at least in the performance pictures. Visually, the focus seems to switch almost exclusively to the contests, and by the second or third quarter of the ninth century, the wall paintings highlight the entertainment value of the last, most compelling contest, exclusively. The new emphasis on dramatic action in the painting contrasts with the verbal text. The bianwen versions without pictures, while giving more

weight to the contests than the sūtra did, still spend two-thirds of the narrative developing the search for the temple site, the haggling over the park with the prince, and the king's intervention. The wall paintings, which date anywhere from 20 to 120 years after the mid-ninth-century performance scroll, also focus on the contests. Yet a large difference exists among these genres. The performance scroll reveals that the storyteller may have used just the verses as a prompt during performance; on the other hand, the bianwen, with their complete prose and verse sections, are post-performance products. By containing both pictures and text, P4524 then occupies a middle ground between performance (the ephemeral narrative) and more formal tellings of the tale not only in vernacular literature but also in another, pictorial format—the wall paintings. When the wall paintings emerged in earnest around 890 in cave temples, they were as much an ossified memory of their oral roots (pictures used in performance) as the bianwen that permanently fixed the language spoken during performances. Just as the bianwen tales are more literary versions of oral performances, the wall paintings are a more fixed version of pictures used in those performances. I am not suggesting that the storytellers used the wall paintings in a performance within the cave temples. In fact, I am arguing the opposite; the wall paintings are a fixed version of the moving visual narrative (in portable scrolls) used in performances. Like the bianwen, the murals are post-performance remnants of both the physical events of performance and their structure.

As the popular performance is transformed by its entry into various other genres, such as wall painting and written vernacular literature, the representation and verbal features change to adapt to those genres.[83] Performed tales woven with prompt words and display pictures are transformed, then, into more enduring forms such as murals. It was in 862, when cave 85 was constructed and painted, that artists clearly envisioned how to convey most effectively the story in the fixed tableau of the grotto wall. The artists settled on one image that encompasses many scenes, framing it between elements of the final contest (Plates 9 and 10, caves 196 and 146 respectively). Once standardized, this composition remained virtually unchanged for 120 years. Unlike the scroll, the fixed, large expanses of the grotto walls perfectly suited this story. Raudrākṣa and Śāriputra become metanarrative figures whose bodies span the entire height of the wall. Their large figures and daises serve as anchors between which the contests take place. They are also depicted with a curious mixture of temporal specificity and iconic stasis. That is, they are engaged in the last encounter, which ends with the gale. Raudrākṣa and his cohorts are animated, touched by the wind that sets every object aflutter. Yet the sheer size of Raudrākṣa and Śāriputra allows them to preside over the entire stage of events in which their human forms are only indirectly impli-

cated. It is as if, in the artist's reworking, all the other events became single-mindedly cognizant of the final, sixth contest, becoming insignificant in comparison even before they occurred. The wall painter boldly interprets the tale in a fresh way. Details of the heretics' physical anguish in the hurricane-like storm are lavishly depicted, whereas the performance scroll's figures were simpler reminders of the contest between the protagonists.

It was not always this way. Two earlier murals depicting the theme reveal how ideally suited the ninth-century versions were to the format. A Northern Zhou wall painting of the Subjugation of the Demons (ca. sixth century), in cave 12 at the nearby sister site of the Western Caves of the Thousand Buddhas, adheres to the earlier jātaka form of storytelling, in which many scenes (in this case, eleven) are placed next to each other. Little spatial integration is found between those on the same line and the scenes placed below in a second row. Presented in scroll-like horizontal bands, these episodic and synoptic scenes approach the format of sūtra frontispieces, presented in narrative sequence.[84] The information presented focuses on the pious aspects of the tale, such as the search for a temple site, and has none of the drama of the contests. Another early mural, in Dunhuang cave 335, dated to 686, contains a depiction of the theme lodged in a small niche behind a sculpture.[85] The artist has settled on an effective design that is the core of all future murals. The two actors are positioned at either end, serving as brackets that enclose scattered scenes between them. Although the number of scenes is limited and the composition small-scale, the artist has decisively eliminated extraneous detail and focused on the six competitions.[86] Yet by partially drawing on the older jātaka format through the use of monoscenic representation, the events seem to have little connection to the main actors. The adaptation of the theme to the full-scale mural does not occur until the third quarter of the ninth century, when the older formats on walls and scrolls had already been jettisoned. The artist draws on new possibilities no doubt suggested by debates over religious practice, the possibilities of an advanced drama tradition, and the larger surfaces of the caves' most important walls.

In addition to explorations of format, the conception of movement and the body is entirely new in late-ninth-century murals, made two-and-a-half centuries after the earlier composition. The performance tradition with which it shares a history seems to suggest more potential for movement and dramatic action. The possibility of actions flowing into each other in drama is captured in the wall painting. The supernatural becomes commonplace to evoke the magic and fantasy of performance. As Śāriputra, in miniature form, flies across a lake in the top of the painting or bathes Raudrākṣa with purified water, the viewer's incredulity is suspended as sheer excitement takes over.

Other features of the composition are filled with drama and suggest how

the theme of performance imbedded in the tale becomes the focus of the wall painting. The six competitions occur in the center, around the king who sits at the middle point in the composition defining the two camps. On the right, Raudrākṣa's dais functions as an anchor around which all sorts of props— ladders, ropes, pillars, and pegs—are arrayed. It is an acrobatic tumbling show on display. One of the heretics flies off the rope held precariously by a peg. He swings bare-chested as gravity forces him down to the ground at a speed greater than he is prepared for (Plate 27a). His legs dangle as if on some type of high wire. Below, a cohort swings a hammer to secure the tent peg (Plate 27a). At the tent's base, a heretic has climbed on top of another, stronger, more muscular man's shoulders; tentatively grasping the tent pole, he leans with a coiled rope hoping to help secure the dais as it is being blown to the ground (Plate 27c). On the other side, heretics assume the positions of trapeze artists, wrapping their bodies around the ladder to give it some weight. Another figure can barely keep himself on the ladder; every part except his hands is air-borne (Plate 27d). Drummers poise themselves to strike the drum of victory (Plate 9, Figure 2.16). These positions, while related to the onslaught of the gale, have a dramatic verve and vigor that suggest the excitement of the stage. They have an appeal beyond Buddhism's message of conversion. They delight the senses with movement and anticipation of disaster in ways that are rare in Chinese, Tibetan, Khotanese, and Uighur traditions. The authenticity of the poses suggests that the artist witnessed this theme or another like it in per-formance and wishes to capture that drama in pictorial form.

The artist has taken real delight in exploring the unlimited possibilities of the body—pulling and pushing, screaming and scurrying, looking left and looking right, and making all manner of gestures. In the iteration in cave 146, two heretics are sucked away by the wind; one, facing forward, leads with his stomach (Plate 27e). The second faces the other direction and leans forward, balancing himself with his hands. Each of four heretic women who brace themselves in the wind are depicted with slightly different arm positions, as if the possibilities of upper-body movement are the real subject (Plate 9, lower right; Figure 2.17). These clusters of figures seem to be studies in postures found in acrobatic drama and dance.

The painter introduces comedic action and humorous touches meant to challenge the stability of the picture plane and poke fun at the picture's seri-ous theme. Three converting heretics to the right of Śāriputra's dais taunt the audience (Plate 28). In a section just to the left, one buries his face as he pros-trates; a second guzzles water, putting his face backward flush with the picture plane. A third peeks at us through his legs, revealing the underside of his pants. Looking directly at the audience, he grins at us, mocking his own igno-rance and our interest in his ridiculous pose (Plates 29a–c). Below the drum

frame, a heretic holding a piece of wood from the drum frame tips back so far that he threatens to fall out of the wall painting into the viewer's space (Plate 30). He looks directly at us, aware of the destabilizing effect his extreme posture has on the viewer's ability to situate him in the normal space inhabited by the other figures. The play of jugglers and acrobats is evoked in the dramatic poses of the heretics who are arrested in action, as if striking a pose on stage (Plates 31a–c).

The kinds of actions and events possible in this tale recall the lively plot of *Xiyou ji* (The Journey to the West), popularly known in English through Arthur Waley's translation as *Monkey (The Journey to the West)*.[87] This late Ming novel grew out of the chronicles of Xuanzang, the Tang dynasty monk who went to India in the seventh century.[88] From at least the Yuan dynasty, *The Journey to the West* became one of the most popular dramas on the Chinese stage, undoubtedly for the visual spectacle of the magic tricks performed by its protagonists—a monkey and his companion named Tripiṭaka. The twenty-fourth chapter of *The Journey to the West* contains a test of supernatural skills between Buddhists and Daoists, much like those between the Buddhists and heretics in The Magic Competition.[89] During this confrontation in *The Journey to the West*, a meditation contest finds the Buddhists disrupting the quietude of the Daoist by placing a centipede in his nostril. Their confrontation is presided over by a king (just as in The Magic Competition), as both sides guess the contents of a royal box. The Buddhists naturally win by successfully transforming those contents into absurd items such as a cracked dish and a peach pit. The Buddhists even manage to transform a Daoist acolyte of the opposing camp into a sūtra-reciting Buddhist adept. Finally, the Buddhists demonstrate their superior physical skills by withstanding a beheading, a cleaning of their entrails, and a bathing in boiling oil. Although the complete novel version of *The Journey to the West*—by Wu Cheng'en (ca. 1500–1582)—does not date until the sixteenth century, early versions of these same competitions date to the Tang dynasty, when Xuanzang's travelog was first being committed to paper.[90] While theatrical interpretations of these magical feats in *The Journey to the West* captivated audiences in late imperial China, the adaptations for the stage probably began in the Tang dynasty.[91] Substantial evidence already reviewed confirms that performers and lecturers spun exciting versions of sūtra material for audiences.[92] A strong tradition of popular entertainment with jugglers, acrobats, and musicians had, of course, existed in China since at least the Han dynasty (206 B.C.E.–C.E. 220), as we know from miniature sculptural tableaux of entertainers that were made for grave installations.[93] Magic Competition murals embody the spirit of performance in the great variety of poses necessary to convey the supernatural transformations that its stories contain. The excitement of rapidly changing

manifestations is captured pictorially by displaying simultaneously all the contests in one integrated, dramatic tableau.

The suggestion of a stage is reinforced in the layout of the contests. Both actors are seated on daises much like those used in religious debates of the day. They face off as if on a public stage and match each other's magical feats of supernatural power, recalling the verbal repartee of monks and scholars. The scene, although alluding to more proper religious debates, effectively becomes a brawl. Physical energy is cleverly harnessed in the wall paintings by bracketing the contests between the oversized Raudrākṣa and Śāriputra figures, implying that the six contests are literally projections of their own bodies. The elephant, vajra-smasher, golden-winged bird, and gale wind are manifested from Śāriputra. He transforms himself into them, or they can be understood as a by-product of his supernatural power (Figure 2.19). Likewise, Raudrākṣa makes the pool, dragon, mountain, and tree from his body. Somatic energy explodes in the late Tang paintings of The Magic Competition. Artists and writers take great care to give the sense of an actual struggle between stronger and weaker opponents; this tale becomes a way of settling the score on various levels.

As displayed in The Magic Competition in cave 196, the contests occur on a grassy knoll, suggested by the striped ground of alternating green and white; little clusters of flowers scattered throughout the compositional ground further indicate a field and a spacious setting (Plates 9 and 10). Tang rules of perspective are in effect. The space is diagrammatically displayed. What is farther up in the composition is to be read as deeper set in space ("up is back"); what is off to both sides is read as temporally earlier. Although the objects lie fairly close to the picture plane and the individually animated figures interact very little as in the two early paintings of The Magic Competition dated respectively to the sixth and seventh centuries, these fifteen later murals represent an entirely different conception of visual space than the earlier paintings. By infusing the composition with a harmonious rhythm from the wind (objects in the right third of the painting bend to the right), the sense of integration or connection between all the figures is heightened.

A logical cultural unit is chosen for presentation of the tale in the ninth- and tenth-century murals. The dramatic stage is one level of organization; reference to the Chinese enceinte (city) is another. The traditional Chinese city, which is divided along the central axis creating symmetrical halves, is invoked by the placement of the king at the upper center of the painting. This position is analogous to the imperial "forbidden quarters" at the northernmost position in a capital like Chang'an.[94] In both political and pictorial space, it is as if the king is watching from the most powerful and revered position at the upper center (Plates 9 and 10, center). The Magic Competition is further

defined into right and left halves by the bell and the drum. In the story, one of the two instruments is to be struck to sound the winner of the six contests. The bell is sounded when Śāriputra's manifestation is triumphant; the drum's deep thunder would signal the heretics' victory, but of course it is never heard. These props can also be read as allusions to the walled towns with bell and drum towers on either side of the main thoroughfare.[95] The choice of instruments signifies that the sides of the painting are to be read as two distinct camps, like parts of the city or parts of the government, which is also divided, in this case into left and right administrative units. Thus, the cultural divisions of city and government are invoked for pictorial clarity.

The artist has clearly conceived of The Magic Competition according to traditional Chinese conceptions of ritual space. Always symmetrical and partitioned into smaller units that mirror the whole, the paradigm contrasts with Indian notions of ritual space, which tend to be circular, working from the outside boundaries toward the center (like the stūpa). Bells and drums, resonating with the left and right halves of a cosmological arena, have, incidentally, been a part of a traditional ritual unit in Chinese culture as far back as the *Shijing* (Classic of Poetry, commentary written ca. 206 B.C.E.–C.E. 220).[96] The call and response of bells and drums enhance the emotions conveyed by the narrator in the text. They modulate the pace of recitation and enhance delivery of its chanted verse.[97] The integral role of musical rhythm in fêtes and feasts is documented in graves of the Later Zhou dynasty (ca. 770–221 B.C.E.), when elaborate bell sets, along with ritual feasting dishes, were used to honor the dead.[98] Consequently, we should understand the bell and drum in The Magic Competition as markers of a magical, symbolic arena.[99] Concrete geographical indicators help establish the boundaries of this sacred realm. In the bianwen, the narrator establishes this by stating, "The Buddhists will sit to the east, the Six Masters on the west, I, the king, will sit to the north, and my officials and people on the south."[100] The combatants hold symbolic positions in a political configuration (Han and Hu) already discussed. Therefore, the geographically concrete is also metaphorical. It is as if a stage full of action becomes a metaphor for the kingdom, transforming a public space into a cosmology of right and wrong, Chinese and foreign, Buddhist and non-Buddhist, and good and evil.

The Vernacular Setting in Magic Competition Wall Paintings

One can sense the recognition of the audience in the wall paintings. In this way they are structurally similar to the bianwen that include audience-conscious enjoinders. The awareness of an audience that visually and aurally apprehends information indicates that both murals and the new literature

encompass vernacular forms of expression. The makers' self-consciousness about a story's reception is manifested in a quotidian armature; the divine or mythological subject matter is naturalized by making references to dramatic action and is instrumental in linking the possibilities of the human actor on stage within the mythological realm. A public arena is needed for the enactment of the tales, as if the theme's political and cultural content requires audience participation. The battles are enacted repeatedly and symbolically in the wall painting for the benefit of the court, even if it did not visit the caves regularly. The paintings are a ritual resolution to ongoing struggles. Vernacular does not necessarily imply a colloquial engagement with that audience for there may be artifice in expression, nor does it mean that the murals were directed at a non-elite clientele. Viewers included both the political leaders of the area and townspeople, thereby excluding questions of class.[101] Instead, what imparts the sense of "everyday" or "freshness" is rhetorical verisimilitude or immediacy actively imbedded in a painting's or text's structure. In other words, the syntax of natural expression commands the viewer into an active relationship with the visual space. This phenomenon of reception may be attributed to the animation of physical form that entices the viewer to identify with its drama. It is also related to the presence of a dialogue between the two actors, and, through the king, with the audience.

Victor Mair believes vernacular Dunhuang literature arose from the influx of dynamic Buddhist narrative from India; as Buddhism began to infiltrate the cultures of East Asia, the strong performance and storytelling traditions of South Asia engendered new popular narratives. New linguistic structures and vocabulary were invented to accommodate the new Buddhist tales. On the other hand, Kenneth DeWoskin contends that vibrant narrative literature was long present in Chinese culture. The emergence of vernacular forms of expression in the Tang, DeWoskin argues, may be attributed to literati recognition of indigenous art forms such as oral narratives and other public performances. Accordingly, new vernacular verbal traditions were merely a sign that literati had begun to value indigenous (folk) forms and commit them to paper.[102] Perhaps both perspectives have merit. Buddhism most likely encouraged a preexisting oral narrative tradition by joining important verbal descriptions to visual forms.

Whatever the degree of Buddhism's cultural transformation of China, The Magic Competition paintings do have a link with popular performance in both form and content. The wall paintings reflect this tradition by including the language of performance in their cartouches. Yet the murals are joined with the vernacular text of popular drama (bian and bianwen) and sūtra lectures (yazuowen, jiangjingwen) in a different way than the performance scroll with the text on its back. In the wall painting, cartouches are placed next to

each scene. They are always visible and often numerous; in cave 146, over eighty cartouche boxes with summary text appear with the figure groups (Plate 10). Although the wall painting is fixed and immobile, each scene is separated with a cartouche as if it were to be told separately, in a performance with pictures. These cartouches are a memory of where oral narrative was once present to give explanation. The murals reflect that tradition without actively sharing it. In the performance handscroll, each contest is presented separately in the oral telling, as in Figure 5.1, where the lion devours the bull. Murals are a memory of performance scrolls just as colloquial literature is a record of spoken theater; joining the two in a fixed tableau is new. Combining colloquial explanations with pictorial action scenes of human movement in pictures is something that is not found in Dunhuang painting earlier than the late Tang. In fact, extensive cartouches in murals proliferate in the late ninth century, indicative of a revolution in joining pictures with words.

In The Magic Competition and other paintings, the text literally comes to punctuate or highlight action. The cartouches are placed to call attention to each episode, underscored by the temporal marker *shi* placed at the end of each cartouche.[103] Literally translated as "when" or "at the time," shi has a function more abstract than linguistic, essentially meaning something like "the episode when." It serves to highlight the segmented quality of the painting composition by isolating all the events from others, rather than linking them. In The Magic Competition murals, the tension between the visual and aurally consumed verbal information remains a prominent feature. The performance origins of the pictures are preserved in scores of scattered cartouches. By definition, aural information is rooted, as Bernard Faure writes regarding notions of Chan (Zen) "gradualism," in "discontinuity, temporal sequence, and referential disclosure of information."[104] The narrative order of the scenes may not be readily apparent outside the immediate dialogue. Information necessary to decode that order in the murals is often lacking because participants are given details at another moment that they will remember in the course of the encounter. Indeed, the cartouches divide the viewer's attention and fracture the composition; for example, the many-colored cartouche boxes in cave 9 are so large they dominate the picture plane. Visual imagery (the mural tableau) instead enjoys "continuity and spatial simultaneity," due to the viewing circumstances of the fixed mural, which imposes on the viewer a sum of all the scenes at once.[105] The entire composition is received simultaneously, but it remains a series of loosely connected, separate events. What animates the painting is the sense of movement and the dramatic possibilities of live performance realized in visual space.

Although The Magic Competition artists employ new directions in painting better than others, the sense of action unfolding is also found in other

murals of the period at Dunhuang. A topographical landscape painting charting a pilgrimage to Mt. Wutai in Shanxi Province in cave 61 also possesses an analogous sense of movement through an everyday world intermixed with the miraculous. Plenty of pictorial details allow the viewer to understand the architectural layout of temples. This information helps the viewer imagine worshipping in each location along the pilgrimage route, conveying the ordinary splendor of such a trip. Other compositions include vignettes of everyday life, such as a butcher chopping meat while dogs gather underfoot to feed on fallen morsels (cave 85), field plowing (cave 196, Plate 3), and many other secular scenes.[106] It is as if the artist is now keen on fusing the observable world with the imaginary by combining these vignettes around iconic tableaux.[107]

Because of the newness of this kind of painting, The Magic Competition preparatory sketches (Figures 2.13–2.17), rare survivals from the Chinese painter's atelier, can date no earlier than the 860s, when late-Tang artists first constructed a mural with the new focus on movement. The dating of wall paintings and text is crucial to establishing the groundbreaking nature of the Later Tang and Five Dynasties visual history. We have established that the exclusive focus on the six contests in The Magic Competition only occurs in the pictorial realm; the performance scroll, which can be dated no earlier than the ninth century, features a skillful division of the contests by isolating them according to the needs of the performer. The wall paintings, however, concentrate on the last gale contest; the first example of this composition is cave 85, dated 862. Because the sketches highlight exactly this kind of composition, the sketches cannot date earlier. A hiatus exists between cave 85 (d. 862–67) and cave 9 (d. 892), where the next example of this kind of mural composition was completed. The surge in wall paintings of this theme around this latter date (ca. 900) is remarkable (Table 2.1). Cave 9 is dated to the autumn of 892; cave 196 to 893–94; cave 146 to the late ninth or early tenth century; and cave 72, considerably faded, to before 907. Furthermore, cave 98 dates to 923–25, or possibly several years earlier; caves 19 and 16 at Yulin were constructed from 924 to 940 and 936 to 940, respectively. Cave 108 was excavated from 935 to 939, and cave 454 from 939 to 944. Given this close succession, 890–920 seems a logical date for the sketches.[108] Once the compositional structure reappears in the 890s, it remains unabatedly popular for another century. Generally, we may say with certainty that artists regularly embellished the walls of the Dunhuang and Yulin grottoes with this subject matter—sometimes every five to seven years.

Fresh interest in the theme must have inspired artists to sharpen the visual impact of the painting by highlighting the gale's havoc. The tale again seems to gain particular popularity after 953 when another group of grottoes was

constructed, including caves 53 (d. 953), 55, and 25 (974); cave 6 and Yulin 32 were constructed sometime after 980. Many of these caves were excavated within a few years of the monk's notebook with a sūtra lecture of The Magic Competition dated to the equivalent of November 28, 944. The reader will remember that the scroll (P2187) was filled with other texts used in ceremonies and that its author penned The Magic Competition text in the extreme cold. Another bianwen (S4398) was written in June–July 949; and yet another— divided into two pieces, but nonetheless complete (S5511 and BJ1589)—was copied sometime in the tenth century. Finally, still another Magic Competition bianwen (P4615) was written sometime in the latter half of the tenth century. Three caves were renovated after 940, including 98 (940–45), Yulin 19 (962), and 454 (976). The overlapping dates of texts (that is, the bianwen and sūtra lectures) and caves, I believe, is no coincidence. The cave-temple production cannot be linked directly to the dedication of these texts; and indeed, the wall paintings are not a pictorial substitute for the written versions of the text, nor were they a site for oral recitation. Nonetheless, the two exist in the same cultural arena of patrons, monastic ritual, and Buddhist storytelling. What we may surmise about this chronology is that the popularity of The Magic Competition theme in the late ninth century, which instigated a string of murals for the next ninety years, was probably inspired by its strong reception in oral performances (with or without pictures). The popularity of the theme in performances was then the catalyst for patrons, artists, and scribes to make additions in more permanent forms. Thus we have several different types of producers of the tale who concern themselves with different media and different kinds of objects with a variety of functions.

Painters, Writers, and Performers: Producing The Magic Competition

It is virtually impossible to establish priority between verbal and visual material, especially in the case of The Magic Competition. In existing scholarship, one camp accords precedence to the textual, while an opposing camp argues for the independence of the wall paintings and their cartouches from the bianwen.[109] According to the latter approach, not only are the texts in the mural cartouches significantly different from contemporaneous bianwen; the murals may have been so innovative as to suggest or determine the focus of the oral performances and written texts.[110] Artists worked with a different set of structural demands than writers of the bianwen and accordingly made compositional decisions that diverged from verbal considerations. Furthermore, it is clear that those inscribing the cartouches—who, as we have argued, were scribes, not painters—were not using bianwen texts as a direct guide. While seeing the wall paintings and their cartouches as distinct from the bianwen

written texts has merit, it would be misleading to suggest that the pictures have nothing to do with verbal traditions. Rather, I have argued for a homology with oral performance, in which circumstances of delivery (in successive episodes) make The Magic Competition pictures and texts analogous in their episodic presentation. The recognition of the audience and adherence to vernacular (fresh, freely moving, animated) expression tie these two narrative worlds together. The storytelling origins of the tale partially explain the structure of the painting even though the murals are not directly connected to active performances.

I prefer to differentiate the work of artists who left cartouche spaces blank as they painted from those specialists or scribes who actually filled the cartouches with characters. The artist's practice was largely independent of the writer's practice. We will never know what texts artists read, but it is clear that they were not active producers of texts; instead, their own sketches, a type of practical manual, provide their primary tools of communication and sources of visual information.[111] Although artists and writers dealt with the same narrative, they operated in different technical spheres of the temple, as is clear for the several reasons enumerated below. This divergence leads us to reconsider the nature of the artist's draft sketches.[112]

First, artists' preparatory material rarely contains written notations; instead, the directions are noted using other readily comprehensible means. For example, as we have noted in Chapter 2, a simple numbering system indicating the order of the scenes such as the numbers "1–12" is found next to scenes in P2868 (Figure 2.4). Another effective device was the dotting of the surface with a variety of colors to indicate palette, as in two sketches in the Pelliot collection, 4518.33 (Plate 23) and 4518.36.[113] These practices intimate master painters were only semiliterate.[114] I am not suggesting that artists did not write, but that the tasks of painting and copying texts were separated in Tang and Five Dynasties workshops and presumably in the preceding Northern Dynasties period as well. When detailed written directions or multiline texts do appear in artists' preparatory materials, they are always on a special category of monochrome drawings—maṇḍalas and other ritual material used and written by monks and Tantric specialists who were literate in the canonical language of sūtras (Figures 4.12–4.16). In addition, the calligraphy belies a sureness of hand that comes from constantly copying texts.[115] Given the demands of their arts, scribes and artists were trained separately, although we can imagine some overlap. This distinct separation is, of course, what the literati theorists in the eleventh century were addressing. They envisioned a new type of painting practice in which both arts were intimately connected. They were the first to join text and painting in a significant way, linking painting inscriptions and poems to the painting's content and production. Often, they argued that both

arts come from the same source and use the same instruments, thereby elevating painting to calligraphy's respectability (see Chapter 6).

Second, if artists did not put cartouche contents alongside scenes for murals in their sketches, this suggests they were not responsible for or involved with filling in the inscription boxes in their final compositions. This assumption is supported by the number of blank cartouches in Dunhuang's murals and portable paintings. If the written versions of the stories had been easily completed and a matter-of-fact element of practice, they would have been more systematically filled in.[116] It is more likely that inscriptions were typically entered by another hand and that sometimes the writing task in this chain of labor did not get completed. Akiyama Terukazu has noted the close correspondence between The Magic Competition bianwen and the text for the cartouches in cave 146; some of the phrases are identical, yet the cartouches do contain much new material.[117] Others maintain that the cartouches alongside paintings and vernacular literature without pictures are not derived from the same source. How can we have both at the same time—some cartouches that correspond to the bianwen and others that do not? Again, both interpretations may contain elements of a valid argument.

One explanation for the correspondence between the written tale and the painting inscriptions is that the writers of the two are from the same part of the temple. It makes more sense that writers and speakers of bianwen would author mural cartouches than to claim that the creators of the two types of text and the wall painters are the same. I do not think anyone would maintain that artists authored the popular transformation tales (bianwen).[118] If artists had been writers, they would have to have had training in textual variation, which does not seem likely. A cartouche writer would need knowledge of other cartouches, bianwen, and performances. The consistent variety in The Magic Competition inscriptions demonstrates that their writers were constantly transforming the text; the general trend seemed to be toward simplification, but there were other, subtle changes as well. This textual knowledge, training, and level of literacy were confined to copyists, higher-level monks, and perhaps educated members of the laity who copied texts for merit; they were most likely not part of the artist's repertoire. While cartouche writing and bianwen writing require similar technical (i.e., scribal) skills, the brush skills for painting were pictorial. It makes more sense to see writing and painting as separate endeavors in ninth- and tenth-century Dunhuang. This may have been slightly different in Nanjing and the central plains. Artists such as Jing Hao (late ninth c.–early tenth c.), Li Cheng (919–967), and, later, Guo Xi (after 1000–ca. 1090) were better educated than their counterparts in the Dunhuang regional academy. A century later literati combined poetry and monochrome drawing in amateur works, but their social status and training

distinguished them from workshop painters, who were considered to be laborers with little social prestige. The literati joining of text and pictures on the pictorial surface (rather than cartouches superimposed on painting) represents a phenomenon that matured almost a century later.

At Dunhuang, literacy levels varied and not all scribal endeavors should be understood as the same. Cartouche writers may not have possessed the same *level* of literacy as the monks who performed the bianwen and penned their lectures after the fact (P2187). That is to say, when distinguishing a painter's from a writer's practice, we should be careful not to assume all writers attached to the monastery belonged to a single, uniform group.

Other evidence supports this interpretation that the cartouche writers were not involved in painting. A scroll in the Pelliot collection (P3304) reveals that cartouche cribs contained only characters. This scroll is a collection of cartouches for at least four different painting tableaux, including the Ten Kings of Hell and Amitābha's Paradise.[119] They appear to be an aid to a cartouche writer. Written in abbreviated characters that only a specialist would use, they contain the wording only for cartouches that an inscriber would have added to a mural. A similar document contains an incomplete transcription of the cartouches for The Magic Competition (S4257.2).[120] Neither of these contains sketches of the scenes to which the cartouches should be attached, indicating that the person charged with completing the inscriptions was not involved with the making of the pictures. The linguistic finesse and sure hand evident in these scrolls betray the brushwork of a professional copyist. Furthermore, their organization would be intelligible only to a specialist.[121]

These materials reveal a specialization of labor that was the foundation of production in Dunhuang workshops. The abbreviations of the figures and flourishes of the brush found in the artist's sketches are similar to these calligraphic shortcuts of the scribe. Both eliminate details in a way that renders them useless to the nonspecialist. For example, the sketches for The Magic Competition have no guide to order or even to the general layout of the scenes. The longest scroll of all extant drawing with The Magic Competition theme (P. tib. 1293[2]) has seven different sections of drawing (recto and verso) with no indication of their order in the finished wall paintings. The first sketch of the scroll is of the guardian of the east, which, as it turns out, is not part of The Magic Competition composition. Instead, it typically appears in the ceiling squinch (half-dome-like niches carved in the upper four corners of the grottoes), fifteen feet directly above The Magic Competition murals. This connection would be obvious to a painter who understood the typical layout of a cave shrine. The other six drawings in the scroll (P. tib. 1293[2]) are not in any intelligible order, although they are full of figures usually positioned in the right half of a Magic Competition mural. This lack of intelligibility is not

simply the result of a millennium separating the objects from the modern viewer; the scenes are truly scattered in the final composition (Figure 2.19). For example, the scroll's second drawing (Figure 2.14) is a composite of five scenes found around Raudrākṣa's dais, but no indication of their order is given in the sketch. The third drawing (Figure 2.15) contains seven heretics wrapped in the drapery who appear in the lower bottom below Raudrākṣa's imposing throne. The fifth drawing includes two of the heretic women and heads of the anguished heretic men that are separated by another scene in the finished mural (Figure 2.17). It is clear that these sketches would be of enormous aid to the skilled artist, but not to many others.

Additional "disorganization" is seen in Pelliot sketch 2868, which contains numbers indicating scene order. This sketch is so messy and casual in omitting details that it could only be decipherable by a trained artist who already possessed a knowledge of the final painting. And, finally, these two kinds of advanced shorthands (calligraphic and visual) from Dunhuang never appear together in the same document or sketch except in the case of ritual diagrams.

Other evidence indicates that scribes were separately trained and retained by the temple, a circumstance that helps to resolve the distinction between artists' practice and writers' practice.[122] Like the artists, they were supervised as a distinct group by outside inspectors, as indicated in a record of a supervisor's visit to a copyist (S2973).[123] Further, while cartouche writers were working in a more colloquial arena than sūtra transcribers, the skill of copying text required training in a guild system that encouraged specialization. Copyists identified themselves with different labels (*bishou, chaoshu, jingsheng, shushou,* and *xiejingsheng*) from painters (*huajiang, huaren, huashi,* and *huasheng*) and others, such as artisans (*gongjiang*) and master sculptors (*nijiang boshi*).[124] Both copyists and artists could and did share skills, yet their identities and function within their respective spheres were different. This is the source of the great prejudice against artisan painters in later Chinese aesthetic theory. That is, the professional painter was not closely aligned with text production and worked outside the literate experience of calligraphers. This explains Zhang Yanyuan's heroic effort to recast painting and calligraphy in the same milieu. He forcefully links painting to cursive-style calligraphy (a subject discussed in Chapter 6). Painting's alliance with calligraphy not only conferred literacy upon the practitioner, but it linked him to the classics and gave him a firm social standing.

We may identify at least four different kinds of tradesmen's manuals at Dunhuang. Three of these have Magic Competition material that permits us to distinguish the role of four kinds of experts who kept specialized notebooks and performed distinct tasks in transmitting this tale. These are: 1) collected notations used by cartouche writers (P3304, S4527.2); 2) notes made before or

copied after performances by monk lecturers/performers (P2187); and 3) sketches used by artists for wall paintings (P. tib. 1293[1–3]), paintings on silk, and pounces, and for drawing practice. The contents of each of these—cartouche notebooks, performers' scrolls, and artists' draft sketches—are vastly different from the others. This underscores the fact that their users would have had to cultivate specific skills. And although the expertise needed in cartouche writing and bianwen performance is relatively similar, a large gap exists between this and the skills represented by the artists' drafts. The training of writers and artists was traditionally separated in the medieval temple. If we can assume that writers were often monastic members, we cannot assume the same of artists.

A fourth collection includes Confucian-style etiquette rites. It contains no Magic Competition material but does provide evidence of specialists who conducted traditional social ceremonies. The scroll consists of drafts for stock thank-you letters for government largesse such as the bestowal of medicine from the local government, proper bowing procedures before playing polo, match-making formalities, and the way in which to thank those who contributed money to funeral ceremonies. This text (P3716, dated to June 14, 930) was kept by a ceremonies master (or member, *lisheng*) of the Rites Academy (*Jishu yuan*) attached to the local frontier government, which indicates that in addition to supporting Buddhist causes, officials also continued to maintain Confucian rites. The title of the writer also indicates that these rites masters were organized into the academy or bureau (*yuan*); the painters, as established, were organized into their own academy (*huayuan*) by the 930s. Thus, not only do the notebooks and drafts allow us to identify various areas of expertise by the specialized nature of their contents, but separate confirmation is also provided by the titles of their writers, highlighting different segments of the government's institutional structure.

There may even be a fifth kind of "specialist's notebook" among the Dunhuang material that sheds further light on the role of pictures in Buddhist religious performance and dramas. Stephen Teiser has suggested that two scrolls with individual scenes of the Scripture of the Ten Kings of Hell (S80 and S3961) may have been used by a ritual specialist who visited families when they had to perform the rites of the dead at seven-day intervals for the first forty-nine days, then at 100 days, at one year, and finally on the three-year anniversary of the death.[125] At these times it was believed that the deceased family member would come before one of the Kings of Hell: the king conducting these evaluations would decide whether the deceased would be reborn into the Western Paradise. One scroll has colloquial descriptions of hellish terror; the other omits the text completely. Two other Ten Kings of Hell scrolls (P2003 and P2870) contain pictures either alternating with the text or positioned

above it, presented in the measured, ordered manner of a sūtra. These also may have been used in ceremonies for the dead performed by a hired ritualist who owned the scrolls. Sometimes it appears that the ritualist may have traced or drawn the pictures himself rather than relying on a skilled artist to do the drawing. These scrolls may, in fact, be close in function to the performance scroll P4524 discussed in detail above because the pictures may have been shown to an audience. In sum, it is important to disaggregate all the types of sketch or notebook material from Dunhuang. This study endeavors to distinguish among the various types of manuals in order to highlight the high degree of specialization of the artists' sketches from the Dunhuang storehouse.

This brings us to question the relationship between texts and paintings; how do we distinguish the artist's realm from those of other practitioners (ritualists and writers)? The materials primarily used by each group, such as artists' sketches and performance notes, reveal that although each may contain the core of one story, paintings are clearly not like texts. Visual material achieves independent goals rather than merely serving as illustrations to texts. If paintings simply functioned as illustrations, the sketches would have more narrative order. Although this is an obvious point, it needs further consideration in the study of Buddhism, in which the authority of sūtras, as the embodiment of the Buddha's word, has led scholars to over-rely on textual evidence. Artists who produced the Magic Competition murals had different tools at their disposal to convey elements of the tale. They could capture action in the posture of a figure and emotion in a facial expression. The growing size of the tree manifested by Raudrākṣa before Śāriputra fells it with the gale may be depicted by exaggerating its size. In verbal renditions, these states may be conveyed equally well but by different means. For example, the performer does not show the great size of the tree but can describe how it grows to an immense height. In the painting, all the objects can be depicted as wind-blown, all bending in the same direction from the natural force of the wind; or the heretics can be shown to recoil from the fire's heat that destroys their heretical texts (Plate 32). The text can also describe these moments by explaining the impact on the heretics, and so forth, but obviously not by visually showing the effects of the wind. Dunhuang's cultural life supported both textual and pictorial versions of this tale. An organic understanding of the story allows for those differences in an interactive environment. The wall paintings assume that every viewer brings with him or her a preexisting knowledge of the narrative formed in the folk arena of performances. To attempt to fully connect text and pictures would be misguided, however. All these genres absorb different elements of the story. While bianwen develop in tandem with painting because they grow from the same roots in the oral tradition, the two nonetheless have to be seen as independent.

I have called up the notion of conceptual and cultural worlds. If neither the sūtras nor the written bianwen tales were the "source" for The Magic Competition wall paintings, then what accounts for a consistency in wall paintings of the theme over a 120-year period? What tools did artists use to instill continuity in the content of their compositions? The sketches of The Magic Competition figure groups discovered among the finished portable paintings offer an obvious explanation for the consistency of the motifs. In this sense, the sketchbooks become the "text" for understanding the wall paintings. And in the same way a verbal text conveys meaning to subsequent readers, the sketches enabled artists in the workshop to communicate with each other across time. The copy sketches are at the center of the artist's practice.[126]

As stated earlier, the artist's practice is distinct from the writer's because painters worked with a different set of demands and principles in mind than those needed by writers; for example, whether a chosen motif would effectively convey a story or an idea visually or whether the compositional layout would be exciting and interesting. An understanding of the role the sketches played in artistic production illuminates the production context.

In short, what distinguishes the artist's sketches? First, the information in them is only useful to a painter or specialist in cave embellishment. They are full of insider's notations that are useful only to muralists. Second, they are similar to notes of work-in-progress; there is nothing finished about them. Instead, they reveal or betray details about the process of making: what was considered important; how the hand moved with the brush (because these preparatory initial lines are not covered with color); how the artist organized space and visual units; what type of motifs were practiced before a final painting was attempted; and so on.

Regardless of the moment in which these Magic Competition sketches were drafted and their relationship to the performances, the connection of these sketches to a group of fifteen caves dated from 862 to 980 and the bianwen of the same theme is clear. The Dunhuang materials permit us to assess the range of skill, labor divisions, painting and writing practices, the relationship of the artist to the temple and calligraphers, and the ephemeral realm of storytelling in medieval public culture. The status of written documents and their bearing on the artist's practice will remain under scrutiny in the remaining chapter of this book. The discourse on wall painting practice by ninth-century critics provides an avenue to investigate the status of artistic production. The theme of performance shifts from pictorial content to the activities of the artist, the subject of Chapter 6.

6. SKETCHING, PERFORMANCE, AND SPONTANEITY IN TANG CHINA

Sketching as an Aesthetic Object

During the ninth century, for purposes of planning, monochrome sketches on paper were drafted during the preliminary stage of a project. To complement the sketches on paper, underdrawing markings on the surfaces to be painted (on silk or grotto walls) were also rendered in a pale ink wash. Except in rare instances, these preparatory sketches were covered with generous amounts of color to create the completed painting.[1] The written record, though, indicates that art critics in the eighth and ninth centuries turned their attention to moments when these sketches were being made, emphasizing a work's unfinished state. We likewise turn our attention to these moments, but do so in order to investigate the critical reception of painting and the ways in which the biographical record differs from the evidence gathered directly from the artists' ateliers. Continuing the theme of artistic performance that has permeated this book, we shift our focus to the critics' understanding of what performance meant for wall painting production. Sketching, as it has been throughout this study, is at the center of our discussion.

The great interest in sketching for ninth-century critics is that it simultaneously provided a glimpse of the artistic process, suggested by the relaxed hand possible during the underdrawing stage, and evoked verisimilitude consistent with nature. In the imagination of viewers and critics during this period, a new link forms between monochrome sketching, spontaneity, artistic performance, and motion depicted in two-dimensional space. In the recep-

tion of painting, these four elements were interdependent. The chapter will
address how sketching became the center of critical reception in the late Tang
and how critics perceived new directions in painting largely framed in the con-
text of the sketch. What concerns us is the representation of wall painting in
contemporaneous literature. How were muralists discussed by literate observ-
ers? What issues were important to the reception of wall painting when this
extraordinary collection of sketches from Dunhuang was being made? And,
finally, how were guilds and the collaborative work setting of mural produc-
tion viewed by painting connoisseurs in the late Tang? It should come as no
surprise that aesthetic standards used to evaluate calligraphy were applied also
to analyze painting. This and other evaluative apparatuses will be reviewed in
this chapter for their relevance to painting criticism.

A tale featured in the important *Record of Famous Painters Throughout the
Ages*, by Zhang Yanyuan, written in ca. 845–47, captures the intersection of
Tang interests in sketching, performance, spontaneity, and pictorial motion.
In this text and in another art history, *Tangchao minghua lu* (Celebrated
Painters of the Tang Dynasty; ca. 842), by Zhu Jingxuan, the careers of hun-
dreds of artists are summarized; the most prominent muralist of the period,
Wu Daozi (fl. 710–60), is featured in the story. Wu, a court painter in
Chang'an, goes to Sichuan under imperial order to capture the waters of the
Jialing River in a sketch for the purpose of painting a landscape at the court.
The scenery is the emperor's favorite and in pictorial form will adorn a palace
wall. When he returns to court, Wu has no physical drawings (*fenben*) or draft
versions of the landscape to record the salient features of what he had
observed. When Wu was asked where his sketches of Sichuan were, he replied,
"I have not a single sketch, but all is recorded in my mind." Further, he is com-
manded to paint a landscape mural opposite another painter, Li Sixun
(651–716). Wu completes his in one day. Li's mural takes several months—
over ninety times as long—and presumably is accomplished with many
preparatory materials and aids. The story begins with the circumstances that
inspired the painting.

> During the Tianbao era (742–55), Emperor Ming Huang suddenly recollected the
> Road to Shu and the waters of the Jialing River. He thereupon gave Master Wu
> temporary leave of absence, sending Wu by post horses to sketch the scenery. Upon
> Wu's return, when asked by the emperor where his sketches were, he replied, "I
> have not a single sketch, but all is recorded in my mind." Later he was commanded
> to depict [the scenery] in the Datong hall. Wu finished more than three hundred
> *li* of the scenery of the Chialing River in a single day. At that time there also was
> a General Li Sixun, who had a great reputation for his landscape painting. The
> Emperor also commanded him to make paintings for the Datong hall, which he
> took several months to finish.[2]

The tale pivots on the physical absence of sketches, emphasizing the visible performance of the sketching. In this record, the typical aids of practice are set aside. Wu abandons the step of consulting sketches during the underdrawing and relies on his own memory and impressions of the landscape. The tale conspicuously rejects the standard method of wall painting exemplified by Li's long and presumably painstaking preparation and execution. Sketches, even with the ad hoc and scattered qualities evident in those from Dunhuang, are made redundant.

In the discursive practices of the ninth century, sketches were regarded as simplistic, for surely Zhang Yanyuan means to privilege Wu over Li. This is clear in the evaluation both he and Zhu Jingxuan give Wu. Zhu Jingxuan accords Wu the highest rating possible in his scheme: "inspired class," top rank (*shenpinshang yiren*).[3] In Zhang's work, Wu is listed alone in the "untrammeled class" (*yipin*).[4] His extraordinarily high rating is directly related to his artistic practice that obviates the preparatory phase in the tale. While physical sketches are represented as superfluous in this tale, the performance of sketching itself—promoting the act of sketching to an aesthetic object to be appreciated on its own terms—becomes the center of discussion. Speed and seeming lack of technique are advanced as ideals; a lengthy, laborious process of mural production is superseded by a simultaneous realization of pictorial form. Connotative, suggestive brushwork is introduced as a viable procedure in wall painting in contradistinction to the traditional, multilayered techniques typical in mural production.

In his account, Zhang Yanyuan emphasizes the impressive display of skill required in freehand mural sketching and further implies the importance of approximating shapes and transposing sizes to fit the required, limited space. With this tale of "The sketch in the mind, not in the hand" one may identify a central tenant of Tang aesthetic theory—the ideal artist relies on intuition rather than learned technique. Discussions of the Wu Daozi style of painting make it clear that the most remarkable feature of production is the sketching performance. For Tang writers, the locus of creativity is in the drawing stage. If, in theory, no tools and other technology mediate in production, the initial moment in the creative process provides a convenient focus for unadulterated expression. Emphasizing that these unusual feats of artistic exchange are witnessed by an audience as if to verify and confirm the process of art making, the texts reveal there was a new perception of the body's active role in making an art aligned with forces of nature.

Tang critics turned their attention to these ephemeral moments of sketching in other biographical tales, and they became objects of interest in their own right. Quick slashes of the brush, approximation of features, and a disregard for the conventional apparatuses of painting are emphasized in theo-

ries of painting practice. Within this intersection of qualities also lies a definition of spontaneity; that is, to draw without preexisting sketches or the intervention of other tools or technologies and to yield to nature as primary "teacher" of genuine verisimilitude. How long the artist spends in faithful delineation of appearance or making preliminary copies is less important than his authentic relationship to nature in the planning stages. This relationship obviates the need for tedious technique executed over many days. That the representation of sketching defies the archaeological evidence poses interesting problems for the interpretation of the claims. The philosophical and religious concerns that permitted this highly idealized representation of painting include the long-standing principles circulating in three spheres: calligraphy, which represented the world of the literate and educated; Chan (Zen) perspectives of meditation; and Daoist perspectives of action and gesture. Let us turn first to calligraphy and determine what Zhang has borrowed or reflects from the world of the literate brush.

In his text, Zhang Yanyuan demonstrates a preference for a fluctuating, modulated brush style. He introduces the concept by contrasting two types of brush work: "Only when you understand that in painting there are the two forms, *su* and *mi*, can you join in a discussion of painting."[5] Two earlier artists, Gu Kaizhi and Lu Tanwei (active 460s–early sixth century), use the mi style, featuring firm, uninterrupted lines without breaks in continuity. A third, Zhang Sengyou, used dots and "dragged and hacking" strokes. Wu Daozi, the only contemporary artist in this four-artist, two-stage development left spaces between his dots and strokes. The sharp dots and strokes of ink are broken in application with "spaces left between them," Zhang Yanyuan writes in reference to the su or "sparse" brushwork represented by the work of Zhang Sengyou and Wu Daozi.[6] Su and mi are not new terms in aesthetic criticism, but this is the first time they are applied so starkly to painting theory.

As terms *su* and *mi* first appear in calligraphy criticism by Zhao Yi (late second century C.E.) in "Fei caoshu" (A pox on cursive script).[7] This text clearly associates the sparse or fluctuating line (su) with new, positive directions in brushwork. "The mind (heart) can be sparse or dense. The hand is either clever or clumsy. Calligraphy can be either beautiful or ugly."[8] In the parallel construction, the first characters in the three pairings are synonymous; the second set of characters is consistent in meaning. Sparse (su), clever (*qiao*), and beautiful (*hao*) are comparable and undifferentiated in meaning. Correspondingly, dense or a meticulous, continuous line (mi) is clumsy (*zhuo*) and ugly (*chou*). In addition to the *Record of Famous Painters Throughout the Ages*, Zhang Yanyuan is also credited with a companion volume on calligraphy entitled *Fashu yaolu* (Essential Records of Calligraphy Exemplars).[9] He republished Zhao Yi's text "Fei caoshu" in this collection of calligraphy texts and,

therefore, was well aware of the meanings of su and mi. We can only assume he borrowed them directly from Zhao's text.

Because painting itself was still not an art widely engaged in by literate men, Zhang relies on an understanding of writing to explore pictures. He articulates a strong preference for the calligraphic arts, asserting emphatically that painting's origins rest in calligraphy.

In calligraphy, the mi or dense style is probably best defined as stilted and uniform. "If the strokes are regular and even like an abacus and square and uniform above and below, symmetrical in front and rear, this is not calligraphy," writes a Lady Wei in the seventh-century text "Colophon to the Battle Diagram of the Brush" (Wei furen bizhentu) that Zhang Yanyuan reprinted.[10] Zhang's section on su and mi addresses the same distinction between looser, freer brushwork and the fine line, but predictable stability, of mi. In another section, Zhang announces that "true" painting is executed free from marking lines and rulers and any other tools that render a picture "dead" or lifeless. While Zhang does not explicitly draw the connection between underdrawing and overdrawing to su and mi, it is useful here, in fact, to think of the loose brushwork of the Dunhuang sketches and the final, precise overdrawing in the Dunhuang murals. In his argument, Zhang does not distinguish between function in discussing these two styles, but the closest examples that correspond to these styles are, in fact, preparatory sketches and the fine-line overdrawing in murals and banners because very few, if any, paintings actually contain "sparse" brushwork. An eighth-century banner of a vajrapāni (door guardian) articulated with breaks in the modulated line is the only Dunhuang example that seems to exemplify such brushwork (Plate 21).[11] As we shall see in the section on Chan and debates on aesthetic theory, this binary structure contrasting two methods of action, one fast, one slow, was a popular method of discussing divergent epistemological structures in the ninth century.

This freedom from traditional tools during the preparatory sketching stage is underscored in another tale in which a vigorous sword dance by General Pei Min (Jiangjun Pei Min) inspires a painting by Wu Daozi.[12] Pei Min's dance is described as physical and dramatic.[13] "Stirring himself up, holding himself back, [Pei Min] was extraordinarily strong and imposing." Wu Daozi's response is equally powerful. The tale, first written and published in a poem by the renowned artist and poet Wang Wei (701–61), begins with General Pei Min's request for a mural in the Tiangong temple in Luoyang. He accompanies his request with gifts of silk and gold. Wu Daozi refuses the gifts and asks instead for the famous general to perform a sword dance. The vigor of the weapon wielded by the general as it slashes through the air inspires Wu to create a painting in a flurry of activity attributed to a supernatural force. In the words of Zhu Jingxuan, "No sooner was [the dance] finished than the brush

was seized and in no time [a painting] was complete. It was as though he had the help of some divinity, to such an extent was it superior."[14]

For his part, Zhang Yanyuan clearly is more interested in the impact of this kind of brushwork over other visual effects. He so favors line over color that he states that shades of gray created by adjusting the ink saturation produce the suggestion of hue without color. Color and form could just as easily be suggested by spaces left open, too. "Mountains are turquoise without needing 'sky blue' and the phoenix is iridescent without the aid of the five colors. For this reason one may be said to have fulfilled one's aim if one can furnish [a painting] with all the five colors by the management of ink (alone)."[15]

As William Acker observes, this is the first formulation of a preference for ink-only painting. According to this formulation, texture and form may be represented in contour lines that describe both the exterior and interior of an object through fluctuating brushwork. Although in practice monochrome painting was still just an early stage in the painting process, for Zhang Yanyuan and presumably other critics a reliance on fluctuating line to describe three-dimensionality and tonal variation to suggest "color" were new possibilities in the appreciation of painting. Qualities usually associated with sketching were now looked at separately from their function in the painting process.

Certain features of the new Tang vernacular style emerge from these enthusiastic impressions of painting by poets, connoisseurs, and art historians. Artists are mobile and agile in their practice, and they have the ability to portray observable phenomena including emotion, movement, and popular customs without stasis and rigidity. This is evident in a story concerning extraordinarily convincing dragons painted by Wu Daozi. "Wu also painted five dragons for an inner [palace] hall, with scaly armor that seemed to be moving in flight. On days when it was about to rain, a mist would rise from them."[16] Judging from the amount of attention they received in the texts, painted objects that were perceived to move fascinated writers on Tang painting. In this passage, Zhu Jingxuan emphasizes the palpability of physical movement with the verb *feidong*, or "moving in flight," to describe the dragons' demeanor. He stresses verisimilitude and the artist's ability to conflate illusion and reality so much so that the dragons seem "real" enough to churn mist from the sea. In this case, art was invested with its own form of living movement and was therefore seen by critics to evoke even the most elemental experience, for here art harnesses nature. This is but one of scores of anecdotes about motion in painting written by Tang critics.

Other qualities include an immediacy and vigor achieved by exploiting key features that define physical and emotional character and a keen sense of the descriptive powers of the modulated line. In compositions with narrative

Figure 6.1. Wrestlers. Assorted sketches on back of a damaged sūtra. Detail, verso. P2002. Ink on paper. Graffiti d. 861 or 921. 23.1–23.4 cm × 446.0 cm. Cliché Bibliothèque nationale de France, BnF.

genre scenes surrounding iconic centers, artists were at greater liberty to modify form, posture, and content. These scenes were full of action and often reflect an interest in the activities of daily life. In the extant preparatory sketches used to plan wall paintings discussed in Chapter 2, this skill of ink drawing is most visible. Because the sketches were unfinished, one senses they were for internal use in the painting atelier and not meant for public consumption. In these informal documents we may observe the quick, lively drawing at which, according to the texts, Tang artists excelled.

In this sense, we might come closer to discovering what was so intriguing to ninth-century critics. The sketches reveal the convergence of a subject matter reflecting daily activities and the new subjective manner in which objects in narratives are portrayed. A small sketch of wrestlers (Figure 6.1), one of several random groupings of figures in an artist's scroll of practice drawings from Dunhuang dated 861 or 921 (P2002), displays an interest in action and movement.[17] Although scenes of sport were depicted as early as the Han dynasty, in this Tang sketch the attention to dynamism makes the figures credible in a three-dimensional space. The artist's attention to how the figures wrap themselves around each other yet maintain their posture captures perfectly a specific moment of action.[18] This balance or sense of composure on the level of composition and rendering of forms is a definitive Tang characteristic evident in other drawings as well.

The heightened sensitivity to emotion is evident in the heretic overcome with anguish (in the upper left side of Figure 2.17). This tiny detail, taken from a preparatory sketch for a much larger mural, demonstrates the skill of the freehand artist at capturing emotions in facial expressions. The frail arms grasping the head makes this display of emotion especially poignant. Tang

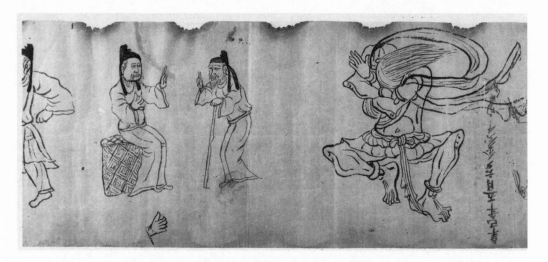

Figure 6.2. Wind god. Assorted sketches on back of a damaged sūtra. Detail, verso.
P2002. Ink on paper. Graffiti d. 861 or 921. 23.1–23.4 cm × 446.0 cm. Cliché
Bibliothèque nationale de France, BnF.

artists achieved a technical understanding of how to describe movement. This
includes the skill of rendering figures in natural, convincing poses combined
with the ability to place them in credible spaces. A scene of two heretics brac-
ing the drum frame in The Magic Competition story (Figure 2.16) exemplifies
the artist's seeming ease of depicting action convincingly in space. The artist
uses the drum base to frame the action. By setting the two figures at opposite
ends along a diagonal, the artist makes the area between them tense with
impending movement. The thrust of the drummer's arm as he pulls back the
baton is especially well rendered.

Another detail from a Dunhuang sketch now in the Pelliot collection
demonstrates Tang artists' mastery of line. In a representation of a whirling
figure (Figure 6.2), the artist uses the triangular shape of the bent legs to uplift
the figure and lend it an airborne quality.[19] This is complemented by the sim-
ilar shape of the folded arms, set slightly off center, imparting a twisting
motion. The circular scarves suggest whirlwind speed and are counterpoised
dramatically with straight, windblown hair. The artist makes each line count;
every stroke has a crucial descriptive function. The turning sensation is cap-
tured primarily by the two strong arcs that form the contours of the scarf in
the upper register. Dashes of dense line in the calves indicate the strength this
figure needs to turn himself. But they also attest to the physicality of the artist's
creative process, that is, the act of vigorously making those marks. These
forceful, modulated brushstrokes convey the power of motion in the depicted
figure as much as they do the force of the artist's brush.

Realism and the Preparatory Process

Our ability to point to examples that embody the qualities prized by Tang art historians does not fully explain their descriptions of the performance of painting during this period. Nor does it explain the veracity and verisimilitude they attribute to scenes of hell, dragons, and landscapes. Zhang Yanyuan and Zhu Jingxuan insist Wu Daozi required nothing in the way of underdrawing markings, rulers, or compasses—aids that we know were a standard part of the Tang painter's routine practice. Zhang emphasizes Wu's divergence from the norm, commenting, "Again I was asked: 'How was it the Master Wu could curve his bows, straighten his blades, make vertical his pillars and horizontal his beams, without use of marking line and ruler?'"[20]

What is the explanation Zhang gives when he poses this rhetorical question to the reader? The question to which he seeks a response is essentially, "How can an artist achieve the effect of perfection without using the tricks of the trade?" His answer locates the authority outside the artist: "He watched over his spirit, concentrating on his own unity. Being in harmony with the work of creation itself (*zaohua*), the spirit of heaven could borrow his brush." In the Sichuan landscape tale, the explanation for the painter's brilliance is that heavenly creative forces "borrow" (*xia/jia*) his brush. In the sword dance tale, Zhang writes that Wu Daozi is "helped by some divinity" (*shenzhu*) as he responds to the general's dance after rejecting material remuneration for his own painting. Wu does not depend on tools, nor is he motivated by monetary reward.[21] The immediacy of his perception and expression is not linked to a painterly verisimilitude, which would be representing nature in a mimetic way. Instead the tale stresses his coherence with the rhythms of nature and the fluidity of dance rather than imitating the appearance of nature directly. Thus, while spontaneity and naturalness are related to nature, they are not a direct imitation of it.

In Dunhuang chronicles of cave construction, we find the same introduction of myth and magic to explain art production. In describing how cave 156 was hewn, the writer of Pelliot scroll 2762 insists "the mountain split of its own accord" with "sand flying" in nature's spontaneous work to dig the cave temple from the mountain scarp. This emphasis on the divine in the formulation of art positions nature as the sole creator. That no human sources can be credited with painting is one of the recurring themes in the critical reception of painting in the late Tang. On the one hand, writers remark on the everyday, vernacular qualities of represented figures; yet, on the other, they insist that no human experience or action is responsible for that achievement. The preparatory process is dominated by inexplicable natural forces; the human hand in making art disappears in eulogies and biographical accounts in Tang times.

The culturally specific realism of the Tang dynasty is a matter of achieving proximity to nature through abbreviated brushwork that emphasizes the preparatory process.[22] In the period of China often described as the most realistic in terms of figural art, we find in the text of Zhu Jingxuan, for example, a brush technique that suggests shapes rather than delineates them in detail and that is more evocative of what one comprehends while viewing. This quality may contradict the verisimilitude that Zhu admires in other instances in the text, but he implies that the suggestion of shape is "more real" than minute detailing. This complements his admiration of "intense vividness" or "immediacy of expression" in the tactile landscapes and misty dragons of Wu Daozi, in which form and content work together to produce a visually and physically dramatic space for the viewer.[23]

Creativity and New Epistemological Directions in the Tang

As inspiration arrives via other-worldly sources, Wu Daozi is described as withdrawn yet in tune with the patterns of the world. As with his teacher, Zhang Xu (active ca. 700–750), and other "mad" calligraphers (*shudian*), the painter who has inherited his praxis from creation loses self-awareness and consciousness during the creative process.[24] Zhang Yanyuan credits the intervention of nature in Wu's practice as the source of "true" or realistic painting. "Being in harmony with the work of Creation itself, [his spirit] could borrow Master Wu's brush. This is what was earlier described as 'formulating the conception before the brush is used' (*yicun bixian*). . . . Now if one makes use of marking line and ruler, the result will be dead painting (*sihua*). But if one guards the spirit and concentrates upon unity, there will be real (or true) painting (*zhenhua*)."[25]

Although heaven borrows his brush, Wu is not isolated and out of rhythm with nature. He simultaneously forgets himself and becomes self-absorbed, but is acutely aware of his surroundings. In fact, this is probably the single most important point to make about theories of creative genius in the Chinese tradition. The model of a brilliant but utterly isolated artist is not celebrated in China's middle period because the key to painterly success is a coherence with the trends, moods, and traditions of natural forces. No painter in the Chinese tradition will be described as a genius if he is estranged from nature. Genius does not have to be intimately connected with humans. Instead, it mimics nature (*ziran*), "so of itself"; thus, spontaneity in painting practice is not necessarily quick but it is self-generating, self-propelling. The genius painter follows the patterns of nature and responds to the world in a way dictated by the rhythm of a larger system. This vision and the language used to describe it lie squarely within the Daoist tradition. Below, we explore

how these claims reflect an intricate web of popular beliefs connected to studies in the occult and alchemy, and to a style of argumentation used to address other problems by writers and authors of the same period.

Divine help (*shenzhu*), "unknowable" (*renmo de zhi*) and "inexhaustible" (*yingling buqiong*) wellsprings of artistic energy, and "borrowing from the creative powers of heaven" (*shenjia tianzao*) are not Buddhist notions, as we might suspect, but Daoist ones, deployed to explain artistic phenomena.[26] Zhang Yanyuan and Zhu Jingxuan attribute Wu's seemingly noble genius and superhuman display of painting to the powers of nature. Clearly, this is not an artist acting on his own. As Zhang Yanyuan states, "As for Wu Daoxuan [-zi], he was endowed by Heaven with a vigorous brush, and even as a youth embraced the divine mysteries (of the art)."[27]

In Daoist philosophy, which formed the backbone of Chinese ideas about creativity, the natural world was believed to have elements that circulated independently of the human sphere. Appropriate human behavior was to aim for harmony with these natural forces by assessing them properly and adapting accordingly.[28] This tenant of Daoism—*ganying* (sympathetic response)—was central to ideas that took shape during the late Eastern Zhou period and was articulated in texts beginning with the *Zhuangzi* in the third century B.C.E. and later in Five Phases (*wuxing*) literature.

Why did these myths of artistic practice develop in the Tang period? Daoist and alchemical understandings of the universe that are brought to bear on claims of realism in these texts obviously predate the Tang. When Zhang Yanyuan and Zhu Jingxuan wrote the first comprehensive art histories in the ninth century, they turned to Daoism and proto-scientific explanations. An interdisciplinary survey of the epistemological concerns impacting art enriches our understanding of it. Daoist ideals pervaded the philosophical underpinnings of aesthetic theory since the third century B.C.E., if not earlier. Daoism does not explain painting, but the Daoist arguments made by ninth-century critics are explored here for their derivation and sources.

In the Six Laws of Painting formulated by Xie He in the early fifth century C.E., one of the earliest works on painting theory, the Daoist notion of interchanging forces between objects and artists figures prominently. The first law reflects the intimate relationship between the successful representation of things and understanding the *qi* or spirit of the object depicted. Xie's first law is "Animation and movement through spirit resonance" (*qiyun shengdong, shiye*). The interpretation of this phrase, more than any of the other laws, has been vehemently contested. The ambiguous grammatical structure is partially to blame; it has not been resolved completely whether the third and fourth characters (animation and movement) are a cause or an effect of the first two (spirit and resonance). What is clear is that in early painting theory, qi—the

pneumonic essence of nature (or primordial breath), of which one had to be cognizant and cultivate within the self in order to adapt to nature, animation, and the movement of represented figures—and painterly realism were interdependent. Thus, whatever the reading of these six characters of Xie He's first law, republished incidentally by Zhang Yanyuan in the first chapter of his *Record of Famous Painters Throughout the Ages*, the artist had to be mindful of the essential character or energy of objects and assess that as part of the painting process in order to achieve verisimilitude.[29]

Early Daoist philosophy and later Tang commentaries on it address the practitioner's role in cultivating the body to align his qi with the Dao (the way of nature). Sometime in the second century C.E., Daoism developed as a popular religion.[30] Procedures to achieve longevity and immortality were also part of the practices we now label Daoist. The search for longevity and immortality contributed directly to the development of science and alchemy—processes that could be invoked to alter the body's state. By the time of Wu Daozi and Zhang Yanyuan, Daoism had undergone a second flowering, and interest was extremely high in pseudo-scientific methodologies of prolonging life.[31] If we doubt Daoism's appeal, we only have to note that Emperor Wuzong (840–46), the ninth Tang ruler, who was pro-Daoist and responsible for the two-year persecution of Buddhism from 843–45, died of poisoning from an immortality potion.[32] His successor, Xuanzong (r. 846–59), died in similar circumstances. Emperor Wuzong's self-induced death occurred while Zhang Yanyuan was writing his text.

During the eighth to tenth centuries, the Daoist liturgical canon was codified for the first time under the hands of the abbots Zhang Wanfu (ca. 711) and Du Guanting (850–933), who standardized religious Daoist practices and precepts.[33] Zhang's Yanyuan's vocabulary betrays an intellectual very much current with Daoist texts and philosophy popular at this time. Zhang demonstrates a familiarity with the mixtures of magic, experimental practices for the body, and the now standard notion that the human world is controlled by nature. How conscious he was of applying this cluster of associations to aesthetics is unclear. What we can say is that for Zhang, nature reigns supreme over the artist's hand in effecting verisimilitude during the sketching phase; this belief appears to be widespread during the ninth century. An example is a text by a contemporary of Zhang's, Tian Tongxiu, entitled *Guanyin zi* (Master Guanyin), written around the late ninth or the tenth century. Tian's work reflects the common belief of nature's primacy and the popularity of Daoist arts devised to control the unknown:

> There are in the world many magical arts; some prefer those which are mysterious, some those which are understandable, some the powerful ones and some the weak ones. If you grasp (apply) them, you may be able to manage affairs; but you must

let them go to attain the Dao. If you can attain to the homogeneity (*hun*) of the Dao, nothing will be able to attack you; your body will be able to caress crocodiles and whales. . . . If you know that the qi emanates from the mind you will be able to attain spiritual inspiration and will succeed in alchemical transmutations of the stove.[34]

This impressionistic conception of the cosmos, presented as a scientific explanation, reveals the futility of trying to conquer the forces of nature through magical techniques. Tian hints at the unreadability of abstract Daoist texts. *Cantong qi* (The Accordance with the Phenomenon of Composite Things), the earliest Chinese alchemical text, admits that one of the reasons for textual inchoateness is to hide the secrets of techniques.[35]

Several other popular texts during the period, particularly those that address alchemy and cultivation techniques to tap into the changing forces of nature, reveal correspondences with Zhang Yanyuan's art theory.[36] These concepts have direct bearing on the kinds of biographical anecdotes that find their way into Zhang's text.

A view of powerful nature characteristic of the Tang is presented by Li Quan, an eighth-century writer, in his *Yinfu jing* (Harmony of the Seen and Unseen).

> The spontaneous Dao (operates in) stillness, and so it was that heaven, earth, and the myriad things were produced. The Dao of heaven and earth (operates like the process of) steeping (i.e., when chemical changes are bought about gently, gradually as in dyeing or retting).
>
> (Thus it is that) the yin and the yang alternately conquer each other, and displace each other, and change and transformation proceed accordingly.
>
> Therefore the sages, knowing that the spontaneous Dao cannot be resisted, follow after it (observing it), and use its regularities. Statues and calendrical tables drawn up by men cannot embody (the fullness of) the insensibly acting Dao, yet there is a wonderful machinery by which all the heavenly bodies are produced.[37]

Pseudo-scientific explanations of the cosmos such as this have considerable implications for aesthetic theory. For instance, the stories of artistic genius recounted in Pei Min's sword dance, which inspired a quick painting by Wu Daozi, and Wu's Sichuan scenery contain a conception of nature consistent with this representation of a mysterious rhythm uncontrollable by humans. If nature is manifest in an ever-changing, unalterable pattern (*yinyang*), the painter who excels at representation would, by definition, have tapped into nature's energy. Zhang Yanyuan describes artists entering a trance-like state, quietly withdrawn and contemplative, then suddenly bursting into action in such a way that seems other forces are in control. As in Daoist thought, the art histories of Zhang Yanyuan and others of the Tang dynasty advance the

belief that the fact we can act and talk does not prove we have intrinsic will.[38] Zhang Yanyuan describes the painter's energy as inexhaustible (yingling buqiong) because it originates in nature, which is itself without beginning and end. It is unknowable (*renmo buzhi*) because nature, while constant, is mysterious. It is precisely these moments of direct engagement with nature that Tang dynasty art critics understood as the most dynamic moments in painting. Sketching is key. It is primary to Tang critics, poets, and, possibly, painters because of its direct connection to forces outside the artist. It was, therefore, least likely to contain the imprint of human artifice, such as excessively meticulous line or mechanically imposed precision. If a painting were ever going to be charged with the veracity and authenticity of natural forces that provided ontological meaning, it was at the preparatory stage when plain ink was set to a virgin painting surface. It is perhaps the greatest irony of the Chinese painting tradition that precisely the record of this seminal contact with nature— the sketch—was not collected or prized by connoisseurs. Instead, it seems to be the verbal circulation of such moments that was savored and reproduced.

This enthusiasm for the performance of the sketch is perhaps best exemplified in another tale about a Tang artist, Zhang Zao, who is described in a battle with nature and brush to produce a painting. The scholar-official Fu Zai (d. 813) recorded the scene.

> Right in the middle of the room, Zhang Zao sat down with his legs spread out, took a deep breath, and his inspiration began to issue forth. Those present were startled as if lightning were shooting across the heavens or a whirlwind sweeping up into the sky. Ravaging and pulling, spreading in all directions, the ink seemed to be spitting from his flying brush. He clapped his hands with a cracking sound. In a flurry of divisions and contractions, strange shapes were suddenly born.
>
> When we contemplate Master Zhang's art, it is not painting, it is the very Dao itself. . . . His ideas reach into the dark mysteries of things, and . . . lay . . . in the spiritual part of his mind.[39]

The "dark mysteries of things" connecting the mind and body to artistic practice is quite similar in conception to the *Guanyin zi*'s explanation of techniques in the alchemical arts. The spectacle of Zhang Zao pulling mimetic forms from thin air is compelling in this account because it is witnessed by a cosmopolitan audience assembled at a banquet. It is essentially a performance of sketching art at the moment of making. His practice contains elements not unlike "inner alchemy" (*neiguan*), a form of silent meditation without visualization intended to empty the spirit and unify it with the Dao. Isabelle Robinet explains how a new trend in mysticism in the Tang engendered an interest in techniques of self-cultivation vis-à-vis nature.[40] As in the above passage by Fu Zai, this conception of the practitioner is very much aligned to forces

beyond the body. In Fu's description, the artist's parallel actors are the heavens and tumultuous sky, not earth-bound forces. The same type of explanation is given in Pelliot scroll 2762, dated 865, eulogizing the construction of cave 156 by Zhang Huaishen, commissioner of Dunhuang's commandery government, constructed in honor to his uncle Zhang Yichao (799–872). As already noted, the author emphasized nature's hand in hewing the mountain scarp into a cave temple, thus borrowing a Daoist framework for a Buddhist cause: "The cutting and chiseling had hardly begun when the mountain split of its own accord; not many days had elapsed, when the cracks opened to a hole. With further prayers and incense, the sand began to fly, and early in the night, suddenly and furiously, with a fearful rush, there was a sound of thunder, splitting the rock wall, and the cliff was cut away. This was creation by Ten Powers (of Buddha), with the Eight Classes of Being supporting from below."[41]

These popular images of creation (zhaohua) intervening in the artistic process drop out of fashion by the Northern Song dynasty. By the eleventh century, ideas of creativity shift to a conception of the artist's agency in production that supplant the hand of the divine or the demonic.[42] Artistic theory again keeps pace with shifts in Daoist philosophy. During the eleventh and twelfth centuries, it was believed that nature could be controlled if the right techniques were used, unlike in the Tang, when the futility of efficacious techniques was openly lamented.[43] Art theory during this later period emphasized the human practitioner working in a privately controlled space, unlike the public, urban performance featured in Tang tales. Consider the spectacle of Su Shi painting bamboo. The images literally emerge from his body in a cathartic exercise in a crude, but intentionally humorous, passage about painting. Read metaphorically, the anecdote points to the violent use of his brush; read literally, Su Shi may be alluding to the use of "nontraditional" tools for painting such as vomiting or urinating.

> When my empty bowels receive wine, angular strokes come forth,
> And my heart's criss-crossings give birth to bamboo and rock.
> What is about to be produced in abundance cannot be retained,
> And will erupt on your snow-white walls.[44]

Su Shi's description puts the control of the brush squarely in the hands of the superior and talented man whose own inspiration (or weak bladder?) is responsible for the picture. This literally erupts on the painting surface as if the wine circulating in the artist's body is projected forth onto a virgin painting surface. The creative impetus belongs to the painter, not an inexplicable divine force. In the Tang, spontaneity that originates outside the artist could only be regulated; to balance spontaneity was the locus of culture and

refinement, according to the *Yinfu jing*, the influential Tang Daoist text.[45] In the Song, the very definition of culture (*wen*) was the educated man (*wenren*) who uses painting as an outlet or vehicle to express his personality.[46] Cultural refinement, once in the realm of nature, was now in the hand of humans. Tang's regulation is Song's freedom and action. This meant, too, that the definition of naturalism or "natural" (or "true") painting (zhenhua, as opposed to sihua, "dead painting") had changed as well. An individual controls substance or resemblance representing the world through a personal, subjective perspective of form. Nature's dominance was diminished as human authority exerted precedence over representation.

Daoist Models and the Zhuangzi *in Aesthetic Theory*

If new aesthetic theory in the Tang demonstrates parallels with the old-fashioned and magical alchemical texts, it is also clear that Zhang Yanyuan, like other late Tang scholars, was very familiar with the *Zhuangzi*. The *Zhuangzi* is a highly important late Warring States Daoist text from which Zhang borrowed stories, vocabulary, and an ideal of the artist.[47] The *Zhuangzi* addresses the attributes of a natural and easy existence free of governmental control and concentrates on questions of spontaneity. It counsels adapting to conditions as they are and acting accordingly. In chapter 20 of the *Zhuangzi*, the author, Zhuang Zhou or Zhuangzi, discusses how skill should be deployed within the limitations and challenges of nature through stories about unconventionally simple but perspicacious characters who teach government officials important lessons.[48] Parts of Zhang Yanyuan's *Record of Famous Painters Throughout the Ages* seem to be lifted directly from the *Zhuangzi*. The essence of the Zhang Zao tale about the artist's performance at a dinner party with lightening cracking as his landscape appears under his hand is also in the *Zhuangzi* (with minor differences in character names and titles). The version in the *Zhuangzi* features a similar spectacle of an artist sprawled on the floor.

> When the First Lord of Song wished to have pictures painted, a multitude of his scribes arrived together. They received his commands respectfully, then stood in attendance. . . . One scribe arrived later, casually and without hurry. He . . . retired immediately. The noble ordered someone to see what he was doing. Behold, he had loosened his robes and was sitting with his legs outspread, half naked. The lord then said: "He will do. He is the real painter."[49]

The close correspondence of this passage with the ninth-century anecdote about Zhang Zao in the *Record of Famous Painters Throughout the Ages* can only lead to the conclusion that either Zhang borrowed directly from the *Zhuangzi* or similar tales were part of common artists' lore circulating in oral

and popular written texts in Zhang Yanyuan's day. We might also consider visual sources. The true sage slumped in a casual pose with loosened robe, already common in literary references in the late Zhou period (fourth c.–third c. B.C.E.), had become a standard image in art by the fifth century C.E.[50] In the Seven Sages in the Bamboo Grove (Zhulin qixian), a popular mortuary composition in fifth-century Eastern Jin– dynasty tombs of the Nanjing area, recluses assume postures of ease, accompanied by the accoutrements of relaxation (musical instruments and wine). The scholar-official who has retired from public life to rustic surroundings to pursue an ideal existence closely aligns the relaxed, open body with forces of nature (see Figures 6.3a–b).[51] In low-relief sculpture on bricks set in tombs, the worthies, seated on reed mats below props symbolic of the natural world (trees with varying foliage), are intimately linked with nature. In the minds of tomb planners and their clients, this iconography evoked cultural heroes who surpassed the confines of official culture and withdrew to commune with nature—the indisputable locus of power in intellectual history during this period. This iconography identifies them as part of the nonconformist strain of Chinese culture; mad calligraphers would be in this same group. These worthies, as ideal representatives of learned culture, understand that real spontaneity comes from a rejection of orthodoxy, although as we have explored above, the spontaneous becomes orthodox very quickly.

In the *Zhuangzi*, as well as the *Liezi*, another text attributed to this same school of early Daoist philosophers, there are numerous stories of artisans who, like mirrors, reflect any given situation, consider their options, and then work in the manner of least resistance.[52] These common artisans, such as butchers, musicians, cicada catchers, boatmen, swimmers, sword makers, bell-stand carvers, wheelwrights, and animal tamers, in the Tang legal code all consigned to the same low status as the painter, possess innate knowledge. Their skills, though, are described as nontransferable and unteachable. Marvelous results are achieved by minute concentration on the Dao, which runs through the objects under their mastery. This promotion in Daoist literature of manual work and artisanal brilliance may be associated with Zhang Yanyuan's conceptions of great artists (such as Wu Daozi, Zhang Zao, and others).[53] Zhang appears to borrow from a rich body of folk tales, legends, gossip, and common talk that mingled daily concerns with divine matters. The Daoist valorization of the laborer was a powerful model for the ninth-century art historian who borrowed the paradigm of effortless production to describe changes he perceived in wall painting.

The well-known *Zhuangzi* story of Cook Ding illustrates this notion of effortless skill. It advances the claim that real knowledge, once carefully acquired, is ultimately forgotten and jettisoned in a lavish display of dramatic,

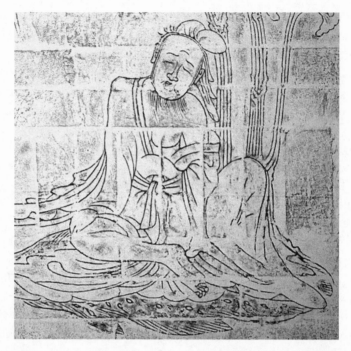

Figure 6.3a. Seven Sages of the Bamboo Grove. Xiang Xiu. Nanjing tomb. Rubbing. Sixth century. Photo by James Cahill. Collection of the Nanjing Museum.

Figure 6.3b. Seven Sages of the Bamboo Grove. Nanjing tomb. Rubbing. Sixth century. Photo by James Cahill. Collection of the Nanjing Museum.

athletic practice. This display is free from constraints because the details of technique are set aside, but no effort is wasted. Ultimately, as in the tales of Wu Daozi, it is nature that guides production.

> Cook Ding was carving an ox for Lord Wen Hui. As his hand slapped, shoulder lunged, foot stamped, knee crooked, with a hiss! with a thud! the brandished blade as it sliced never missed the rhythm. . . .
>
> "What your servant cares about is the Way, I have left skill behind me. . . . I rely on Heaven's structuring, cleave along the main seams, let myself be guided by the main cavities. . . . A ligament or tendon I never touch, not to mention solid bone. A good cook changes his chopper once a year, because he hacks. A common cook changes it once a month, because he smashes. Now I have had this chopper for nineteen years, and have taken apart several thousand oxen, but the edge is as though it were fresh from the grindstone. . . .
>
> "Whenever I come to something intricate . . . , my gaze settles on it, action slows down for it, you scarcely see the flick of the chopper—and at one stroke the tangle has been unraveled."[54]

Cook Ding, and other idealized artisans in the *Zhuangzi*, possess a knack. Their innate sense of proper movement allows them to forget technique. These tales promote an antitechnological ideology that rejects all mechanisms, invention, and cunning maneuvers. The lack of artifice is exemplified by the carpenter who can make things round or angular by applying his natural knowledge rather than by use of a compass or square as a guide. Models and tools are ultimately obstacles. The etymology for "implement" or "tool" (*jie*), as Joseph Needham points out, includes meanings such as "to shackle" or "to impede."[55] With this in mind, the almost naive-sounding statements of Zhang Yanyuan and Zhu Jingxuan marveling at Wu Daozi's rejection of underdrawing markings, rulers, and compasses may be viewed in a new light.[56] Tang readers would have read these rejections, given their obvious derivation from the discussions of ideal artisans in Daoist texts, in a positive light, as analogous to the school of su (sparse) brushwork.

Reading *Zhuangzi* gives one a new appreciation for Zhang Yanyuan's plea to steer painting in the direction of natural knowledge and away from the direction of workaday, meticulous procedures. For Zhang, the artist of the future is really a follower of great artisans of the past. Whether this was a sophisticated notion or a naive, nostalgic one is open to question. It seems that Zhang, in particular, was swayed by studies of the occult (*xuanxue*) and alchemy in addition to common folklore. To explore what, if any, are the common Daoist images of work and production, we have to turn to tomb art.

The ubiquitous cosmic couple, Fu Xi and Nü Wa (Figure 6.4), seem to be progenitors of all artisans and function on some level, at least in terms of their

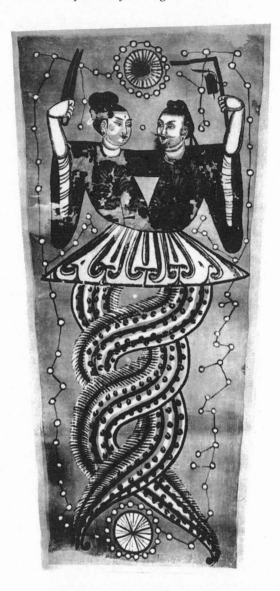

Figure 6.4. Fu Xi and Nü Wa. Ink and colors on silk.
Astana tomb, Turfan. Fifth–seventh century. 220.0 cm ×
80.9–106.0 cm. Wenwu chubanshe.

implements (the set square and the compass), as the patron god and goddess
of artisans and laborers. In tombs, particularly in burials in oasis towns on the
Silk Road in what is now western Gansu Province and eastern Xinjiang
Autonomous Region, paintings of the pair on banners, featuring human heads
coalescing below the waist into serpentine bodies, are surrounded by a com-

plement of planetary constellations. They are the only deities found in tombs of Han residents who, judging by the tools and other paraphernalia buried with them, were artisans, particularly in the silk trade.[57] Paintings of Fu Xi and Nü Wa on silk and linen, such as the one reproduced in Figure 6.4, were hung on the back wall of tombs or from chamber ceilings in Astana and Kharakhoja graveyards during the late Gaochang and Xizhou periods (fifth–ninth centuries).[58] The gods hold the compass and the set square that regulate the heavens that are clustered around them on the painting surface.[59] These instruments, also the tools of the common artisan painter, symbolize the humanizing forces of pictures, charts, and words. In traditional folklore, Fu Xi invented writing from broken and unbroken lines of the trigrams. This collection of changing and unchanging lines is the primary tool for prognosticating the forces of nature as described in the *Yijing* (Book of Changes).[60] They are the key to regulating the forces of spontaneity for they reflect the directions of change in human and natural affairs.

The mortuary pictures of Fu Xi and Nü Wa, prominently displaying their set square and compass, are relevant to painting theory of the period for, before the Song dynasty, the couple symbolized the origins of culture in which nature was the source of all action and change. Therefore, it is not surprising to find that they were important fixtures in the history of painting for the Tang critic Pei Xiaoyuan (ca. 639), author of *Zhenguan gongsi hualu* (Record of Paintings in Public and Private Collections in the Zhenguan Era). Pei traces the origins of painting back to Daoism, placing Fu Xi in a pivotal role as transmitter of the Dragon Chart, which inspired scribes to devise the first pictures.[61] Pei Xiaoyuan, along with Zhang Yanyuan, Zhu Jingxuan, and other Tang art critics, was influenced by ideas and lore that circulated in many levels of literacy and forms in Chinese society.[62] Their privileged status as literati did not preclude them from introducing views of the art practitioner as a simple, guileless performer who worked in tune with the Dao—a common notion during the Tang.

About Chinese art in this period, and indeed about art during critical junctures in all cultures, we must ask "What mediating forces are allowed to participate in the production of art?" In Tang dynasty China, the answer obviously involves the role of the sketch, which, as we have seen, plays such a crucial role in the cognitive process of mural production. In China during the ninth century are there any "teachers" that can be positioned between the practitioner and nature to facilitate this flow of energy? Compasses and rulers make paintings dead, Zhang Yanyuan announces. Wine, however, could be an acceptable mediator because it mitigated logical, rational thinking and induced a dreamy state of creativity. A passage in the *Zhuangzi* points out the advantages of drunkenness by describing the souse who falls out of a carriage.

He may be injured, the text explains, but he does not die because his body is relaxed. He is not cognizant and possesses no will or intent; this is a positive state according to the antirationalist perspective of this text.[63] We find a similar advocacy of wine in the biography of Wu Daozi, who uses spirits to induce a selfless, trance-like state in order to paint. "Wu loved wine (*haojiu*), which stimulates his vital breath. Whenever he wished to flourish his brush, he had to become intoxicated."[64] These states of inebriation and inspiration from the sword dance are part of the narrative construct that portrays Wu as a painter in tune with the Dao; they are also ideals that were promoted in calligraphy. Scores of Tang poets celebrate drunken expression; by the Northern Song dynasty it became a commonplace that poets and artists boasted about their slightly mad, drunken, artistic exploits.[65] Alcohol, in short, liberated spontaneity of expression, an issue central to contemporary debates on philosophy, linguistics, and religion.[66]

Questions about cognitive acquisition and the deployment of knowledge were of monumental importance throughout the history of Chinese thought. Whereas practicing artisans might not talk about unfettered creation, it mattered to the educated elite who were used to valuing free, uninhibited expression in calligraphy since the fourth century C.E. Since the fourth century B.C.E., the ideals of the sage and his service to the state, the rejection of moral, official culture, and the appeal of official retirement also played a leading role in the promotion of spontaneity.[67]

Chan (Zen) Debates and Painting Theory in the Tang

If the phrases and narrative structures in ninth-century art history were consistent with this long discourse on spontaneity in Daoist philosophy and calligraphy, many of Zhang Yanyuan's ideas regarding the superiority of intuition over effort in expression share a great deal with concerns in the Chan (Zen) debate about *upāya* (skillful means). Nowhere did questions of unmediated expression take center stage more aggressively during the Tang than in the sectarian elite circles of Chan (Zen) Buddhists. Zhang's art theory and Chan engage similar fundamental questions about how the mind and the body process information.

Naturalness and spontaneity became central to a great debate among schools of Chan (Zen) during the eighth–ninth centuries. The basic issue, in the words of Robert Gimello, was: "Is ultimate reality so distant from and yet so continuous with the mundane that one can have only a mediated and step by step access to it? Or is it so proximate, and yet so autonomous and so utterly unlike our illusions or expectations of it, that one can reach it only all-at-once and only without any mediation whatsoever?"[68] If one were to interpret this

question in light of Tang art, which emphasized formal likeness, the problem would be similar to the one posed in Zhang's staged debate about the meticulous and the approximate styles of brush. In other words, "Is verisimilitude only to be achieved by the gradual application of strokes to achieve a textured resemblance of form? Or can likeness only be realized when the painter approximates form with quickly applied brushwork (without the aid of other instruments) suggesting shape rather than denoting it?"

Zhang still argues for formal likeness—a realism that is ordained by nature, not an imitation inspired by it. But he believes this is best achieved through a relaxed pictorial vocabulary. In Buddhism, where enlightenment is the goal, the crucial issue for a proponent of the subitist or sudden in Chan was how to establish a mode of expression untainted by gradual, mediated, or cumulative notions of practice and realization.[69] There is a correspondence in concerns of immediacy between Chan questions about enlightenment and Zhang's "debate" in his *Record of Famous Painters Throughout the Ages* over su and mi styles. Tang aesthetic theory and Chan theoretical discourse share a heightened awareness of what can be perceived by the eyes and the mind; critics of both equally disdain forces that interfere with immediacy of perception. The Chan debates eventually compressed into a "gradual" northern school and an opposing, "subitist" (sudden) southern school.[70] Painting theory is not specially informed by Chan debates unlike other parts of literary culture; nonetheless, the similarities are striking at this early date.[71] During the Tang, as Richard Lynn notes, literati rarely used explicit Chan Buddhist models in their writing; yet poets like Du Fu were interested in and moved in Chan circles.[72] Something similar is likely the case with Zhang Yanyuan. He and Zhu Jingxuan do not imitate consciously the Chan dichotomous lineages of northern and southern. Later painting theory that does so probably models itself after poetic theory first developed in the Song. Yet it is clear that the writers' strategy of pitting the meticulous, courtly style of Li Sixun (mi) against the spontaneous bravura of the new vernacular school of Wu Daozi (su) reflects some of the same concerns and preferences that informed the contemporaneous Buddhist debate about the proper path to enlightenment.

The debate over daily religious practice, and the sudden (*dunwu*) versus gradual (*jianxiu*) path to enlightenment, were part of much larger philosophical schisms in Buddhism.[73] Current scholarship in Chan studies holds that the subitist/gradualist distinction emerged only in the ninth century, after about a hundred years of intense, self-conscious critique of the Chan tradition.[74] Scholars of Chan have pointed out, however, that this divide in religious practice cannot exist on a philosophical level because truly sudden instantaneous realization can never be represented.[75] The position of Wuzhu, the founder of the Baotang school, who advocated a radical form of the sud-

den path that denied all life outside the monastery and all practice within it, was of course untenable.[76] Similarly, Shenhui's (684–758) interpretation of ultimate truth was still conventional because the radical experience he advocated did not exist in actual practice.[77] The point for our discussion of artistic practice is that expression would always be mediated, regardless of a rhetoric of spontaneity.

The binary division in Chan is a representation, not a practice or an experience of spirituality. In other words, it is a question of style. As we have seen in calligraphy and painting, spontaneity was a claim to prestige and status, which are neither spontaneous nor unfettered. In Chan, arguments for sudden enlightenment were bound to a centuries-old debate over elitism, authority, and legitimacy in the Buddhist church.[78] For example, Shenhui, who promoted his teacher Huineng (d. 713) as the sixth patriarch of the Chan school, wanting to disqualify Huineng's rival Shenxin (606–706), conveniently cast the two approaches to meditation and enlightenment as irreconcilable.[79] The claim of having no rank was a good strategy for getting or keeping rank.[80] The sudden argument needed a gradual school against which it could define and promote itself. This is equally true of the tale of landscape painting in which Wu Daozi's painting takes one day; this fact becomes remarkable against the backdrop of Li Sixun's slower painting production. This juxtaposition of fast and slow in painting theory undoubtedly reflects the intellectual debate in Chan occurring at the same time in monasteries and in the capital.

The divide is best understood as a binary complementarity that had been deployed in explanations, rhetorical strategies, and the Five Phases system in China since at least the fourth century B.C.E. Dualism, where opposites imply each other, a favorite trope of Chinese theorists, bears the imprint of the yin-yang theories of early thought that were eventually labeled Daoist.[81] Correlative thinking endures throughout the history of China and is especially evident in narrative structures in later novels and plays.[82] In this paradigm, where unresolved but complementary opposites imply each other's existence, the tension between antithetical elements is necessary for conceptual resolution. Recurring "bipolarity" is also a dominant feature of visual narratives, particularly in Daoist and Buddhist wall painting, where two sages, deities, or demons are often paired in compositions, a topic addressed in Chapters 2 and 5.[83]

In Chan Buddhism, the theoretical underpinnings of religious awakening represented by the two polarities—sudden awakening and gradual practice—were used as a vehicle in sectarian power struggles. In drawing, dividing brushwork into two extremes (mi and su) was ostensibly a result of concern with standards for brushwork and the future of the artist's practice. But Zhang

Yanyuan's staged conflict over the two types of drawing was also a matter of class status. Plain drawing was associated with a literati (elite) practice that was just beginning to emerge. Meticulous painting with layers of drawing and color would come to be associated with the professional who painted to earn a living. Both the debate in Chan and new notions of painting addressed similar epistemological questions by focusing on mediation, spontaneity, and process. For example, the sword dance tale—the quintessential su school "experience"—is essentially a denial of sequence. Su brushwork involves moving the brush speedily, leaving dots and spaces between lines, rather than painstakingly and continually applying the brush to the painting surface as in the mi style of courtly painters such as Li Sixun. Both the mi style of painting and the Chan jianxiu approach to enlightenment address mediated, gradual, and sequential procedures.

The essence of the sudden approach to enlightenment or "instantaneous illumination" is its arrival without warning—occurring in a single moment of comprehension rather than by degrees. This is similar to the "quickness of execution" as practiced by the new Tang artist. Zhang Yanyuan and Zhu Jingxuan imply that the quickly executed painting is aesthetically superior to the laboriously rendered one because it depicts a landscape comprehensively in a suggestive or connotative rather than a denotative way.

There are actually two types of artistic activity alluded to in the practice of su brushwork: the practice of art and its achievement or realization. The image of Zhang Zao moving about as if lightning had shot through the room identifies a heightened state of creativity identical to the whirlwind of Wu Daozi's painting that followed General Pei Min's sword dance. A modern parallel is the sketching performance highlighted in the well-known photograph of Pablo Picasso in his studio painting with an electric, neon pen.[84] His brush is literally electrified, similar to the "electric storm" of Zhang Zao's performance. Similarly, Zhang Zao's artistic state is much like the *huopo podi*, or "vivid and lively," adept of the sudden school of Chan Buddhism who practices vigilantly in a heightened state of awareness, a condition articulated in Wuzhu's contemporary (ninth-century) Chan text. The term actually refers to fish who leap from the water in a continuously animated state.[85]

In both Chan and artistic practice, the body is a vehicle for expression as well as an outlet of natural forces. Chan practitioners are enjoined to maintain a mental and physical disposition of immediacy; Zhang Yanyuan maintains the same standards for artists, warning that painting and calligraphy are not for the timid. Zhang uses the mental vigilance or state of immediacy to describe painting practice (the behavior of the artist) and painting (the product of artistic effort and the creative act). Other aspects of the Zhang Zao

anecdote recall Chan literary images of spiritual and mental states. The clapping of hands is analogous to the moment of enlightenment in Chan Buddhism.[86] The flurry of division from which the strange shapes are born tells us that the motifs in the painting were realized "simultaneously." The alternative is a painting that is realized in parts or segments, akin to the gradual form of enlightenment, which recalls the anecdote of Li Sixun, who required three months to complete a landscape painting. Typically, the practice of wall painting depended on using tools of painting; their rejection signals a praxis without intermediary aids.

The ideal of painting without traditional aids in the Wu Daozi school parallels the rejection of religious-practice accoutrements by the Chan subitist school. In both, again the problem was: What mediating forces enter into human expression? Are instruments such as books, institutional structures, inherited models, draft sketches, and added colors a hindrance to creativity and purity? Obviously, the answer was "yes" in both painting and religious practice according to the "radical" or "alternative" approaches (which eventually became orthodox). Complex rites, elaborate ritual accoutrements, and magical formulas should be jettisoned for a more naturalized approach to enlightenment or pure "nonthought." Thus "nonaction" in harmony with nature celebrated in philosophical Daoism, subitist (sudden) Chan, and calligraphy was extended to painting.

In its formative years, southern Chan's rejection of scriptural teaching in favor of oral transmission idealized rejection of the typical ritual aids (sūtra study, daily recitation of scriptures, prayer, and the like); sudden intuition made any meditation supplementary. In the eighth century, Shenhui, the first to champion the subitist school, argued that instead of book learning, spontaneous (or natural) knowledge (*ziranzhi*) was the vehicle to realize ultimate truth. Enlightenment would be achieved through everyday activities rather than in the confines of formal, monastic ritual. The Mazu school advocated an interpretation of Shenhui's theories promoting *pingchang xin shi dao*, or the "common mind is the Dao."[87] As the Chan scholar Yanagida Seizan points out, there is an intense fascination with freedom in the Chan belief of ziranzhi; the actor is imagined to be beyond all limitations.[88]

Zhang Yanyuan articulated similar ideals and inserted them into his schema by favoring artists who do not need sketches, rulers, compasses, and other standard tools of the trade for wall painting. Tang painting theorists idealized and promoted painting practice that emulated the archetypal Wu Daozi, who never needed these common aids, and who relied on wine, dance, or music to induce creativity. As both Wu Daozi and Zhang Zao sketch, they are in an entranced state in which they listen to inner voices. This is painting's parallel to ziranzhi, or spontaneous knowledge.

The entranced state of painters is like that ascribed to thaumaturges or wonder-workers who perform great feats of spiritual magic.[89] They, too, enter into elevated states of consciousness to effect some supernatural act. Should we view Wu Daozi as a painter of that ilk? A thaumaturge of painting who can transcend—via his artistic act—the line between illusion and reality, magic and skill?[90] There is no indication that Wu Daozi was a Chan adept. Although the discussion of Wu in the *Record of Famous Painters Throughout the Ages* and *Celebrated Painters of the Tang Dynasty* focuses on spontaneous creation and other aspects of philosophical Daoism, it is unlikely Wu was an active Daoist master, either. The one small piece of information we have about Wu Daozi's religious inclinations is his frequent reading of the Jingang jing (Diamond Sūtra), which he was said to have carried at all times.[91] This was the text that, on first hearing, enlightened Huineng, the sixth patriarch and founder of the southern or subitist Chan school.[92] We know that at Dunhuang the painters were not monks (as explained in Chapters 1 and 5). But, in Wu Daozi's case, the sūtra, in effect, became his "painting tool," replacing the ordinary tools for which, we have noted, he had no need.

This raises the question, what were painters' tools at Dunhuang? The Diamond Sūtra Wu Daozi carried might have been similar to some of the small popular booklets of the sūtra found at Dunhuang, dated to the late ninth and early tenth centuries, which could be carried easily on a person. An example of the illustrations with line drawings of the eight vajra holders in these portable prayer books depicts figures as powerful, muscular deities about to burst forth into action (Figures 6.5a–b).[93] A similar posture and attitude are assumed by Vajrapāṇi in silk banners and sketches from Dunhuang (Figure 4.10 and Plate 21). These figures, with their swirling drapery, suggest movement analogous to the artistic practice of Wu Daozi, who "swirls about as if in a whirlwind."[94] These small monochrome drawings with their twirling figures evoke the images of the artist in the creative act referred to in the texts of Zhu Jingxuan and Zhang Yanyuan. It appears that illustrations to the Diamond Sūtra captured the flair of the artist's style. Thus, while it is unclear that sūtras' contents played any role in the making of art, there is something about the power of the portable, pocket sūtra in the readers' mind that suggested a compelling, dramatic performance by the artist.

Another point of intersection between ninth-century Chan doctrine and ninth-century aesthetics is the appreciation of lack of artifice. Chan's rejection of the written word and the preference for relaxed expression is analogous to the emphasis on plain drawing in Wu Daozi's repertoire. *Pingchang shi dao* ("the dao is in the daily or common") is as much a simplification of the Dao as *yunmo er wuse ju* ("ink [alone] is the tool for effecting the five colors") is an emphasis on "plainness" in art. Zhang Yanyuan consciously rejects the

奉請第六足尼金剛　奉請第五赤聲金剛

4096

奉請第八大神金剛　奉請第七紫賢金剛

shading and color rhythms that entered China through Central Asia (typified by the style of Zhang Sengyou). After the Tang, shading fell almost entirely out of favor. Zhang's disdain of color and celebration of linear expression may be connected to a general rejection of foreign ideas and cultures in the late Tang. It was also a matter of class, as noted above. Colors and meticulous painting would soon be associated with professionals; monochrome ink drawing, of course, would be linked to educated "amateur" literati painters. During the eighth and ninth centuries, Neo-Confucianists such as Han Yu condemned Buddhism as foreign and successfully incited anti-Buddhist sentiment in the court.[95] Zhang Yanyuan did not go so far as to reject Buddhism for being foreign; in fact, he celebrated its artistic achievements. Yet he did prefer linear composition and the calligraphic line, which have technical roots in China. His statements on ink drawing and his preference for the Wu school could be considered a revival of indigenous aesthetics.

The nonindigenous and unspontaneous aspects of the Li Sixun aesthetic included brilliant landscapes reflecting Central Asian aesthetics. Li seems to have favored the intense colors of landscape murals in Qizil cave temples and elsewhere along the silk route.[96] These bright colors, especially blue and green, had foreign connotations; red and black were the traditional colors used for landscape until Buddhist traditions began to take hold in the fifth century.[97] When Zhang Yanyuan was writing the *Record of Famous Painters Throughout the Ages*, Han Yu had already formulated and circulated his ideas on a *fugu* (or return to the ancient) movement in literature. Among the tenets of the fugu movement were simplification and freshness in expression, characteristics believed to be typical of ancient literature.[98] Coupled with this insistence on plainness (despite all the trouble plainness required) was the new emphasis on a vernacular environment for both spiritual pursuits and painting. Tales of public performances in secular, urban venues in a relaxed casual atmosphere are part of a broader promotion of spontaneity. They mark a shift from formal, studied expression and their environments for practice—an atelier for a painting, a monastic hall for meditation.

Figure 6.5a. (top) Four drawings of Vajrapāni in the frontispiece of a Diamond Sūtra prayer booklet, incomplete. P4096.2–3. Ink drawings and calligraphy on paper. Tenth century. Sheet: 16.0 cm × 11.5 cm. Cliché Bibliothèque nationale de France, BnF.

Figure 6.5b. (bottom) Four drawings of Vajrapāni in the frontispiece of a Diamond Sūtra prayer booklet, incomplete. P4096.4–5. Ink drawings and calligraphy on paper. Tenth century. Sheet: 16.0 cm × 11.5 cm. Cliché Bibliothèque nationale de France, BnF.

Conclusion

Three aspects of Tang-dynasty religious philosophy and ninth-century painting theory intersected to produce a new aesthetics. First, Chan Buddhist debates mirror the critical theories of Zhang Yanyuan in the *Record of Famous Painters Throughout the Ages* and the descriptions of painting practice in Zhu Jingxuan's *Celebrated Painters of the Tang Dynasty*. In religion, as in the arts, unmediated pursuit of enlightenment without traditional aids became the ideal; much of the rhetoric of Chan meditation technique and of painting practice seems interchangeable. Second, Daoist constructs were also mixed with ideals of artistic praxis. Literary descriptions of painting production praised free-form, unmediated expression marked by a vigorous physical posture and intense mental attitude. Third, calligraphic models of evaluation to which critics gravitated provided criteria for analyzing and evaluating painting, highlighting spontaneity and connotation. In this context, the values expressed in the biographical anecdotes of Wu Daozi and other wall painters reflect larger traditions and trends in the late Tang dynasty.

Experiences of the body in the ninth century, whether during creative moments or spiritually aware actions, were promoted in these three arenas as dramatic and spontaneous occasions, mediated only by nature. The link with actual paintings and sketches is not direct. That is, we cannot connect ninth- and tenth-century works directly with philosophical statements without considerable attention to the agendas of the critics and connoisseurs who endeavored to explain shifts in the arts. Keeping this in mind, the ink sketches from Dunhuang themselves present a great deal of evidence for the artist's practice. What they demonstrate is that, as the artist quickly draws, the sketch becomes a visual notation and translation of how he envisages painting large surfaces in a systematic way. If we believe the texts are a parallel form of cognitive notation and view them together with the images, it is clear that Tang writers and artists perceived the world quite differently from their predecessors or, at the very least, that they had an investment in declaring and constructing that difference. They recognized vivacious states, appreciating them not only in visual representations, but also in the actual process or practice of rendering. The artist's bodily posture, his style of wielding the brush, his state of mind and physical cultivation became subjects of the viewer's attention in their own right. Reception and the performance of art became linked for the first time in discursive practices. And, thematically, stage performance in the magical world of Buddhism became a subject painted systematically for the first time as well.

Ninth-century art historians used myth and magic to account for some of these perceived differences and shifts in aesthetic directions. In tracking the

discourse of spontaneity, it is clear that the most significant force mediating art during the ninth century was nature dominated by divine forces. It is not until late in the Northern Song dynasty that subjectivity in vision was discussed. In the Tang perspective, natural forces determined representation. It was in the sketching that these natural forces manifested themselves most powerfully. An artist that was well positioned vis-à-vis nature, the critics argued, would best achieve realism. The most critical exchange occurred during the sketching phase, when a picture was being conceived and realized. Definitions of realism during the Tang, a culmination of aesthetic principles developed most directly from the third and fourth centuries c.e., fixed on the draft and the process of painting at a work's inception. During the Tang, verisimilitude was not a reflection of the painter's personality, as it was later in China, or a product of individual genius but, rather, the intervention of a force outside of the artist's body.

At issue for ninth-century art historians was what constituted art: the process or the completed work. Critics were less interested in actual procedures used by artists in active ateliers, such as those at Dunhuang and in the metropolitan art circles. Sketching was a critical tool in the medieval atelier, but it was not the physical sketches that were valued before or after a work was completed. Instead, the *process* or *act of drawing* was the connoisseur's primary interest. It was the ephemeral moment of sketching that engaged critics. While addressing notions of creativity, Zhang Yanyuan and Zhu Jingxuan turned to the storehouse of literature on spontaneity and invention in advancing theories that promoted the artist's performance in drawing. But, to repeat, it was not the individual's imprint that was recorded in the image, it was nature's.

Daoist notions about work, performance, and the body are central to these problems; spontaneity and non-action—concepts first articulated in the *Zhuangzi*—are mentioned frequently in the *Celebrated Painters of the Tang Dynasty*, demonstrating the importance of philosophical models for analyzing art in the ninth century. As it turns out, artists engaging in the initial stages of wall painting practice did use loose brushwork, working without rigid constraints. The sketches reflect an ad hoc process and are executed in abbreviated form. The texts celebrate these initial stages of painting when the underdrawing was applied in a quick, approximate manner; they praise ephemeral practice, gesture and action. Thus, to some extent, theory and practice overlap, but there is not a complete match. Finished temple paintings do not resemble the looser underdrawing, but the texts rarely treat anything finished or complete (except for listing titles of compositions); their interest is instead on the act of preparatory painting (sketching). This demonstrates how sketching becomes an aesthetic object of interest independent of works of art.

Unfinished work held appeal; as a result, descriptions were couched in language privileging the intervention of nature. While the bulk of wall paintings cannot be explained in the fantastic, mythical language of creativity, these art legends and myths nevertheless are an important feature of the medieval rhetoric about art.

The popularity and seeming ubiquity of the wall painter, embellishing the increasing number of temples throughout China, captured the attention of critics fascinated with the spectacle of freehand sketching. At this moment in Chinese painting, as we have seen in the case of Dunhuang, murals were the dominant pictorial enterprise. The ratio of wall paintings to portable paintings, in both the written record of the capital and the archaeological record of Dunhuang, was more than seventy percent. Wall painting also adorned secular spaces such as palaces, court buildings, and administrative spaces. Further, a good portion of painting not imbedded within a temple was still often connected to another object. Paintings were placed in screen frames and within furniture as decorative backdrops. With mural production achieving its greatest moment, the sketch understandably becomes a center of production and discussion because of the many stages required to complete murals. Sketches on paper were an initial draft; the synopia (underdrawing) on the wall was yet another step in the preparatory process. This two-part operation was embellished further with color and then overdrawing. The multifaceted process of painting consisted of acts largely in public—in plain view. Unlike banner and scribal activities, which involved close work near a light source on a flat surface, wall painting occupied the interiors of rooms. The stages of painting were visible for all to see. The impressive spectacle of a wall painter setting down the contours of the composition, and then, over months, working with others to finish hundreds of figures and thousands of pictorial details in costume and architecture drew attention in the Tang (Plate 33). Wall painting in secular and temple interiors also represented the move of murals from largely a tomb environment to above-ground spaces. Temples attracted lay patronage, support, and attention; they were the site of ritual spectacles. During the Tang, the artist moved out of the ground or the privileged spaces of imperial production to a wide range of institutions to which more people had physical and social access.

These developments help explain why sketching became a focus during the ninth and tenth centuries, first as a tool in production and second as an object of interest in its own right. Monochrome painting started to become a skill and style appreciated apart from its workaday function in the atelier. The improvisational technique of the wall painter, who created within a flexible but measured structure, still remains one of the functions of the atelier—this was not an environment of unfettered creativity in the modern sense. Yet, the

problems associated with the technique of ad hoc underdrawing are consistent with the high-stakes philosophical debates on the nature of creativity and invention during the period. The aims of the atelier and the interests of the connoisseur—perfectly matched yet headed in different directions—for a moment during the late Tang and early Song joined into a shared aesthetic. Yet it became clear that both order, imposed by the atelier to suggest a pictorial unified space, and spontaneity, touted by the critics, were illusions. There is an irony here. Order and spontaneity are constructs of the workshop artist and the writer, respectively. Iconography in Buddhist murals and the process used to realize it appear to be schematic, but in fact there is an ad hoc, adaptive spirit to wall painting. Writers stress spontaneity of expression and the artist's body as a conduit for nature. Yet we have seen that the artist conceals the spontaneity and randomness of practice in service of the subject matter that demands consistency. With that understood, it is now possible to appreciate the workshop artisan as an active participant in artistic production, responsible for the effectiveness of storytelling in Buddhist art in medieval China.

Appendix 1
Ground Plans and Elevations of Fifteen
Cave-temples with The Magic Competition, 862–980 C.E.

Dunhuang Mogao Cave 6

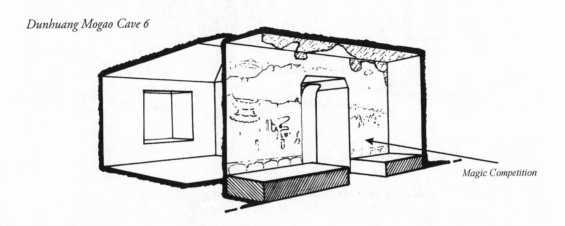

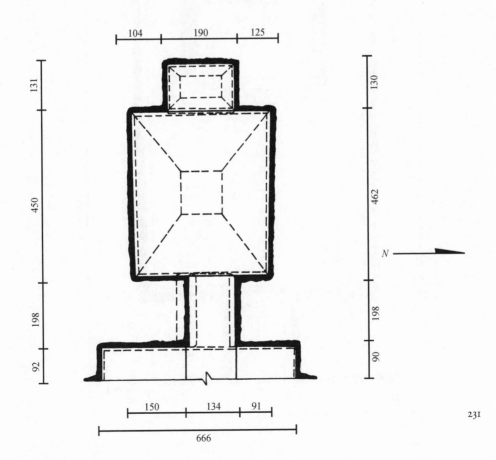

Magic Competition

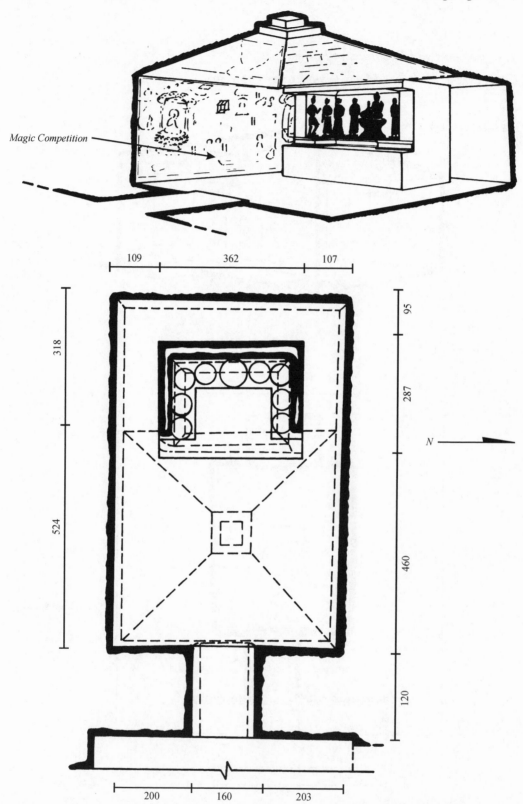

Magic Competition

Dunhuang Mogao Cave 25

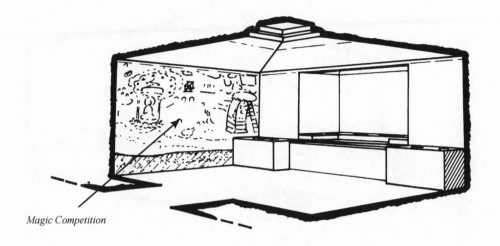

Magic Competition

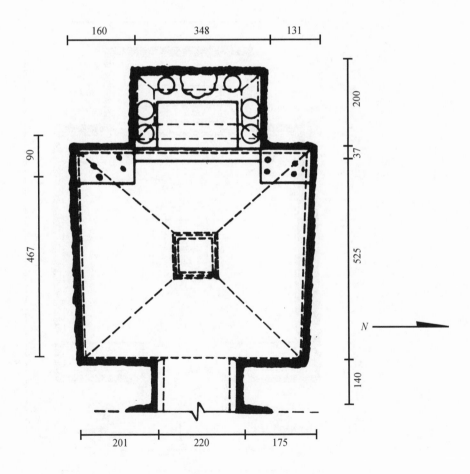

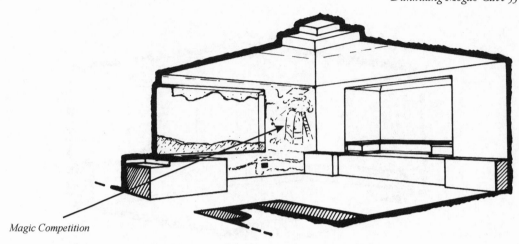

Magic Competition

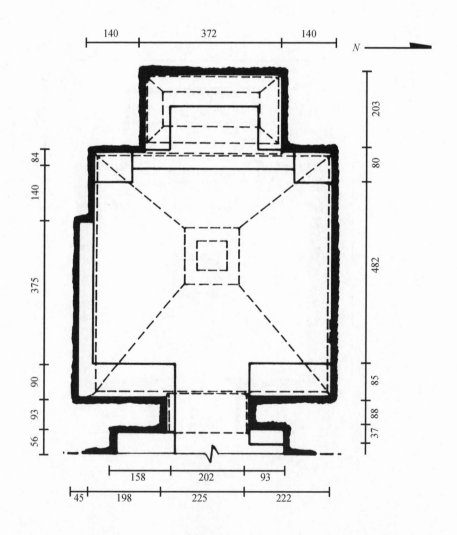

Dunhuang Mogao Cave 55

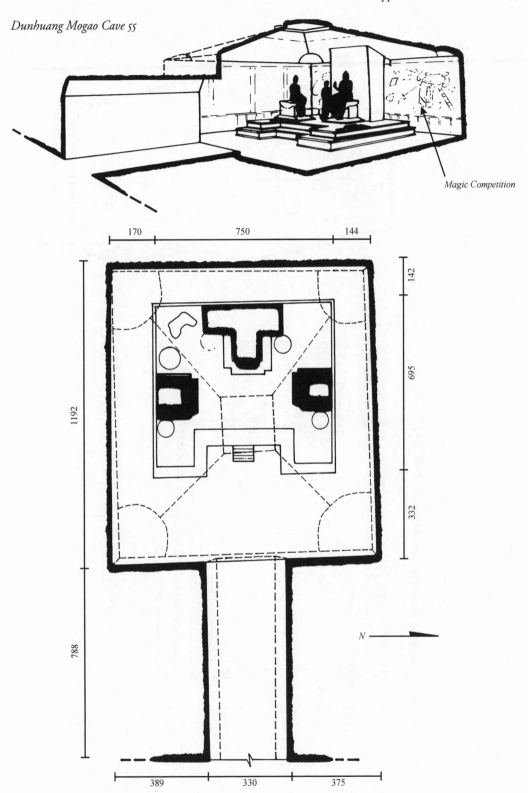

Magic Competition

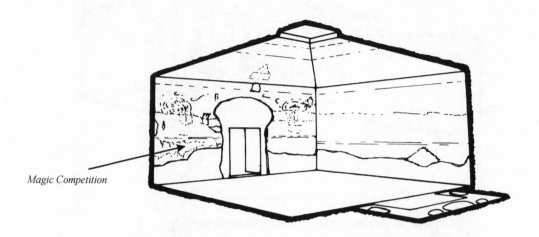

Magic Competition

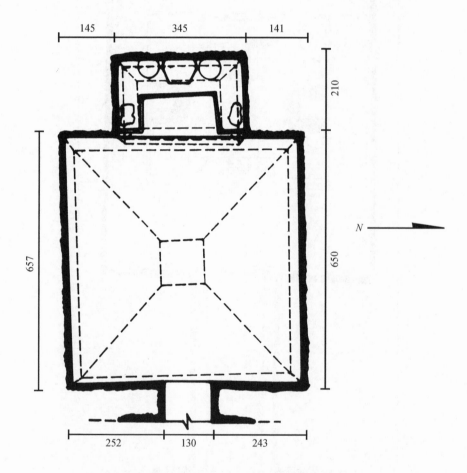

Dunhuang Mogao Cave 85

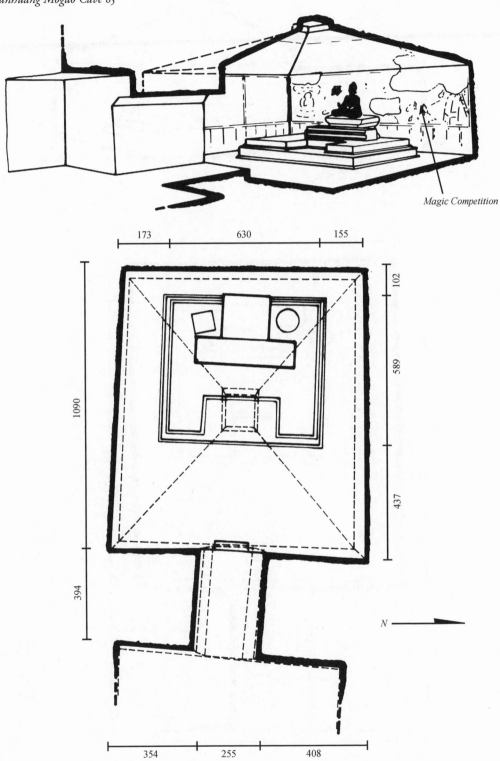

Magic Competition

Dunhuang Mogao Cave 98

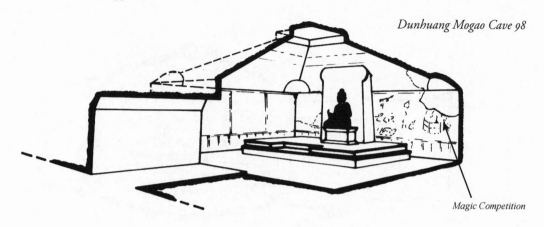

Magic Competition

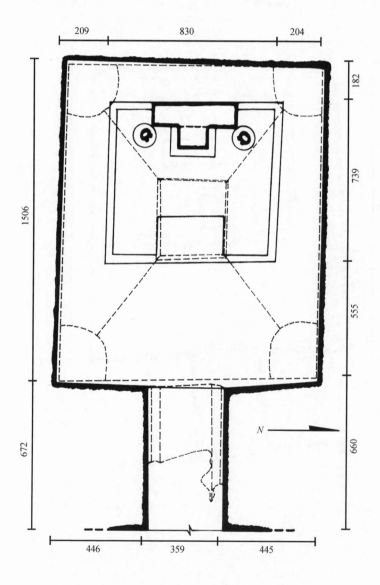

Dunhuang Mogao Cave 108

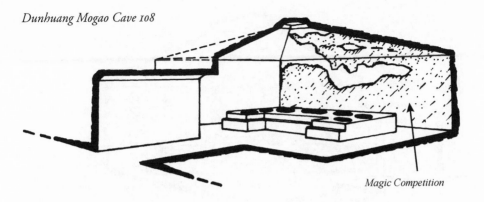

Magic Competition

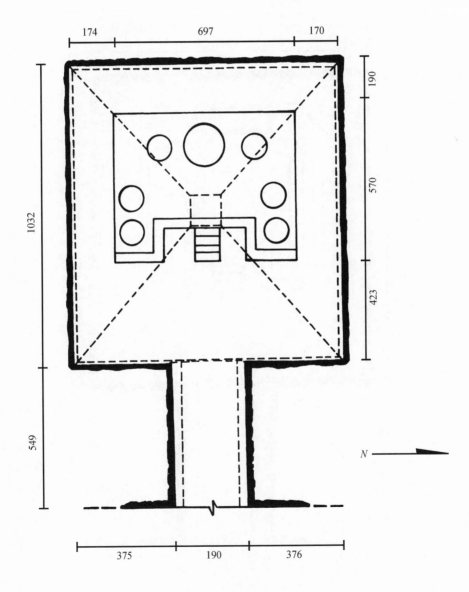

Dunhuang Mogao Cave 146

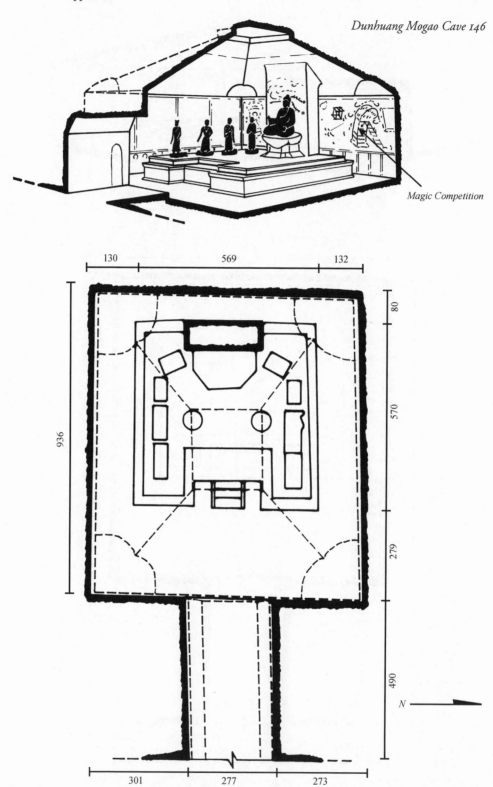

Magic Competition

Dunhuang Mogao Cave 196

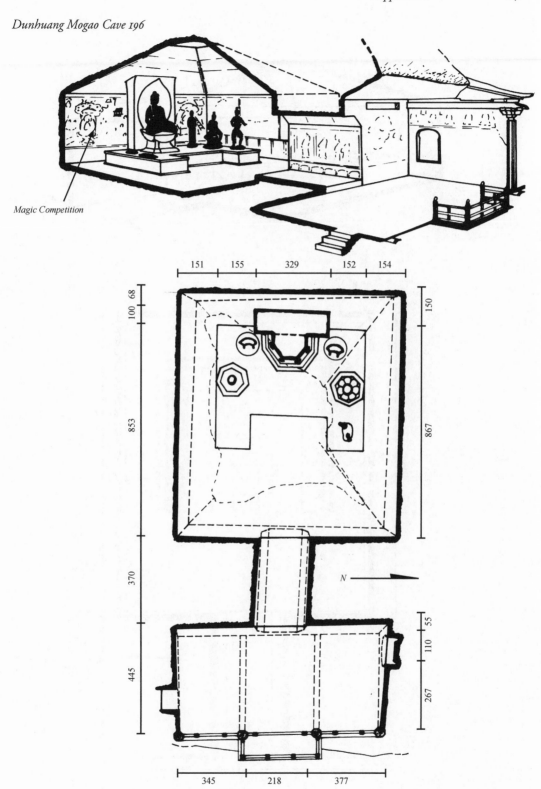

Magic Competition

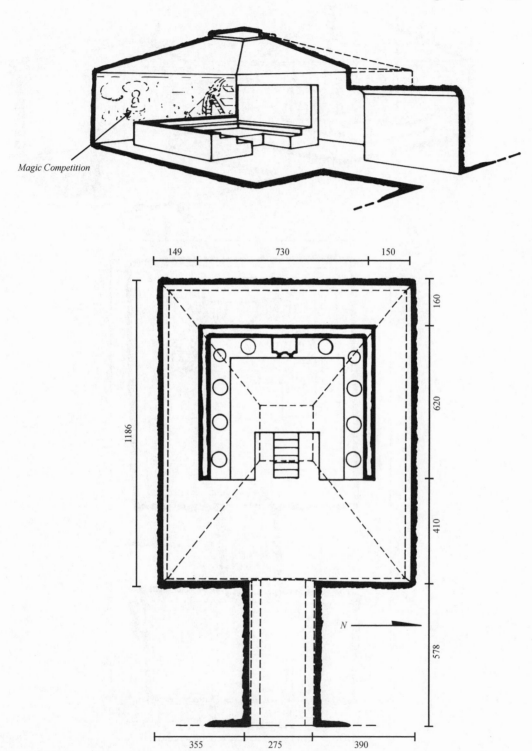

Magic Competition

Yulin Cave 16

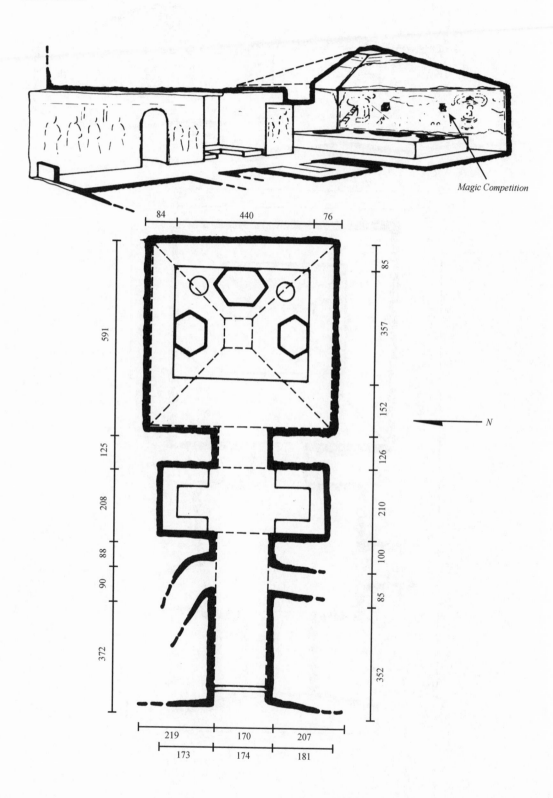

Magic Competition

Yulin Cave 19

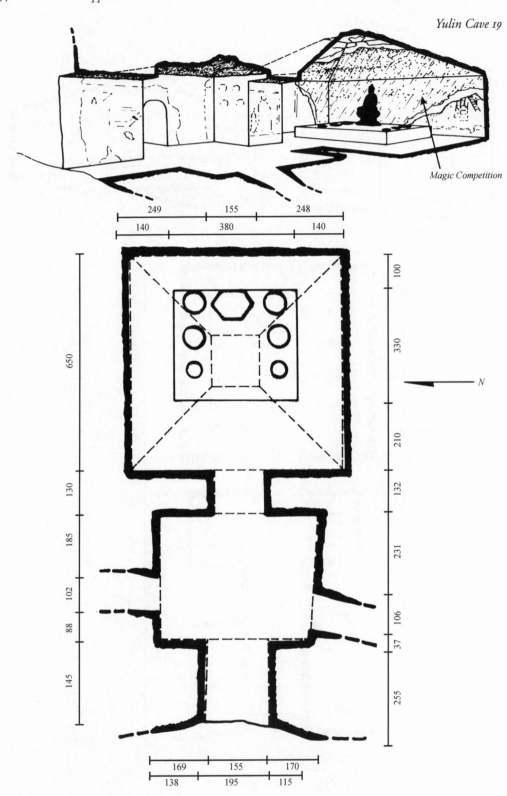

Magic Competition

Yulin Cave 32

Magic Competition

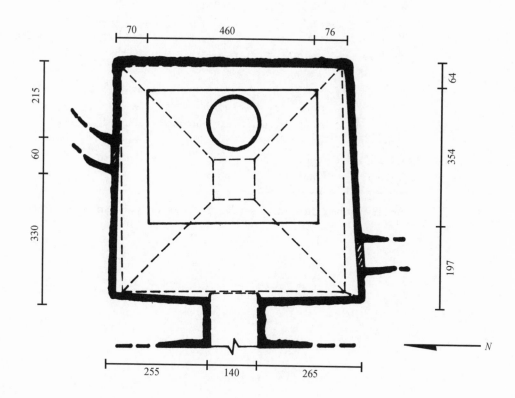

Appendix 2

Location of Common Compositions in Grottoes, 862-980 C.E.

	Magic Competition	Vimalakīrti & Mañjuśrī	Amitābha's Paradise	Sūtra of Golden Light
Cave 85	west wall	east wall	south, 2	——
Cave 9	south	north	——	——
Cave 196	west	——	south, 2	south, 1
Cave 72	east	——		severely damaged
Cave 146	west	east	south, 2	——
Cave 98	west	east	south, 2	——
Yulin 19	east	——	south, 1	ceiling damaged
Yulin 16	south	——	north, 1	——
Cave 108	west	east	——	——
Cave 55	west	——	south, 2	——
Cave 25	south	north	——	——
Cave 6	south, 1st rm	east, interior	south, 1	——
Cave 454	west	east	south, 3	——
Cave 53	south	north	damaged	
Yulin 32	south	north	——	——

NOTE: Numbers after locations indicate position on wall from western corner.

Bhaiṣajyaguru's Paradise	Lotus Sūtra	Maitreya's Paradise	Flower Garland	Requiting Kindness	Heavenly Blessings
north, 2	ceiling, 4	ceiling, 1	ceiling, 2	south, 3	——
——	——	ceiling, 4	ceiling, 1, 2, 4	——	——
north, 2	south, 3	north, 3	north, 1	——	south, 1
[severely damaged]		north, 2			
north, 2	south, 3	south, 1	north, 3	south, 4	north, 1
north, 2	south, 3	south, 1	north, 3	south, 4	north, 1
north, 1	——	——	——	north, 2	south, 2
south	——	——	——	——	north, 2
north, 2	south, 2	south, 1	north, 3	south, 4	north, 4
north, 3	——	south, 1	——	south, 3	north, 4
[small cave, limited wall space]					
north, 1	south, 2	——	north, 2	——	——
north, 3	ceiling, 1, 4	ceiling, 3	ceiling, 2	south, 2	south, 1
[damaged]	——	ceiling, 1	ceiling, 2, 4	——	ceiling, 3
——	——	——	——	——	——

Appendix 3

A. Measurements of The Magic Competition Murals and Sketches, in Meters

Murals	Wall length	Wall height	Height of composition
Cave 85	9.58	5.55	2.99
Cave 9	8.42	3.72	3.57
Cave 196	9.4	5.30	3.66
Cave 146	8.31	5.09	2.90
Cave 98	12.43	6.50	3.73
Yulin 19	6.52	3.58	3.55
Yulin 16	6.0	3.20	3.20
Cave 55	10.64	5.73	3.47
Cave 25	5.57	4.05	2.96*
Cave 6#	6.66	2.99	2.38
Cave 454	10.2	5.03	2.99
Cave 53	6.52	4.72	2.74
Yulin 32	6.05	2.93	2.93

Sketches	Length	Height	Date
P. tib. 1293(1)	0.36	.57	ca. 893–920
P. tib. 1293(2)	1.76	.29–.35	ca. 893–920
	*5 sheets, each ~0.35 long		
P. tib. 1293(3)	0.29	0.43	ca. 893–920

#The composition is spread over 2–3 walls: on either side of the door of the antechamber (west wall) and continuing on the south wall. Presumably, it also extended to the north wall of the antechamber, but that is damaged and was replaced with concrete when the cave facade was stabilized.

*Painting is damaged on the bottom; composition size is estimated.

(Caves 108 and 72 are too damaged for inclusion here.)

B. Measurements of Raudrākṣa and Śāriputra in The Magic Competition, in Meters

	Raudrākṣa dais, height	Raudrākṣa dais, width	Śāriputra dais, height	Śāriputra dais, width
Cave 85	0.76+[a]	0.76	2.10	0.80
Cave 9	2.90	0.73	2.15	0.53
Cave 196	2.44[b]	0.95	2.75	0.99
Cave 146	2.05	0.65	2.42	0.80
Cave 55	1.93	0.77	2.55	0.55
Cave 25	1.59	0.73	1.82	0.64
Cave 454	1.48	0.57	1.78	0.57
Yulin 16	1.53	0.57	1.73	0.56[b]
P. tib. 1293(1)	0.36[bc]	0.11[b]	none	none

NOTE: The height of the Raudrākṣa throne excludes the flying drapes and tassels that decorate the top; they typically reach to the upper edge of the composition, matching and often surpassing the height of Śāriputra's more stable and rigid dais.
[a]Raudrākṣa is damaged; measurement is what remains.
[b]Figures rounded up by fraction of a centimeter.
[c]Partially damaged.

C. Height of Subsidiary Figures Depicted
Near Raudrākṣa's Dais in the Magic Competition, in meters

	Raudrākṣa dais	Raudrākṣa dais, width	men climbing poles, left	hammering dais stake	grasping heads / fallen vert. / horz.	shimmying fig. left	man flying on rope	officials, gesture left
Cave 85	0.76+**	0.76	0.70	0.46	0.35 /.69	none	unclear	none
Cave 9	2.90	0.73	0.68	0.34	damaged	0.19	0.40	none
Cave 196	2.44[a]	0.95	1.33[b]	0.56[c]	0.51 / 0.81[d]	0.35[e]	0.52[f]	none
Cave 146	2.05	0.65	0.95	0.43	0.43 / 0.59	none	0.32	0.37[g]
Cave 55	1.93	0.77	0.92	unclear	none	0.51	unclear	0.32
Cave 25	1.59	0.73	0.65	0.40	none?	0.29	0.32	none
Cave 454	1.48	0.57	0.77	0.53	damaged	none	0.31	0.34
Yulin 16	1.53	0.57	0.77	0.46	0.35 / ?	0.27	0.26	0.38
1293(1)	0.36	0.11	0.17	0.11	fall: 0.08 / 0.09 grasp: 0.10 / 0.14	0.07*	0.08	0.13

** Cave 85's Raudrākṣa is damaged; measurement is what remains.
Figures rounded-up by fraction of a centimeter.
* Partially damaged.

[a] Corresponds to Plate 7.
[b] Corresponds to Plate 27c.
[c] Corresponds to Plate 27b.
[d] Corresponds to Plate 25, lower left.
[e] Corresponds to Plate 25, upper left pole; see same, Cave 146, Plate 8.
[f] Corresponds to Plate 27a.
[g] Corresponds to Plate 10, left of Raudrākṣa's dais, mid-point.

Appendix 4
Sets of Near-Identical Banners

1) Kṣitigarbha
Stein painting 125
Stein painting 118
3) Bodhisattva, hands crossed
 a) Monastic robes:
 EO1414
 EO1399 (P120)
 b) Bodhisattva's robes:
 MG17769
 EO1399 (P112)
 TA159
5) Bodhisattvas, mirror images
Stein painting 136
Stein painting 125*
Stein painting 122
7) Padmapani
Stein painting 117
Stein painting 117*
Sketch: P4082

9) Vaiśravaṇa
Stein painting 45
Sketch: P5018(1)

2) Guardian of the East
EO1172c
EO1172a
4) Vajrapāni
 a) same set:
 Stein painting 123
 EO1172b

 b) similar:
 MG17774a

6) Bodhisattva with jade ring/ornament
EO1399 (P144)
EO1399 (P119)

8) Bodhisattva with glass bowl
Stein painting 113
Stein painting 120
Stein painting 104
Sketch: P3050

10) Avalokiteśvara
Stein painting 14
Sketch: S.9137

REFERENCE MATTER

Notes

Introduction

1. A drawing of a monastery inscribed "Here is the residence of the master of the doctrine of the community (*saṅgha*) at the land at the base [of the cliff]" is among the Tibetan manuscripts found in the Dunhuang sūtra cave, P. tib. 993. Giès and Cohen, *Sérinde*, 195–96.

2. Hongbian (?–862) was a Shazhou monk who rose through the monastic ranks during the Tibetan period. The complex of three caves comprised of 16–17, 365 (d. 832–34), and 366 above was known as the "Wu family cluster." S1519; P3720; S1947; and P4640.

3. Transcription annotation, Édouard Chavannes, appendix A, "Chinese Inscriptions and Records," in Stein, *Serindia*, 3: 1329–39, fig. 345; 4: pl. CLXXV. S1519 records details on the merit accrued by those who dedicated the memorial chapel (now cave 17) in Hongbian's memory; P2913 records the making of cave 16, known as the *dafotang* 大佛堂, in 851.

4. By diasporic I refer to those areas with a mixed population where political leaders used the Chinese language and Chinese models for religious and political documents; this does not preclude the use of other languages or other cultural models.

5. Translated in Schafer, "The Last Years of Ch'ang-an," 149.

6. Drawing on Japanese scholarship, Denis Twitchett outlines the impact of Buddhist persecutions on the Tang economy including the melting of statues to produce coins, which were in short supply. Twitchett, *Financial Administration under the T'ang*, 69, 82.

7. Some drawing in stone such as on lintels and stelae still remain in temple collections in Xi'an (formerly Chang'an). These represent a close, parallel pictorial world to murals, and confirm the tensile line and sureness of hand that the texts celebrate. The wall painting that does survive from the capital is found below ground in imperial tombs. An estimated five percent of capital art remains, including a handful of scroll paintings attributed to court painters such as Zhou Fang (ca. 730–800), Zhang Xuan (fl. first half eighth c.), and Yan Liben (d. 673) that preserve the spirit and themes of eighth-century courtly painting. For a list of Tang paintings in handscroll format, see Cahill, *An Index of Early Chinese Painters*.

8. Although local scholars had signaled the collection's importance as soon as Wang Yuanlu circulated paintings and manuscripts from 1900 to 1904, the far-reaching implications of the sūtra-cave materials were nationally recognized and pressure

was put on the Republican government to retrieve the remains (after French and British removal of scrolls in 1907–8) when Paul Pelliot (1878–1945) showed Dunhuang manuscripts to literary scholar Luo Chenyu in Beijing. Zhang Daqian, who spent one-and-a-half years during 1941 to 1943 at Dunhuang, further publicized Dunhuang through a series of exhibitions of his mural copies in the wartime capital of Chongqing, Sichuan, in the 1940s. This will be the subject of another book on modern Dunhuang currently underway by this author.

9. Daozhen 道真 was the librarian of the Sanjie si 三界寺; this temple's seal was found in a large percentage of the documents sealed in the sūtra cave, leading scholars to speculate that the contents of the hidden library were from this one temple. Daozhen repaired thousands of sūtras and made an equally large number of sūtra wrappers (*shuyi* 書衣). Shi Pingting, "Sanjie si"; Rong Xinjiang, "The Historical Importance of the Chinese Fragments from Dunhuang," 81.

10. Why and how the scrolls and other manuscripts were placed in cave 17 is still unresolved. (The larger assembly hall in which 17 is embedded is cave 16.) Earlier theories placed the imminence of a Tangut invasion (ca. 1035) as the impetus for closure. More recent theories conclude that news from Dunhuang relatives in Khotan of a Muslim attack on Buddhist sanctuaries led to the closure. Among scholars of Dunhuang materials it is also now widely accepted that the chamber always held portable artifacts, acting as a library storehouse over the centuries, particularly for the library at Sanjie si, which may have been located opposite caves 16–17. (This monastery is now known as the Xia si 下寺 [Lower Temple].) Earlier, it had been thought that the Dunhuang overseers hurriedly placed the scrolls in bundles in a sealed chamber after collecting them from local temples. But the breadth of the materials and the careful inclusion of scraps of precious cloth and paper reused in rebinding manuscripts indicate the sealed grotto contained the remnants of a working library. Rong Xinjiang, "Dunhuang zangjingku," 23–24, 38–39.

11. F32A in St. Petersburg. Men'shikov, *Ecang Dunhuang wenxian*, 1: 321–22. Other documents from Dunhuang are dated to the thirteenth century, but they are from the northern section of the caves used actively when the Mongols controlled the region during the Yuan dynasty. Rong Xinjiang, "The Nature of the Dunhuang Library Cave," 270–71.

12. Rong Xinjiang, "The Nature of the Dunhuang Library Cave," 272–73.

13. National Museum of Chinese History, *Shandong qingzhou*; Nattier, *Once Upon a Future Time*; Weidner, *Latter Days of the Law*; and Fraser, Review of *Latter Days of the Law*.

14. Eleventh- to twelfth-century scholar-amateur painters may have seen the sketches of Tang and Five Dynasties professional artists who produced and consulted drawings in temple workshops. The fluctuating line and spontaneous quality may have suggested brushwork possibilities to these literati artists.

15. The strong line with light color was known as the Wu style of decoration by later Song and Yuan dynasty critics. See translations of Guo Ruoxu (ca. 1080), Mi Fu (1052–1107), Huang Gongwang (1269–1354), and Tang Hou, in Bush and Hsio-yen Shih, *Early Chinese Texts*, 106, 250, 263.

16. Wu Daozi (fl. 710–60) drew the black underdrawing, but it was normal for his assistants to fill these with color although, as the author of the *Famous Painters of the Tang Dynasty* stressed, no one was really competent to perform such a task on his tensile lines. Bush and Hsio-yen Shih, ibid., 64. Two extant Tang paintings that are largely monochromatic are Han Gan's *Night Shining White*, a horse painting dated to the eighth century in the Metropolitan Museum of Art, and the ink-rendered robe of Vimalakīrti in cave 103 at Dunhuang. These are exceptions to the vast number of extant paintings with color; nonetheless, they both contain shading and overpainting that in the case of the cave 103 figure obscured the lines to a greater degree than what appears today.

17. Upton and Vlach, "Introduction," *Common Places*, xviii–xx; Upton, *Architecture in the United States*. Upton uses probate inventories as an index of original spatial function based on the placement of furniture outlined in those lists.

18. Han Zhuo (fl. 1095–1125); the preface to his landscape treatise is dated 1121. Maeda, *Two Twelfth Century Texts*. The original texts are in Maeda, *Two Sung Texts*. The sūtra, 造像量度經解, T.1419, was written by a Mongolian scholar of Tibetan studies, 工布查布 (Tib., Mgon po skyabs), who resided in Beijing in 1742–43. Demiéville, *Répertoire du canon bouddhique*, 266.

19. Cao Buxing (third century), Zhang Mo, and Wei Xie (the latter two of the fourth century) are the three cited in Jao Tsong-yi, *Dunhuang baihua*, 1: 7.

20. Zheng Qian, Bi Hong, Wang Wei, Dong E, Han Gan, Yang Tingguang, and Wu Daozi. See Zhang Yanyuan, *Lidai minghua ji* (ca. 845–47) in Yu Jianhua, *Zhongguo hualun leibian*, 2: 27–40; and Duan Chengshi, "Chusita ji," the last two chapters of his *Yuyou zazu*, which circulated separately, cited in Jao Tsong-yi, *Dunhuang baihua*, fascicule 8.

21. Four extant pieces remain; the best of them may be a close copy dated to the Northern Song (960–1127) or Southern Song (1127–1279). Wai-kam Ho et al., *Eight Dynasties of Chinese Painting*, 27–29; and Cahill, *An Index of Early Chinese Painters*, 29.

22. Of course, Zhang Yanyuan's statement about Wu Daozi's painting emphasizes his ability to paint without rulers and markings and, by implication, his ability to paint without reference to copybooks or the need to prepare sketches beforehand. Bush and Hsio-yen Shih, *Early Chinese Texts*, 61–62. From the confident brushwork in the preparatory sketch for The Competition Between Raudrākṣa and Sāriputra wall painting in the Bibliothèque nationale, it is understandable that sketching without aids was a skill necessary for preparing drafts for wall paintings.

23. Acker, *Some T'ang and Pre-T'ang Texts*. The second volume of this work was published posthumously and includes an overview of Acker's long engagement with the text's translation and interpretation.

24. Stein, *Serindia*, 4: plates; Jao Tsong-yi, *Dunhuang baihua*.

25. In fact, two major works employing such an approach were published by Stanford University Press nearly forty years ago: *The Confucian Persuasion* (1960), edited by Arthur Wright, and *Confucian Personalities* (1962), edited by Wright and Denis Twitchett. Oxford University Press also published a study in the 1960s entitled *Histo-*

rians of China and Japan (1961), edited by Beasley and Pulleyblank. Historians of European art have long recognized the value of critical interpretations of the biographical genre; see, for instance, Kris and Kurtz, *Legend, Myth, and Magic*, originally published in 1934 as *Die Legende Vom Künstler: ein historischer Versuch*. In religious studies, close readings of hagiographic literature are, of course, mainstream; several important works on the Bodhidharma by Bernard Faure were published in the 1980s.

26. In exploring the vast visual materials from Dunhuang in terms of the extant sketches, I find that models supplied by anthropology, ethnoarchaeology, and perceptual theory are helpful. In the later chapters, post-structuralist approaches widely used in research for two decades are useful tools for analyzing artists' biographies.

27. Bakhtin, *Toward a Philosophy*, x, 9, passim.

28. Vadim Liapunov in Bakhtin, *Toward a Philosophy*, xviii.

29. Harold Rosenberg, "The American Action Painters," *Art News* (Dec. 1952): 22–23, 48–50; idem, "Action Painting: A Decade of Distortion," *Art News* (Dec. 1962): 42–44, 62–63; Meyer Schapiro, "The Liberating Quality of Avant-Garde Art," *Art News* (Summer 1957): 36–40; Nancy Jachec, "The Space Between Art and Political Action: Ab Ex and Ethical Choice in Post-War America 1945–1950," *Oxford Art Journal* 2 (1991): 18–29; and George Didi-Huberman, *L'empreinte*, Collection Procédures (Paris: Centre Georges Pompidou), 1997.

30. The eleventh-century literati notion of painting as a record of the self and the artist's personality is explored in Bush, *Chinese Literati on Painting*; and Cahill, "Confucian Elements."

31. Eric Trombert, "La vigne et le vin en Chine."

Chapter 1

1. It was also a question of literacy. To be expressive in art was to be literate, in alliance with calligraphers who were performative and, by definition, learned. Of course, many levels of literacy existed in medieval China. Literacy enabled one to experience the joys, privileges, entitlements, and urbanity associated with education and writing with the brush. Painting, as we shall see in this chapter, was still associated with a socially inferior class of artisans.

2. Zhang Yanyuan, *Lidai minghua ji*, book 9: 109.

3. P2032 (dated 939) and P2049 (dated to 925 and 931) are financial accounts of the prosperous Jingtu temple (Jingtu si) 淨土寺, which was patronized by the local rulers, the Cao family. These records were studied in Fraser, "The Artist's Practice," 245–66.

4. The earliest date that an academy could have been founded by the Song emperors is 965; in fact, it may not have been formalized until two decades later. Song sources indicate the founding date was 984. In 998 the Hanlin Painting Academy was moved to its own quarters outside the eastern gate of the imperial palace. See Scarlett Jang, "Issues of Public Service," 25–26.

5. The increased status of the professional artist added to the prestige of painting and to the emergence of the literati (amateur) artists who held court positions other than those connected to painting.

6. On the origins of the painting academy in the Tang and Five Dynasties (618–960) and early academies founded in Sichuan (935) and Nanjing (943), see Scarlett Jang, "Issues of Public Service," 25–26.

7. Titles for court artists in Shu include painters-in-attendance (*daizhao* 待招). Huang Xiufu, *Yizhou minghua lu*, 4/1: 13.

8. In the other two centers a precious few paintings survive and the administrative papers that provide context are not extant.

9. *Yinqingguanglu dafu* 銀青光祿大夫; S3929. Hucker, *A Dictionary of Titles*, 581: 7981.

10. The inscriptions are badly damaged, but the characters 畫匠弟子 are clearly visible. See Huo Xiliang, "Anxi Yulinku."

11. For a discussion of the terms, see Jiang Boqin, "Dunhuang de 'huahang' yu 'huayuan.'"

12. Other important phases are the Tibetan period (ca. 800) and the Xi Xia period (ca. 1050).

13. See Su Bai, "Nan Song de diaoban yinshua."

14. P2049.

15. The author of the text has a name—Zhang Rutong—that hints he is conversant with Confucian rites. Translated literally, his name means, "Zhang, a Confucian insider."

16. The family manners and rites described in P3716 reflect contemporary, basically Tang models. The title of the document is *xinji shuyi* (新集書儀), or "new collection of letters and rites."

17. The date of the document, *tiancheng* 天成, which is given at the end along with title and scribe/author, is a reign date of the Later Tang dynasty (the Later Tang reign dates were often used in Dunhuang) corresponding to 926. The king of Shazhou at that time, Cao Yijin (reigned ca. 914–35), is also mentioned in the text, further securing a date of ca. 925.

18. Stein painting 123 measures 64.0 cm × 18.5 cm; EO1172b is 72.0 cm × 17.0 cm. Discrepancies in the height with its Guimet counterpart arise from the lack of a canopy above the clouds. Differences in width are traceable to the cropping of the Guimet painting's black-line bordering whereas the Stein painting still retains the thick band. Many paintings are identical in the length and width of the composition but differ in details along their edges. For example, the compositions with decorative elements in Stein paintings 118 and 125 of Kṣitigarbha measure 58.1 cm and 54.5 cm from top to bottom. But if their bodies (from top of head to feet) are measured, their measurements differ only a fraction of a centimeter, 37.6 cm and 37.3 cm, respectively.

19. Lothar Ledderose makes a similar argument about the production of bronzes, clay figures, and other types of art in *Ten Thousand Things*.

20. The biography of Dong Baode is found in a Record of Merit for repairing temples (S3929). Document reproduced in Zhongguo shehui kexueyuan, *Yingcang Dunhuang xiyu wenxian* 英藏敦煌西域文獻 no. 3939 (1991): 214.

21. Other documents also refer to project managers. S3905, a document dated to 901 (唐天复元年), is a description of the rebuilding of Jinguangming si 金光明寺. A *duliao* 都料 named Ma 馬 is listed along with various assistants with titles such as

huajiang 畫匠 (painting artisan) and *boshi* 博士 (master or specialist) that also indicate a hierarchy of status and skill.

22. S2949.

23. Jiang Boqin, "Dunhuang de 'huahang' yu 'huayuan.'"

24. The print depicts Vaiśravaṇa, the heavenly king of the north. See Cohen and Monnet, *Impressions de Chine*, pl. 34. In addition to the explicit mention of the two prefectures, the rest of the Gansu prefectures under his control are referred to with the general term "other prefectures" 等州.

25. Su Bai, "Tang Wudai shiqi." The woodblock prints are published in Cohen and Monnet, *Impressions de Chine*, 53–57. A duplicate of the print dated to August 4, 947, in the Stein collection is published in Whitfield and Farrer, *Caves of the Thousand Buddhas*, 103.

26. Zhongguo wenwu yanjiu suo, *Tulufan chutu wenshu*, 1: 282.

27. Ikeda On, *Chūgoku kodai*; Yamamoto Tatsuro, Ikeda On, and Okano Makoto, *Tun-huang and Turfan Documents*; Hori Toshikazu, "Tonkō shakai no henshitsu."

28. Jiang Boqin, "Dunhuang de 'huahang' yu 'huayuan,'" 186.

29. Only eighteen full names remain because much of the original document was cut to form the shoes.

30. Jiang Boqin, "Dunhuang de 'huahang' yu 'huayuan,'" 186.

31. Turfan calligraphers were also lumped with these workers, presumably because they were copying texts at the behest of others rather than composing poetry. Guojia wenwuju guwenxian yanjiu shi, *Tulufan chutu wenshu*, 4: 15–17; 6: 466–69. Dong Guodong, "Tulufan chutu wenshu," 2: 307–9.

32. Jiang Boqin, "Dunhuang de 'huahang' yu 'huayuan,'" 187; Ikeda On, *Chūgoku kodai*, 361.

33. Document fragments 64TKM1: 28(b)31(b) and 64TKM1: 37(2)b. Dating is explored by Dong Guodong, "Tulufan chutu wenshu," 2: 309.

34. Guojia wenwuju guwenxian yanjiushi, *Tulufan chutu wenshu*, 4: 15–17.

35. Ibid., 6: 466–69; Dong Guodong, "Tulufan chutu wenshu," 2: 307–9.

36. After the An Lushan Rebellion in 756, direct imperial control waned as Tang administration become increasingly decentralized and power, in the hands of governors, filtered to regional centers, particularly in the northeast and northwest. Pulleyblank, "The An Lu-shan Rebellion"; idem, *The Background of the Rebellion of An Lushan*; and Twitchett, "Varied Patterns of Provincial Autonomy."

37. Dong Guodong, "Tulufan chutu wenshu," 2: 310.

38. The different types of artisans in the Tang are discussed in Zhang Zexian, *Tangdai gongshangye*, 206–13.

39. Zhu Lei, "Lun Qushi Gaochang shiqi."

40. S0542, a text written in the ninth century, during the Tibetan period, discusses the work gangs called upon to restore Dunhuang-area temples. The workers apparently were directed to fulfill orders by the monastic government administration, forced into corvée service by village administrative units. The surname of several of the work leaders, An 安, indicates that a population with Samarkand origins was

pressed into service under the Tibetans. Fraser, "Turfan Artists" (1998); and idem, "A Reconsideration."

41. Jiang Boqin, *Tang Wudai*, 279–81.

42. Jiang Lihong, *Dunhuang bianwenziyi tongshi*, 43–46. Also see Li Linfu, *Tang Liudian*, 21: 559–66. This imperially edited book on court administration and law reflects the earlier usage of boshi.

43. These and other specialists' titles are found in P2032 (dated 939), P2040, P2049 (dated 925 and 930), and P3234. There is also a discussion of them in Jiang Boqin, *Tang Wudai*, 280–86.

44. 社長押衙知金銀行都料銀青光祿大夫撿校太子窩賓客鬱遲寶今心供養.

45. 屠行社官安令環合社人造經一條 . . . Zhao Pu, *Fangshan shijing*, 95; Zeng Yigong, "Beijing shike"; and Lin Yuanbai, "Fangshan."

46. The wine guild is referred to in P4979, dated 752. The music guild and associated documents are discussed in *Dunhuang yanjiu* (1988, no. 4). The tea guild is noted in two Pelliot documents: P2875 and P2972; Ji Yuanzhi, "Tangdai cha wenhua."

47. 行. An early study of guilds is found in Maspero and Balazs, *Histoire et institutions de la Chine ancienne*, 226–30.

48. Angela Sheng, "Innovations in Textile Techniques," 135–36, 137; and Yan Wenru, "Tulufan de Gaochang."

49. Jiang Boqin, *Tang Wudai*, 49.

50. Rong Xinjiang, "Guanyu Shazhou guiyijundu," 76.

51. Summary and translation modified from Waley, *A Catalogue of Paintings*, 316–17. New transcription of the original kindly provided by Rong Xinjiang, professor of medieval history, Beijing University.

52. Waley, *A Catalogue of Paintings*, 317.

53. P4640 celebrates his role in facilitating the construction of cave 85. See Rong Xinjiang, "Guanyu Shazhou guiyijundu," 72; Zheng Binglin, *Dunhuang beimingzan jishi*, 54–62.

54. Yuanrong, *falü* (administrator) of the temple, wrote up the notes of the controller's lecture. The sūtra performance is recorded in P2187. Strassberg, "Buddhist Storytelling Texts." Chikasa Masaaki discusses the position of falü in "Tonkō no sōkan seido" (The monastic official system at Dunhuang), *Tōhō gakuhō* 31 (1961): 126–32, cited in Strassberg, "Buddhist Storytelling Texts," 67 n38, 68 n41.

55. A statue of Hongbian was placed in cave 16, but was moved sometime in the ensuing two centuries to accommodate some 40,000 manuscripts and paintings that were boarded up in the early eleventh century (ca. 1002–6). Hongbian's statue was replaced to its original position after 1942.

56. Ma De's studies on artists' payments, which reached me after my study was complete, also address the questions of payments and organization. See Ma De, *Dunhuang Mogaoku shi yanjiu*.

57. P2032 (dated 939) and P2049 (dated to 925 and 931).

58. The wealth of the temple compared to other local temples suggests government support. A financial analysis of Jingtu si appears in Gernet, *Buddhism in Chinese Society*, 187–88. Note that Gernet dates P2049, section 1 to 924 rather than 925.

59. Gernet estimates that one *dou* (peck or bushel) was equivalent to 2 liters in the Jin dynasty, and 6 liters in the Tang. Gernet, *Buddhism in Chinese Society*, appendix B.

60. Jean-Pierre Drège's study of early libraries leaves open the question of where he believes the temples are located. See Drège, *Les bibliothèques en Chine*, 238–47.

61. A sheng would be equivalent to either 0.2 liters (in the Jin dynasty) or 600 ml (in the Tang). Gernet, *Buddhism in Chinese Society*, appendix B.

62. One shi equaled approximately 133 lbs.

63. Cahill, *The Painter's Practice*.

64. The total weight of the payment would surely represent the product of several fields.

65. Analogous systems for European medieval and Renaissance guilds are explored in Alexander, *Medieval Illuminators*, 4–34; and Baxandall, *The Limewood Sculptors*, xii.

66. Reischauer, *Ennin's Diary*.

67. Weiner, *Inalienable Possessions*; Schrift, *The Logic of the Gift*; Mauss, *The Gift*; and Derrida, *Given Time*.

Chapter 2

1. Daozhen 道真 was the librarian of the Sanjie si 三界寺; this temple's seal was found in a large percentage of the documents sealed in the sūtra cave, leading scholars to speculate that the contents of the hidden library were from this one temple. Daozhen repaired thousands of sūtras and made an equally large number of sūtra wrappers (*shuyi* 書衣). Shi Pingting, "Sanjie si"; Rong Xinjiang, "The Historical Importance of the Chinese Fragments from Dunhuang," 81.

2. Zhang Yanyuan's statement about Wu Daozi's painting emphasizes his ability to paint without rulers and markings and, by implication, his ability to paint without reference to copybooks or the need to prepare sketches beforehand. See Bush and Hsio-yen Shih, *Early Chinese Texts*, 61–62. From the confident brushwork in the preparatory sketches for wall paintings, The Magic Competition, in the Bibliothèque nationale, it is easy to see that sketching without aids was a skill necessary for preparing drafts for wall paintings.

3. See The Magic Competition, Amitābha's Paradise, and Maitreya's Paradise drawings (Figures 2.5, 2.6a–d, and 2.13–2.17).

4. It also seems likely that the Boston painting on silk may be a distillation of what was once a more complex wall painting. The Boston painting represents a reduction in theme from a nonextant original, just as themes on murals like that of Vimalakīrti and Mañjuśrī found their way into later handscrolls.

5. Jinguangming zuishengwang jing, T.665; Mile xiasheng chengfo jing, T.454; Laoducha dousheng jingbian, T.202; and *Weimojie jing*, T.474, T.475.

6. This dance, performed by Kutchean women whose Central Asian origins had exotic associations, was apparently a favorite in the Chang'an court. The dance had erotic connotations as well, in part because the dancers' upraised arms emphasized the breasts.

7. Because the dancing figures are damaged in the paintings of Amitābha's Paradise in both cave 146 and 196, the measurements derive from the Jingang jing tableau, which contains a dancing figure and stages; it is located to the left (east) of the damaged Amitābha's Paradise tableau (south wall, center) in cave 196. The dancer itself is 2.75 in wide and 10.4 in tall.

8. A second conceptual guide, most probably for an Amitābha's Paradise (P4518.37), also contains schematically rendered corridors, bridges, and other architectural structures. This second example indicates that artists relied on this type of broad, rough diagram for large sections of compositions.

9. The shaky, broken line in this sketch gives new meaning to the term *zhanbi* or "tremulous brush." While one forms a mental picture of uneven strokes, the term is used to describe an elegant, wavering depiction of figures and their drapery by emphasizing the twist and turn of the brush. This technique is said to have begun in the tenth century, but the drawing reproduced here is probably not an example of it.

10. The fire motif suggests yet another identification. Fires are one of the nine forms of violent death that Bhaiṣajyaguru, the Buddha of Medicine (or Health), protects against. This whole section would then be identified as the first five of the nine forms of violent death frequently depicted in ninth- to tenth-century Dunhuang painting.

11. One hundred and eighty-eight figures remain; over 33 percent of the wall painting is completely missing. Cave 146, constructed approximately thirty years later, survives intact (see Plate 4b, far right panel).

12. Examples are found in Northern Wei caves 257 and 254 at Dunhuang in sculptures placed on the upper sections of walls. Dunhuang Research Institute, *Chūgoku sekkutsu*, vol. 1, pls. 34, 39. Similar early works are also found in cave 7 at Yungang, Shanxi Province. For an overview of early Chinese Maitreya worship, see Lewis Lancaster, "Maitreya in Korea," in Sponberg, *Maitreya, the Future Buddha*, 135–36; Li Yongning and Cai Weitang, "Dunhuang bihua zhong de 'mile jingbian,'" 247.

13. These images of Maitreya are inexorably linked with theories of dharma decline. The last stage is known as *mofa* 末法, the latter years of the dharma. According to Indian Buddhists, all the years after the Buddha's death were considered the "latter years" of spiritual decline. However, East Asian theorists further divided the cycle of decline into three periods. The Buddha of the Future is to appear at the end of this long, inauspicious period after the dharma has disappeared. See Nattier, *Once Upon a Future Time*, 136.

14. The colors that we now see in late Tang and Five Dynasties paintings are in some cases quite different from the original palette. In cave 196, for example, copious amounts of yellow and sky blue are no longer extant. Undoubtedly, the organic composition of the chemicals in the paints caused them to fade.

15. Suvarnaprābhasa Sūtra 金光明經 (Jinguangming zhishenwang jing) is a popular Tiantai-school text. Soothill and Hodous, *A Dictionary of Chinese Buddhist Terms*, 280.

16. Mair translates *bianxiang* as "transformation tableau." *Painting and Performance*, 1. Wu Hung discusses the term at length in "What is *Bianxiang*?" 111–70.

17. Similar to post–high-Tang renditions of Amitābha's Paradise, the narrative of Maitreya's Paradise may also be placed in four vertical screens below the vision of splendor. For diagrams of possible formats of Maitreya's realm, see Li Yongning and Cai Weitang, "Dunhuang bihue Zhangde 'mile jingbian,'" 249.

18. For careful studies on the anecdotes in wall and silk paintings of Maitreya's Paradise, see Waley, *A Catalogue of Paintings*, 16–20 (Stein painting 11); Matsumoto Eiichi, *Tonkō ga no kenkyū*, 1: 91–109; Warner, *Buddhist Wall Paintings*, 21–27; Akiyama Terukazu, "Miroku geshō," French abstract, 5–8; Whitfield, *The Arts of Central Asia*, 2: 308–13.

19. Jan Nattier distinguishes four states of Maitreya—here/there, now/later—amounting to subtle distinctions between the various states in which Maitreya may be imagined. The main distinction centers on whether he is conceived as a force in the present or as a spiritual leader in the future. See Nattier, *Once Upon a Future Time*. The wall painting encompasses both states.

20. Good reproductions of the tonsuring in cave 25, Yulin, were published by Langdon Warner after his trip there in 1925. See Warner, *Buddhist Wall Paintings*, pls. 32, 35; also Dunhuang wenwu yanjiusuo, *Zhongguo shiku, Anxi Yulin*, pls. 14, 15. For details of these scenes in the silk banner, see Whitfield, *The Arts of Central Asia*, 2: pls. 12–16.

21. Longevity allows women to postpone marriage until much later in life, when they become 500 years old. This apparently reveals a Buddhist sensitivity to the pain associated with childbirth. This permitted 500 years of freedom before marriage and childbearing.

22. Mile xiashengjing (Sūtra of Maitreya's Paradise), T. 454.

23. This scene is also found in cave 25, Yulin. It is located in the upper left just below the transmission-of-the-robe scene. On the same side near the center are the harvesting scenes. Warner, *Buddhist Wall Paintings*, pls. 30, 36. On the right side of cave 25 is Maitreya's entrance into town where he bestows many gifts and performs miracles. Although Dunhuang cave 196 is damaged on the left, it is almost certain that what appears on the left side of this cave appears on the right at Yulin, indicating that although many of the parts in murals were stable, the artist moved them around and added features depending on his skill and resources.

24. Yulin cave 25 also includes a generic scene associated with Maitreya's blissful realm, that of meditating figures being worshipped by the laity. Popularity of meditation is another hallmark of Maitreya's realm. It appears that the artist who made the Yulin version was more familiar with the meaning of the Maitreya episodes and devised a clear way to depict them. This clarity is not present in the version in cave 196 at Dunhuang.

25. Whitfield, *Buddhist Wall Paintings*, 311.

26. Whitfield identifies an identical scene in both the Dunhuang silk banner and Yulin cave 25. Ibid.

27. The meditations are found in the Sūtra of Immeasurable Life (Guan wuliang-shou jing 觀無量壽經, Amitāyurbuddhānusmṛtisūtra), an apocryphal sūtra, which describes the path to Sukhāvatī, the Western Paradise, T.365, vol. 12. Demiéville, *Répertoire du canon bouddhique*, 46. It is important to consider indigenous texts with

no Sanskrit origins when delving into the origins of authorial voice. An Indian pedigree for a text signified authenticity of message. Yet, in current scholarship, texts composed in Central Asia and China are viewed as the more pertinent sources when researching the Chinese Buddhist tradition. For more on apocrypha, see Buswell, *Chinese Buddhist Apocrypha*, 17, passim.

It appears a Central Asian translator, Kālayaśas (Kyōryōyasha), to whom the translation of the Sūtra of Immeasurable Life is attributed, participated in its creation. Supporting this hypothesis of Central Asian origins, the earliest representation of the meditations appears in wall paintings at the caves of Toyok, near Turfan, datable to the late fourth–early fifth centuries. See Fraser, "A Reconsideration." Nobuyoshi Yamabe argues that the Sūtra on the Ocean-Like Concentration on the Visualization of the Buddha (C., Guanfo sanmei hui jing) is a precursor and that the Toyok murals may contain the beginnings of visualization cults centered around Amitābha and the Western Paradise. "On the Mural Paintings of Visualizing Monks." In the eighth–tenth centuries, the lay devotee Queen Vaidehī performs the visualizations. At Toyok, a monk is depicted performing these activities, making them representations of actual practice rather than objects of devotion.

28. The scenes on the right edge of the page precede the visualizations. I suggest the following identification of the scenes. In their quest for an heir, 1) the king has a hermit starved in his hut; 2) below, the hermit changes into a hare to escape; moving right, 3) the king has the hermit dragged off to be slain; 4) queen and king are visited by an envoy of Amitābha, probably Maudgalyāyana; 5) the king is imprisoned; 6) the queen is approached by guards; 7) Ajātaśatru tries to attack his mother; Candraprabha and Jīva intervene; 8) the queen imprisoned; 9) Avalokiteśvara visits the royal couple in prison. The number of scenes is consistent with finished versions of this theme; they range from seven to nine.

29. This theme was immensely popular in representations on silk and on grotto walls. At least eight paintings on silk of the paradise with accompanying scenes of imprisonment (typically bordering the right side) and thirteen meditations are split between the Musée Guimet (EO1128, MG17669, MG17672, and MG17673) and the British Museum (Stein paintings 35*, 37, and 70). At least one of the Stein collection's is housed in the Delhi Museum, no. 501. See Giès et al., *Seiiki bijutsu*, 1: pls. 16, 17, 18, 19; Whitfield, *The Arts of Central Asia*, 1: pls. 10, 15, 19; Waley, *A Catalogue*, 290.

Although these sketches could have been used for the portable paintings, the brushwork and organization is most consistent with wall painting drawings. This theme was most popular in the late eighth century and early ninth centuries; it continues to appear through the tenth century. The format for presenting the narrative episodes changes considerably from the eighth century; simply put, these vignettes move from lateral registers directly on the side of the paradise (e.g., cave 320) to a place below the palatial setting of paradise in large flat screens (imitating screens used as a backdrop in rooms) (cave 18). For diagrams on these transformations of the Western Paradise scenes, see Ning Qiang, *Dunhuang fojiao yishu*, 239, 265.

30. The figures are identified by title; e.g., 梵釋四天王, 三萬六千婆羅門, 僧慎而耶藥叉 and 後有四萬二千天.

31. P3998 and Stein paintings 83(1)–(2) are a set of three sketches for the same

compositional theme now divided between two collections. The place indicators include: 中心第三:中心第四:上一, with submarkers indicating the placement of scenes within the "upper, one" region of the mural, including 第四, 第三.

32. Additional sketches include P3998, which features three groups of figures labeled "four heavenly kings," "36,000 attendants," and "yakśas." Jao Tsong-yi, *Dunhuang baihua*, 3: pl. 28, im. 32. In addition to cave 196, other late-Tang caves with similar panels of the *Jinguangming zuishengwang jingbian* are caves 156, 85, 138; a Five Dynasties cave with similar iconography is cave 55. The list of sūtras is indicative of a canon popular in Tibetan circles indicating the sketches date to around the Tibetan period of control in Dunhuang, 781–848.

33. Gibson, "The Pickup of Ambient Information," 252.

34. Ibid., 251. On attention and memory, see Humphreys and Bruce, "Visual Memory and Imagery."

35. Hereafter, this composition will be referred to as The Magic Competition.

36. All the measurements of the caves in this book were taken by the author over a period of six years and four visits to Dunhuang from 1993, first as a Beijing University visiting fellow under the auspices of the Committee on Scholarly Communication with China; the last in the summer of 1999, with a grant from Northwestern University. In sum, I spent five months investigating these grottoes. Each visit was hosted by Fan Jinshi, director of the Dunhuang Research Academy, which permitted access to resources and ample time needed to conduct extensive measuring. The Magic Competition murals were studied by many important scholars including Matsumoto Eiichi as early as 1930; Jin Weinuo during the 1950s; Akiyama Terukazu in the 1960s; Li Yongning and Cai Weitang, who transcribed all the cartouches in the extent murals, in the 1980s; Victor Mair, who focused on the written literature of the tale; and, most recently, Wu Hung, who revisited the problem of the mural cartouches vis-à-vis the bianwen. On the literature on The Magic Competition, see Chapter 5.

37. In a typical cave at Dunhuang, the theme appears on the west wall but also migrates to the south and east walls of the main room and the antechamber. At Yulin, it appears on the east walls of the eastern cliff facade and on the south wall of the western cliffs. Dunhuang, Mogaoku, west wall: caves 55, 85, 98, 108, 146, 196, 454; south wall: 9, 25, 53; east wall: 72; antechamber: 6. Yulin: caves 16 and 19, eastern cliff facade: east wall; cave 32, western cliff facade: south wall.

38. This figure is derived from the measurements of the width of the back (west) wall and the height in the northwest corner (cave 25) and in the southwest corner (cave 55): cave 25: h. 4.01 m, w. 6.39 m; cave 55: h. 5.73 m, w. 10.64 m. The sloped, pyramidal ceiling also adds considerably to the height, but this is not taken into consideration in the measurements here.

39. The other thirteen also fall within a ninety-year span, ca. 892–980. Two early murals of The Magic Competition are found in the Dunhuang area. A Northern Zhou (ca. sixth century) version is in cave 12 (formerly known as cave 10) at the nearby sister site of the Western Caves of the Thousand Buddhas. See Jin Weinuo, "Zhiyuanji tu kao," 382, for an "ordering" of the scenes on two lines; and Akiyama Terukazu, *Heian jidai*, 439, for a photograph and cartouche transcription. Another

early mural in Dunhuang, cave 335, dated to 686, is reproduced in Akiyama Terukazu, *Heian jidai*, 408. It contains a depiction of the theme lodged in a small niche behind a sculptural installation; this placement is considerably less prominent than the wall paintings across the back (west) or left (north) walls in later caves considered in this book. Wu Hung discusses the shifting arrangement of theme in "What is *Bianxiang*?"

40. These measurements pertain to the caves at Mogaoku; others, at Yulin, are much squatter due to the extremely sandy soil that prevents the construction of high caves. At Dunhuang these ranges include cave 6, which has a mural of The Magic Competition spread over the walls of the antechamber in four sections; in the other caves, the mural occupies one wall. Ground plans and overall measurements for each cave are in Appendix 1.

41. These wall paintings appear behind the sculpture screen, or false wall, that stretches from the altar to the ceiling. The middle portion is completely in shadow due to the closeness of this false wall to the back wall. For example, in cave 196 only 19 inches separates them. Therefore, it is impossible with conventional photographic means to capture the middle portion. With considerable support from the Mellon and Luce Foundations, a cooperative project was formed with the Dunhuang Research Academy to research methods for documenting these inaccessible spaces. With the assistance of the technical staff of Northwestern University in June and November, 1999, these two caves were photographed in their entirety. The back walls were captured in approximately 300 (cave 146) and 900 (cave 196) photographs, each with 50 percent overlap. The results were stitched together from July 1999 to May 2000 by Northwestern project team members, yielding the spectacular results evident in Plates 9 and 10.

42. The cartouches in the lower portions of the wall in cave 196 are completely faded. Yet on the ceiling, the characters are still extant; thick, black calligraphy fills the cartouches with the Buddhas' names.

43. See Appendix 3, Tables A–C.

44. For a detailed analysis of this fieldwork and measuring, see Fraser, "The Artist's Practice."

45. Akiyama Terukazu, in a series of articles in *Bijutsu kenkyū* in 1958 and 1960, was the first to publish an account of the sketches and their connection to the wall paintings. He revised his findings in "Rōdo shatō."

46. The other single-sheet sketch is P. tib. 1293(3), one of the Tibetan-language materials brought back from Dunhuang by Paul Pelliot and now housed in the Bibliothèque nationale de France. It is a detail of the king's chambers and courtyard where he decides the two sides must engage in a battle to determine the fate of the Buddhist temple and park. Reproduced in Jao Tsong-yi, *Dunhuang baihua*, 3: imp. 28–29; Fraser, "The Artist's Practice," fig. 13.

47. The inscription in Tibetan script is largely untranslatable. Lalou, *Inventaire des manuscrits*, 4. It appears to be a transliteration into Tibetan of a Chinese name, suggesting that the artist or patron of the sketches was Tibetan. Transcriptions of the inscription are in Akiyama Terukazu, "Rōdo shatō," 13.

48. The compositions are measured without the registers, which are often 5–7

inches in width. In the corners, the registers are considerably larger and asymmetrical in width in order to fill in the odd spaces near the angled, rough-hewn edges of the chamber. The compositions on the north and south walls, respectively, of other caves, beginning from the western corner, are (in inches), cave 98: 139/148; 141/136; 139/146; 139/144; cave 55: 76/74; 83/86; 96/85; 72/85 (the third and fourth positions are an exception to the general principle); cave 108: 103/104; 104/103; 103 (estimated due to damage) /104; damage/105.

49. The powder for pounces was also red, indicating that color was appropriate for marking or measuring wall spaces. See the section in this chapter entitled "Ceiling Decor" for further discussion of pounces.

50. A painting bureau member or student (*yuansheng* 院生) is mentioned in P2032 (dated to 939), one of several extant revenue and expenditure reports of the Jingtu si. Also, a later donor inscription in cave 35 (ca. 976) at nearby Yulin includes mention of an official of the painting academy (*huayuan* 畫院); see Chapter 1 and Huo Xiliang, "Anxi Yulinku." S3929, not dated, outlines the achievements of Dong Baode 董保德, a project manager (*duliao* 都料) in the government-sponsored painting guild, ca. tenth century.

51. The first figure of the south wall in cave 196, where Zhang Chengfeng is presumed to stand, is damaged, but given Zhang's position in the government, this figure should be he.

52. Cave 85 predates cave 9 by thirty years. The back wall with The Magic Competition is severely damaged and the contents are increasingly difficult to discern. The composition appears to be similar to that in cave 196, suggesting that many of the details appearing in cave 196 had been resolved by 862. In no other cave after 196 (ca. 893–94), however, do we see any formats other than those that first appeared in the ninth century. Tenth-century artists keep the layout, style, and iconography consistent.

53. I extensively measured and investigated eight of these fifteen caves (Dunhuang 9, 25, 55, 85, 146, 196, 454, and Yulin 16). Their relatively good state of preservation made them candidates for scrutiny, unlike caves 108 and 44, whose wall paintings are all but reduced to rubble. My choices were also conditioned by access and the investigation was guided by one important issue: Could the sketches of The Magic Competition have been used in the production of these cave chapels?

54. For reproductions of Indian examples, see Huntington, *The Art of Ancient India*, Bhārhut 5.9; Bhājā, 5.21, 5.30; Kārlī, 9.5; and Ajaṇṭā 12.3, 12.9, and 12.19.

55. The pagoda contains a colossal image of Maitreya executed in living rock (the mountain's matrix) augmented with plaster layers filling out the Buddha's features. Judging from old photographs, it is clear that sometime after the Guangxu period (1895–1908), probably from 1927 to 1934, the wooden eaves were added and the pagoda was expanded to nine stories. In a ca. 1890s photograph, simple wooden beams support the porches. In place of the wooden eaves is stone plaster. See Ji Xianlin, *Dunhuangxue da cidian*, 2. Yet it is clear that when it was first constructed in the late seventh century, the wooden facade was included. New excavations at the cliff's facade reveal base stones for extremely large wooden pillars. However, the best indication of

the importance of wooden prototypes for Dunhuang cave temples is the many areas of the cliff facade riddled with holes where support beams once existed. See Ma Shichang and Pan Yunei, *Mogaoku kuqian diantang.*

56. Ma Shichang and Pan Yunei, *Mogaoku kuqian diantang.* In addition to Figure 2.21, other photographs of the facade taken in 1942–43 are in the Lo Archives, Princeton University, Art Library.

57. These remnants were present before the 1960s renovation. Recent changes to stabilize the cliff and promote cultural tourism have permanently removed them from the researcher's grasp, effectively rendering them inaccessible behind layers of concrete.

58. These patterns endured in many media; they were ubiquitous in textile designs for clothing and carpets.

59. The most prominent example, Hōryuji, survives in Japan.

60. Of course, the noted exceptions are the meditation caves in the northern section of Dunhuang with carved earthen beds, rudimentary stoves, cooking-exhaust systems, and shelves dug from the hollow. These caves do not contain wall paintings, however. A recent study of the meditation caves has been completed by Peng Jinzhang and Wang Jianjun, *Dunhuang Mogaoku beiqu shiku.* Cave dwellings are part of the vernacular residential architecture throughout Shaanxi province, particularly near Yan'an (Yenan), where the Communists under Mao Zedong remained after the Long March.

61. Todorov, *The Fantastic.* The pictorial argument is applicable to Chinese literature of immortals. See DeWoskin, "Xian Descended."

62. Matsumoto Eiichi describes the making of these plaques or molds in "Kata ni yoru zozo." The models in the Hermitage (from Qizil?) include hands, legs, heads, ears, drapery, and scarves, as well as a torso and diadem. Face and drapery molds are in the Xinjiang Autonomous Regional Museum.

Molds were used in early bronze production during the Shang dynasty (ca. 1500–1100 B.C.E.). A large number were found at the bronze casting site of Houmachen, in southern Shanxi Province. Thirty thousand molds were unearthed at Xintian including those for arrowheads, tools, utensils, and vessels used in ancestral worship and buried in tombs. The latter include decorative motifs: ducks, *taotie* masks, and tigers, as well as written inscriptions and decorative pieces for chariots. See *China Pictorial* no. 6, 1962. Bronze casting and molds are also discussed extensively by Ledderose, *Ten Thousand Things.*

63. Fraser, "Régimes of Production."

64. Ibid.

65. Wu Hung, "Buddhist Elements."

66. An additional example is the well-known depiction of Fu Xi and Nü Wa in the ceiling of cave 285, Western Wei period, d. 532–35.

67. In 842 Zhu Jingxuan recounted the tale of Emperor Minghuang's request for Sichuan river scenery from the painter Wu Daozi, who was sent to observe the landscape in Sichuan. Upon his return, when asked by the emperor where his sketches were, Wu replied, "I have not a single sketch (*fenben*), but all is recorded in my

mind." Zhu Jingxuan, *Tangchao minghua lu*, 75. Translation, modified, from Soper, "*T'ang Ch'ao Ming Hua Lu*," 209. The story is not recounted in Zhang Yanyuan's text *Lidai minghua ji*. The term is used again by Zhu to designate extant sketches by Zhou Fang of the "Lonely Concubine Begins a Sung Poem" 獨孤妃按曲圖粉本. Zhu Jingxuan, *Tangchao minghua lu*, 77.

68. The traditional meaning of *ben* as a quantitative signifier is expanded here to mean "piece" or "aspect."

69. 古人畫稿，謂之粉本. Xia Wenyan, *Tuhui baojian*, 3.

70. 昉不假朽筆奮筆立成皆 ("Fang did not rely on sketching but snatched his brush and rapidly completed the figures"). Translation, modified, from Liu Daoshun, *Shengchao minghua ping*, 37, 1.12r. Note that the first character of the book's title varies: *song* 宋 and *sheng* 聖.

71. *Xiu* 朽 means "rotten" or, in one early gloss, "the bones that are left after meat or leaves have rotted away." It could, therefore, indicate the underpinning or foundation of a painting, thus underdrawing. See Morohashi Tetsuji, *Dakanwa jiten*, 6: 14439, 6: 16364 (variant). Morohashi also defines *xiubi* 朽筆 as charcoal. In this case, I think a more literal rendering of the character is probably closest to its meaning; i.e., underdrawing destroyed or covered.

72. This is consistent with modern practices; red powder was applied over pounces in Qinghai temple workshops I visited in November 1992.

73. The separation between the underdrawing and overdrawing stages is relaxed in the paintings drawn in the Tang imperial tombs near Xi'an. Working underground, artists rarely lavished the kind of attention on their tomb murals that they did on temple walls with a living audience. Tomb murals are touched only with broad sweeps of color and contain little or no overdrawing. Examples of exposed underdrawing—in some cases there appears to be no underdrawing and the initial brushwork is also the final layer—in the Xi'an area are found in the tombs of Li Xian 李賢 (Prince Zhanghuai 皇太子, 章懷) and Li Chongrun 李重潤 (Prince Yide 懿德). Shaanxi lishi bowuguan, *Tangmu bihua zhenpin xuancai*, 44, 64.

74. Cappel, "A Substitute Cartoon for Raphael's *Disputa*"; idem, "Michelangelo's Cartoon."

75. Two paintings were discovered. One, now lost, is reproduced in Ol'denburg, *Materially po buddiiskoi ikonografii Khara-khoto*. The second is in the collection of the Russian Oriental Institute in St. Petersburg.

76. The statistics were gleaned from P4517.2–6; P4518.29; Stein painting 73(1); and Stein painting 73(2). A seventh pounce measures 54.4 cm in height.

77. The design was measured by the author in Mogao caves 44, 152, 172, 196, and 437. Cave 196 dates from 893–94; the others date approximately 100 years later. This sampling was partially dictated by the accessibility of the design. It typically appears on the sloped ceiling of the later Tang period (848–907); in the early Song dynasty (late tenth century), it appears on the lower reaches of the wall as it did during the Sui dynasty (586–618). In cave 61, ca. 947–51, each Thousand Buddha motif in the ceiling measures 10 inches wide by 17 inches high.

78. For reproductions of the wall painting, see Pelliot's field notes in Mission Paul

Pelliot, *Carnet*, 4: 228; Dunhuang wenwu yanjiusuo, *Zhongguo shiku*, 5: pls. 52–53; and Whitfield, *Dunhuang: Caves of the Singing Sands*, 1: pls. 142–43. For the section in cave 146, see Dunhuang wenwu yanjiusuo, *Zhongguo shiku*, 5: 50. Stein painting 72, the largest pounce from Dunhuang, is reproduced in Whitfield and Farrer, *Caves of the Thousand Buddhas*, pl. 70; Whitfield, *The Arts of Central Asia*, 2: pl. 78, fig. 138.

79. Fraser, "Formulas of Creativity," 195–98.

80. Lothar Ledderose draws connections between production in different media by highlighting flexible, moveable pieces. *Ten Thousand Things*.

81. Lothar Ledderose, "A King of Hell"; Wen Fong, *Beyond Representation*.

82. It is unclear from the reproductions if only one pounce is extant or if two additional line drawings reproduced in the volume have holes punched along the contour lines. From the accompanying text, it appears only catalog no. 65 has perforations. Huang Wenbi, "Tulufan kaogu ji." Further investigation would clarify this; but unfortunately, these items now seem to be lost. During an October 1998 visit to the Lishi bowuguan (History Museum, Beijing), where the items were purported to be held, they could not be located after an exhaustive search.

83. Fraser, "A Reconsideration."

Chapter 3

1. An artist's manual with similar sketches drawn on grid patterns is published by Taer Temple outside of Xining 西寧, Qinghai Province. The translated title (on the cover) reads *New-Sun Self-Learning Book on the Art of Tibetan Painting*, n.d. (purchased 1992). Accomplished artists do not use these grid patterns to make paintings; today, they are popular among lesser or untrained artists.

2. Wang Qingzheng, "The Arts of Ming Woodblock-printed Images and Decorated Paper Albums," chap. in Chu-tsing Li and James Watt, *The Chinese Scholar's Studio*, 56–57. Li Kan, the well-known bamboo painter, also wrote a manual on this subject in the Yuan dynasty.

3. Bickford, *Ink Plum*.

4. Carter, *The Invention of Printing*; Twitchett, *Printing and Publishing in Medieval China*.

5. Wai-kam Ho et al., *Eight Dynasties of Chinese Painting*, 342–47.

6. A similar version is in the Pelliot collection, P3905, reproduced in Ji Xianlin, *Dunhuangxue da cidian*, color plates, page 47.

7. The sketch was used by the Qing Imperial Painting Academy to produce a scroll for a set of twelve detailing the southern tour. Five of the scrolls and the sketch are in the Palace Museum collection in Beijing, reproduced in part in Palace Museum, *Qingdai gongting huihua*, 54–80 (catalog nos. 16–32); Nie Zongzheng, "Qingdai de gongting huihua he huajia," includes an overview of the Qing court painting academy.

8. Fraser, "Turfan Artists" (2000), expanded from "Turfan Artists" (1998). The drawing and murals are also reproduced in Xinjiang Weiwuer zizhiqu bowuguan, *Xinjiang chutu wenwu*, 29, pl. 37; *Zhongguo meishu quanji, Huihua bian, Mushi bihua*, pls. 52, 53.

9. Spiro, *Contemplating the Ancients*; Laing, "Patterns and Problems."

10. Xu Bangda, "Cong bihua fuben"; Huang Miaozi, "Wu Zongyuan," 58.

11. Two versions of this copy of a Daoist wall painting exist, one in the Xu Beihong collection and the other in the C. C. Wang family collection; the latter is generally regarded as the earlier, perhaps genuine copy after a mural. See Cahill, *An Index of Early Chinese Painters,* 189.

12. In later periods sketching remained part of the artist's practice. Although no Northern Song dynasty sketches are extant, descriptions of painting in Huizong's court in particular make clear that preparatory sketching was a standard procedure in the painting academy. See Scarlett Jang, "Issues of Public Service," 1: 39. After the formulation of baimiao in the eleventh century, sketching and monochrome painting remained distinct.

13. This brushwork also is typical of the Shanxi provincial style of wall painting of the Yuan and Ming dynasties (ca. 1300–1600).

14. *The Buddha Receiving a Foreign King,* with Vaisravana and other deities, is another example of the later Buddhist handscroll. Ink on paper, Yuan dynasty (thirteenth century); originally attr. Li Gonglin.

15. A complete reproduction of *One Hundred Flowers* (the original is in the Palace Museum, Beijing) is in Gugong bowuyuan, *Songren baihua tu.* A painting similar to *One Hundred Flowers* in the Palace Museum, Taiwan, by Zhao Zhong, is *Ink Flowers,* d. 1361. Reproduced in Wai-Kam Ho, *Eight Dynasties of Chinese Painting,* 91–92; also in University of California, Berkeley Photo Archive, 29C4/1361.11/1.

16. Xu Bangda, "Cong bihua fuben."

17. An anecdote about the tracing of a mural on wax-treated paper reveals that in addition to small-scale copies, copies directly from the walls might have been possible, and indeed common, from the Song dynasty onward. Liu Daoshun, *Shengchao minghua ping,* 41, 1.15r; Cahill, *The Painter's Practice,* 94.

18. An excellent review of the extant scroll paintings and scholarship on the Vimalakīrti and Mañjuśrī paintings is in Weidner, *Latter Days of the Law,* cat. 43, pp. 349–54.

19. T.474, T.475. Weimojie jing (Vimalakīrtinirdeśa Sūtra) contains the key elements of the composition related to the Dacheng dingwang jing 大乘頂王經, T.478.

20. On early representations at Dunhuang, see Judy C. Ho, "Tunhuang Cave 249." For translations of the Chinese and Tibetan sūtras, see Thurman, *The Holy Teaching of Vimalakirti.*

21. The Chinese dating system in sixty-year cycles makes it unclear whether the work is in the earlier or latter part of the century; it seems certain that it does date to the tenth century.

22. The wall is 27.9 feet (8.51 m) in length but only 5.74 m—or four times as long—if the space occupied by the doorway is excluded. It's width is only 16.7 feet (5.09 m) but only 9.5 feet (2.90 m) if the lower unrelated register is omitted. See Appendix 1.

23. A sketch of the Three Worlds and the Nine Realms, possibly a depiction related to the Avataṃsaka Sūtra (Huayan jing, Flower Garland Sūtra), demonstrates how difficult it must have been to use paper only approximately a foot wide to sketch

the information needed for the massive wall paintings. Now joined as a long, thin scroll, at one time this sketch consisted of two pieces of paper pasted side by side. In the sketch, Mt. Sumeru, the mythological geological core from which the nine worlds described in the Avataṃsaka Sūtra emerge, is long and columnar, occupying over approximately 2.5 meters of paper. The nine worlds are sketched in quick shorthand; nearby notes indicate the placement of pavilions (*louzi*). When an image of Mt. Sumeru is used in a wall painting during the Five Dynasties, it is typically approximately four to seven feet in length; e.g., in cave 61, north wall, fourth bay from east, in the Devatā Sūtra (Requesting Heavenly Blessings, Tianqingwen jing, T. 592) and the south wall, second panel from east, Lotus Sūtra; cave 6, first bay from east, Lotus Sūtra. The sketch, P2012, recto and verso, accompanied by confession drawings, is reproduced in Jao Tsong-yi, *Dunhuang baihua*, 3: planches 56–57, imp. 66–69.

24. Two additional sketches may also be associated with the wall paintings of The Debate Between Vimalakīrti and Mañjuśrī. The king arriving at the debate may be depicted in P2993 and Vimalakīrti on his spiritual quest appears in P4049. Ink on paper, ca. ninth century. Bibliothèque nationale.

25. Nienhauser, *The Indiana Companion*, 347.

26. Versions of the *Nine Songs* are numerous; e.g., one by Zhang Wu, active 1360, held in the Cleveland Museum of Art; see C. C. Wang negative #Y-CW-101–10, University of California, Berkeley Photo Archive 29C4/ nd. 11/10; and another attributed to Zhao Mengfu (1254–1322), in the Metropolitan Museum of Art, New York.

27. The theme of Yang Pu moving is also depicted in an anonymous painting in the Art Institute of Chicago. With the same iconography, both Yan Geng (act. ca. 1300) and Yan Hui (act. late thirteenth–early fourteenth c.) executed paintings about Zhong Kui, yet they are of two different themes. The one by Yan Geng (*Demon-Queller Zhong Kui Giving Away His Sister in Marriage*) revives the moving theme; the second, by Yan Hui (*Zhong Kui's Excursion on the Night of the Lantern Festival*), invokes the topic of nighttime travel. Both paintings are cited in the Cleveland Museum of Art, *Eight Dynasties of Chinese Painting*, 111–12. The best-known version of Zhong Kui's escorting his sister to her betrothed is Gong Kai's painting in the Freer Gallery. See Lawton, *Chinese Figure Painting*, 142–44, pl. 35. Other copies also exist.

28. Grabe and Sims, *Between China and Iran*.

29. Mi Fu confirms that Li Gonglin was something of a follower of Wu Daozi. See Bush and Hsio-yen Shih, *Early Chinese Texts*, 213.

30. Scholar-amateur painters of the eleventh and twelfth centuries may have seen the sketches of Tang and Five Dynasty professional artists who produced and consulted sketches in temple workshops. The fluctuating line and spontaneous quality may have suggested brushwork possibilities to these literati artists.

31. Several other versions of the *Filial Piety* scrolls are extant including the *Book of Filial Piety, Calligraphy, and Painting*, attr. Zhao Mengfu, 20 sections, Palace Museum, Taiwan; University of Michigan Photo Archive m/f no. 2930. Qiao Zhongchang (fl. first half of the twelfth century), a professional painter employed by the court, worked in the literati baimiao style associated with Li Gonglin and was part of Su Shi's milieu.

32. For a reproduction of a calligraphic work by Su Shi, *Poems Written at Huang-zhou on the Cold Food Festival* (ca. 1082), see Wen Fong and James Watt, *Possessing the Past: Treasures from the National Palace Museum*, pl. 66.

33. For sacred objects, a figure is brought to life with the dotting of the eye (opening eye ceremony), marking a painted deity's completion.

34. Reproductions and a discussion of the Hāritī theme are found in Murray, "Representations of Hāriti."

35. Ink splashing (*pomo*), graffiti writing, and ink wash for landscape passages were also beginning at this time, although they are different traditions. Landscape techniques, in particular, are drastically different from figure drawing at this stage. Studies on the rise of ink monochrome include Yonezawa Yoshio, "Hakubyō"; Kiyohiko Munakata, "The Rise of Ink-Wash Landscape Painting," 7–18, passim; Wai-Kam Ho, "The Original Meaning of P'o-mo"; Shujiro Shimada, "Concerning the I-p'in Style of Painting," I.

36. Baihua encompasses all styles of finished, monochromatic drawing. Baimiao is a refined style of drawing in unfluctuating, fine line. Jao Tsong-yi mistakenly, I think, considers baihua and baimiao to be the same thing. He quotes Fang Xun (1736–99): "Today we call baimiao (fine line drawing) the washes of ink that the ancients called monochrome painting (baihua)," and concludes that the two are identical. Jao Tsong-yi, *Dunhuang baihua*, 1: x.

37. Nor should they be confused with the few banners done only in ink, such as a famous banner of a bodhisattva produced for the opening of the Tōdaiji (ca. 752), preserved in the Shōsōīn. Although unusual, this bodhisattva banner from the Tōdaiji is in a style also found in Dunhuang banners, which include a creamy yellow silk with figures executed in black ink and other styles such as silver ink on silk and hemp dyed red or indigo. All types appear to be finished paintings and feature multiple images of the Buddha or bodhisattvas; presumably, these were hung to fly in the wind outside a temple or cave-shrine and plain black ink sufficed, as it probably did in the Tōdaiji example flown during the opening ceremonies. This type is a small minority of the overall production of a Buddhist atelier, though. See MG17675, MG17791, EO3648, and EO1228 in Hambis and Vandier-Nicolas, *Bannières et peintures*, pls. 33, 34, and 182, pp. 72–73, 354–55.

38. Barnhart, "Survivals"; Judy C. Ho, "The Perpetuation of an Ancient Model."

39. Tang Hou and Xia Wenyan praise the value and quality of old fenben. See Tang Hou, *Hua Lun*, 60, cited in Bush and Hsio-yen Shih, *Early Chinese Texts*, 256; and Xia Wenyan, *Tuhui baojian* (Precious Mirror for Examining Painting), dated 1365, in *Huashi congshu*, 3.

Chapter 4

1. Stein painting 45, reproduced in Whitfield, *The Arts of Central Asia*, 2: pl. 16, pp. 314–15; Whitfield and Farrer, *Caves of the Thousand Buddhas*, pl. 9.

2. Zhao Xigu 趙希鵠 in *Dongtian qinglu*, 28: 51a–b. The *linmo* section is solely concerned with copying. Zhao mentions the dangers of lending paintings lest they be damaged by ink that has seeped through the copy paper. This admonition confirms

the widespread practice of copying. According to James Cahill, in the painting *Sixteen Lohan* by the twelfth-century master Fan Long, the copyist's brush has leaked through, leaving ink blots on the original. The painting is in the Freer Gallery and is published in Lawton, *Chinese Figure Painting*, pl. 20.

3. An anecdote about the tracing of a mural is noted in Liu Daoshun, *Shengchao minghua ping*, 41, 1.15r; also cited and discussed in Cahill, *The Painter's Practice*, 94. Nothing like the waxed or translucent paper survives at Dunhuang, but a collection of sketches on treated paper is in the Nelson-Atkins Museum of Art, Kansas City. These are datable to the Qing dynasty and were collected by Sherman Lee. Waxed paper may have also been used in rubbings; see Zhang Yanyuan, *Lidai minghua ji*, translation and transcription in Acker, *Some T'ang and Pre-T'ang Texts*, Sinica Leidensia VIII: 191.

4. MG17666, reproduced in Hambis and Vandier-Nicolas, *Bannières et peintures*, pl. 192; and Giès, Soymié, Drège, et al., *Les arts de L'Asie centrale*, 2: pl. 77.

5. At least two other paintings seem to be in the same lineage of non-Han models. Stein painting 104 has a slightly different configuration; a pearl-studded lotus is held in the arm behind the bodhisattva's head. Another is in the Musée Guimet, EO1170; see Giès, Soymié, Drège, et al., *Les arts de L'Asie centrale*, 2: 18.

6. Stein painting 104. Whitfield, *The Arts of Central Asia*, 1: pl. 49-2; Fraser, "The Artist's Practice," fig. 138, bottom.

7. Matsumoto Eiichi, "Tonkō shutsu 'kaiyuan' nendai ga ni tsuite."

8. I saw this technique being used with great success in training students in Tongren, Qinghai, June 1999.

9. The monastic-robed deities are: 76.0 cm × 18.0 cm for the bodhisattva garbed in the black-lined robe (EO1414), and 73.5 cm × 18.3 cm for the deity in the red-dyed robe (EO1399). The other three paintings with bodhisattva robes are MG17769, EO1399 (P112), TA159 (now in the Tokyo National Museum). Their respective measurements are: 71.0 × 17.4; 81.4 × 17.0 (but includes the triangular head on top [10 cm] missing from the others); and 70.0 × 17.3. They are reproduced in Giès, Soymié, Drège, et al., *Les arts de L'Asie centrale*, 2: pls. 36, 35, and 34, respectively; also in Hambis and Vandier-Nicolas, *Bannières et peintures*, pls. 154, 153, 153 bis.

10. Gu Kaizhi cited in Bush and Hsio-yen Shih, *Early Chinese Texts*, 33; Ecke, "A Reconsideration."

11. Liu Daoshun, *Shengchao minghua ping*, 41. Zhang Shinan (?–after 1230), author of the Southern Song text *Youzhen jiwen*, discusses wax-treated paper in the context of other copying techniques. "*Yinghuang* 硬黄 means to put paper over a hot flatiron, then melt yellow wax." Zhang Shinan, *Youzhen jiwen*, 5/2a.

12. These sketches were collected by the late Lawrence Sickman in China for the Nelson-Atkins Museum in Kansas City.

13. As noted earlier, this procedure, which I viewed in modern Buddhist ateliers in 1999, could also explain the paintings that appear to be mirror images. The design could be inverted to produce an identical image with reverse features visible in several of the painting sets extant from Dunhuang. Zhang Shinan, the Southern Song official

whose collectanea includes observations gathered during his postings to Fujian, Sichuan, and elsewhere, calls this procedure *xiangta* 響搨. He writes, "Xiangta meant to cover it [the design] with paper, then take it to a lit window and copy it by the light coming through" 知不足齋嚴書. Zhang Shinan, *Youzhen jiwen*, 5/2a. It is also possible to imagine that the design would transfer when the surface was rubbed if the paper had a waxy surface.

14. Whitfield and Farrer, *Caves of the Thousand Buddhas*, 34–37; Whitfield, *The Arts of Central Asia*, 2: 301.

15. See Jao Tsong-yi, *Dunhuang baihua*, 3: 44, im. 51; Fraser, "The Artist's Practice," fig. 146; idem, "Formulas of Creativity," fig. 20. The paintings on silk are EO1172a, c.

16. Stein painting 112, reproduced in Whitfield, *The Arts of Central Asia*, 2: fig. 107; other, similar paintings are Stein paintings 106, 129, 108, 137*, 138, 107, and 112. See ibid., 1: pls. 61–65, figs. 107 and 108.

17. Color flaking reveals how ubiquitous fine-line black underdrawing was in the late Tang and Five Dynasties painting atelier. Often, the flesh parts are covered with red overdrawing while the costume and other details are finished with a black linear design that echoes the invisible black underdrawing. See reproductions in Giès, Soymié, Drège, et al., *Les arts de L'Asie centrale*, 2: pl. 68 (EO1133).

18. Stein collection, New Delhi Museum. Ink on silk, tenth century. Source: Matsumoto Eiichi, *Tonkō ga no kenkyū*, 2: pl. 109.

19. The same composition in a finished banner is reproduced in Whitfield, *The Arts of Central Asia*, 2: pl. 24 (Stein painting 23). Both date to the tenth century.

20. An additional Vajrapāni in the Guimet collection is reproduced in Hambis and Vandier-Nicolas, *Bannières et peintures*, pl. 200 (MG17774a).

21. Stein painting 123 measures 64.0 cm × 18.5 cm; EO1172b is 72.0 cm × 17.0 cm. The former is shorter because it lacks the canopy above the clouds depicted in the Guimet painting. Differences in width result from the cropping of the Guimet painting's black line border, while the Stein painting still retains the thick band. Many paintings are identical in the length and width of the composition but differ in details along the edges (Plates 20a–b). For example, Stein paintings 118 and 125 of Kṣitigarbha measure 58.1 cm and 54.5 cm respectively from top to bottom in whole length. If only the representations of Kṣitigarbha (from top of head to feet) are measured, then the measurements differ just a fraction of a centimeter: 37.6 cm and 37.3 cm, respectively.

22. On the draft texts, see Soymié et al., *Catalogue des manuscrits chinois*, 1: 10–11.

23. Kuo Li-ying, *Confession et contrition*.

24. When this scroll is divided at the center, turned over, and the two backs joined along the vertical edge, there is another drawing that depicts the three worlds and nine lands (understood as the stages to bodhisattvahood) of the Avataṃsaka Sūtra (P2012). The artist has again used verbal rather than pictorial means to convey information. Characters identify the moon and "southern sun," immortals, pavilions, and bodhisattvas. The catalog of the Bibliothèque nationale maintains that this sketch could be a draft for an ink-and-color version on paper, but this lacks the nine-square

maṇḍala on the left side associated with this subject. It appears in this form in silk and on the slopes of grotto ceilings. See Giès, Soymié, Drège, et al., *Les arts de L'Asie centrale*, 1: 51–67.

25. A third painting, of Avalokisteśvara (P4518.11), also has these same color dots. Reproduced in Fraser, "The Artist's Practice," fig. 70. See also Fraser, "The Manuals and Drawings of Artists."

26. Examples of other finished paintings combining diagrams and text are in the Musée Guimet (EO1182) and the Yale University Art Gallery (1955.7.1); both are on silk. Another rare example of red-ink text and picture is a Tibetan print (P. tib. 4216) with a dhāraṇī in Chinese written freehand in black ink in the center. See Cohen and Monnet, *Impressions de Chine*, pl. 38.

27. An exact duplicate of this print is in the Bibliothèque nationale de France (TH2). Another printed Sanskrit dhārani (TH1) in the same collection is published in Cohen and Monnet, *Impressions de Chine*, pl. 39.

28. Drège, "Les premières impressions."

Chapter 5

1. Wu Hung, although arguing persuasively that *bianwen* or "transformation tales" (discussed below) had an identity separate from the wall paintings, implies that artists wrote the inscriptions in the cartouches. However, the evidence does not support this. Wu Hung, "What is *Bianxiang*?" 159, 188.

2. The text is translated into English in Mair, *Tun-huang Popular Narratives*, 31–84.

3. These studies include works by Akiyama Terukazu, Cai Weitang and Li Yongning, Eugene Eoyang, Jin Weinuo, Kanaoka Shōkō, Victor Mair, Matsumoto Eiichi, Richard Strassberg, Nicole Vandier-Nicolas, and Wu Hung. Their works will be cited as they become relevant.

4. T.202:10, 418b–21b. Takakusu Junjiro, "Tales of the Wise Man and the Fool"; Lévi, "Le sūtra du sage et du fou."

5. Takakusu Junjiro 高楠順次郎 was actually in charge of the compilation and publication of this newly organized Buddhist canon of texts (*Taishō shinshū daizōkyō* 大正新修大藏經), and his familiarity with the thousands of texts under his editorial hand surely contributed to his study of the Sūtra of the Wise and Foolish.

6. Paul Pelliot transcribed The Magic Competition cartouches in caves 146 and 55, although these and his other Dunhuang field notes (including full descriptions of fourteen of the eighteen caves with the Raudrākṣa and Śāriputra theme) were not published until the 1980s. See Mission Paul Pelliot, *Grottes de Touen-Houang*, 9: 1–6; 1: 14–29 (cave 146/P8); 4: 22–28 (cave 55/P118f). Stein's expedition encompassed Yulin, and his photographs include the north wall of cave 32, which contains a painting of The Magic Competition. For Stein's reports, see *Serindia*, 2: 549–60, 603–7, 791–1088, fig. 213 (cave 55), 233–34, 236 (cave 146); 3: photos, fig. 245 (Yulin 32).

7. A listing of thirteen versions of the Sūtra of the Wise and Foolish found at Dunhuang is in Strassberg, "Buddhist Storytelling Texts," 70 n82.

8. The plurality of the Buddhist tradition manifests itself in, among other things,

the unrecoverability of the historical Buddha's life, the 2,500-year-long tradition(s) after his death, and the proliferation of Buddhism(s) across Asia. See Lopez, *Buddhism in Practice*, 3.

9. Matsumoto Eiichi, *Tonkō ga no kenkyū*, 1: 201–11, 2: pls. 67a–71b.

10. It is still open to speculation whether the scroll was prepared for a performance or written afterwards as a memory of one. The scroll's text seems too polished, both in linguistic style and calligraphic neatness, to be considered an oral prompt. Nonetheless, Eugene Eoyang and Victor Mair believe P4524 was owned and used by a storyteller. See Eugene Eoyang, "Word of Mouth," 49, 162; Mair, *Tang Transformation Texts*, 115, 121. Mair has revised his hypothesis and now believes the text is much later than the pictures, perhaps by as much as two centuries. He thinks the text was written as a memory of the act of performance rather than actually being used in performance itself. See Mair, "Śāriputra Defeats the Six Heterodox Masters," 41. Richard Strassberg reserves judgment, questioning the lack of scribal errors or homophonic mistakes typical of storytellers' materials. "Buddhist Storytelling Texts," 62.

11. Vandier-Nicolas, *Sariputra et les six maîtres*, 1–32. Mair, *Asia Major* 3rd s., vol. VIII, part 1 (1995): 1–52.

12. Mair, *Painting and Performance*, 2.

13. The popular novelist and short-story writer Lu Xun was the greatest proponent of the movement (*baihua yundong* 白話運動) in the 1920s. The movement's aim was to honor and develop a vernacular voice in Chinese culture that included the folk art of woodcuts and illustrations to novels written in the vernacular, as a conscious alternative to classical language still used in most texts.

14. Wang Zhongmin, *Dunhuang bianwenji*.

15. Xiang Da, "Tangdai sujiang kao."

16. Six Magic Competition bianwen survive. 1) The most complete is divided into two fragments now housed in the Beijing National Library 散文 1589 (the text is often referred to as formerly in the possession of Hu Shi, and owned by Luo Zhenyu [1866–1940] before that) and the British Library S5511, respectively; they date to ca. tenth century; 2) S4398, dated 949, is a largely unusable fragment; 3) P4615, also a fragment, is dated to the latter half of the tenth century and includes an epitaph for an elite family member; 4) Luo Zhenyu supposedly owned another version and transcribed it in his *Dunhuang lingshi* 敦煌零拾; 5) S4257.2; and 6) P3302 (which also contains the cartouche texts of other popular murals). The last two (numbers 5 and 6) are not bianwen proper but are transcriptions of the Magic Competition mural cartouches.

Kanaoka Shōkō has made a careful study of P2187, updating research on sūtra lectures 敦煌文學文獻, 敦煌講座. *Tonkō no bungaku*, 11: 4, 369–75. P2187 (which dates to 944) was formerly labeled a bian or bianwen (transformation tale); Kanaoka discusses it as a 押座文 (*yazuowen*), a seat-settling text.

17. On how bianwen categories compare with sūtra lectures, see Bai Huawen, "What is Pien-wen," 493–96.

18. I assume Akiyama used what has now become the standard bianwen text of *The Magic Competition* (now divided in two fragments, S5511 and BJ1589). See Akiyama Terukazu, *Heian jidai*, 389–467.

19. Transcription of cartouches (plot summaries in murals, donor identification, and random notes left by premodern travelers) has been an important part of the research conducted at Dunhuang since the Dunhuang Research Academy was established in 1942.

20. Li Yongning and Cai Weitang compare Magic Competition bianwen S4257.2 and the cartouches from 13 caves; therefore, they do not use the same bianwen texts for comparison as Akiyama. See Li Yongning and Cai Weitang, "Xiangmo bianwen."

21. Akiyama's study reflected the then common assumption that the wall paintings were used in sūtra lectures. *Heian jidai*, xxxi, 427. Li Yongning and Cai Weitang, "Xiangmo bianwen," 187–89.

22. Wu Hung, "What is *Bianxiang?*" 190–91.

23. Akiyama Terukazu, "Rōdo shatō." In a broad sense Akiyama and Li Yongting and Cai Weitang draw on the early articles of The Magic Competition bianwen and wall paintings by Jin Weinuo, "Zhiyuanji tu kao" and "Zhiyuanji tu yu bianwen," both originally published 1958.

24. For an important theoretical study on oral culture, see Walter Ong, *Orality and Literacy.*

25. The supremacy of the oral version of a narrative over written versions is discussed in Kuipers, *Power in Performance*, 2–5.

26. Sengyu's 僧祐 catalog, *Collected Notes on the Formation of the Tripiṭaka*, is traditionally dated ca. 506–12; T.2145:55.67c. The relevant passage is translated in Mair, *Painting and Performance*, 39–40.

27. Mair, *Painting and Performance*, 39–40; Demiéville, *Répertoire du canon bouddhique*, 31, 245; Lévi, "Le sūtra du sage et du fou," 312–13; Takakusu Junjiro, "Tales of the Wise Man and the Fool," 458–59; Akiyama Terukazu, *Heian jidai*, xxxi, 394; Vandier-Nicolas, *Sariputra et les six maîtres*, 2.

28. Takakusu Junjiro lists all sixty-nine stories. "Tales of the Wise Man and the Fool," 448–52. He characterizes the Sūtra of the Wise and Foolish as "a sort of Jataka or Avadāna," p. 447; Lévi, "Le sūtra du sage et du fou," 313, states the sūtra emerged from the avadāna (origins or causes of ensuing effects) literature; Vandier-Nicolas, *Sariputra et les six maîtres*, 2, considers it part of the vinaya tradition. The Taishō guide places it in the second collection of avadānas *benyuan* 本緣; Demiéville, *Répertoire du canon bouddhique*, 31.

29. 如是我聞. T.202:10, 419–23.

30. "Sudatta Erects a Temple" is preceded by the tale of King Maitrībala giving his blood and followed by "Koda Offering His Body," T.202:10, 418a, 422b–23a. Takakusu Junjiro, "Tales of the Wise Man and the Fool," 449, identifies these stories in sections labeled II and III, numbers 13–15, although this numeration does not correspond to that in the Taishō canon.

31. The textual history of "Sudatta Erects a Temple" is briefly as follows. Two texts associated exclusively with the competitions (although these contain four, not the six found in T.202:10, Sūtra of the Wise and Foolish) are: T.1450:7 根本説一切有部毗奈耶破僧事, related to an earlier vinaya of the *Mūlasarvāstivādins*, and T.191:12 (眾許摩訶帝經 Mahā-sammatarāja Sūtra). See Eugene Eoyang, "Word of Mouth,"

158–59; Matsumoto Eiichi, *Tonkō ga no kenkyū*, 1: 201–11. One of the contests appears in the *Record of the Western Regions* (T.2087 大唐西域記, 室羅伐悉底國條), a chronicle of Xuanzang's journey to India; this early Tang account eventually becomes the basis for the *Xiyou ji* 西游記 or *Monkey*, the popular Ming novel.

32. The story of the search for a parkland on which to build the temple is imbedded in many sūtras as part of a larger narrative. It also exists in a record (*ji* 記) that has slightly different actors; neither form contains the contests. Two Dunhuang texts (P2344 and P3784), ca. ninth–tenth century, entitled 祇園圖記 (The Record of the Jetavana Garden Picture), are examples of how the garden tale circulated as a separate story. P2344 and P3784 are reproduced in Akiyama Terukazu, *Heian jidai*, 433–34, pls. 174–75.

33. Buswell, *Chinese Buddhist Apocrypha*, 17, passim.

34. This does not mean there could not have been a Khotanese oral text from which these monks borrowed.

35. Most writers on this subject from 1901 to 88 maintain that the sūtra has Indian origins. See, for instance, Takakusu Junjiro, "Tales of the Wise Man and the Fool," 453; Mair, *Painting and Performance*, 40. Vandier-Nicolas, *Sariputra et les six maîtres*, 2, asserts it has Chinese origins.

36. One of the most popular tales in Chinese vernacular literature is the search of Mulian (Maudgalyayana) for his mother in Hell. Significantly, it emerges from one of the apocryphal classics, the Sūtra of the Pure Land Ullambau (Jingtu yulanben jing, P2185; Damukanlian mingjian jiumu bianwen pingtu, T.2858), rather than a sūtra of Indian origins. Buswell, *Chinese Buddhist Apocrypha*, 19, 28–30. The Magic Competition tale has a history similar to the Mulian tale; both ultimately relate to an indigenous tradition and themes of particular interest to the local populace.

37. These typically include texts that deal with filial piety and the afterlife—Chinese concerns that predated Buddhism and were inconsistent with Buddhist Indian conceptions of death; e.g., Sūtra of Requiting Parental Kindness (Fumu enzhong jing 父母恩重經, T.2887), The Scripture on the Ten Kings of Hell (Yanluo wang shouji jing, 閻羅王授記經, P2003, S2815, and S3147), and Sūtra of the Contemplation of Immeasurable Life (Amitābha's Western Paradise, Guan wuliangshou jing 觀無量壽經, T.365).

38. Sengyu, *Collected Notes on the Formation of the Tripiṭaka*, cited in Mair, *Painting and Performance*, 39–40.

39. Ibid.

40. McRae, "Encounter Dialogue," 340–41. McRae points out that the encounter dialogue did not emerge in Chan literature until the tenth century; this observation supports my claim that the conversational pretense in the fifth-century sūtra was only in its nascent form.

41. Berling, "Bringing the Buddhist Down to Earth," 62–65 passim, 71, 86. In Indonesian literature the oral, performed version has the most authority. Kuipers, *Power in Performance*. Indeed, that is often true in the Buddhist tradition, in which texts are memorized and recited regularly.

42. Both Eugene Eoyang and Victor Mair briefly note the connection of lively

debates to the story of the encounter between Raudrāksha and Śāriputra. Eoyang, "Word of Mouth," 46 n40; Mair, *Tang Transformation Texts*, 202 n103.

43. Paul Demiéville, *Le concile de Lhasa*, 9–13.

44. The Tibetans eventually chose the latter, rejecting the notion of simultaneous illumination. The differences between these two traditions is simplified for discussion. On the quietist, nonscholastic Chan school and the intricate ritual tradition of Yogācāra-Mādhyamika of India, see Ruegg, *Buddha Nature*, 56.

45. Whether the Lhasa debate happened the way it is recounted in P4646 is questionable. See Ruegg, *Buddha Nature*, 56–67. For the purposes of this argument, it does not matter; the point is that a Dunhuang writer in the ninth–tenth centuries perceived religious practice debates in such binary terms as oral/aural events, no doubt reflecting on some level local temple activities. The chronicler, Wang Xi, was an inspector (*guancha* 觀察) in the governor's office of Hexi (Dunhuang area). The text of the debate is reproduced in Demiéville, *Le concile*, planches 1–32.

46. On the Three Teachings debates, see Hartman, *Han Yü*, 129, 319 n24. On the Chan style of teaching through encounter dialogues, see McRae, *The Northern School*, 73–74, 95.

47. Both Ruegg and McRae characterize debates in Buddhist circles as a creative tension, suggesting that philosophical differences couched in terms of bipolar opposition were tolerated, even encouraged. Ruegg, *Buddha Nature*, 136; McRae, "Encounter Dialogue," 362.

48. On the history of the Tibetans in Gansu, see Beckwith, *The Tibetan Empire in Central Asia*.

49. The Tibetans augmented the population of the Dunhuang-area temples by making prisoners into temple dependents or households (*sihu* 寺户) (P3918; S0542); they also regularly gave oil for lamps, apparently an important gesture to the local populace that enabled them to maintain ritual schedules. Jiang Boqin, *Tang Wudai*, 9–12. On the Tibetans' social control, see Rong Xinjiang, "Mthong-Khyab," 294–97.

50. Zhang administered eleven prefectures. Rong Xinjiang, "Mthong-Khyab," 282.

51. For a detailed analysis of the title *jiedu shi*, see Pulleyblank, *The Background of the Rebellion of An Lu-shan*, 140–52, n32. For an in-depth study of the office and variations of the title, see Rong Xinjiang, "Shazhou guiyijunli renjiedushi," 32, passim.

52. Shi Weixiang, "Guanyu Dunhuang Mogaoku neirong zonglu," 194.

53. For reproductions of prints of Vaiśravaṇa and others, and a discussion of Vaiśravaṇa as the deity most called upon to guard against threats to the territory, see Cohen and Monnet, *Impressions de Chine*, 53–56.

54. 觀察處•置*管內營田押蕃. Emphasis mine. Whitfield and Farrer, *Caves of the Thousand Buddhas*, pl. 108, 101–6. •Modern variant; *modern variant for medieval character; Morohashi no. 543.

55. Caves 98 and 61 are important examples. For the latter, see Dorothy C. Wong, "A Reassessment."

56. One of the donor portraits in cave 61 depicts the Khotanese wife of Cao Yanlu and her retinue; the Cao family had previously married one of their daughters to the

king of Khotan. *Zhongguo meishu quanji*, 60 and pl. 168. Also Rong Xinjiang, "Mthong-Khyab," 288.

57. 破魔軍. Transcription of P4524 in Vandier-Nicolas, *Sariputra et les six maîtres*, facsimile of painting and text, last page.

58. Reproductions are found in *Zhongguo meishu quanji*, 15: pls. 99, 100.

59. Hartman, *Han Yü*, 85, 129.

60. It should be pointed out, however, that the emperor's concubines, who numbered in the hundreds throughout the Tang, were comprised of a real mélange of women given to the court by tributary powers.

61. Transcription of text in Vandier-Nicolas, *Sariputra et les six maîtres*, facsimile of painting and text, last page; translation, modified, from Eugene Eoyang, "Word of Mouth," 273–74.

62. The Magic Competition judge was the (imaginary and mythological) king of Śrāvastī. The Tibetan king Khri Sron lde btsan, who ruled 755–94 (?), was probably present at the historical great debate. See Ruegg, *Buddha Nature*, 57, 60.

63. The lavishness of the park-temple project is obvious. The heretics question the spending as a pretext for canceling the project. Their disapproval of spending on Buddhist projects (in the bianwen) is similar in tone to Han Yu's famous memorial (ca. 819) to the throne in which he denounces the religion; his jealousy of imperial generosity for Buddhist causes is evident. Dunhuang bianwen translation in Mair, *Tun-huang Popular Narratives*, 53, 56, 57. Han Yu memorial translated in Hartman, *Han Yü*, 84–86.

64. The most significant change is the increasing emphasis on the six contests and their transformed order. The Sūtra of the Wise and Foolish begins rather than ends with the wind and tree. Sūtra order: 1) tree/wind; 2) water/elephant; 3) mountain / vajra holder; 4) dragon/bird; 5) ghost or monster / Vaisravana and fire; 6) water/fire. T.202:10, 420b–c.

The order in bianwen passages (P4524 and S5511 / BJ1589): 1) mountain / vajra holder; 2) buffalo/lion; 3) water/elephant; 4) dragon/bird; 5) ghost or monster / Vaiśravaṇa; and 6) tree/wind. Therefore, using the sūtra order, the bianwen episodes are now numbered: 3, new, 2, 4, 5, and 1. The P4524 episodes are in Eugene Eoyang, "Word of Mouth," 269–73; a translation of S5511/BJ1589 is in Mair, *Tun-huang Popular Narratives*, 74–83; on discrepancies of order, see Akiyama Terukazu, *Heian jidai*, 429–32. P4524 does not contain the final episode of the tree and wind. The "order" of the episodes in the murals is not so easily determined; they are not numbered or presented in a linear text.

65. This is the bianwen of The Magic Competition mentioned above; it consists of two parts split between the British Museum (S5511) and the Beijing National Library (散文 1589); translated in Mair, *Tun-huang Popular Narratives*, 31–84; transcribed in Wang Zhongmin, *Dunhuang bianwenji*.

66. Eugene Eoyang believes texts labeled 變 *bian* are literature at a stage of vernacular lecture closer to performance, rather than the bianwen, which were copied and recopied versions of those performances. "Word of Mouth," 157–58. Mair thinks the two terms are interchangeable. *Tang Transformation Texts*, 14. Note, however, that

despite the title "bian" (literally "a transformation"), Kanaoka Shōkō believes this to be a sūtra lecture or yazuowen. *Tonkō no bungaku*, 11: 371.

67. "This" refers to The Magic Competition tale given a variant title, "Smashing the Demons, one chapter" (破魔變一卷, *pomo bian*), P2187. The first of these binomes, "pomo," is a homophone for "splashing ink" (*pomo* 潑墨). Ink splashing was a landscape painting technique that became popular during the Tang dynasty. See Munakata, "The Rise of Ink-Wash Landscape Painting."

68. The colophons are transcribed and translated in Strassberg, "Buddhist Storytelling Texts," 49, 88. Strassberg mentions that although others think the monastic controller delivered the bianwen, the evidence does not seem to support this view.

69. Ibid., 47, 88.

70. Ibid., 50. It seems these texts were documents for personal use rather than for the donors or hosts.

71. This issue is discussed in depth by Johnson, "The Wu Tzu-hsü *Pien-wen*," pt. 1: 101–4; Eugene Eoyang, "Word of Mouth," 156–57, passim; and Mair, *Tang Transformation Texts*, 36–72. Strassberg states that most bianwen were too stylized to function as prompt texts; even if performed, they would not have been understood by most audiences, and therefore they were exclusively literary products. "Buddhist Storytelling Texts," 44–45.

72. A photo reproduction of the last portion of BJ1589, where this phrase appears, is in Mair, *Tun-huang Popular Narratives*, 30, pl. 2; for a detailed discussion of the meaning of the term and a summary of the relevant scholarship see ibid., 27–28.

73. See, for instance, Mair's translation of S5511 and BJ1589 in *Tun-huang Popular Narratives*, 79–80. The dragon and golden-winged bird section (discussed below) is but one example of how the writer retells the episode within a very short space.

74. As mentioned earlier in the review of literature on The Magic Competition, specialists dispute whether this scroll was actually used by a performer or is a re-creation of such a document, perhaps for a wealthy or devout fan. As shown, even performers made copies of their own lectures after the fact. This problem is probably unresolvable, but ultimately moot, I think. Strassberg describes how performers' promptbooks (*diben*) gave rise to a bianwen and other types of vernacular literature. The storyteller's script was transformed into manuscripts that satisfied the literate (reading) audience's demand for written versions. "Buddhist Storytelling Texts," 54–55.

75. However, P4524 has no text or picture corresponding to the gale/tree encounter; although the scroll is damaged at the end, the last section of text appears to finish resolutely with the conversion of the heretics without any mention of the wind struggle. Three explanations are possible: 1) the damaged end portion (completely broken off) contained the battle; 2) the wind battle was not included; or 3) the artist and storyteller placed the wind/tree fight at the beginning (which also sustained damage), recalling the configuration in the fifth-century sūtra. I think the evidence supports the third interpretation.

76. This observation is made by Eugene Eoyang, "Word of Mouth," 49.

77. This is the only extant example from China of a storytelling scroll. But since

it is uncertain if the text and actual performance were linked, we can only speculate about how the text may have been used.

78. Mair, "The Narrative Revolution."

79. On the dramatic aspects of performance literature in the Tang dynasty, see Johnson, "*Mu-lien* in Pao-ch'uan," 94–95.

80. Akiyama emphasizes how the garden lecture by the Buddha in the Diamond Sūtra is the most complete reference to the story without the competition discussed. See Akiyama Terukazu, "Rōdo shatō," 3.

81. The printed sūtra (British Library S8210 and also listed in Giles's *Descriptive Catalogue* as P 2 [P = printed]) is well known as the first printed book, although a Sichuan dhāraṇi d. 757 is the first extant Chinese printed page.

82. This development is consistent with a general trend in late Tang and Five Dynasties art. Bo Songnian, "Folk Arts of China," lectures, University of California, Berkeley, Oct. 2–4, 1991.

83. A sole fragment on silk close to the wall painting composition is in the British Museum's Dunhuang collection. It contains parts of images of two heretics screaming and grimacing as they are being toppled in the wind. They lie on an embankment overlooking the pool of water being consumed by an elephant—one of the six competitions between the Buddhists and heretics. This scene corresponds to a center-right position in the wall paintings; apparently, this is the center portion of the painting and is missing considerable portions of the left, right, and top of the finished piece. We have no way of knowing if it was a hanging scroll identical to the murals or whether many portable versions like it existed. The fragment is reproduced in Akiyama Terukazu, *Heian jidai*, pl. 93.

84. Cave 12 was formerly known as cave 10. See Jin Weinuo, "Zhiyuanji tu kao," 382, for an "ordering" of the scenes on two lines; and Akiyama Terukazu, *Heian jidai*, 439, for a photograph, diagram, and transcription of a cartouche.

85. This mural is found in a niche behind a shallow altar unlike the wall paintings across the back (west) or left (north) wall in later caves dated to 890–980. The mural is reproduced in Akiyama Terukazu, *Heian jidai*, 408. See also Wu Hung, "What is *Bianxiang?*"

86. Śāriputra is placed on the (viewer's) right, Raudrākṣa on the left. This order is similar to that in the performance scroll but opposite that in the later wall paintings.

87. Wu Chengen, *Monkey*. The novel has also been translated by Anthony Yu. See *The Journey to the West*.

88. One of The Magic Competition contests actually appears in the Tang-dynasty chronicle of Xuanzang's journey, *Record of the Western Regions* (Xiyou ji) (T.2087 大唐 西域記, 室羅伐悉底國條), suggesting that The Magic Competition shared some of the same drama and performance traditions enjoyed by the Ming-dynasty novel *Monkey*. For a translation of the early chronicle, see Watter, *On Yuan Chwang's Travels*.

89. Wu Chengen, *Monkey*, 234–46.

90. Rare Yuan-dynasty album-leaf pictures of *The Journey to the West* are held in the private family collection of Mr. Yabumoto, Nishinomiya, Japan. These were kindly shown to me in May 1991. That they appear in pictorial form before the Ming

novel substantiates the claim that oral versions of tales share a close history with pictures. This is to say that written narratives cannot be understood as the reason pictures were painted. Written narratives are often the later embodiments of earlier versions in folk and pictorial environments. Or at the very least, they have parallel histories.

91. For twentieth-century opera paraphernalia, shadow puppets, and theater costumes of *Journey to the West*, see Humphrey, *Monkey King*.

92. A scribal note highlights their existence. The writer entreats the audience to return the following day to hear the more formal sūtra recitation of the Mulian bianwen. (Thus, bianwen may be understood as a subcategory of promptbooks for sūtra lectures.) 今日為君宣此事明朝早來聽真經. "Today I have told this story for you; come early tomorrow to hear the real sūtra." Wang Zhongmin, *Dunhuang bianwenji* (Collection of Dunhuang Transformation Tale Literature [bianwen]), 712, cited in Strassberg, "Buddhist Storytelling Texts," 52, 68 n47–48.

93. Sculptures of storytellers, jugglers, and other entertainers unearthed from Han tombs are reproduced in Lucy Lim et al., *Stories from China's Past*, 14–15, 131–35, 143–45.

94. A detailed map of Tang Chang'an and another of the later, Ming Xi'an are found in Wang Renpo, *Sui Tang wenhua*, 8–9 (frontispieces). For archaeological reports of Xi'an excavations (i.e., Tang Chang'an), see Su Bai, "Sui Tang Chang'ancheng."

95. In Qing Beijing, the bell and drum towers were placed along the main north-south axis of the city, directly across the avenue from each other. In Ming dynasty Xi'an, the still-extant bell and drum towers occupy eastern and western sides of the same avenue. Although no vestiges of the earlier, Tang bell and drum towers remain, the principles of symmetry in Chinese architecture permeated the organization of the Tang capital. On either side of its main avenue, the east and west markets, along with countless other structures, effectively divided the urban space into two. A detailed map of the Qing capital is in ter Molen and Uitzinger, *De Verboden Stad*, 20–21. For discussion of Tang-Qing capital planning, see Steinhardt, *Chinese Imperial City Planning*, 1–28. I have found no archaeological evidence of the location of the Tang capital's bell and drum towers.

96. The sounding of bells and drums marks the delight of the *Shijing*'s narrator in a particular lady. *Guanju* 關雎 chapter. "Here long, there short, is the duckweed; On the left, on the right, we gather it. The modest, retiring, virtuous, young lady; With lutes, small and large, let us give her friendly welcome. Here long, there short, is the duckweed; On the left, on the right, we cook and present it. The modest, retiring virtuous young lady; With bells and drums let us show our delight in her." Legge, *The She King*, 1: 4.

97. C. H. Wang, *The Bell and the Drum*, ix, 16–18.

98. Wen Fong, *The Great Bronze Age*, pls. 77–90.

99. On the importance of music, especially bells, in government and social rituals, see DeWoskin, *A Song for One or Two*, 19, 24–25, 45–47, 51 passim. DeWoskin makes the point that musical or aesthetic harmony was thought to be a reflection of nature's patterning of the human mind.

100. Strassberg, "Buddhist Storytelling Texts," 70 n83. In the Dunhuang caves, true east and west are transposed so as to make the caves symbolically conform to Chinese notions of proper placement. The back wall in the caves is really west, but it is considered to be north; the north wall is east; the south wall is west. Nonetheless, even taking into account these adjustments, Raudrāksha appears on the king's left (our right), which is still east. The geographical assignments in the bianwen are not used in the painting.

101. In fact, the presence of literary verses with no prose in a text often indicates a greater closeness to performed pieces whose prose descriptions remain undocumented in written form. An example is the performance scroll P4524 with verses on the back and no prose; prose versions of the tale (bianwen) were written *after* the performance (P2187). Another possible example of this format (verse and pictures used in an oral performance) are the Avalokiteśvara as Savior scrolls (chapter 25 of the Lotus Sūtra) and possibly the Ten Kings of Hell scrolls (P2870 and P2003). These contain lively, dramatic pictures, with verses below (P2010); the scrolls could have been shown to an audience and explained on a different linguistic level than the text found beneath. This format was then codified into "sūtra booklets," crude pictures with colloquial, popular versions of the sūtras (S6983, Avalokiteśvara as Savior; Stein paintings 158* and 212; P4096 and 4098 Diamond Sūtra). The audience or patrons for these would be the semiliterate laity (possibly even monks).

102. Mair, "The Narrative Revolution"; and response by DeWoskin, "On Narrative Revolutions."

103. Much has been written on the grammatical structure of the cartouches that typically end in *shi* 時. Mair, *Tang Transformation Texts*, 82–86. Another scholar has noted, however, that this colloquial vernacular quality of the cartouches does not indicate that the murals were used as props in storytelling performances in the caves. That is, the murals themselves were not the site of sūtra lectures for a lay audience. See Bai Huawen, "Bianwen he bangti," 148.

104. David Chidester, "Word against Light: Perception and the Conflict of Symbols," *Journal of Religion* 65, no. 1 (Jan. 1985): 46–62, cited in Faure, "Space and Place," 345 n17.

105. Ibid.

106. A reproduction of the butcher scene is in the Lo photo archive, no. 85: 9a, Princeton University, Art Library.

107. Johnson, "Scripted Performances," 42–43.

108. It may also be that the sketches were made at two other crucial times in cave production. The year 862, when the earliest late-Tang cave, number 85, was excavated, is a possibility. Or, the sketches could have been made later in the tenth century, when patrons commissioned another group of caves with the theme; that is, the second quarter of the tenth century, when caves 23, 53, and 55 were excavated.

109. Akiyama Terukazu and Wu Hung present opposing models. Akiyama, *Heian jidai*, 422–26, places authority in textual history of the tale; Wu Hung, "What is

Bianxiang?" 138–40, argues for textual and pictorial divergence by demonstrating how the bianwen text and mural cartouches differ.

110. For a study on how the inscriptions and bianwen differ and specific examples of where the cartouches embellish or create new plots, see Wu Hung, "What is *Bianxiang?*" 138–40, 170–92. Wu Hung points out that these Magic Competition wall paintings were not used in storytelling performances as has been a common assumption since Lu Xun began studying bianwen as part of the vernacular literature movement in the 1920s.

111. The Dunhuang artists were unlike the educated painters such as Jing Hao of the tenth century and later amateur painters of the eleventh century who operated fully in a literate sphere.

112. Jonathan Alexander notes a similar division of labor in the French manuscript tradition, where scribes often had more clearly defined identities than did artists. *Medieval Illuminators*, 4–34.

113. P3998 and Stein paintings 83(1) (Figure 2.9a) and 83(2), which are a set of three sketches (now divided between two collections) of the Sūtra of Golden Light, indicate the order of the figure groupings by number and title. These notations, which identify figures by title, e.g., 梵釋四天王 and 三萬大千婆羅門 and 僧慎而耶藥叉, are very different from the narrative texts that appear in the mural cartouches. Pelliot 2868 contains very abbreviated sketches of twelve scenes numbered in a tremulous hand. See Chapter 2.

114. Damaged portions in the Qizil grottoes reveal exposed underdrawing. Ma Shichang, professor of archaeology at Beijing University, indicates that in some areas under wall paintings artists' directions—probably shorthand notes that directed assistants in the application of colors—have been exposed.

115. The making of maṇḍalas is, in some instances, considered a sacred act in itself, and their production would be more suited to monks rather than lay community members. See Chapter 4.

116. Whitfield has suggested that artists of portable paintings prepared the works in advance, leaving all cartouches blank until a donor placed an order. See *The Arts of Central Asia*, 1: 308. There are several problems with this interpretation, however. Artists probably could not afford to buy the expensive silk and apply their labor in advance before a patron was secured. Paintings were commissioned first, I think, then painted. Others speculate that merchants and others traveling through Dunhuang could purchase paintings and have them inscribed to personalize the offerings. Yet works that do contain inscriptions connect them to local elite families, thus eliminating the relevance of the "traveler-as-patron" theory.

117. Akiyama Terukazu, *Heian jidai*, 422–26.

118. As mentioned earlier, evidence culled from scribal notes that follow copies of bianwen and sūtra lectures (jiangjingwen) proves that monks performed and wrote these texts; e.g., P2187 (Subjugation of the Demons), P2292 (Vimalakīrti Sūtra lecture), and P3107 (Mulian bianwen). Lay students of the temple sometimes copied the texts of the performances (S2614). Strassberg, "Buddhist Storytelling Texts," 51.

119. Cartouches for the Paradise of Bhaiṣajyaguru subplots of the twelve generals and nine violent deaths are also found in the scroll. The Magic Competition text is found in columns 90–136, the longest of the four cartouche texts in the scroll P3304. In its forty-six lines are sixty cartouches, all of which end in "shi." Each is separated by a space or a bracket along the top right corner. In content, the cartouches encompass the entire range of the tale from the search for the garden to the contests. Michel Soymié notes correspondences between this collection of Magic Competition cartouches and those in caves 98 and 55, datable to 923–25 and 962, respectively. He dates the scroll as a whole to after the first quarter of the tenth century. The text for The Magic Competition cartouches in P3304 and photographs of the original text are in Soymié, "Un recueil d'inscriptions," 194–96 and planches 21–23; the question of dating is discussed on pp. 169–70.

120. Li Yongning and Cai Weitang, "Xiangmo bianwen," 190–91.

121. Soymié points out that the disorganization of P3304 would have made it unintelligible to all but specialists. Soymié, "Un recueil d'inscriptions," 204. (There is some speculation that these kinds of texts are copies of completed mural inscriptions; even if this were true, writing notations and visual notations are still resolutely segregated in copy materials from Dunhuang.)

122. Mair, *Tang Transformation Texts*, 110–15; Schneider, "Les copies de sūtra."

123. See Chapter 1 for a discussion of the intertemple supervisory board members and their visits to artists.

124. Fraser, "The Manuals and Drawings of Artists." P2133 signed by the scribe (*chaoshu*) Qingmi is dated to the first month (Jan. 24–Feb. 22), 920; the term *bishou* is used in *Song gaoseng zhuan* 宋高僧傳, T.2061:15.19.

125. Stein paintings 80 and 3961 are reproduced in Whitfield, *The Arts of Central Asia*, 2: pls. 63 and 64, text p. 339. Teiser, "The Growth of Purgatory," 124. For a complete study of Dunhuang and the texts of The Scripture of the Ten Kings of Hell, see Teiser, *The Scripture on the Ten Kings*, 20–30.

126. The argument that artists have a parallel relationship to the written world through oral culture can be made for other medieval cultural traditions, such as in India during the Gupta period, when Sarnath workshops were host to prolific sculptors who created a wealth of Buddhist art. Williams, "Sarnath Gupta Steles."

Chapter 6

1. Shih Shou-ch'ien discusses the difference between "to draw" (*miao* 描) and "to complete" (*cheng* 成) a painting; the latter means "to color." *Fengge yu shibian*, 23.

2. Zhu Jingxuan, *Tangchao minghua lu*, 75. See also Soper, "*T'ang Ch'ao Ming Hua Lu*." The tale is spurious: Li Sixun, who died in 716, could not have participated in the "paint-off" since it is said to have occurred in the Tianbao era (742–55).

3. Three members of the imperial family are listed separately in the *Celebrated Painters of the Tang Dynasty*, before the formal ranking begins. Zhu has little to say about the imperials; and it is a convention that they be placed first, leaving them out of the ranking with professional artists. 一人 means there was only one person in this class.

4. Other honorary epithets given to Wu Daozi include "the Sage of Painting for all time" 後無來者 . . . 畫聖.

5. Zhang Yanyuan, *Lidai minghua ji*, book 2, "On The Brushwork of Gu, Lu, Zhang, and Wu," 22; translated in Bush and Hsio-yen Shih, *Early Chinese Texts*, 62. Bush and Shih translate *su* and *mi* as "dense" and "sparse."

6. 疏*, modern variant of Morohashi 7: 22002. Pronounced *su* or *shu*.

7. For a study on Zhang Yanyuan's text on calligraphy see McNair, "Fa shu yao lu."

8. 心有疏密,手有巧拙,書之好醜, 在心與手,可強為之哉! Zhao Yi, "Fei caoshu" 非草書 in *Fashu yaolu* (Essential Records of Calligraphy Exemplars) in Lu Fusheng, *Zhongguo shuhua quanshu*, I: 31b.

9. A biography of Zhang Yanyuan, concentrating on his interest in calligraphy, precedes the text of the *Fashu yaolu* in Lu Fusheng, *Zhongguo shuhua quanshu*, I: 30. See also McNair, "Fa shu yao lu."

10. "Wei furen bizhentu," *Fashu yaolu*, in Lu Fusheng, *Zhongguo shuhua quanshu*, I: 32b; translated in Barnhart, "Wei Fu-jen's *Pi-chen T'u*," 21.

11. A Dunhuang wall painting commonly cited as an example of the new trend for monochrome painting in the Tang—the figure of Vimalakīrti in cave 103—was originally not monochromatic, as it appears today. It is executed in fine line and was once covered with a pale, gray wash.

12. Elsewhere in Tang literature, references to nature's forces are used to describe painterly practice. The painter Zhang Zao (mid- to late eighth century) was known for his whirlwind-like performances. At a banquet he painted with the force of nature as if "lightening were shooting across the heavens" or "a whirlwind sweeping up into the sky." Fu Zai (d. 813), excerpt from "Preface on Observing Secretary Zhang Painting Pines and Rocks," in Yu Jianhua, *Zhongguo hualun leibian*, 20.

13. Zhang Yanyuan, *Lidai minghua ji*, book 9: 109.

14. 舞畢奮筆俄頃而成, 有若神助,尤為冠絕. Zhu Jingxuan, *Tangchao minghua lu*, 75; translated in Bush and Hsio-yen Shih, *Early Chinese Texts*, 64; and in Acker, *Some T'ang and Pre-T'ang Texts*, Sinica Leidensia XII, II/1: 234.

15. Zhang Yanyuan, *Lidai minghua ji*, book 2, "On the Brushwork of Gu, Lu, Zhang, and Wu," in Yu Anlan, *Huashi congshu*, I: 23; translated in Acker, *Some T'ang and Pre-T'ang Texts*, Sinica Leidensia VIII, II/1: 185.

16. 又畫內殿五龍,其鱗甲飛動,每天欲雨, 即生煙霧. Zhu Jingxuan, *Tangchao minghua lu*, 75; adapted from a translation in Soper, "T'ang Ch'ao Ming Hua Lu," 209.

17. This scroll has graffiti with a date that may provide a *terminus post quem*. It corresponds to either 861 or 921 (assuming it dates to the late Tang–Five Dynasties). This inscription is accompanied by two ineptly drawn horses and some figures (not reproduced). The inscriptions reads: 辛巳年五月六夕金亥千旬／？／施.

18. Sculptures of storytellers, entertainers, and jugglers depicted in action have been unearthed from Latter Han tombs (ca. 20 C.E.); they are reproduced in Lucy Lim et al., *Stories from China's Past*, 14–15, 131–35, 143–45.

19. The figure may be the wind god (*fengshen* 風神).

20. 彎弧挺刃, 植柱構梁, 不假筆界直尺, 虯鬚雲鬢數尺風動 "[His] curved bows, straight blades, vertical pillars, and horizontal beams did not require the use of

marking lines or rulers. Bristling whiskers, curved coiffures, stream out several feet [as if] animated." Zhang Yanyuan, *Lidai minghua ji*, book 2: 22; modified translation from Bush, *Chinese Literati on Painting*, 61.

On drawing haloes: 其圓光立筆揮掃，勢若風施，人皆謂之神助 "Whenever he painted haloes, he never used a compass but completed them in a single stroke." Zhu Jingxuan, *Tangchao minghua lu*, 75–76; translated in Bush and Hsio-yen Shih, *Early Chinese Texts*, 64.

21. This tale was considerably embellished in the Song-dynasty text by Guo Ruoxu, *Tuhua jianwenzhi*, indicating the centrality of the story for later Chinese art historians.

22. This "realism"—in Zhang's own words, "true" or "natural" painting (*zhen-hua*)—as in all other moments in art history, is culturally bound and contextually specific. In the Dutch tradition of still-life and figure painting, brush precision, light source, and illumination are crucial for revealing the most important aspects of objects. In contrast, shading and illumination were little if ever used in Chinese painting. In another example of the how conceptions of realism and space are culturally bound, during late fourteenth- to fifteenth-century Italy, mathematical precision and one-point perspective were understood as the vehicles for realizing objects in two-dimensional space. In the landscape genre, at which Chinese artists excelled, one-point perspective was never used; usually three points of perspective were used simultaneously in the same painting to increase its efficacy and trueness. The treatment of the body is another area where notions of verisimilitude depended on cultural practices. For example, the virtual absence of the nude in Chinese art does not mean that artists and viewers were not interested in depicting the physique but rather that they conveyed "the body" in an equally symbolic language through textiles and other signifiers of health, physical balance, and robustness. Memories of the self could take the form of calligraphy and personal seals could be added directly to almost any type of painting surface. By contrast, during the late Italian Renaissance, naturalism in physique and anatomical correctness were valued for representing the robust body. See Zito and Barlow, *Body, Subject, and Power in China*, introduction, and essay by John Hay, 42–77; Wu Hung and Katherine T. Mino, *Body and Face in Chinese Visual Culture*; Vinograd, *Boundaries of the Self*; Ledderose, *Ten Thousand Things*.

23. "Wu sometimes painted the walls of Buddhist temples, boldly using strange rocks and rushing torrents that seemed as if they could be touched or poured out." 吳 ... 往往於佛寺畫壁，縱以怪石崩灘，若可捫酌 Zhang Yanyuan, *Lidai minghua ji*, book 1, "On Mountains and Waters, Trees and Rocks," 16; translated in Bush and Hsio-yen Shih, *Early Chinese Texts*, 66. An anecdote about Wei Wutian (eighth century) is consistent with the new sense of naturalism in the Tang. "Painters of earlier generations might indicate an animal's anger by a gaping mouth or its contentment with a lowered head, but none could distinguish its temperament with a single movement of the brush or identify its species by dashing off a single hair. What the ancients could not do, only Master Wei could." Zhu Jingxuan, *Tangchao minghua lu*, 80; translated in Bush, *Chinese Literati on Painting*, 58.

24. See my forthcoming article on the problematics of Wu Daozi's biography.

25. Zhang Yanyuan, *Lidai minghua ji*, book 2: 22; translated in Bush, *Chinese Literati on Painting*, 62.

26. While some artists received divine help, others received daemonic help. Du Fu (712–70), the well-known poet, wrote a eulogy to General Cao Ba, whom he described as having received divine intervention as he painted a portrait of Jade Flower, an imperial concubine. Hawkes, *A Little Primer of Tu Fu*, 136–37, 144.

On identifying Buddhist and Daoist strains in philosophical and aesthetic discussions, see Susan Bush, "Tsung Ping's Essay on Painting Landscape and the 'Landscape Buddhism' of Mount Lu," chap. in Bush and Murck, *Theories of the Arts in China*, 132–64.

27. 吳道玄者,天付勁毫,幼抱神奧. Zhang Yanyuan, *Lidai minghua ji*, book 1: 16; translated in Bush, *Chinese Literati on Painting*, 66. Zhang repeats himself on this point in chapter 9 of *Lidai minghua ji*; translated in Acker, *Some T'ang and Pre-T'ang Texts*, Sinica Leidensia XII, II/1: 234.

28. Shigehisa Kuriyama describes how classical notions of hygiene are linked to the proper balancing of personal *qi* and the winds, or energy, of nature; equally important was being able to distinguish when to withdraw. "The Imagination of Winds and the Development of the Chinese Conception of the Body," chap. in Zito and Barlow, *Body, Subject and Power in China*, 24, 36–38.

29. Han Zhuo (d. 1121), author of the 1121 *Shanshui chunquan ji* (Chunquan's Compilation on Landscape), splits this binome and explains each character separately. Although he mistakenly identifies them as two separate laws, his interpretation indicates that the artist's qi or creative spirit should be focused to realize the representation without hesitation. For Han Zhuo, *yun* (resonance) points to achieving a consistent image with the original but hiding technical effort. "The first is called spirit (qi 氣). Spirit means to move the brush in accordance with form and to seize the image without hesitation. The second is called 'resonance' (yun 韻). Resonance means to conceal the obvious when making form and to be refined without vulgarity." Translation, modified, from Robert Maeda, *Two Sung Texts*, 48. Deng Chun's *Huaji*, preface d. 1167, written as a sequel to Zhang Yanyuan's *Record of Famous Painters Throughout the Ages*, notes that Wu Daozi was one of only two artists who achieved the six laws of Xie He, of which *qiyun* is part. Translated in Robert Maeda, *Two Sung Texts*, 81, 90.

30. There is a considerable literature on the distinction between *Daojia* (philosophical Daoism, or school of the Way) and *Daojiao* (Daoism as a religion). A recent symposium and essays in an exhibition catalog have clarified the issues. Little and Eichman, *Taoism and the Arts of China*. Historically, the *Zhuangzi* (perceived as applicable or relevant to government during its early history), was separate from the yinyang schools that merged Legalism with the *Laozi*, also known as *Huanglao* studies. (The latter term is a combination of the first character of *huangdi* [emperor] and *Laozi*). Graham, *Disputers of the Tao*, 170–72. While it is widely recognized that something significant occurred in the second century C.E., namely, the establishment of Daojiao, some dispute the relevance of distinguishing between the "doctrine" and the

"philosophy." Essentially, this divide ceases to be meaningful during the post-Han period when philosophical and practical elements coalesced. See Robinet, *Taoism*, 3; Major, *Heaven and Earth*, 10.

31. Needham, *Science and Civilization in China*, 443; Robinet, *Taoism*, 184–90, passim.

32. Barrett, *Taoism Under the T'ang*, 87, 91–92. On Wuzong's persecution of Buddhism, see Twitchett, *Financial Administration under the Tang*, 69, 82.

33. Robinet, *Taoism*, 190.

34. Translation adapted from Needham, *Science and Civilization in China*, 449.

35. Wei Boyang 魏伯陽, ca. 142 C.E., to whom *The Accordance [of the Book of Changes] with the Phenomenon of Composite Things* or *The Kinship of the Three* 參同契 (Cantong qi), is attributed, is stingy in revealing secrets about chemical potions. "There are directions for the processes, the more important principles of which shall be set forth but the details shall not be divulged." Chou Zhaoao 仇兆鰲 (Qing dynasty), ed., *Guben zhouyi can tonqi jizhu* 古本周易參同契集註 (The Annotated Edition of The Accordance of the Book of Changes with the Phenomenon of Composite Things) (Taipei: Zhengda yingshu guan, 1974); translation in Lu-ch'iang Wu and Tenney L. Davis, "An Ancient Chinese Treatise," 243. In the late Five Dynasties and early Northern Song, Chen Tuan 陳摶 (d. 989) wrote a commentary on the *Cantong qi*. Chen was called to the Later Zhou court in 954 and then served the second Song emperor from 976 to 984 as an alchemist. In turn, Chen's commentary fostered another very influential study of the text by the important Neo-Confucian philosopher Zhu Xi 朱熹 (1130–1200), *A Study of the Kinship of the Three* 參同契考異 (Cantongqi kaoyi; d. 1197), written under Zhu's pseudonym, Zou Xin 鄒訢. Later, Qing writings also deal extensively with these pseudo-scientific texts.

36. Making links between Daoist thought and painting theory is problematic, however. While Daoist connections to art have appeared obvious to some scholars, others have not been so sanguine. During the 1960s, a new generation of American art historians distanced themselves from earlier, less well researched books, such as Mai-mai Sze's *The Tao of Painting* (New York, Pantheon Books, 1956), that treated Chinese painting in a vague, inchoate, and ahistorical way. Max Loehr, in particular, rejected ahistorical or religious explanations for painting. In his Abby Aldrich Rockefeller Inaugural Lecture in 1961, ostensibly about Buddhist art, Loehr argued for dissociating "Buddhism" from "art." Cited in Cohen, *East Asian Art in America*, 172. See also Silbergeld, "Chinese Painting Studies in the West," 860–64, passim. Instead, scholars turned to the implications of Confucian thought, viewed primarily at this time as a moral code, not a religion. Research on amateur literati painters and their theories of self-expression became dominant in the field. See Cahill, "Confucian Elements." The field has changed considerably since then. Despite the negative associations of popular conceptions of Daoism, alchemical notions of creativity, and conceptions of invention are worth another look.

37. Translation adapted from Needham, *Science and Civilization in China*, 448. John Major's translation of and commentary on the *Huainan zi*, the third- to fourth-

century B.C.E. eclectic Daoist book of miscellany, elucidates the importance of the "cyclical, self-created universe" in early China; see *Heaven and Earth*, 1–3, passim. A. C. Graham has studied a range of Daoist texts. See Graham, *Yin-Yang and the Nature of Correlative Thinking*.

38. Needham, *Science and Civilization in China*, 45–46.

39. Fu Zai, "Preface on Observing Secretary Shang Painting Pines and Rocks"; translated in Bush and Hsio-yen Shih, *Early Chinese Texts*, 85. Fu Zai was a poet and official.

40. Robinet explains Daoists developed this technique in response to the challenges and competition posed by Buddhists. The Daoist response is exemplified by the text *The Scripture of Inner Contemplation*. Robinet, *Taoism*, 202–3. The Song manifestation of *neiguan* 內 觀 was *neidan* 內 丹 ("inner cinnabar," referring to immortality elixirs). Ibid., 215.

41. P2762. Translated in Whitfield, *Dunhuang: Caves of the Singing Sands*, 2: 327.

42. A. C. Graham translates *shen* 神 as "daemonic," following Goethe's use of the term. He also refers to Rudolph Otto's use of "numinous" to "identify a power and intelligence higher than and alien to man." Graham, *Chuang-tzu*, 35 n72. On literati uses of Daoism in later critical theory, in the eleventh to the thirteenth centuries, see Bush and Hsio-yen Shih, *Early Chinese Texts*, 48, 191–96.

43. Needham, *Science and Civilization in China*, 443–52.

44. 枯腸得酒芒角出, 肝肺槎 (枒) 生竹石。森然欲作不可回, 寫向君家雪色壁。Su Shi 蘇軾, *Jizhu fenlei dongpo xiansheng shi* 集注分類東坡先生詩 (Collected Annotations of Su Dongpo's Poetry); translated in Bush in *Chinese Literati on Painting*, 35–36; texts, 189.

45. Needham, *Science and Civilization*, 448.

46. Bush, *Chinese Literati on Painting*; Cahill, "Confucian Elements," 114–40.

47. The *Zhuangzi* was written ca. 320 B.C.E. to 205 B.C.E. A. C. Graham and others identify at least five major portions of the text that were written at different times and by different hands over a 120-year period. Tang interpretations of the *Zhuangzi* were filtered through the Guo Xiang recension (312 C.E.). The text itself is divided into three parts (nei, wai, and zapian). Zhuang Zhou or Zhuangzi was said to have lived during the reign of King Hui of Liang (370–319 B.C.E.) and King Xuan of Qi (319–301 B.C.E.). See Graham, *Disputers of the Tao*, 173; H. D. Roth, "Chuang tzu," chap. in Loewe, *Early Chinese Texts*, 56–57.

48. See for instance the passages collected by Graham, *Chuang-tzu*, 170–75.

49. 宋元君將畫圖, 眾史皆至, 受揖而立, 舐筆和墨, 在外者半, 有一史後至者, 儃儃然不趨, 受揖不立, 因之舍. 公使人視之, 則解衣般礡. 嬴君曰: "可矣, 是真畫者也." *Zhuangzi*, 21, "Tian Zifang" 田子方, *Zhuangzi jishi*, 莊子集釋, 314. Translated by Bush and Hsio-yen Shih, *Early Chinese Texts*, 42.

50. The image was also part of the artistic repertoire during the Han dynasty (206 B.C.E.–C.E. 220), although in nascent form. Spiro, *Contemplating the Ancients*, 14.

51. An eighth figure, Rong Qiqi, is usually depicted with the Seven Sages, the latter being a reference to a historical gathering. Rong is understood to be a legendary

character, unrelated to the event. Spiro, *Contemplating the Ancients*, 3, 63. For an overview of the "Homecoming Ode" by Tao Yuanming, see Ebrey, *Cambridge Illustrated History of China*, 100–101.

52. Graham, Zhuangzi, 281. See Graham, *Disputers of the Dao*, 192. Here Graham quotes the famous passage, "Moving, be like water / Still, be like a mirror / Respond like an echo." 其動若水。其靜若鏡。其應若響。 See Zhuangzi 33, "Tianxia" 天下 *Zhuangzi jishi*, 473.

53. On the Daoist exultation of manual labor, see Needham, *Science and Civilization in China*, 121.

54. 庖丁為文惠君解牛,手之所觸,肩之所倚,足之所履,膝之所踦,砉然嚮然, 奏刀騞然,莫不中音。合於桑林之舞,乃中經首之會。 Zhuangzi 3, "Yangsheng" 養生. *Zhuangzi jishi*, 55. Translation by Graham, *Zhuangzi*, 63–64. The butcher's precision is analogous to the carpenter's knack who removes plaster off a human model without a nick. "There was a man of Ying who, when he got a smear of plaster no thicker than a fly's wing on the tip of his nose, would make Carpenter Shi slice it off. Carpenter Shi would raise the wind whirling his hatchet, wait for a moment, and slice it; every speck of the plaster would be gone without hurt to the nose, while the man of Ying stood there perfectly composed." Zhuangzi 24 "Xu Wugui" 徐無鬼. Zhuangzi jishi 莊子集釋, Xinbian zhuzi jicheng 新編諸子集成 (Taipei: Shijie shuju, 1983), 365. Graham, *Disputers*, 175; translation, Idem., *Zhuangzi*, 124.

55. 戒; Needham, *Science and Civilization in China*, 125.

56. Zhu Jingxuan, *Tangchao minghua lu*, 75–76; Zhang Yanyuan, *Lidai minghua ji*, book 2: 22.

57. For a brief period, 543–655 C.E., we see Buddhist references in Turfan tomb documents but no images of the Buddha. See Hansen, "The Path of Buddhism," 50–53. Despite much looting of the tombs of the more valuable objects, it seems no images of Buddhist deities were ever located in the tombs; the people of Turfan kept images of gods above ground only. Fu Xi and Nü Wa were the exception, a measure of their importance. Tombs in Tang Chang'an similarly do not contain Buddhist images. On the Turfan textile trade, see Angela Sheng, "Innovations in Textile Techniques."

58. At least eight paintings of this subject are extant, but hundreds must have been produced. See Xinjiang Weiwuer zizhiqu bowuguan, *Zhongguo bowuguan congshu*, pl. 145 (Astana Tang tomb no. 76); idem, *Xinjiang chutu wenwu*, pls. 115, 116; *Tulufan bowuguan*, pl. 197; and a fifth Tang (seventh–eighth century) example on blue-dyed silk is now in the British Museum, Mu Shunying, *Zhongguo Xinjiang gudai yishu*, pl. 221. Two others are in the Palace Museum Collection, Beijing, and another is in the History Museum in Beijing.

59. Originally Fu Xi and Nü Wa (Gua) were unrelated deities; after yinyang philosophies and concepts spread, perhaps from Shandong, ca. first century C.E., they were frequently paired. Similarly, Xiwangmu (Queen Mother of the West) eventually became paired with a male deity, the Lord of the East. See Wu Hung, *The Wu Liang Shrine*, 12–14, 116–17, 157, 161, 357. Fu Xi and Nü Wa are depicted at least three times

on the Wu Liang family shrine, ca. 151 C.E.; reproduced in Chavannes, *Mission archéologique*, 2: 70, 123, 134, 156 pl. LXXXIII; Major, *Heaven and Earth*, 267. For early Chu (Eastern Warring States, ca. fourth–third c. B.C.E.) Daoist images, see Cook, "Ideology of the Chu Ruling Class," 67–76.

60. Lynn, *The Classic of Changes*, 66, 74 n52. The couple is also associated with the great flood. Cook, "Three High Gods," 2; *Huainanzi*, "Lanmingxun," Sibubeiyao edition, 6.6b–10a, as quoted in Cook, "Three High Gods," 9 n18.

61. Pei Xiaoyuan, preface, translated and excerpted in Bush and Hsio-yen Shih, *Early Chinese Texts*, 49–50.

62. John Major remarks that the once-accepted distinction between "high" Daoism (Daojia) and "low" Daoism (Daojiao) is artificial. Philosophical Daoism is rather a historical term for Daoism before the Han dynasty (founded 206 B.C.E.); religious Daoism is really a reference to a set of practices of the late Eastern Han (25–220 C.E.) and the ensuing periods when Daoism evolved into a practice with followers. *Heaven and Earth*, 10. Therefore, this range of beliefs is coherent to the belief system coming under the title "Daoist."

63. *Zhuangzi* 21, "Tian Zifang" 田子方; *Zhuangzi jishi*, 314. The tale of the drunkard is translated in Legge, *The Texts of Taoism*, 40: 13–14; and Bush and Hsio-yen Shih, *Early Chinese Texts*, 42.

64. 好酒使氣,每欲揮毫,必須酣飲。 Zhang Yanyuan, *Lidai minghua ji*, book 9: 108. The Chinese text is also reprinted in Acker, *Some T'ang and Pre-T'ang Texts*, Sinica Leidensia XII, II/2: 108, and translated there (II/1: 232), as well as in Bush and Hsio-yen Shih, *Early Chinese Texts*, 64, from which the translation here has been adapted.

65. Drinking could also have negative associations. In the eleventh century, Mi Fu, for instance, criticized wild-cursive calligraphers, such as Wu Daozi's teacher Zhang Xu, in the context of promoting a particular lineage of calligraphic spontaneity. Su Shi also derided Zhang Xu's drinking. Sturman, "Wine and Cursive," 215, 221. It is clear that by this period, wine and cursive calligraphy—important in Wu Daozi's praxis—were intimately linked.

66. On spontaneity and immediacy as ideals in Su Shi's poetry, see Fuller "Pursuing the Complete Bamboo." A. C. Graham explores spontaneity in Asian and European cultures in *Reason and Spontaneity*, 1–55.

67. On the famous critic and calligrapher Mi Fu and his notion of "intentionally practicing spontaneity," see Ledderose, *Mi Fu and the Classical Tradition*, 56–58.

68. Quotation cited in Gregory, "Conference Report," 484; also cited and discussed in Faure, *Rhetoric of Immediacy*, 33.

69. Of course, this sudden enlightenment was just a version of the mediated approach to enlightenment, for the former cannot be represented in form or discussed on any level. Both sudden and gradual are different versions of the gradual. Faure, *Rhetoric of Immediacy*, 36, 40.

70. On Dong Qichang's use of the northern and southern schools paradigm to explain the history of painting, see James Cahill, "Tung Ch'i-ch'ang's 'Southern and Northern Schools'"; Levenson, "The Amateur Ideal," 22–24. The northern/southern

split has been used to describe the gradual/sudden schism in Chan polemics; however, the "southern" refers to southern India, from whence Bodhidharma was said to have brought Buddhism to China. Faure, *Rhetoric of Immediacy*, 13.

71. Cahill, "Style as Idea," 140–41. See also Silbergeld, "Chinese Painting Studies in the West," 863.

72. Lynn, "Sudden and Gradual in Chinese Poetry Criticism," 384.

73. R. A. Stein differs from other scholars in his understanding of *dunwu*. In an analysis of Tibetan texts that reflect the earliest debates in the Chan over this issue (culminating in the famous Council of Lhasa in 780 C.E.), Stein finds that *dun* is more analogous to "simultaneous" than "sudden." The difference is in cognitive perception between the two, the former indicating comprehension (or enlightenment) that "happens all at once" rather than just "suddenly." Stein, "Sudden Illumination," 43–44 n50.

74. McRae, "Shenhui and the Teaching of Sudden Enlightenment," 229. I am indebted to the essays in Gregory, *Sudden and Gradual*, which address the sudden/gradual distinction in religion, poetry, and art.

75. Faure, *Rhetoric of Immediacy*, 43–45.

76. On the radical interpretation of subitism and for a translation of the ninth-century Zen philosopher Zongmi's description in the "Subcommentary on the Perfect Enlightenment Sūtra," see Jeffrey Broughton, "Early Ch'an Schools in Tibet," in Robert M. Gimello and Peter N. Gregory, eds., *Studies in Ch'an and Hua-Yen* (Honolulu: University of Hawaii Press, 1983): 38–40. Cited in Faure, *Rhetoric of Immediacy*, 60.

77. Faure, *Rhetoric of Immediacy*, 40, 54.

78. Biography was a way to privilege sudden enlightenment, Wendi Adamek argues, because existing genres and paradigms were perceived as inadequate. Adamek, "Issues in Chinese Buddhist Transmission," 7–8, passim.

79. Ibid., 37.

80. Faure, *Rhetoric of Immediacy*, 39.

81. Granet, *La pensée chinoise*, 115–48, Graham, *Yin-Yang and the Nature of Correlative Thinking*, 10, 30–31, 70–73; Paul Demiéville, "Le vocabulaire philosophique chinois," cited in Faure, *Rhetoric of Immediacy*, 36–37; Wu Hung, "The Transparent Stone."

82. Plaks, "Towards a Critical Theory of Chinese Narrative," 335–38.

83. On Dunhuang painting, see Fraser, "Narrative Strategies in Murals of *The Magic Competition Between Sariputra and Raudraksha*"; on complementarity in early ritual and writing, see Myhre, "The Eater and the Eaten"; and Cook, "The Inner and the Outer."

84. Mili, *Picasso's Third Dimension*, 10–29.

85. Yanagida Seizan, "Li-Tai Fa-Pao Chi," 19.

86. It should not surprise us that literati would draw from the rhetoric of Chan experience to describe painting; intellectuals, such as the lay Buddhist writer and painter Cong Bing (375–443), used Buddhist terminology in essays beginning in the Northern and Southern Dynasties.

87. *Pingchang xin shi dao*, a Buddhist phrase, is a reduction of the ziranzhi notion articulated in Daoist philosophy. The former characterizes the Mazu school, which Zongmi, a ninth-century Chan theorist, felt was a debasement of Shenhui's teachings. See Yanagida Seizan, "The Li-Tai Fa-Pao Chi," 20; and idem, "The 'Recorded Sayings,'" 186–88.

88. Yanagida Seizan, "Li-Tai Fa-Pao Chi," 19.

89. On thaumaturges and tricksters, see Faure, *Rhetoric of Immediacy*, 96–129.

90. Something about his name encourages this line of thought. Daozi, or "one who follows the Dao," is an unusual name for a painter. "Dao" is typically found in the names of monks or followers of the Buddhist dharma or law; for example, Daoxuan 道璿 (702–60), a disciple of Puji, and Daoxin 道信 (580–651), an early teacher of Chan. On the other hand, *zi* 子 is typically applied to the names of sages and teachers; for example, it is the second component in the names of Laozi, Mengzi, and Kongzi (Confucius). Wu might have earned this title for his sagacity. Also, the *dao* character in his name is rendered less prominent when we consider the alternative character that was used in his name: Wu Daoxuan 吳道玄. This second sobriquet does not have the religious connotation associated with Daozi.

91. Zhu Jingxuan, *Tangchao minghua lu*, 75; translation in Soper, "*T'ang Ch'ao Ming Hua Lu*," 209.

92. Yampolsky, *The Platform Sūtra*, 127.

93. See also P4098, Stein paintings 212 and 158* (the latter reproduced in Whitfield, *The Arts of Central Asia*, 2: fig. 94), and S5646 (ibid.: fig. 93). The last one is a *Dizang pusa jing* (Sūtra of the Bodhisattva Kṣitigarbha) dated to the late ninth century. The drawings in these new prayer booklets accompany simplified versions of sūtras in colloquial language.

94. Grace Yen of the Academia Sinica, Taipei, has written a paper (unpublished and unavailable for consultation) on Tantrism and Wu Daozi.

95. Hartman, *Han Yü*, 84–85, 129, 148. Eventually, Han was censored.

96. Mackenzie, "The Origins of the Blue-and-Green Style," 153–54. Other scholars have associated the blue-and-green style with Daoism. See Silbergeld, "Chinese Painting Studies in the West," 869; Schafer, "Mineral Imagery"; and John Hay, "Huang Kung-wang's 'Dwelling in the Fu-ch'un Mountains,'" 295.

97. Mackenzie, "The Origins of the Blue-and-Green Style," 153–54.

98. The fugu movement was a Tang literati response to larger changes and forces in society that privileged a simplified but dynamic aesthetic. Despite the aversion to foreign models inherent in this movement, Buddhism by the Tang had irreversibly altered and enriched Chinese literature, language, and society. Mair, *Tun-huang Popular Narratives*, 13–26.

Bibliography

Primary Sources of Financial Accounts, Eulogies,
Merit Records, Bianwen, Administrative Papers, and Artists' Drawings

BEIJING NATIONAL LIBRARY

Beijing National Library (散文 1589)

BIBLIOTHÈQUE NATIONALE DE FRANCE

P120; P2002; P2003; P2012; P2032; P2049; P2133; P2168; P2185; P2187; P2292; P2613;
P2629; P2641; P2718; P2762; P2824; P2868; P2870; P2913; P2991; P2993; P3050;
P3067; P3107; P3234; P3302; P3304; P3432; P3565; P3608; P3638; P3716; P3720;
P3939; P3964; P3998; P4004; P4044; P4049; P4082; P4096; P4098; P4514.16(2);
P4515; P4517(1–9); P4518(11); P4518(33); P4518(34); P4518(36); P4518(38); P4524;
P4638; P4640; P4908; P4979; P5018(1); P. tib. 1293(1–3)

BRITISH LIBRARY

S1519; S1947; S2687; S2949; S2973; S3147; S3540; S3929; S3961; S4037; S4211; S4257.2;
S4373; S4632; S4706; S5511; S5656; S5973; S6348; S8210; S9137; P.2

BRITISH MUSEUM

Stein paintings 44(1–5); 72; 73(1); 76; 77; 83*; 83(1); 83(2); 163, 172; 173; 174; 245; 249;
259; 260

OTANI COLLECTION

Otani document 3774 (Tuyugou)

XINJIANG AUTONOMOUS REGIONAL MUSEUM,
ARCHAEOLOGICAL INSTITUTE OF XINJIANG, AND THE TURFAN MUSEUM

72TAM153: 29, 30; 73TAM210: 12–1 (2)
64TKM1: 28(b)31(b); 64TKM1: 37(2)b; 66TAM61: 16a; 66TAM61: 27(5)a

Primary Sources on Art

Deng Chun 鄧椿. *Huaji* 畫繼 (More on Painting), preface d. 1167. In *Huashi cong-shu*, vol. 1, ed. Yu Anlan.

Fu Zai 符載 (d. ca. 813). *Guan Zhangyuan wai hua songshi xu* 觀張員外畫松石序 (Preface on Observing Secretary Zhang Painting Pines and Rocks). In *Zhongguo hualun leibian*, vol. 1, ed. Yu Jianhua.

Guo Ruoxu 郭若虛. *Tuhua jianwen zhi* 圖畫見聞志 (The Record of Things Seen and Heard [about] Paintings and Drawings), completed ca. 1080–1085, ed. Huang Miaozi 黃苗子. Shanghai: Renmin meishu chubanshe, 1963.

Han Zhuo 韓拙 (active ca. 1095–ca. 1125). *Shanshui chunquan ji* 山水純全集 (Chunquan's Compilation on Landscape), preface d. 1121. In *Hualun congkan*, ed. Yu Anlan. Also in *Meishu congshu*, comp. by Huang Binhong and Deng Shi.

Huang Xiufu 黃休復. *Yizhou minghua lu* 益州名畫錄 (Record of Famous Painters of Yizhou [Sichuan]), ca. 1005–6. In *Huashi congshu*, vol. 1, ed. Yu Anlan.

Jing Hao 荊浩 (fl. 907–23). *Bifa ji* 筆法記 (A Note on the Art of the Brush). Ed. translation by Kiyohiko Munakata. Ascona: Artibus Asiae Publishers, 1974.

Liu Daoshun 劉道醇. *Shengchao minghua ping* 聖朝名畫評 (Critique of Famous Painters of the Present Dynasty), ca. 1059. Trans. by Charles Lachman as *Evaluations of Sung Dynasty Painters of Renown*. Monographies du T'oung Pao, vol. 16. Leiden: Brill, 1989.

Tang Hou 湯垕. *Hua Lun* 畫論 (A Discussion on Painting), ca. 1320–30. In *Meishu congshu*, comp. Huang Binhong and Deng Shi.

Xia Wenyan 夏文彥. *Tuhui baojian* 圖書寶鑒 (Precious Mirror for Examining Painting), d. 1365. In *Huashi congshu*, vol. 1, ed. Yu Anlan.

Xuanhe huapu 宣和畫譜. (Painting Catalog of the Xuanhe Era), preface d. to 1120. In *Huashi congshu*, vol. 1, ed. Yu Anlan.

Zhang Shinan 張世南. *Youzhen jiwen* 游宦紀聞 (Experiences of a Provincial Official), ca. 1208–33. In *Zhibuzu zhai congshu* 知不足齋叢書 (Collected Books of the Studio of Insufficient Knowledge), book 7.

Zhang Yanyuan 張彥遠. *Lidai minghua ji* 歷代名畫記 (Record of Famous Painters Throughout the Ages), ca. 845–47. In *Huashi congshu*, vol. 1, ed. Yu Anlan.

Zhao Xigu 趙希鵠. *Dongtian qinglu (ji)* 洞天清錄(集) (Compilation of Pure Earnings in the Realm of Immortals), ca. 1242. In *Meishu congshu*, comp. Huang Binhong and Deng Shi.

Zhu Jingxuan 朱景玄. *Tangchao minghua lu* 唐朝名畫錄 (Celebrated Painters of the Tang Dynasty), ca. 842. In *Huapin congshu*, ed. Yu Anlan.

Buddhist and Daoist Texts

Dacheng dingwang jing 大乘頂王經 (Mahāvaipulyamūrdharāja Sūtra). T.478.

Damuganlian mingjian jiumu bianwen bingtu 大目乾連冥間救母變文并圖 (Transformation Text on Mahāmaudgalyāyana Rescuing His Mother from the Underworld, With Pictures). T.2858.

Datang xiyu ji 大唐西域記, 室羅伐悉底國條 (Record of the Western Regions, Śrāvasti section). T.2087.

Fumu enzhong jing 父母恩重經 (Sūtra of Requiting Parental Kindness). T.2887.

Guan wuliangshou jing 觀無量壽經 (Sūtra of Immeasurable Life, Amitāyurbuddhānusmṛtisūtra Sūtra), Sukhāvatī (the Western Paradise). T.365.

Huayan jing 華嚴經 (Flower Garland Sūtra, Avataṁsaka Sūtra). T.278, T.279.

Jingang panruopoluomi jing 金剛般若波羅蜜經 (Diamond Sūtra, Vajracchedikā). T.235.

Jingtu yulanpen jing 淨土盂蘭盆經 (The Sūtra of the Pure Land Ullambau, Ullambanapātra). T.685.

Jinguangming zuishengwang jing 金光明最勝王經 (Sūtra of Golden Light, Survarṇaprabhāsa-uttamarāja Sūtra). T.665.

Laoducha dousheng jingbian 勞度叉鬥聖經變 (The Magic Competition; aka Xiangmobian, Subjugation of the Demons), in Xianyu jing 賢愚經 (Sūtra of the Wise and Foolish). T.202.

Longkan shoujing 龍龕手鏡 (Hand Mirror of the Dragon Niche). Beijing: Zhonghua shuju, 1985.

Mile xiasheng chengfo jing 彌勒下生成佛經 (Sūtra of Maitreya's Paradise [Life After Maitreya's Coming as a Buddha], Maitreya-vyākaraṇa). T.454.

Pan Chonggui 潘重規, ed. *Longkan shoujing xinbian* 龍龕手鏡新編 (The newly edited Longkan shoujing). Beijing: Zhonghua shuju, 1988.

Sengyu 僧祐, Collected Notes on the Formation of the Tripitaka. Traditionally dated ca. 506–12 C.E. T.2145.

Song gaoseng zhuan 宋高僧傳 (The Biography of Eminent Monks). T.2061.

Weimojie jing 維摩詰經 (The Debate Between Vimalakīrti and Mañjuśrī, Vimalakīrtinirdeśa Sūtra). T.474, T.475.

Xianyu jing 賢愚經 (The Sūtra of the Wise and Foolish). T.202.

"Xuda qi qingshe" 須達起精舍 (Sudatta Erects a Temple) in Xianyu jing 賢愚經 (The Sūtra of the Wise and Foolish), T.202; and Genbenshuo yiqie youbu pinai yepo zengshi 根本説一切有部毗奈耶破僧事 (Vinaya of the Mūlasarvāstivādins), T.1450: 7, and Zhongxu mohe dijing 眾許摩訶帝經 (Mahā-sammatarāja Sūtra), T.191: 12.

Zhaoxiang liangdu jingjie 造像量度經解 (A Commentary on the Sūtra of Measurements in the Making of Icons, Pratimālakṣaṇa) by Mgon po skyabs 工布楂布 (Mongolian scholar of Tibetan studies), ed., ca. 1742–43. T.1419.

Edited Editions of Texts

Carnet de Notes de Paul Pelliot. *Inscriptions et peintures murales, Mission Paul Pelliot, documents conservés au Musée Guimet*. Documents Archéologiques, vol. 11: 1–6. Paris: Collège de France, 1981–92.

Les Grottes de Touen Houang. Peintures et sculptures bouddhiques des époques des Wei, des T'ang et des Song. 6 vols. Paris: P. Geuthner, 1914–24. (Mission Pelliot en Asie Centrale I).

Guojia wenwuju guwenxian yanjiushi, Xinjiang Weiwuer zizhiqu bowuguan 國家文物局古文獻研究室, 新疆維吾爾自治區博物館, Wuhan daxue lishixi 武漢大學歷史系 (Ancient Document Research Unit of the National Cultural Relics Board, Xinjiang Museum, and the History Department, Wuhan University), eds. *Tulufan chutu wenshu* 吐魯番出土文書 (Manuscripts Excavated from Turfan). 10 vols. Beijing: Wenwu chubanshe, 1981–90.

Huang Binhong 黃賓虹, and Deng Shi 鄧實, comps. *Meishu congshu* 美術叢書 (Collected Works on Fine Arts). Shanghai: 1947. Reprint, Taipei: Yiwen yinshuguan, 1975.

Li Linfu 李林甫, ed. *Tang liudian* 唐六典 (The Six Tang Canons). 14 vols. Beijing: Zhonghua shuju, 1992.

Liu Wendian 劉文典, ed. *Zhuangzi buzheng* 莊子補正 (Complete Works of Zhuangzi). Shanghai: Shangwu yinshu guan, 1947. Reprint, Kunming: Yunnan renmin chubanshe, 1962.

Lu Fusheng 盧輔聖, ed. *Zhongguo shuhua quanshu* 中國書畫全書 (Complete Texts of Chinese Painting and Calligraphy). Shanghai: Shanghai shuhua chubanshe, 1993.

Su Dongpo 蘇東坡. *Jizhu fenlei dongpo xiansheng shi* 集註分類東坡先生詩 (Collected Poems), in Sibu congkan 四部叢刊. 3 series, compiled by Chang Yuanqi 張元濟 et al. Shanghai: Hanfenlou, 1919–36.

Takakusu Junjiro 高楠順次郎, and Watanabe Kaigyoku 渡邊海旭, eds. *Taishō shinshū daizōkyō* 大正新修大藏經 (Buddhist Canon of Texts). 84 vols. Tokyo: Issaikyō kankōkai, 1912–25.

Tang Gengou 唐耕耦, and Lu Xiongxi 陸鴻基, eds. *Dunhuang shehui jingji wenxian zhenji shilu* 敦煌社會經濟文獻真蹟釋錄 (Annotated Catalog of the Original Records [Photos] of the Social and Economic Documents of Dunhuang). Research Center of Dunhuang and Turfan Materials of the Beijing Library. Beijing: Microfilm Copying Center of Documents, National Library, 1990.

Yu Anlan 于安瀾, ed. *Hualun congkan* 畫論叢刊 (Collected Reprints on Painting Theory). Shanghai: Renmin meishu chubanshe, 1962.

———, ed. *Huashi congshu* 畫史叢書 (Compendium of Painting Histories). Shanghai: Shanghai meishu renmin chubanshe, 1963. Reprint, Fukushima, Japan: Kokushō kankōkai, 1972.

———, ed. *Huapin congshu* 畫品叢書 (Compendium of Art Writings). Shanghai: Shanghai renmin meishu chubanshe, 1982.

Zhong Renjie 鐘人傑, ed. *Tangsong congshu* 唐宋叢書 (Tang and Song Collectanea). In *Baibu congshu jicheng* 百部叢書集成 (Compilation of the Hundred Part Collectanea). 20 vols. Taipei: Yiwen yinshuguan, 1965.

Zhongguo wenwu yanjiusuo 中國文物研究所 (Chinese Cultural Relics Research Institute). Xinjiang Wewuer Zizhiqu Museum and Wuhan daxue lishi xi 武漢大學歷史系, eds.; Tang Zhangru, chief ed. *Tulufan chutu wenshu* 吐魯番出土文書 (Manuscripts Excavated from Turfan). 4 vols. Beijing: Wenwu chubanshe, 1992.

Zhuangzi jishi 莊子集釋 (Collected Works of Zhuangzi). Xinbian zhuzi jicheng 新編諸子集成 (New Editorial Committee). Taipei: Shijie shuju, 1983.

Dunhuang Reference and Reproductions

Bibliothèque nationale de France, ed. *Faguo guojia tushuguan zang Dunhuang xiyu wenxian* 法國國家圖書館藏敦煌西域文獻 (Dunhuang Manuscripts in the Bibliothèque nationale de France). 8 vols. Shanghai: Shanghai guji chubanshe, 1995.

Dunhuang Research Institute, ed. *Chūgoku sekkutsu, Tonkō bakkokutsu* 中國石窟敦

煌莫高窟 (Chinese Cave Temples: Dunhuang Grottoes), vol. 1. Tokyo: Heibon-sha, 1980.

Dunhuang wenwu yanjiusuo 敦煌文物研究所 (Dunhuang Cultural Research Institute), ed. *Dunhuang Mogaoku neirong zonglu* 敦煌莫高窟內容總錄 (Complete Record Regarding the Contents of the Mogao Caves, Dunhuang). Beijing: Wenwu chubanshe, 1982.

————. *Zhongguo shiku* 中國石窟 (Chinese Caves), *Dunhuang Mogaoku* 敦煌莫高窟 (The Mogao Caves, Dunhuang). 5 vols. Beijing: Wenwu chubanshe, 1982–87.

————. *Dunhuang Mogaoku gongyangren tiji* 敦煌莫高窟供養人題記 (Donor Inscriptions at the Mogao Caves, Dunhuang). Beijing: Wenwu chubanshe, 1986.

————. *Zhongguo shiku* 中國石窟 (Chinese Caves), *Anxi Yulin* 安西榆林 (Anxi Grottoes). Beijing: Wenwu chubanshe, 1990.

Giles, Lionel. *Descriptive Catalogue of the Chinese Manuscripts from Tunhuang in the British Museum.* British Museum, Department of Oriental Printed Books and Manuscripts. London: Trustees of the British Museum, 1957.

Ji Xianlin 季羨林, ed. *Dunhuangxue da cidian* 敦煌學大辭典 (Dictionary of Dunhuang Studies). Shanghai: Shanghai cishu chubanshe, 1998.

Men'shikov, L. N., et al. *Ecang Dunhuang wenxian* 俄藏敦煌文獻 (Dunhuang Manuscripts Collected in the St. Petersburg Institute of Oriental Studies of the Russian Academy of Sciences). 13 vols. Shanghai: Shanghai Classics Publishing House, 1992–99.

Soymié, Michel, et al., eds. *Catalogue des manuscrits chinois de Touen-Houang, Fonds Pelliot chinois de la Bibliothèque nationale,* vols. 1, 3, 4, 5. Publications hors série de l'École française d'Extrême-Orient. Paris: École française d'Extrême-Orient, 1970–95.

Waley, Arthur. *A Catalogue of Paintings Recovered from Tun-huang by Sir Aurel Stein.* London: British Museum, 1931.

Zhongguo shehui kexueyuan lishi yanjiusuo 中國社會科學院歷史研究所 (Institute of History, Chinese Academy of Social Sciences), ed. *Yingcang Dunhuang xiyu wenxian* 英藏敦煌西域文獻 (Dunhuang Central Asian Documents in British Collections). 13 vols. Chengdu: Sichuan renmin chubanshe, 1990–94.

Books and Articles

Abe, Stanley K. "Mogao Cave 254: A Case Study in Early Chinese Buddhist Art." Ph.D. diss., University of California, Berkeley, 1989.

Acker, William. *Some T'ang and Pre-T'ang Texts on Painting.* 2 vols.: Sinica Leidensia VIII (1954) and Sinica Leidensia XII (in two parts), II/1 and II/2 (1974). Leiden: E. J. Brill, 1954, 1974.

Adamek, Wendi L. "Issues in Chinese Buddhist Transmission as Seen Through the *Lidai fabao ji* (Record of the Dharma-Jewel Through the Ages)." Ph.D. diss., Stanford University, 1997.

Akiyama Terukazu 秋山光和. "Miroku geshō kyōhen hakubyō funpon (S259v) to Tonkō hekiga no seisaku" 弥勒下生経変白描粉本 (S259v) と敦煌壁画の制作

(The plain drawing preparatory sketches (S259v) of *The Future Life of Maitreya Sūtra* tale and the production of Dunhuang murals)." *Seiiki bunka kenkyū* 6 西域文化研究 (1963): 53–74.

———. *Heian jidai sezōkuga no kenkyū* 平安時代世俗画の研究 (Research on Secular Painting in Early Medieval Japan), vol. 3. Tokyo: Yoshikawa kōbunkan, 1967.

———. "Rōdo shatō seihen hakubyō funpon (Pelliot Tibetan 1293) to Tonkō biga" 牢度叉闘聖変白描粉本と敦煌壁画 (The connections between the scroll of ink line drawings of The Magic Competition Between Śariputra and Raudrākṣa and the wall paintings at Dunhuang). In *Bunka kōryū shisetsu kenkyū kiyō* 文化交流施設研究紀要 (Annual Report of the Institute for the Study of Cultural Exchange), no. 2/3 (1978): 1–28. Tokyo: Tokyo University, Faculty of Letters.

Alexander, Jonathan J. G. *Medieval Illuminators and Their Methods of Work.* New Haven, CT: Yale University Press, 1992.

Alpers, Svetlana. *The Art of Describing: Dutch Art in the Seventeenth Century.* Chicago: University of Chicago Press, 1983.

———. *Rembrandt's Enterprise: The Studio and the Market.* Chicago: University of Chicago Press, 1988.

———. "No Telling, with Tiepolo." In *Sight and Insight: Essays on Art and Culture in Honour of E. H. Gombrich at 85*, ed. John Onians, 326–40. London: Phaidon Press, 1994.

Alpers, Svetlana, and Michael Baxandall. *Tiepolo and the Pictorial Intelligence.* New Haven, CT: Yale University Press, 1994.

Aoyama Sadao 青山定雄. *Tō Sō jidai no kōtsū to chishi chizu no kenkyū* 唐宋時代の交通と地誌地圖の研究 (Study of the communication systems, topography, and cartography of Tang and Song China). Tokyo: Yoshikawa Koubunkan, 1963.

Bacot, Jacques, F. W. Thomas, and Charles Toussaing, eds. *Documents de Touen-houang relatifs a l'histoire du Tibet.* Paris: P. Geuthner, 1940.

Bai Huawen 白化文. "What is Pien-wen 變文?" Trans. Victor H. Mair. *Harvard Journal of Asiatic Studies* 44, no. 2 (Dec. 1984): 493–514.

———. "Bianwen he bangti" 變文和榜題 (Bianwen and mural inscriptions). In *Dunhuang yuyan wenxue yanjiu* 敦煌語言文學研究 (Studies on Dunhuang Language and Literature). *Zhongguo Dunhuang Tulufan xuehui yuyan wenxue fenhui bianzuan* 中國敦煌吐魯番學會語言文學分會編纂 (Publication of the Language and Literature Subgroup of the Dunhuang and Turfan Study Group of China), ed. Zhou Shaoliang 周紹良, et al., 113–49. Beijing: Beijing daxue chubanshe, 1988.

Bailey, Harold W. "Story-telling in Buddhist Central Asia." *Acta Asiatica* 23 (Sept. 1972): 63–77.

Baker, Joan Stanley. "Forgeries in Chinese Painting." *Oriental Art* 32, no. 1 (Spring 1986): 54–66.

Bakhtin, M. M. *Art and Answerability: Early Philosophical Essays*, ed. Michael Holquist and Vadim Liapunov; trans. and notes by Vadim Liapunov; supplement trans. by Kenneth Brostrom. Austin: University of Texas Press, 1990.

———. *Toward a Philosophy of the Act*. Trans. and notes by Vadim Liapunov. Austin: University of Texas Press, 1993.

Barnhart, Richard. "Wei Fu-jen's Pi-chen T'u." *Archives of the Chinese Art Society in America* 18 (1964): 13–25.

———. "Li Kung-lin's *Hsiao Ching t'u*." Ph.D. diss., Princeton University, 1967.

———. "Survivals, Revivals, and the Classical Tradition of Chinese Figure Painting." In *Proceedings of the International Symposium on Chinese Painting*, 143–218. Taipei: National Palace Museum, 1972.

Barnhart, Richard, Robert E. Harrist, and Hui-liang J. Chu. *Li Kung-lin's Classic of Filial Piety*. New York: Metropolitan Museum of Art, 1993.

Barrett, T. H. *Taoism Under the T'ang: Religion and Empire during the Golden Age of Chinese History*. London: Wellsweep, 1996.

Baxandall, Michael. *Giotto and the Orator: Humanist Observers of Painting in Italy and the Discovery of Pictorial Composition, 1350–1450*. Oxford: Clarendon Press, 1971.

———. *The Limewood Sculptors of Renaissance Germany*. Princeton, NJ: Princeton University Press, 1986.

———. *Painting and Experience in Fifteenth-Century Italy: A Primer in the Social History of Pictorial Style*. Oxford: Oxford University Press, 1972, 1974, 1983, 1988.

Beal, Samuel. *The Life of Hiuen-Tsiang*. London: Kegan Paul, Trench, Trübner, 1911.

Beckwith, Christopher I. *The Tibetan Empire in Central Asia: A History of the Struggle for Great Power among Tibetans, Turks, Arabs, and Chinese during the Early Middle Ages*. Princeton, NJ: Princeton University Press, 1987.

Berling, Judith A. "Bringing the Buddhist Down to Earth: Notes on the Emergence of Yü-lu as a Buddhist Genre." *History of Religions* 27, no. 1 (Aug. 1987): 56–88.

Bickford, Maggie. *Ink Plum: The Making of a Chinese Scholar-painting Genre*. Cambridge, Eng.: Cambridge University Press, 1996.

Bingham, Woodbridge. *The Founding of the T'ang Dynasty*. Waverly Press, Baltimore, 1941.

Bol, Peter K. *"This Culture of Ours": Intellectual Transitions in T'ang and Sung China*. Stanford, CA: Stanford University Press, 1992.

Bray, Francesca. *The Rice Economies: Technology and Development in Asian Societies*. New York: Blackwell, 1986.

Bush, Susan. *Chinese Literati on Painting: From Su Shih (1037–1101) to Tung Ch'i-ch'ang (1555–1636)*. Harvard Yen-ching Institute Series 27. Cambridge, MA: Harvard University Press, 1971.

Bush, Susan, and Christian Murck. *Theories of the Arts in China*. Princeton, NJ: Princeton University Press, 1983.

Bush, Susan, and Hsio-yen Shih, eds. and comps. *Early Chinese Texts on Painting*. Cambridge, MA: Harvard University Press, 1985.

Buswell, Robert E., Jr., ed. *Chinese Buddhist Apocrypha*. Honolulu: University of Hawaii Press, 1990.

Buswell, Robert E., Jr., and Robert Gimello, eds. *Paths to Liberation: The Mārga and Its Transformation in Buddhist Thought*. Kuroda Institute, Studies in East Asian Buddhism 7. Honolulu: University of Hawaii Press, 1992.

Cahill, James. "Confucian Elements in the Theory of Painting." In *The Confucian Persuasion*, ed. Arthur Wright, 114–40. Stanford, CA: Stanford University Press, 1960.

———. "The Six Laws and How to Read Them." *Ars Orientalis*, 4 (1961): 372–81.

———. "Style as Idea in Ming-Ch'ing Painting." In *The Mozartian Historian: Essays on the Works of Joseph R. Levenson*, ed. Maurice Meisner and Rhoads Murphey, 137–56. Berkeley: University of California Press, 1976.

———. *An Index of Early Chinese Painters and Paintings: Tang, Sung and Yuan*. Berkeley: University of California Press, 1980.

———. "Tung Ch'i-ch'ang's 'Southern and Northern Schools' in the History and Theory of Painting: A Reconsideration." In *Sudden and Gradual: Approaches to Enlightenment in Chinese Thought*, ed. Gregory, 429–46.

———. *The Painter's Practice: How Artists Lived and Worked in Traditional China*. New York: Columbia University Press, 1994.

———. "The Imperial Painting Academy." In *Possessing the Past: A History of Chinese Art Treasures from the National Palace Museum, Taipei*, ed. Wen Fong and James Watt, 158–98. New York: Metropolitan Museum of Art, 1996.

Cappel, Carmen Bambach. "Michelangelo's Cartoon for the *Crucifixion of St. Peter* Reconsidered." *Master Drawings* 25 (Summer 1987): 131–42.

———. "A Substitute Cartoon for Raphael's *Disputa*." *Master Drawings* 30 (Spring 1992): 9–30.

Carter, Thomas Francis. *The Invention of Printing in China and Its Spread Westward*. 2nd ed., revised by L. Carrington Goodrich. New York: Ronald Press, 1955.

de Certeau, Michel. *The Practice of Everyday Life*. Trans. Steven Rendall. Berkeley: University of California Press.

Chang Shana 常沙娜, ed. *Dunhuang lidai fuzhuang tu'an* 敦煌歷代服裝圖案 (Period Costume Designs of Dunhuang). Hong Kong: Wanli shudian, 1986.

Chao Huashan 晁華山. "Xunmi yinmo qiannian de dongfang Moni si" 尋覓湮沒千年的東方摩尼寺 (Searching for the buried 1,000 year [remains] of East Asian Manichean temples). *Zhongguo wenhua* 中國文化 8 (1993): 1–20.

Chavannes, Édouard. *Mission archéologique dans la Chine septentrionale*. 13 vols. Paris: Imprimerie nationale, 1913.

Chidester, David. "Word against Light: Perception and the Conflict of Symbols." *Journal of Religion* 65, no. 1 (Jan. 1985): 46–62.

Cohen, Monique, and Nathalie Monnet. *Impressions de Chine*. Paris: Bibliothèque nationale, 1992.

Cohen, Warren I. *East Asian Art in America: A Study in International Relations*. New York: Columbia University Press, 1992.

Cook, Constance A. "Three High Gods of Chu." *Journal of Chinese Religions* 22 (Fall 1994): 1–22.

———. "The Inner and the Outer: Negotiating Space in the Zhou." Paper presented at the annual conference of the Association for Asian Studies, Chicago, Mar. 17, 1997.

————. "The Ideology of the Chu Ruling Class." In *Defining Chu: Image and Reality in Ancient China*, ed. Constance A. Cook and John S. Major. Honolulu: University of Hawaii Press, 1999.

Davis, Whitney. *Replications: Archaeology, Art History and Psychoanalysis*. University Park: Pennsylvania State University Press, 1996.

Demiéville, Paul. *Le concile de Lhasa, une controverse sur le quiétisme entre bouddhistes de l'Inde et le la Chine au VIII siècle*. Bibliothèque de L'Institut des Hautes Études Chinoises, vol. 7. Paris: Imprimerie nationale de France, 1952.

————. ed. *Répertoire du canon bouddhique Sino-Japonais, Édition de Taisho*. L'Académie des inscriptions et belles-lettres, Institut de France. Paris: Andrien-Maisonneuve, 1978.

————. *Choix d'études bouddhiques*. Leiden: E. J. Brill, 1993.

Derrida, Jacques. *Given Time: I. Counterfeit Money*. Chicago: University of Chicago Press, 1992.

DeWoskin, Kenneth J. *A Song for One or Two: Music and the Concept of Art in Early China*. Michigan Papers in Chinese Studies no. 4. Ann Arbor: University of Michigan, Center for Chinese Studies, 1982.

————. "On Narrative Revolutions." *CLEAR* 5, no. 1 (July 1983): 29–45.

————. "Xian Descended: Narrating Xian Among Mortals." *Taoist Resources* 2, no. 1 (Nov. 1990): 70–86.

Dong Guodong 凍國棟. "Tulufan chutu wenshu suojian Tangdai qianqi de gongjiang" 吐魯番出土文書所見唐代前期的工匠 (Craftsmen of the early Tang as seen in Turfan documents). In *Dunhuang Tulufan wenshu chutan* 吐魯番文書初探 (Early Investigations of Dunhuang and Turfan Documents), vol. 2, ed. Tang Changru 唐長孺. Wuchang: Wuhan daxue chubanshe, 1990.

Drège, Jean-Pierre. *Les bibliothèques en Chine au temps des manuscrits* (Jusqu'au Xe siècle). Publications de l'École française d'Extrême-Orient, vol. CLXI. Paris: École française d'Extrême-Orient, 1991.

————. "Les premières impressions des dhāraṇī de Mahāpratisara." *Cahiers d'Extrême-Asie* 11 (1999–2000): 25–44.

————. *Images de Dunhuang: Dessins et peintures sur papier des fonds Pelliot et Stein*. Memoires Archeologiques 24. Paris: École française d'Extrême-Orient, 1999.

"Dunhuang wenwu zhanlan tekan" 敦煌文物展覽特刊 (Special issue of the exhibition of Dunhuang cultural relics). *Wenwu cankao ziliao* 文物參考資料 2, no. 3 (1951).

Ebrey, Patricia. *The Aristocratic Families of Early Imperial China*. Cambridge, Eng.: Cambridge University Press, 1978.

————. *The Inner Quarters: Marriage and the Lives of Chinese Women in the Sung Period*. Berkeley: University of California Press, 1993.

————, ed. *The Cambridge Illustrated History of China*. Cambridge, Eng.: Cambridge University Press, 1996.

Ecke, Tseng Yu-ho. "A Reconsideration of *Ch'uan-mo-i-hsieh*, the Sixth Principle of Hsieh Ho." In *Proceedings of the International Symposium on Chinese Painting*, 313–50. Taipei: National Palace Museum, 1972.

Ebine Toshio 海老根聰郎. "Gendai hakubyōga so no shosō" 元代白描画—その諸相 (Various aspects of Yuan dynasty monochrome-ink painting). *Suiboku bijutsu taikei* 水墨美術大系 (Series on the Art of Ink Painting), 51–62. Tokyo: Kōdansha, 1975.

Eoyang, Eugene. "Word of Mouth: Oral Storytelling in the Pien-wen." Ph.D. diss., Indiana University, 1971.

———. "The Historical Context of Tun-huang Pien-wen." *Literature East and West* 5, no. 3 (1971): 339–57.

Faure, Bernard. "Bodhidharma as Textual and Religious Paradigm." *History of Religions* 25, no. 3 (Feb. 1986): 187–98.

———. "Space and Place in Chinese Religious Traditions." *History of Religions* 26, no. 4 (1987): 337–56.

———. *Rhetoric of Immediacy*. Princeton, NJ: Princeton University Press, 1992.

Fong, Mary. "Wu Daozi's Legacy in the Popular Door Gods (Menshen) Qin Shubao and Yuchi Gong." *Archives of Asian Art* 42 (1989): 6–24.

Fong, Wen. *Beyond Representation: Chinese Painting and Calligraphy, 8th–14th Century*. New York: Metropolitan Museum of Art, 1992.

———, ed. *The Great Bronze Age of China*. New York: Metropolitan Museum of Art, 1980.

Fong, Wen, and James Watt, eds. *Possessing the Past: A History of Chinese Art Treasures from the National Palace Museum*. New York: Metropolitan Museum of Art, 1996.

Fontein, Jan, and Money Hickman. *Zen Painting and Calligraphy*. Boston: Museum of Fine Arts, 1970.

Foucault, Michael. *The Archaeology of Knowledge*. Trans. A. M. Sheridan Smith. New York: Pantheon Books, 1972.

Fraser, Sarah E. "The Artist's Practice in Tang China, Eighth–Tenth Centuries." Ph.D. diss., University of California, Berkeley, 1996.

———. "Régimes of Production: The Use of Pounces in Temple Construction." *Orientations* 37, no. 9. Special issue on Dunhuang. (Nov./Dec. 1996): 69–79.

———. Review of *Latter Days of the Law*, in *China Review International* 3, no. 1 (Spring 1996): 288–93.

———. "Narrative Strategies in Murals of *The Magic Competition Between Sariputra and Raudraksha*." Paper presented at the annual conference of the Association for Asian Studies, Chicago, Mar. 17, 1997.

———. 胡素馨 "Dunhuang de fenben he bihua zhijian de guanxi" 敦煌的粉本和壁畫之間的關係 (The relationship between draft sketches and wall paintings at Dunhuang). *Tang yanjiu* 唐研究 no. 3 (Dec. 1997): 437–43.

———. "Turfan Artists, Fifth–Ninth Centuries." In *The Third Silk Road Conference at Yale University*, 77–143. Conference Proceedings, II. July 10–12, 1998.

———. "The Manuals and Drawings of Artists, Calligraphers, and other Specialists from Dunhuang." In *Images de Dunhuang: Dessins et peintures sur papier des fonds Pelliot et Stein*, ed. Jean-Pierre Drège. Mémoires Archéologiques 24, 55–104. Paris: École française d'Extrême-Orient, 1999.

———. "A Reconsideration of Archaeological Finds from the Turfan Region." *Dunhuang Tulufan yanjiu* 敦煌吐魯番研究 4 (1999): 375–418.

———. "Formulas of Creativity: Artist's Sketches and Techniques of Copying at Dunhuang." *Artibus Asiae* 59, no. 3/4 (2000): 189–224.

———. "Turfan Artists, Fifth–Ninth Centuries." *Dunhuang Tulufan yanjiu* 6 (Spring 2000): 375–418.

———. "Technology for Archaeology." Dunhuang International Conference, July 29, 2000, *Proceedings* (forthcoming).

Fu Shen, and Jan Stuart. *Challenging the Past: The Paintings of Chang Dai-chien.* Washington, D.C.: Smithsonian Institution, 1991.

Fujieda Akira 藤枝晃. "Tonkō no sōniseki" 敦煌の僧尼籍 (Registers of Dunhuang monks and nuns). *Tōhō gakuhō* 東方學報 29 (Mar. 1959): 285–338.

———. "Toban shihaiki no Tonkō" 吐蕃支配期の敦煌 (Dunhuang under the Tibetans). *Tōhō gakuhō* 東方學報 31 (Mar. 1961): 199–292.

Fuller, Michael. "Pursuing the Complete Bamboo in the Breast: Reflections on a Classical Chinese Image of Immediacy." *Harvard Journal of Asiatic Studies* 53, no. 1 (1993): 5–24.

Gernet, Jacques. *Buddhism in Chinese Society: An Economic History from the Fifth to the Tenth Centuries.* Trans. Franciscus Verellen. New York: Columbia University Press, 1995.

Gibson, James J. *The Senses Considered as Perceptual Systems.* Boston: Houghton Mifflin, 1966.

Giès, Jacques, and Monique Cohen, eds. *Sérinde, terre de Bouddha.* Paris: Réunion des Musés nationaux, 1995.

Giès, Jacques, Michel Soymié, Jean-Pierre Drège, et al. *Les Arts de l'Asie centrale: La Collection Paul Pelliot du Musée nationale de Arts asiatiques–Guimet.* 2 vols. Tokyo: Kodansha, 1994. Also, with English trans. by Hero Friesen; London: Serindia Publications, 1996.

Giles, Lionel. "Dated Chinese Manuscripts in the Stein Collection." *Bulletin of the School of Oriental and African Studies* 7, no. 4 (1933–35): 809–36; 8, no. 1 (1935–37): 1–26; 9, no. 1 (1937–39): 1–22; 10, no. 1 (1939–42): 317–44; 11, no. 1 (1943–46): 148–73.

Grabe, Ernst J., and Eleanor Sims, eds. *Between China and Iran: Paintings from Four Istanbul Albums.* A colloquy held 23–26 June 1980. Colloquies on Art and Archaeology in Asia, no. 10. London: University of London, Percival David Foundation of Chinese Art, 1985.

Graham, A. C. *Reason and Spontaneity: A New Solution to the Problem of Fact and Value.* London: Curzon Press, 1985.

———. *Yin-Yang and the Nature of Correlative Thinking.* Occasional Paper and Monograph Series no. 6. Singapore: Institute of East Asian Philosophies, 1986.

———. *Disputers of the Tao: Philosophical Argument in Ancient China.* Chicago: Open Court Press, 1989.

———, trans. *Chuang-tzu, Seven Inner Chapters and Other Writings from the Book Chuang-tzu.* London: George Allen & Unwin, 1981.

Graham, Thomas Edward. "The Reconstruction of Popular Buddhism in Medieval China, Using Selected 'Pien-wen' from Tun-huang." Ph.D. diss., University of Iowa, 1975.

Granet, Marcel. *La pensée chinoise*. L'evolution de l'humanité, synthèse collective, 1. Section 25 bis. Paris: La Renaissance du Livre, 1934, 1975.

Granoff, Phyllis, and Kochi Shinohara, eds., *Monks and Magicians: Religious Biographies in Asia*. Oakville, Ontario: Mosaic Press, 1988.

Gray, Basil. *Buddhist Cave Paintings at Tun-huang*. London: Faber and Faber, 1959.

Gregory, Peter N. "Conference Report: The Sudden/Gradual Polarity, A Recurrent Theme in Chinese Thought." *Journal of Chinese Philosophy* 9, no. 4 (Dec. 1982): 471–86.

———, ed. *Sudden and Gradual: Approaches to Enlightenment in Chinese Thought*. Studies in East Asian Buddhism 5. Honolulu: University of Hawaii Press, 1987.

Gugong bowuyuan 故宮博物院 (National Palace Museum), ed. *Songren baihua tu* 宋人白畫圖 (A Song Dynasty Painter's Monochrome Flower Painting). Beijing: Wenwu chubanshe, 1958.

Hambis, Louis, and Nicole Vandier-Nicolas, eds. Mission Paul Pelliot XV. *Bannières et peintures de Touen-Houang conservées au Musée Guimet*, vols. 14–15. Paris: Andrien-Maisonneuve, 1974.

Hansen, Valerie. "The Path of Buddhism into China: The View from Turfan." *Asia Major* 3rd series, 11, no. 2 (1998): 37–66.

Hao Chunwen 郝春文. *Tang houqi Wudai Songchu Dunhuang sengni de shehui shenghuo* 唐后期五代宋初敦煌僧尼的社會生活 (The Social Life of Buddhist Monks and Nuns in Dunhuang during the Late Tang, Five Dynasties, and the Early Song). Beijing: Zhongguo shehui kexue chubanshe, 1998.

Hartman, Charles. *Han Yü and the T'ang Search for Unity*. Princeton, NJ: Princeton University Press, 1986.

Hartwell, Robert M. "Demographic, Political, and Social Transformations of China, 750–1550." *Harvard Journal of Asian Studies* 42, no. 2, (Dec. 1982): 365–442.

Hawkes, David. *A Little Primer of Tu Fu*. Hong Kong: Research Centre for Translation, Chinese University of Hong Kong, 1987.

Hay, John. "Huang Kung-wang's 'Dwelling in the Fu-ch'un Mountains': Dimensions of a Landscape." Ph.D. diss., Princeton University, 1978.

Higashi, Yamken Goro. "Presentation Forms of Jataka Stories as Examples." In *International Conference on Dunhuang Studies, Summary of Papers, 1990*. By Dunhuang Academy. Dunhuang, Gansu (1990): 110–11.

Ho, Judy C. "Tunhuang Cave 249: A Representation of the Vimalakirtinirdesa." Ph.D. diss., Yale University, 1985.

———. "The Perpetuation of an Ancient Model." *Archives of Asian Art* 41 (1988): 33–46.

Ho, Wai-Kam. "The Original Meaning of P'o-mo and Its Musical Origins." Unpublished paper.

———, et al. *Eight Dynasties of Chinese Painting: The Collections of the Nelson Gallery–Atkins Museum, Kansas City, and the Cleveland Museum of Art*. Cleveland: Cleveland Museum of Art, 1980.

Hopkirk, Peter. *Foreign Devils on the Silk Road*. Amherst: University of Massachusetts Press, 1980.

Hori Toshikazu 堀敏一. "Tonkō shakai no henshitsu: Chūgoku shakai zenpan no hatten to mo karenshite" 燉煌社会の変質：中国社会全般の発展とも関連して (The transformation of Dunhuang society seen in relation to the development of Chinese society as a whole). Kōza: Tonkō, vol. 3, *Tonkō no shakai* 燉煌の社会 (1980): 149–96.

———. "Social Change in Tun-huang from the Latter half of the T'ang Dynasty." Viewpoints of T'ang China, *Acta Asiatica* 55 (1988): 48–74.

Hrdlickova, V. "The First Translations of Buddhist Sutras in Chinese Literature and Their Place in the Development of Storytelling." *Archiv Orientalni* 26, no. 26 (1958): 114–44.

Hsü, Ginger Cheng-chi. "Patronage and the Economic Life of the Artist in Eighteenth-Century Yangchow Painting." 2 vols. Ph.D. diss., University of California, Berkeley, 1987.

———. *A Bushel of Pearls: Painting for Sale in Eighteenth-Century Yangchow*. Stanford, CA: Stanford University Press, 2001.

Huang Miaozi 黄苗子. "Wu Zongyuan he chaoyuan xianzhang tu" 武宗元和朝元仙仗圖 (Wu Zongyuan and *The Star Gods Procession*). *Zhongguo hua* 中國畫 no. 2 (1982): 56–62.

Huang Wenbi 黄文弼. "Tulufan kaogu ji" 吐魯番考古集 (Collection of Turfan archaeology). *Kaoguxue tekan* 考古學特刊 no. 3 (Apr. 1954): 54–58.

Hucker, Charles O. *A Dictionary of Titles in Imperial China*. Stanford, CA: Stanford University Press, 1985.

Humphrey, Jo. *Monkey King: A Celestial Heritage*. Exhibition catalog. Jamaica, NY: St. John's University, 1980.

Humphreys, Glyn W., and Vicki Bruce. *Visual Cognition: Computational, Experimental, and Neuropsychological Perspectives*. Hove, UK: Lawrence Erlbaum Assoc., 1989.

Huntington, Susan L. *The Art of Ancient India: Buddhist, Hindu, Jain*. New York: Weatherhill, 1985.

Huo Xiliang 霍熙亮. "Anxi Yulinku di sanshier ku de 'Fanwang jing'" 安西榆林窟第３２窟的梵網經變 (The Fangang Sūtra Representation in cave no. 32 at the Yulin grottoes, Anxi). *Dunhuang yanjiu* 敦煌研究 no. 3 (1987): 24–34.

Ikeda On. "T'ang Household Registers and Related Documents." In *Perspectives on the T'ang*, ed. Wright and Twitchett, 307–42.

———. *Chūgoku kodai sekichō kenkyū* 中國古代籍帳研究 (Research into Ancient Chinese Contracts). Tokyo: Tōkyō daigaku shuppansha, 1979.

———. "Les Marchands sogdiens dans les documents de Dunhuang et de Turfan." *Journal Asiatique* 296 (1981): 77–79.

———. "A Review of T'ang Studies in Japan in Recent Years." Viewpoints of T'ang China, *Acta Asiatica* 55 (1988): 102–33.

Jang, Scarlett. "The Organization of the Sung Painting Academy." Sōgenga seminar, University of California, Berkeley, 1982. Unpublished paper. Photocopied.

———. "Issues of Public Service in the Themes of Chinese Court Painting." 2 vols. Ph.D. diss., University of California, Berkeley, 1989.

Jao Tsong-yi 饒宗頤. *Dunhuang baihua* 敦煌白畫 (Dunhuang Monochrome Draw-
ing). Adapted into French by Pierre Ryckmans. *Peintures monochromes de Dun-
huang.* Publications de l'École française d'Extrême-Orient, Memoires Arche-
ologiques 13. 3 fascicules. Paris: École française d'Extrême-Orient, 1978.

Jera-Bezard, Robert, and Monique Maillard. "Origine et montage des bannières pein-
tures de Dunhuang." *Arts Asiatiques* (1981): 83–91.

Ji Yuanzhi 暨遠志. "Tangdai cha wenhua de jieduanxing" 唐代茶文化的階段性
(Some stages of tea culture in the Tang dynasty). *Dunhuang yanjiu* 敦煌研究 no.
2 (1991): 99–107.

Jiang Boqin 姜伯勤. "Dunhuang de 'huahang' yu 'huayuan'" 敦煌的畫行與畫院
(Dunhuang's painting guild and painting academy). In *Quanguo Dunhuang xueshu
taolunhui wenji, shiku, yishubian, xia* 全國敦煌學術討論會文集, 石窟藝術篇,
下 (Essays from the 1983 International Symposium on Dunhuang Literature and
Arts, vol. 2: The Caves, Essays on Art), 172–79. Lanzhou: Gansu renmin chuban-
she, 1985.

———. *Tang Wudai Dunhuang sihuzhidu* 唐五代敦煌寺戶制度 (The Temple Pop-
ulation System at Dunhuang in the Tang and Five Dynasties). Beijing: Zhonghua
shuju, 1987.

———. "Dunhuang yinshengren lüelun 敦煌音聲人略論 (A brief discussion of
musicians and dancers at Dunhuang). *Dunhuang yanjiu* 敦煌研究 no. 4 (1988):
1–9.

———. *Dunhuang yishu zongjiao yu luyue wenming* 敦煌藝術宗教與禮樂文明
(Dunhuang Civilization in the Arts, Religion, and Ritual). Beijing: Zhongguo
shehui kexue chubanshe, 1996.

Jiang Liangfu 姜亮夫. *Mogaoku nianbiao* 莫高窟年表 (Chronology of the Mogao
Caves). Shanghai: Guji chubanshe, 1985.

Jiang Lihong 蔣禮鴻. *Dunhuang bianwenziyi tongshi* 敦煌變文字義通釋 (The
Meaning and Translations of Dunhuang *Bianwen* Characters). Shanghai guji
chubanshe, 1981.

Jin Weinuo 金維諾. "Zhiyuanji tu kao" 祇園記圖考 (Research on pictures of the
Record of Jetavana Garden) and "Zhiyuanji tu yu bianwen" 祇園記圖與變文
(Pictures and Bianwen of the Record of the Jetavana Garden), 1958. Reprinted in
Zhongguo meishushi lunji 中國美術史論集 (Collected Essays on Chinese Art His-
tory), 379–96. Beijing: Renmin meishu chubanshe, 1981.

———. *Sui Tang Wudai huihua* 隋唐五代繪畫 (Painting of the Sui, Tang, and Five
Dynasties), vol. 2, *Huihua bian* 繪畫編 (Painting Volume), *Zhongguo meishu
quanji* 中國美術全集 (Complete Collection of Chinese Arts). Beijing: Renmin
chubanshe, 1984

Johnson, David. "The Wu Tzu-hsü *Pien-wen* and Its Sources." *Harvard Journal of Asi-
atic Studies,* part 1: 40, no. 1 (June 1980): 93–119, 143–51; part 2: 40, no. 2 (Dec.
1980): 498–505.

———. "Scripted Performances in Chinese Culture: An Approach to the Analysis of
Popular Literature." *Han-hsüeh yen-chiu* (Taipei) 8, no. 1 (1990).

———. "*Mu-lien* in Pao-ch'uan, The Performance Context and Religious Meaning

of the *Yu-ming Pao-Chuan.*" In *Ritual and Scripture in Chinese Popular Religion*, ed. David Johnson. Publications of the Chinese Popular Culture Project 3, 55–103. Berkeley: Chinese Popular Culture Project, University of California, Berkeley, 1995.

Juliano, Annette, and Judith Lerner. *Monks and Merchants: Silk Road Treasures from Northwest China.* New York: Harry N. Abrams, 2001.

Kanaoka Shōkō 金岡照光. *Tonkō no bungaku to gengo* 敦煌の文學と文獻 (Dunhuang Literature and Manuscripts). Tonkō kōza (Dunhuang Colloquium), vol. 11. Tokyo: Tōkyō daigaku shuppansha, 1990.

Kieschnick, John. *The Eminent Monk: Buddhist Ideals in Medieval Chinese Hagiography.* Kuroda Institute, Studies in East Asian Buddhism 10. Honolulu: University of Hawaii Press, 1997.

Klimburg-Salter, Deborah E., ed. *Diamond Path and the Silk Road: Esoteric Buddhist Art on the Trans-Himalayan Trade Routes.* Los Angeles: UCLA Arts Council, 1982.

Kong Shoushan 孔壽山, ed. *Tangchao tihuashi zhu* 唐朝題畫詩注 (A Collection of Tang Dynasty Poems on Painting Topics). Chengdu: Sichuan meishu chubanshe, 1988.

Kramer, Carol, ed. *Ethnoarchaeology: Implications of Ethnography for Archaeology.* New York: Columbia University Press, 1979.

Kris, Ernst, and Otto Kurz. *Legend, Myth, and Magic in the Image of the Artist: A Historical Experiment.* New Haven, CT: Yale University Press, 1979. Revision and translation of *Die Legende Vom Künstler: ein historischer Versuch.* Vienna: Krystall, 1934.

Kroll, Paul W. "Basic Data on Reign-Dates and Local Government." *Tang Studies* 5 (1987): 95–104.

Kuipers, Joel C. *Power in Performance: The Creation of Textual Authority in Weyewa Ritual Speech.* Philadelphia: University of Pennsylvania Press, 1990.

Kuo Li-ying. *Confession et contrition dans le bouddhisme chinois du Ve au Xe siècle.* Publications de École française d'Extrême-Orient, Monographies, no. 170. Paris: École française d'Extrême-Orient, 1994.

Lai, Whalen, and Lewis R. Lancaster, eds. *Early Ch'an in China and Tibet.* Berkeley Buddhist Studies Series. Berkeley, CA: Asian Humanities Press, 1983.

Laing, Ellen. "Patterns and Problems in Later Chinese Tomb Decoration." *Journal of Oriental Studies* 16, 1–2 (1978): 3–19.

Lalou, Marcelle. *Inventaire des manuscrits tibétains de Touen-houang, conservés à la Bibliothèque nationale* (fonds Pelliot tibétain), vol. 3. Paris: Bibliothèque nationale, 1961.

Lawton, Thomas. *Chinese Figure Painting.* Freer Gallery of Art, Fiftieth Anniversary Exhibition, II. Washington, D.C.: Smithsonian Institution, 1973.

Ledderose, Lothar. *Mi Fu and the Classical Tradition of Chinese Calligraphy.* Princeton: Princeton University Press, 1979.

———. "A King of Hell." In *Suzuki Kei sensei kanreki kineni, Chūgoku kaiga shi ronshū* (Suzuki Kei Feschscrift, Collected Studies on the History of Chinese Painting), 33–42. Tokyo: Yoshikawa, 1981.

————. *Ten Thousand Things: Module and Mass Production in Chinese Art.* Princeton, NJ: Princeton University Press, 2000.

Lee, Sherman. *Reflections of Reality in Japanese Art.* Cleveland: Cleveland Museum of Art, 1983.

Legge, James, trans. *The She King.* Reprint, Taipei: Wenhua tushu gongsi, 1977.

————. *The Texts of Taoism.* Vols. 39 and 40 in *The Sacred Books of China*, ed. F. Max Müller. Oxford: Clarendon Press, 1891.

Levenson, Joseph. "The Amateur Ideal in Ming and Early Ch'ing Society: Evidence from Painting." In *Confucian China and Its Modern Fate: The Problem of Intellectual Continuity*, 15–43. Berkeley: University of California Press, 1958.

Lévi, Sylvain. "Le sūtra du sage et du fou dans la littérature de l'Asie centrale." *Journal Asiatique* 207, no. 2 (Oct.–Dec. 1925): 305–32.

Li, Chu-tsing, and James C. Y. Watt, eds. *The Chinese Scholar's Studio: Artistic Life in the Late Ming Period.* New York: Thames and Hudson, published in association with the Asia Society, 1987.

Li Yongning 李永寧, and Cai Weitang 蔡偉堂. "Xiangmo bianwen yu Dunhuang bihuazhong de Laoducha dousheng bian" 降魔變文與敦煌壁畫中的勞度叉鬥聖變 (Subjugation of the Demons Transformation Tale and the Raudrākṣa Competition painting tableaux in Dunhuang murals). In *1983 nian quanguo Dunhuang xueshu taolunhui wenji* 1983 年全國敦煌學術討論會文集 (Collected Writings of the 1983 International Conference on Dunhuang Studies), *shiku, yishubian, shang* 石窟, 藝術篇, 上 (caves, art), vol. 1, ed. Dunhuang wenwu yanjiusuo 敦煌文物研究所 (Dunhuang Cultural Relics Research Institute), 167–233. Lanzhou: Gansu renmin chubanshe, 1985.

————. "Dunhuang bihua zhong de 'mile jingbian'" 敦煌壁畫中的彌勒經變 (Maitreya Sūtra Representations in Dunhuang's Murals). In *1987 nian Dunhuang shiku yanjiu guoji taolunhui wenji* 1987 年敦煌石窟研究國際討論會文集 (Collected Papers from the 1987 International Conference on Dunhuang Grotto Research), ed. Dunhuang yanjiu yuan 敦煌研究院 (Dunhuang Research Academy), 247–72. Shenyang: Liaoning meishu chubanshe, 1990.

Lim, Lucy, et al. *Stories from China's Past: Han Dynasty Pictorial Tomb Reliefs and Archaeological Objects from Sichuan Province.* San Francisco: Chinese Culture Center, 1987.

Lin Yuanbai 林元白. "Fangshan shijing chufen guomuji" 房山石經初分過目記 (Review of analyzed early engraved sūtras at Fangshan). *Xiandai foxue* 現代佛學 no. 9 (1957): 2–13.

Liu Lingyuan 劉凌源. *Tangdai renwu hua* 唐代人物畫 (Tang Dynasty Figure Painting). Beijing: Zhongguo gudian yishu chubanshe, 1958.

Little, Stephen, with Shawn Eichman, eds. *Taoism and the Arts of China.* Berkeley: University of California Press, 2000.

Loehr, Max. *Chinese Landscape Woodcuts, From an Imperial Commentary to the Tenth-Century Printed Edition of the Buddhist Canon.* Cambridge, MA: Harvard University Press, 1968.

Loewe, Michael, ed. *Early Chinese Texts: A Bibliographical Guide.* Society for the Study

of Early China. Berkeley: Institute of East Asian Studies, University of California, Berkeley, 1993.

Lopez, Donald S., Jr., ed. *Buddhism in Practice*. Princeton Readings in Religion. Princeton, NJ: Princeton University Press, 1995.

Luo Jimei 羅寄梅. "Anxi Yulin ku de bihua" 安西榆林窟的壁畫 (Mural paintings at the Yulin caves, Anxi). *Zhongguo dongya xueshu yanjiu jihua* 中國東亞學術研究計劃(Annual Bulletin of the China Council for East Asian Studies, Taipei), 3. 1963: 1–42.

Luo Zhenyu 羅振玉. *Dunhuang lingshi* 敦煌零拾 (A Gathering of Assorted Texts from Dunhuang). By the compiler, 1924. N.p.: Shangyu luoshi. Reprint, Taipei: Wenhua chuban gongsi, 1970.

Lynn, Richard John, trans. *The Classic of Changes*. Commentary by Wang Bi. New York: Columbia University Press, 1994.

Ma De 馬德. *Dunhuang Mogaoku shi yanjiu* 敦煌莫高窟史研究 (Research on the History of the Mogao Grottoes at Dunhuang). Lanzhou: Gansu jiaoyu chubanshe, 1996.

Ma Shichang 馬世長, and Pan Yushan 潘玉閃. *Mogaoku kuqian diantang yizhi* 莫高窟窟前殿堂遺址 (Remains of Hall Structures in Front of the Caves at Mogao Grottoes). Dunhuang Research Institute. Beijing: Wenwu chubanshe, 1985.

Mackenzie, Colin. "The Origins of the Blue-and-Green Style of Landscape and the Use of Color in Buddhist Mural Painting." In *1994 nian Dunhuangxue guoji xueshu yantaohui, lunwen tiyao* (1994 International Conference on Dunhuang Studies, Abstracts), Dunhuang, China, 153–54. Dunhuang Research Institute, 1994.

Maeda, Robert. *Two Twelfth Century Texts on Painting*. Michigan Papers in Chinese Studies, vol. 8. Ann Arbor: University of Michigan Press, 1973.

——. *Two Sung Texts on Chinese Painting and the Landscape Style of the Eleventh and Twelfth Centuries*. New York: Garland, 1978.

Mair, Victor H. "Lay Students and the Making of Vernacular Narrative: An Inventory of Tun-huang Manuscripts." *Chinoperl* 10 (1981): 5–96

——. "The Narrative Revolution in Chinese Literature: Ontological Presuppositions." *CLEAR* 5, no. 1 (July 1983): 1–27.

——. *Tun-huang Popular Narratives*. Cambridge Studies in Chinese History, Literature, and Institutions. Cambridge, Eng.: Cambridge University Press, 1983.

——. "The Origins of an Iconographical Form of the Pilgrim Hsuang-tsang." *Tang Studies* 4 (1986): 29–41.

——. "Records of Transformation Tableaux (Pien Hsiang)." *T'oung Pao* 72 (1986): 3–39.

——. *Painting and Performance: Chinese Picture Recitation and Its Indian Genesis*. Honolulu: University of Hawaii Press, 1988.

——. *Tang Transformation Texts: A Study on the Buddhist Contribution to the Rise of Vernacular Fiction and Drama in China*. Cambridge, MA: Council on East Asian Studies, Harvard University, 1989.

——. "Śāriputra Defeats the Six Heterodox Masters: Oral-Visual Aspects of an Illustrated Transformation Scroll, P.4524." *Asia Major*, 3rd series, 8/2 (1995): 1–52.

Major, John S. *Heaven and Earth in Early Han Thought: Chapters Three, Four, and Five of the* Huainanzi. Albany: State University of New York Press, 1993.

March, Benjamin. *Some Technical Terms of Chinese Painting*. Baltimore: Waverly Press, 1935.

Martin, F. R. *Zeichnungen nach Wu Tao-tze aus der Götter und Sagenwelt Chinas*. Munich: Bruchmann, 1913.

Maspero, Henri, and Etienne Balazs. *Histoire et institutions de la Chine ancienne*. Annales du Musée Guimet, Bibliothèque d'études, vol. 73. Paris: Presses universitaires de France, 1967.

Matsumoto Eiichi 松本栄一. "Tonkō shutsu 'kaiyuan' nendai ga ni tsuite" 燉煌出開元年代画に就て (On a painting from Dunhuang dated to the year "kaiyuan" [729]). *Kokka* 國華 no. 511 (1933): 153–57.

———. *Tonkō ga no kenkyū* 燉煌畫の研究 (Research on the Painting of Dunhuang). 2 vols. Tokyo: Tōhō bunka gakuin, 1937.

———. "Kata ni yoru zōzō" (Constructing Buddhist figures from models). *Bijutsu kenkyū* 美術研究 156 (1950): 1–15.

Mauss, Marcel. *The Gift: The Form and Reason for Exchange in Archaic Societies*. Trans. W. D. Halls. New York: W. W. Norton, 1950.

McNair, Amy. "Fa shu yao lu, A Ninth-Century Compendium of Texts on Calligraphy." *Tang Studies* 5 (1987): 69–86.

McRae, John R. *The Northern School and the Formation of Early Ch'an Buddhism*. Studies in East Asian Buddhism 3. Honolulu: University of Hawaii Press, 1986.

———. "Shenhui and the Teaching of Sudden Enlightenment in Early Ch'an Buddhism." In *Sudden and Gradual: Approaches to Enlightenment in Chinese Thought*, ed. Gregory, 227–78.

———. "Encounter Dialogue and the Transformation of the Spiritual Path in Chinese Ch'an." In *Paths to Liberation: The Mārga and Its Transformation in Buddhist Thought*, ed. Buswell and Gimello, 339–70.

Mili, Gjon. *Picasso's Third Dimension*. New York: Triton Press, 1970.

Mission Paul Pelliot, ed. *Grottes de Touen-Houang, carnet de notes de Paul Pelliot, inscriptions et peintures murales. Documents conservés au Musée Guimet, Documents archéologiques*, 6 vols. Paris: Collège de France, 1981–92.

Montell, Goesta. "A Sketch from the Tang Period." *Ethnos* 15 (1950): 101–7.

Mu Shunying 穆舜英, et al., eds. *Zhongguo Xinjiang gudai yishu* 中國新疆古代藝術 (Ancient Art of Xinjiang China). Urumqi: Xinjiang meishu sheying chubanshe, 1994.

Munakata, Kiyohiko. "The Rise of Ink-Wash Landscape Painting in the T'ang Dynasty." Ph.D. diss., Princeton University, 1965. Ann Arbor, MI: University Microfilms 65-13-156.

———, ed. and trans. "Ching Hao's Pi-fa-chi: A Note on the Art of the Brush." Annotated by K. Munakata. *Artibus Asiae Supplementum* 31. Ascona, Geneva: Artibus Asiae Publishers, 1974.

Murray, Julia K. "Representations of Hāriti, the Mother of Demons and the Theme

of 'Raising the Alms Bowl' in Chinese Painting." *Artibus Asiae* 43, 4 (1982): 253–84.

Myhre, Karin E. "The Eater and the Eaten: Theatrical and Ritual Perspectives on Exorcism and Entertainment." Paper presented at the annual conference of the Association for Asian Studies, Chicago, Mar. 17, 1997.

National Museum of Chinese History, ed. *Shandong Qingzhou longxingsi chutu fojiao shike zaoxiang jingpin* 山東青州龍興寺出土佛教石刻造像精品 (Masterpieces of Buddhist Statuary from Qingzhou). Qingzhou City Museum. Beijing: Beijing Huaguan yishupin, 1999.

Nattier, Jan. *Once Upon a Future Time: Studies in a Buddhist Prophecy of Decline.* Berkeley, CA: Asian Humanities Press, 1991.

Needham, Joseph. *Science and Civilization in China.* Vol. 2: *History of Scientific Thought.* Cambridge, Eng.: Cambridge University Press, 1969.

Nie Zongzheng 聶宗正. "Qingdai de gongting huihua he huajia" 清代的宮廷繪畫和畫家 (Court painting and court painters of the Qing dynasty). In *Gongting huihua* 宮庭繪畫 (Qing Dynasty Court Painting), ed. The Palace Museum 故宮博物院, 1–27. Beijing: Wenwu chubanshe, 1992.

Nienhauser, William H., Jr., ed. *The Indiana Companion to Traditional Chinese Literature.* Bloomington: Indiana University Press, 1986.

Ning Qiang 甯強. *Dunhuang fojiao yishu* 敦煌佛教藝術 (Buddhist Art at Dunhuang). Kao Hsiung: Kao Hsiung fuwentushu chubanshe, 1992.

Ningxia huizu zizhiqu wenwu guanli weiyuanhui 寧夏回族自治區文物管理委員會 (Ningxia Hui Ethnic Autonomous Region Cultural Relic Board), and Beijing daxue kaoguxi 北京大學考古系 (Beijing University, Department of Archaeology). *Xumishan shiku neirong zonglu* 須彌山石窟內容總錄 (Complete Records Regarding the Content of Xumishan). Beijing: Wenwu chubanshe, 1997.

Ol'denburg, S. F. *Materially po buddiiskoi ikonografii Khara-khoto* (*obraza-tangka Tibetskogo pis'ma*) (Materials on the Buddhist Iconography of Kharakhoto [Tibetan Thangka Images]). St. Petersburg, 1914.

Ong, Walter. *Orality and Literacy: The Technologizing of the Word.* New York: Routledge, 1988.

Overmyer, Daniel L. "Buddhism in the Trenches: Attitudes Towards Popular Religion in Indigenous Scriptures from Tun-huang." Presented at the annual conference of the Association for Asian Studies, San Francisco, Mar. 1988.

Palace Museum, ed. *Qingdai gongting huihua* 清代宮廷繪畫 (Court Painting of the Qing Dynasty). Beijing: Wenwu chubanshu, 1992.

Pelliot, Paul. *Les débuts de l'imprimerie en Chine.* Oeuvres posthumes de Paul Pelliot, vol. 4. Paris: Andrien-Maisonneuve, 1953.

———. "Deux termes techniques de l'art chinois: 脱沙 t'o-cha et 隱起 yin-k'i." *T'oung Pao* 23 (1924): 260–66.

———. "Notes sur quelques artistes des six dynasties et des T'ang." *T'oung Pao* 22 (1923): 215–91.

Peng Jinzhang 彭金章, and Wang Jianjun 王建軍. *Dunhuang Mogaoku beiqu shiku*

敦煌莫高窟北區石窟 (The Northern Caves at the Dunhuang Grottoes), vol. 1. Beijing: Wenwu chubanshe, 2000. Vol. 2 is forthcoming.

Peterson, C. A. "Court and Province in Mid- and Late-Tang." In *Cambridge History of China*, vol. 3: Sui and T'ang, 589–906, Part 1, ed. Denis Twitchett, 464–560. Cambridge, Eng.: Cambridge University Press, 1979–87.

———. "The Restoration Completed: Emperor Hsien-tsung and the Provinces." In *Perspectives on the T'ang*, ed. Wright and Twitchett, 151–91.

Plaks, Andrew H. "Towards a Critical Theory of Chinese Narrative." In *Chinese Narrative: Critical and Theoretical Essays*, ed. idem, 309–52. Princeton, NJ: Princeton University Press, 1977.

Powers, Martin J. "Character (*Ch'i*) and Gesture (*Shih*) in Early Chinese Art and Criticism." In *Chung-kuo i-shu wen-wu t'ao-lun-hui* (International Colloquium on Chinese Art History, 1991). Part 2, Painting and Calligraphy, ed. National Palace Museum, Taiwan, 90–931. Taipei: National Palace Museum, 1992.

Pulleyblank, Edwin G. *The Background of the Rebellion of An Lu-shan*. London: Oxford University Press, 1955, repr. 1966.

———. "The An Lu-shan Rebellion and the Origins of Chronic Militarism in Late T'ang China." In *Essays on T'ang Society: The Interplay of Social, Political, and Economic Forces*, ed. John Curtis Perry and Bardwell L. Smith, 33–60. Leiden: Brill, 1976.

Reischauer, Edwin. *Ennin's Diary: The Record of a Pilgrimage in Search of the Law*. 2 vols. New York: Ronald Press, 1955.

Robinet, Isabelle. *Taoism: Growth of a Religion*. Trans. Phyllis Brooks. Stanford, CA: Stanford University Press, 1997.

Rong Xinjiang 榮新江. "Guanyu Shazhou guiyijun dusengtong niandai de jige wenti" 關於沙州歸義軍都僧統年代的幾個問題 (Several problems concerning the dates of the General Controller of the Clergy [position] in the Shazhou Returning Commandery government). *Dunhuang yanjiu* 敦煌研究 no. 4 (1989): 15–67.

———. "Mthong-Khyab or Tongjia: A Tribe in the Sino-Tibetan Frontiers in the Seventh to Tenth Centuries." Trans. Wilhelm K. Müller. *Monumenta Serindia* no. 39 (1990–91): 247–99.

———. "Jinshanguo shi bianzheng" 金山國史辨正 (Analysis of the history of Jinshan kingdom). *Zhonghua wenshi luncong* 中華文史論叢 no. 50 (1992): 73–85.

———. "Shazhou guiyijunli renjiedushi chenghao yanjiu" 沙州歸義軍歷任節度史稱號研究 (Research on the titles of those who held the High Commissioner [post] during the Returning Commandery Government period in Shazhou). Revised text, *Dunhuangxue* 敦煌學 no. 19 (Oct. 1992): 15–67.

———. *Guiyijun shi yanjiu* 歸義軍史研究 (History of the Returning Commandery Government Period in Shazhou). Shanghai: Shanghai guji chubanshe, 1996.

———. "Dunhuang cangjingku de xingzhi jiqi fengbi yuanyin" 敦煌藏經窟的形制及其封閉原因 (The nature of the Dunhuang sūtra cave and the reasons for its sealing). *Dunhuang Tulufan yanjiu* 敦煌吐魯番研究 no. 2 (1996): 23–48.

———. "The historical importance of the Chinese fragments from Dunhuang in the British Library." *British Library Journal* 24, no. 1 (Spring 1998): 78–89.

———. "The Nature of the Dunhuang Library Cave and the Reasons for Its Sealing." *Cahiers d'Extrême-Asie* 11 (1999–2000): 247–75.

des Rotours, Robert. *Traite des fonctionnaires et Traite de l'armée, traduits de la nouvelle histoire des Tang*, 2 vol. Reprint, San Francisco: Chinese Materials Center, 1974.

Ruegg, David Seyfort. *Buddha Nature, Mind, and the Problem of Gradualism in a Comparative Perspective: On the Transmission and Reception of Buddhism in India and Tibet*. School of African and Oriental Studies. New Delhi: Heritage Publishers, 1992.

Schafer, Edward H. "Mineral Imagery in the Paradise Poems of Kuan Hsiu." *Asia Major* 10 (1963): 73–102.

———. *The Golden Peaches of Samarkand: A Study of Tang Exotics*. Berkeley: University of California Press, 1963.

———. "The Last Years of Ch'ang-an." *Oriens Extremus* 10, 2 (1963): 133–79.

———. "Notes on T'ang Culture." *Monumenta Serica* 21 (1962): 194–221; 24 (1965): 130–54.

Schneider, Richard. "Les copies de sūtra défectueuses dans les manuscrits de Touen-houang." In *De Dunhuang au Japon, études chinoises et bouddhiques offertes à Michel Soymié*, ed. Jean-Pierre Drège, 141–62. École Pratiques des Hautes Études, II, Hautes Études Orientales, 31. Geneva: Librairie Droz, 1996.

Schrift, Alan D., ed. *The Logic of the Gift: Toward an Ethic of Generosity*. New York: Routledge, 1997.

Séguy, Marie-Rose. "Images xylographique conservées dans les collections de Touen-houang de la Bibliothèque nationale." *Contributions aux études sur Touen-houang*, vol. 1, ed. Michel Soymié, 119–34. Hautes Études Orientales, vol. 10. Geneva: Librairie Droz, 1979.

SenGupta, Sankar, ed. *The Patas and the Patuas of Bengal*. Calcutta: Indian Publications, 1973.

Sharf, Robert. "The Treasure Store Treatise (Pao-Tsang lun) and the Sinification of Buddhism in Eighth-Century China." Ph.D. diss., University of Michigan, 1991.

Sheng, Angela. "Innovations in Textile Techniques on China's Northwest Frontier, 500–700." *Asia Major* 3rd series, 11, no. 2 (1998): 117–60.

Shaanxi lishi bowuguan 陝西歷史博物館 (Shaanxi History Museum), ed. *Tangmu bihua zhenpin xuancui* 唐墓壁畫珍品選粹 (Selected Masterpieces of Tang Dynasty Tomb Murals). [Xi'an]: Shaanxi renmin meishu chubanshe, 1991.

Shi Pingting 施萍亭. "Sanjie si, Daozhen, Dunhuang zangjing" 三界寺, 道真, 敦煌藏經 (Sanjie Monastery, the monk Daozhen and the Dunhuang Buddhist canon). *1990 nian Dunhuang xueshu taolunhui wenji* 1990 年敦煌學術討論會文集 (Proceedings of the 1990 Conference on Dunhuang Studies), 178–209. Shengyang: Dunhuang Research Academy, 1995.

Shi Weixiang 史葦湘. "Guanyu Dunhuang Mogaoku neirong zonglu" 關于敦煌莫

高窟內容總錄 (Complete record of the contents of the Mogao caves, Dunhuang). In *Dunhuang Mogaoku neirong zonglu* 敦煌文物研究所 (Complete Record of the Contents of the Mogao Caves, Dunhuang), comp. Dunhuang wenwu yanjiusuo 敦煌莫高窟內容總錄. Beijing: Wenwu chubanshe, 1982.

Shi Xingbang 石興邦, ed. *Famen si digong zhenbao* 法門寺地宮珍寶 (Precious Cultural Relics in the Crypt of Famen Temple). Xi'an: Shaanxi renmin meishu chubanshe, 1989.

Shih Shou-ch'ien [Shi Shouqian] 石守謙. *Fengge yu shibian* 風格與世變 (Style and Dynastic Change). *Zhongguo huihuashi lunji* 中國繪畫史論集 (Collected Essays on the History of Chinese Painting). *Meishu kaogu zongkan* 美術考古綜刊 4 (Compendium of Art and Archaeology). Taipei: Yunchen wenhua, 1996.

Shimada, Shujiro. "Concerning the I-p'in Style of Painting." Trans. James Cahill. *Oriental Art* I, n.s. 7, no. 2 (Summer 1961): 66–74; II, n.s. 8, no. 3 (Autumn 1962): 130–37; III, n.s. 10, no. 1 (Spring 1964): 19–26.

Silbergeld, Jerome. "Chinese Painting Studies in the West: A State-of-the-Field Article." *Journal of Asian Studies* 46, no. 4 (Nov. 1987): 849–97.

Somers, Robert. "Time, Space, and Structure in the Consolidation of the T'ang Dynasty (A.D. 617–700)." *Journal of Asian Studies* 45, no. 3 (Nov. 1986): 971–94.

Soothill, William, and L. Hodous, comps. *A Dictionary of Chinese Buddhist Terms.* Reprint, Kao Hsiung: Fo-kuang Publishers, 1991.

Soper, Alexander C. "Some Technical Terms in the Early Literature of Chinese Painting." *Harvard Journal of Asiatic Studies* 11 (1948): 163–73.

———. "A Northern Sung Descriptive Catalogue of Paintings (The Hua P'in of Li Ch'ih)." *Journal of American Oriental Society* 69 (1949): 8–33.

———. "Early Buddhist Attitudes Toward the Art of Painting." *Art Bulletin* 32 (1950): 147–51.

———. "Kuo Jo-Hsu's Experience in Painting (T'u-hua chien-wen chih): An Eleventh-Century History of Chinese Painting." Washington, D.C.: American Council on Learned Societies, 1951. Original texts included.

———. "*T'ang Ch'ao Ming Hua Lu*: Celebrated Painters of the T'ang Dynasty by Chu Ching-hsuan of T'ang." *Artibus Asiae* 21, 3/4 (1958): 204–30.

———. "The Relationship of Early Chinese Paintings to Its Own Past." In *Arts and Traditions: Uses of Past in Chinese Culture*, ed. Christian F. Murck, 21–47. Princeton, NJ: Princeton University Press, 1976.

Soymié, Michel. "Un recueil d'inscriptions sur peintures, le manuscrit P. 3304 verso." In *Nouvelles contributions aux études de Touen-houang*, vol. 17, ed. Michel Soymié, 169–204. Hautes Études Orientales, vol. 2. Geneva: Librairie Droz, 1981.

Spiro, Audrey. *Contemplating the Ancients: Aesthetic and Social Issues in Early Chinese Portraiture.* Berkeley: University of California Press, 1990.

Sponberg, Alan, ed. *Maitreya, The Future Buddha.* Cambridge, Eng.: Cambridge University Press, 1988.

State Hermitage Museum, ed. *Lost Empire of the Silk Road: Buddhist Art from KharaKhoto (X–XIIIth century).* Milan: Electa with Thyssen-Bornemisza Foundation, 1993.

Stein, Aurel. *Ancient Khotan: Detailed Report of Archeological Explorations in Chinese Turkestan*. Oxford: Clarendon Press, 1907.

———. *Ruins of the Desert Cathay*. London: Macmillan, 1912.

———. *Serindia*. 5 vols. London: Claredon Press, 1921.

———. *The Thousand Buddhas: Ancient Buddhist Paintings from the Cave-Temples of Tun-huang on the Western Frontier of China*. London: B. Quaritch, 1921.

———. *Innermost Asia: Detailed Report of Explorations in Central Asia*. 4 vols. Oxford: Clarendon Press, 1928.

Stein, R. A. "Sudden Illumination or Simultaneous Comprehension: Remarks on Chinese and Tibetan Terminology." In *Sudden and Gradual: Approaches to Enlightenment in Chinese Thought*, ed. Gregory, 41–66.

Steinhardt, Nancy Shatzman. *Chinese Imperial City Planning*. Honolulu: University of Hawaii Press, 1990.

Strassberg, Richard. "Buddhist Storytelling Texts from Tun-huang." *Chinoperl Papers* 8 (1978): 39–99.

Sturman, Peter C. *Mi Fu: Style and the Art of Calligraphy in Northern Song China*. New Haven, CT: Yale University Press, 1997.

———. "Wine and Cursive: The Limits of Individualism in Northern Sung China." In *Character and Content in Chinese Calligraphy*, ed. Cary Y. Liu, et al., 200–31. Conference proceedings, Princeton, NJ, Princeton University, 1999.

Su Bai 宿白. "Nan Song de diaoban yinshua" 南宋的雕版印刷 (Woodblock printing in the Southern Song). *Wenwu* 文物 no. 1 (1962): 1–18.

———. "Sui Tang Chang'an-cheng he Luoyang cheng" 隋唐長安城和洛陽城 (The cities of Luoyang and Chang'an during the Sui and Tang dynasties). *Kaogu* 考古 no. 6 (1978): 409–26.

———. "Tang Wudai shiqi diaoban yinshua shougongye de fazhan" 唐五代時期雕版印刷手工業的發展 (The development of the woodcarving and printing handicraft industries in the Tang and Five Dynasties period). *Wenwu* 文物 no. 5 (1981): 65–68.

Takakusu, Junjiro. "Tales of the Wise Man and the Fool, In Tibetan and Chinese." *Journal of the Royal Asiatic Society* (1901): 447–60.

Tan Chung, ed. *Dunhuang Through the Eyes of Duan Wenjie*. Indira Gandhi National Center for the Arts. New Delhi: Abhinav Publications, 1994.

Teiser, Stephen F. "Having Once Died and Returned to Life: Representations of Hell in Medieval China." *Harvard Journal of Asiatic Studies* 48, no. 2 (Dec. 1988): 433–64.

———. "The Growth of Purgatory." In *Religion and Society in T'ang and Sung China*, ed. Patricia Ebrey and Peter N. Gregory, 115–35. Honolulu: University of Hawaii Press, 1993.

———. *The Scripture on the Ten Kings and the Making of Purgatory in Medieval Chinese Buddhism*. Honolulu: University of Hawaii Press, 1994.

ter Molen, J. R., and E. Uitzinger, eds. *De Verboden Stad: Hofcultuur van de Chinese Keizers (1644–1911)* (The Forbidden City: Court Culture of the Chinese Emperors, 1644–1911). Rotterdam: Museum Boymans-van Beuningen, 1990.

Thangavelu, Kirtana. "The Painted Puranas of Telangana: A Study of a Scroll Painting Tradition in South India." Ph.D. diss., University of California, Berkeley, 1998.

Thurman, Robert A. *The Holy Teaching of Vimalakirti: A Mahayana Scripture.* University Park: Pennsylvania State University Press, 1976.

Todorov, Tzvetan. *The Fantastic: A Structural Approach to a Literary Genre.* Trans. Richard Howard. Cleveland: Case Western Reserve University Press, 1973.

Tonami, Mamoru. "Changes in the Bureaucratic System and the Aristocracy during the T'ang Period." Photocopy of paper presented at American Council of Learned Societies conference on the T'ang Studies, held at Cambridge, MA, 1969.

Trombert, Eric. "La vigne and le vin en Chine: Misères et succès d'une tradition allogène." *Journal asiatique* 289, no. 2 (2001): 285–327.

Tulufan bowuguan 吐魯番博物館 (Turfan Museum), ed. *Tulufan bowuguan* 吐魯番博物館 (Turfan Museum). Urumqi: Xinjiang meishu sheying chubanshe, 1992.

Twitchett, Denis. "The Government of T'ang in the Early Eighth Century." *Bulletin of the School of Oriental and African Studies* 18, no. 2 (1956): 322–30.

———. "Monastic Estates in T'ang China." *Asia Major* n.s. 5, no. 2 (1956): 123–46.

———. "Chinese Biographical Writing." In *Historians of China and Japan*, ed. W. G. Beasley and E. G. Pulleyblank, 95–115. Oxford: Oxford University Press, 1961.

———. *Land Tenure and the Social Order in T'ang and Sung China.* London: School of Oriental and African Studies, 1961.

———. "Provincial Autonomy and Central Finance in Late T'ang." *Asia Major* n.s. 11, no. 2 (1965): 211–23.

———, ed. "Chinese Social History from the Seventh to the Tenth Centuries: The Tunhuang Documents and Their Implications." *Past and Present* 35 (1966): 28–53.

———. *Financial Administration under the T'ang Dynasty.* 2nd ed. Cambridge, Eng.: Cambridge University Press, 1970.

———. "The Composition of the T'ang Ruling Class: New Evidence from Tunhuang." In *Perspectives on the Tang*, ed. Wright and Twitchett, 47–85.

———. "Varied Patterns of Provincial Autonomy in the T'ang Dynasty." In *Essays on T'ang Society: The Interplay of Social, Political, and Economic Forces*, ed. John Curtis Perry and Bardwell L. Smith, 90–109. Leiden: Brill, 1976.

———. *Printing and Publishing in Medieval China.* London: Wynken de Worde Society, 1981.

———. *The Writing of Official History Under the T'ang.* New York: Cambridge University Press, 1992.

Upton, Dell. *Architecture in the United States.* Oxford: Oxford University Press, 1998.

Upton, Dell, and John M. Vlach, eds. *Common Places: Readings in American Vernacular Architecture.* Athens: University of Georgia Press, 1986.

Vandier-Nicolas, Nicole. *Sariputra et les six maîtres d'erreur, facsimilé du manuscrit chinois 4524 de la Bibliothèque nationale.* Mission Pelliot en Asie Centrale, Série in-quarto. Paris: Imprimerie nationale, 1954.

———. *Art et sagesse en Chine: Mi Fu (1051–1107), Peintre et connnoisseur d'art dans la perspective de l'esthétique des lettrés.* Paris: Presses universitaires de France, 1963.

Vinograd, Richard. *Boundaries of the Self: Chinese Portraits, 1600–1900*. New York: Cambridge University Press, 1992.

Wang, C. H. *The Bell and the Drum: Shih Ching as Formulaic Poetry in an Oral Tradition*. Berkeley: University of California Press, 1974.

Wang, Eugene Y. "The Taming of the Shrew: Wang Hsi-chih (303–361) and Calligraphic Gentrification in the Seventh Century." In *Character and Content in Chinese Calligraphy*, ed. Cary Y. Liu, et al., 132–73. Conference proceedings, Princeton, NJ, Princeton University, 1999.

Wang Gungwu. *The Structure of Power in North China during the Five Dynasties*. Stanford, CA: Stanford University Press, 1963.

Wang Qingfan 王慶藩, ed. *Zhuangzi jishi* 莊子集釋 (Zhuangzi: Collected Expositions). Xinbian zhuzi jicheng 新編諸子集成 (Works of Collected Philosophers, Newly Edited). Vol. 3. Taipei: 世界書局 Shijie shuju, 1983.

Wang Renpo 王仁波, ed. *Sui Tang wenhua* 隋唐文化 (Sui and Tang Culture). Hong Kong: Zhonghua shuju, 1990.

Wang Zhongmin 王重民, et al. *Dunhuang bianwenji* 敦煌變文集 (Collection of Dunhuang Transformation Tale Literature). Beijing: Renmin wenxue chubanshe, 1957.

———. *Dunhuang yishu congmu suoyin* 敦煌遺書總目索引 (Index to Dunhuang Manuscripts). Beijing: Shangwu yinshuguan, 1962.

Warner, Langdon. *Buddhist Wall Paintings: A Study of a Ninth-Century Grotto at Wan Fo Hsia*. Cambridge, MA: Harvard University Press, 1938.

Watter, Thomas. *On Yuan Chwang's Travels in India, 629–645 A.D.* Oriental Translation Fund, n.s., vol. 15. London: Royal Asiatic Society, 1905.

Wechsler, Howard J. *Offerings of Jade and Silk: Ritual and Symbol in the Legitimation of the T'ang Dynasty*. New Haven, CT: Yale University Press, 1985.

Weidner, Marsha, ed. *Latter Days of the Law: Images of Chinese Buddhism, 850–1850*. Honolulu: University of Hawaii Press, 1994.

Weiner, Annette. *Inalienable Possessions: The Paradox of Keeping-While-Giving*. Berkeley: University of California Press, 1992.

Weinstein, Stanley. "Imperial Patronage in the Formation of T'ang Buddhism." In *Perspectives on the Tang*, ed. Wright and Twitchett, 265–306.

———. *Buddhism Under the T'ang*. Cambridge, Eng.: Cambridge University Press, 1987.

Wenwu bianjibu 文物編輯部, ed. *Wenwu wubaiqi zongmu suoyin* 文物500期總目索引 (Index to the Catalog for Five Hundred Issues of *Wenwu*). Beijing: Wenwu chubanshe, 1998.

Whitfield, Roderick. *Dunhuang: Caves of the Singing Sands. Buddhist Art from the Silk Road*. London: Textile and Art Publications, 1995.

———, ed. *The Arts of Central Asia: The Stein Collection in the British Museum*. 3 vols. Tokyo: Kodansha, 1982–85.

Whitfield, Roderick, and Anne Farrer. *Caves of The Thousand Buddhas*. London: Thames and Hudson, 1990.

Williams, Joanna. "Sarnath Gupta Steles of the Buddha's Life." *Ars Orientalis* 10 (1975): 171–92.

———. "From the Fifth to the Twentieth Century and Back." *College Art Journal* 49 (1990): 363–69.

Wilson, Thomas. A. *Genealogy of the Way: The Construction and Uses of the Confucian Tradition in Late Imperial China*. Stanford, CA: Stanford University Press, 1995.

Wong, Dorothy C. "A Reassessment of the 'Representation of Mt. Wutai' from Dunhuang—Cave 61." *Archives of Asian Art* 46 (1993): 27–52.

Wright, Arthur F., and Denis Twitchett, eds. *Confucian Personalities*. Palo Alto, CA: Stanford University Press, 1962.

———, eds. *Perspectives on the T'ang*. New Haven, CT: Yale University Press, 1973.

Wu Chengen [Wu Cheng'en]. *The Journey to the West*. Trans. Anthony C. Yu. Chicago: University of Chicago Press, 1977.

———. *Monkey (Journey to the West)*. Trans. Arthur Waley. Taipei: Huang-chia tu-shu Ltd., 1978.

Wu Hung. "Buddhist Elements in Early Chinese Art." *Artibus Asiae* 47, 3/4 (1986): 263–352.

———. *The Wu Liang Shrine: The Ideology of Early Chinese Pictorial Art*. Stanford, CA: Stanford University Press, 1989.

———. "What is *Bianxiang* 變相? On the Relationship Between Dunhuang Art and Dunhuang Literature." *Harvard Journal of Asiatic Studies* 52, no. 1 (Spring 1992): 111–92.

———. "The Transparent Stone: Inverted Vision and Binary Imagery in Medieval Chinese Art." *Representations* 46 (Spring 1994): 58–86.

———. *The Double Screen: Medium and Representation in Chinese Painting*. Chicago: University of Chicago Press, 1996.

Wu Hung, and Katherine T. Mino, eds. *Body and Face in Chinese Visual Culture*. Chicago: University of Chicago Press, forthcoming.

Wu, Lu-ch'iang, and Tenney L. Davis. "An Ancient Chinese Treatise on Alchemy." *ISIS, History of Science Society and International Committee of the History of Science* 18.2, no. 53 (1932): 210–89.

Xiang Da 向達, ed. *Tangdai Chang'an yu xiyu wenming* 唐代長安與西域文明 (Chang'an and Central Asian Civilization during the Tang Dynasty). Beijing: Xinhua, 1957.

———. "Tangdai sujiang kao" 唐代俗講考 (Research on Tang dynasty sūtra lectures [for the laity]). *Yanjing xuebao* 燕京學報 no. 16 (1934): 119–32; Reprint in *Tangdai Chang'an yu xiyu wenming*, ed. Xiang Da, 294–336.

———. "Chang'an xiyu renzhi huahua" 長安西域人之華化 (The thriving culture of Chang'an's Central Asian people.) In *Tangdai Chang'an yu xiyu wenming*, ed. Xiang Da, 96–100. 1957.

———. "Kaiyuan qianhou Chang'an zhi huhua" 開元前後長安之胡化 (Foreign culture in Chang'an around the time of the Kaiyuan period). In *Tangdai Chang'an yu xiyu wenming*, ed. Xiang Da, 41–55.

———. "Mogao Yulin er ku zakao" 莫高榆林二窟雜考 (Various studies on the Mogao and Yulin grottoes). In *Tangdai Chang'an yu xiyu wenming*, ed. Xiang Da, 393–415.

Xinjiang Weiwuer zizhiqu bowuguan 新疆維吾爾自治區博物館編 (Xinjiang Uighur Autonomous Regional Museum), ed. *Xinjiang chutu wenwu* 新疆出土文物 (Excavated Cultural Artifacts from Xinjiang). Beijing: Wenwu chubanshe, 1975.

———. *Xinjiang Weiwuer zizhiqu Bowuguan* 新疆維吾爾自治區博物館 (Xinjiang Autonomous Regional Museum). *Zhongguo bowuguan congshu* 中國博物館叢書 (Compendium of Chinese Museums), vol. 9. Beijing: Wenwu chubanshe, 1991.

Xu Bangda 徐邦達. "Cong bihua fuben xiaoyang shuodao liangjuan songhua—Chaoyuan xianzhang tu" 從壁畫副本小樣說到兩卷宋畫—'朝元仙仗圖' (Charting [the development] of supplementary miniature copies [of wall paintings] to two Song dynasty scrolls—*The Star Gods Procession*). *Wenwu* 文物 no. 2 (1956): 56–57.

Yamabe, Nobuyoshi. "On the Mural Paintings of Visualizing Monks in Toyok Caves: In Conjunction with the Origin of Some Apocryphal Visualization Texts." In *The Third Silk Road Conference at Yale University*, 452–529. Conference Proceedings, II. July 10–12, 1998.

Yamamoto Tatsuro, Ikeda On, and Okano Makoto, eds. *Tun-huang and Turfan Documents Concerning Social and Economic History*, 6 tômes (3 volumes, parts 1 and 2). Committee for the Study of Tun-huang Manuscripts. Tokyo: Toyo Bunko, 1980.

Yampolsky, Phillip, trans. *The Platform Sūtra of the Sixth Patriarch*. New York: Columbia University Press, 1967.

Yan Wenru 閻文儒. "Tulufan de Gaochang gucheng" 吐魯番的高昌古城 (The ancient city of Gaochang at Turfan). *Wenwu* 文物 no. 7–8 (1962). Reprinted in *Xinjiang kaogu sanshinian* 新疆考古三十年, ed. Xinjiang shehui kexueyuan kaogu yanjiu suo 新疆社會科學院考古研究所 (Archaeological Research Institute of the Xinjiang Academy of Social Sciences), 136–41. Urumqi: Xinjiang renmin chubanshe, 1983.

Yanagida Seizan. "The Li-Tai Fa-Pao Chi and the Ch'an Doctrine of Sudden Awakening." Trans. Carl Bielefeldt. In *Early Ch'an in China and Tibet*, ed. Lai and Lancaster, 13–49.

———. "The 'Recorded Sayings' Texts of Chinese Ch'an Buddhism." Trans. John R. McRae. In *Early Ch'an in China and Tibet*, ed. Lai and Lancaster, 185–205.

Yonezawa Yoshio 米澤嘉圃. "Tōchō ni okeru gain no genryū" 唐朝に於ける畫院の源流 (The origin of the Huayuan [Art Academy] in Tang dynasty China). *Kokka* 國華 554 (1937): 3–9.

———. "Hakubyō ga kara suiboga e no tenkai" 白描畫から水墨畫への展開 (Development of ink drawing to ink painting). *Suiboku bijutsu taikei* 水墨美術大系 (Series on the Art of Ink Painting), vol. 1: 127–32. Tokyo: Kodansha, 1975.

Yu Jianhua 俞劍華, ed. *Zhongguo hualun leibian* 中國畫論類編 (Chinese Painting Theory by Categories). 2 vols. Beijing: Renmin meishu chubanshe, 1957.

Yu Jianhua 俞劍華, and Luo Shuzi 羅叔子, et al., eds. *Gu Kaizhi yanjiu ziliao* 顧愷

之研究資料 (Research Materials on Gu Kaizhi). Beijing: Renmin meishu chuban-she, 1962.

Zeng Yigong 曾毅公. "Beijing shike zhong suo baocun de zhengyao shiliao" 北京石刻中所保存的重要史料 (Important historical material in extant Beijing stone inscriptions). *Wenwu* 文物 no. 9 (1959): 16–20.

Zhang Daoyi. *The Art of Chinese Papercuts*. Beijing: Foreign Languages Press, 1989.

Zhang Qun 章群. *Tangdai bojiang yanjiu* 唐代蕃將研究 (Research on the Foreign Generals of the Tang Dynasty). Taipei: Lianjing chubanshe, 1986.

Zhang Zexian 張澤咸. *Tangdai gongshangye* 唐代工商業 (The Arts Industries of the Tang Dynasty). Beijing: Zhongguo shehui kexue chubanshe, 1995.

Zhao Pu 趙樸. *Fangshan shijing tiji huibian* 房山石經題記匯編 (Edited Collection of the Stone Sūtra Colophons at Fangshan). Beijing: Shumu wenxian chubanshe, 1987.

Zheng Binglin 鄭炳林. *Dunhuang beimingzan jishi* 敦煌碑銘贊輯釋 (A Collection of Inscriptions, Epitaphs, and Eulogies from the Dunhuang Manuscripts). Lanzhou: Gansu jiaoyu chubanshe, 1992.

———. *Dunhuang Guiyijun shi chuanti yanjiu* 敦煌歸義軍史專題研究 (Studies in the Returning Commandery Government of Dunhuang). Lanzhou: Lanzhou da-xue chubanshe, 1997

Zhongguo bihua quanji bianji weiyuanhui 中國壁畫全集編輯委員會 (Editorial Committee of the Complete Collection of Chinese Wall Painting), eds. *Zhongguo Xinjiang bihua quanji* 中國新疆壁畫全集 (Complete Collection of Chinese Xin-jiang Wall Painting), vol. 6. Liaoning: Liaoning chubanshe, 1995.

Zhongguo gudai shuhua jianding zubian 中國古代書畫鑑定組編 (Editorial Group of the Connoisseurship of Ancient Chinese Painting and Calligraphy), ed. *Zhong-guo gudai shuhua mulu* 中國古代書畫目錄 (Catalog of Ancient Chinese Paint-ing and Calligraphy), vol. 2. Beijing: Wenwu chubanshe, 1985.

Zhongguo meishu quanji 中國美術全集 (Complete Collection of the Arts of China), *Huihua bian* 繪畫編 (Painting), vol. 12, *Mushi bihua* 墓室壁畫 (Tomb Murals). Beijing: Wenwu chubanshe, 1989.

Zhongguo meishu quanji 中國美術全集 (Complete Collection of the Arts of China), *Huihua bian* 繪畫編 (Painting), vol. 14–15, *Dunhuang bihua xia* 敦煌壁畫下 (Dunhuang Wall Painting, part 2). Shanghai: Shanghai renmin meishu chubanshe, 1993.

Zhou Yiliang 周一良 and Zhao Heping 趙和平. *Tang Wudai shuyi yanjiu* 唐五代書儀研究 (Research on the Collectanea of the Tang and Five Dynasties). Beijing: Zhongguo shehui kexue chubanshe, 1995.

Zhu Lei 朱雷. "Lun Qushi Gaochang shiqi de 'zuoren'" 論麴氏高昌時期的'作人' (A discussion of laborers in the Qu family period of Gaochang). In *Dunhuang Tulufan wenshu chutan* 敦煌吐魯番文書初探 (Early Investigations of Dunhuang and Turfan Documents), vol. 1, ed. Tang Changru 唐長孺, 32–65. Wuchang: Wuhan daxue chubanshe, 1990.

Zito, Angela, and Tani E. Barlow, eds. *Body, Subject, and Power in China*. Chicago: University of Chicago Press, 1994.

Character List

□ = Character is either damaged or not yet identified.

Bai Ban □ 白般 □
baihua 白話
baimiao 白描
Baotang 保唐
bianxiang 變相
bishou 筆受
boshi 博士

Cantong qi 參同契
Cao Yangong 曹延恭
Cao Yanlu 曹延祿
Cao Yijin 曹議金
Cao Yuanzhong 曹元忠
Cao Zhongda 曹仲達
chanzong 禪宗
chaoshu 抄書
Chaoyuan xianzhang tu 朝元仙仗圖
chixin 痴心
chou 醜

Daci dabei qiuku guanshiyin pusa
　大慈大悲救苦觀世音菩薩
Dangchuan 宕泉
Daozhen 道真
Daxiang si 大像寺
Dayan si 大雁寺
Dayun si 大雲寺
Dharmatrāta (Ch. Damaduoluo) 達摩
　多羅
diaoban yaya 雕版押衙
diben 底本
dihuang 地黃

diqing 地青
diwuse 地五色
Dong Baode 董保德
Dongtian qinglu 洞天清錄
dou 斗
duhuajiang zuo 都畫匠作 Chief
　Artisan of the Painting Workshop
duliao (shi) 都料 (使) Chief of
　Materials or Head Designer
duliaoshi 都料使 Guild head
Dunhuang 燉(敦)煌
dunwu 頓悟
dusengtong 都僧統

falü 法律
Fan Changshou 范長壽
fang 坊
Fashu yaolu 法書要錄
Fei caoshu 非草書
feidong 飛動
fenben 粉本
Foguang si, Wutaishan 佛光寺，五台山
fuben xiaoyang 副本小樣
fugu 復古
Fu Zai 符載
Fuxi 伏羲

Ganghui 鋼慧
ganying 感應
Gaochang 高昌
gongjiang 功匠
gou 勾

[Gu] huapin [lu] 古畫品錄
Gu Jianlong 顧見龍
Gu Kaizhi 顧愷之
Guanyin 觀音
Guanyin zi 關尹子
Guazhou 瓜州
guiyijun jiedu 歸義軍節度
guiyijun jiedushi 歸義軍節度史
Guo Ruoxu 郭若虛
Guo Xi 郭熙
Guo Xiang 郭象

Han Yu 韓愈
haojiu 好酒
Heicheng 黑城
Hexi 河西
Hōryuji 法隆寺
Houshu pin 後書品
huagao 畫稿
huahang 畫行 painting guild
huahang duliao painting guild materials
 manager 畫行都料
Hua-Hu 華胡
huajiang 畫匠 painter
huajiang dizi 畫匠弟子
Huang Xiufu 黃休復
huaren 畫人
huasheng 畫生
huashi 畫師
huayuan duliao painting bureau
 (academy) materials manager
 畫院都料
huayuan shi 畫院使
Huijue 慧覺
hun 混
huopo podi 活潑潑地

jiajiang 甲匠 armor artisan
jiang 將
jiang 匠

jiangjingwen 講經文
Jiangjun Peimin 將軍裴旻
jiangren 匠人
Jianjiao taizi binke 檢校太子賓客
jianxiu 漸修
Jiaohe 交河
jiedu shi 節度使
jiedu yaya 節度押牙[衙]
jiedu yaya □ zuoxiang 節度押衙□左廂
jilu jianda 機錄間答
Jin Hao 荊浩
Jingang jing 金剛經
jingbian 經變
jingsheng 經生
Jingtu si 淨土寺
Jinguangming zuishengwang jing 金光
 明最勝王經
jintang 金堂
jinyin gong 金銀工
Jiuquan 酒泉
jishu yuan 知[伎]術院 Rites (Skills)
 Academy
jishu yuan 知[1][技]術院
juntian 均田
juxi 局席

ke 鏍

Lei Yanmei 雷延美
Li Cheng 李成
Li Gonglin 李公麟
Li Quan 李筌
Li Sixun 李思訓
Li Sizhen 李嗣真
Liangzhou 涼州
Liezi 列子
linmo 臨摹
lisheng 禮生
Liu Daoshun 劉道醇
louzi 樓子

[1] This variant character is written in the Dunhuang text; the character to which it
corresponds in standard tenth century Chinese, is indicated in the brackets. The Dun-
huang documents are riddled with local variations.

Lu Tanwei 陸探微
lüluo 驢騾

ma yunqing 馬云卿
Meihua xiesheng pu 梅花寫生譜
Meng 孟
mi 密
Mi Fu 米芾
mijiu 米酒
mingwang 明王
minjian fang 民間坊
mo 摸
mofa 末法
Mogao 莫高
Moheyan 摩訶衍

neiguan 內觀
neijiao boshi 內教博士
nijiang boshi 泥匠博士
Nüwa 女娃

panguan (判官)
Pei Xiaoyuan 裴孝源
pingchang xin shi dao 平常心是道
pomo 潑墨

qianfo 千佛
qiao 巧
Qiao Zhongchang 喬仲常
qiyun shengdong, shiye 氣韻生動,
 是也。
qu 屈

renmo dezhi 人莫得知
ruowei 若為
ruzuoren 入作人

Sanjie si 三界寺
Sanwei shan 三危山
shangxia ku 上下窟
Shanhui 善慧
Shanshui chunquan ji 山水純全集
Shazhou 沙州
Shazhou dugongjiang 沙州都工匠

sheng 勝
Shenhui 神會
shenjia tianzhao 神假天造
shenpinshang yiren 神品上一人
shenzhu 神助
shi 時
shi 施
shi/shuo 碩
Shijing 詩經
shougong 手工
shudian 書顛
shushou 書手
sihua 死畫
su or shu 疏
Su Shi 蘇軾
Suo Xun 索勳
suzhai 素齋

Taishi 太師
Tang Hou 湯垕
tanxian 彈線
Tian Tongxiu 田同秀
tiedun 貼頓
Tōdaiji 東大寺
tuantou 團頭
Tuhua jianwen zhi 圖書見聞志
Tuyugou 吐峪溝

waidao 外道
Wang Zhenpeng 王振鵬
Wei furen bizhentu 衛夫人筆陣圖
Weitixi 韋提希
wojiu 臥酒
Wu Baolin 武保琳
Wu Daozi 吳道子
Wu Zitian 武則天
Wu Zongyuan 武宗元
wuxing 五行
Wuzhu 無住
Wuzong 武宗

xia/jia 假
Xia Wenyan 夏文彥

xiangta 響榻
Xie He 謝赫
xiejingsheng 寫經生
Xiku si 西窟寺
xiuhua 朽畫
Xixia 西夏
Xiyou ji 西游記
xuanxue 玄學
Xuda qi qingshe 須達起精舍

Yan Liben 閻立本
yaya 押牙[衙]
yicun bixian 意存筆先
Yinfu jing 陰符經
yingling bu qiong 英靈不窮
yinqingguanglu dafu 銀青光錄大夫
yinghuang 硬黃
yipin 逸品
youjiang 油匠
Yu Chibao 鬱遲寶
yuan 院
Yuanrong 願榮
yuansheng 院生
Yulanpen hui 孟蘭盆會

zaohua 造化
zhaijie 齋戒
zhanbi 顫筆

Zhang Chengfeng 張承奉
Zhang Fang 張昉
Zhang Huaishen 張淮深
Zhang Rutong 張儒通
Zhang Sengyou 張僧繇
Zhang Xu 張旭
Zhang Yichao 張議潮
Zhang Zao 張璪
Zhao Anding 趙安定
Zhao Xigu 趙希鵠
Zhao Yi 趙壹
Zhenguan gongsi hualu 貞觀公私畫錄
zhenhua 真畫
zhi huashou 知(＝技)畫手
zhou 拙
Zhou Fang 周昉
Zhou Jichang 周季常
Zhou Wenju 周文矩
Zhu Bao 竺保
Zhuang Zhou 莊周
Zhuangzi 莊子
zhugongjiang 諸工匠
Zhulin qixian 竹林七賢
ziran 自然
ziranzhi 自然知
zuo 作
zuoren 作人

General Index

accounts: household register (Turfan), 31, 32, 260n29; Jingtu si monastery account books, 15, 20, 25(fig.), 42–43

Acker, William, 11, 202

acrobats, 166, 182, 183

aesthetic theory: Daoist influences on, 206–10, 291–92n30, 292–93nn36,37; Zen Buddhist influences on, 218–25; *Zhuangzi* Daoist models, 212–18, 227, 293n47, 295n62

Akiyama Terukazu, 164–65, 191, 279n21,23, 284n80, 286–87n109

alchemy. *See* occult practices

alcohol, 217–18, 295n65

Alexander, Jonathan, 287n112

altar diagram, 154–55, 156(fig.)

Amitābha's Paradise, 55–68, 263n8, 265nn28,29; cartouches for, 192; as common theme, 54, 246(tab.); detail of dancer, 57(fig.), 58, 108(pl.2), 262n6; iconography, 89; numbered scenes in, 58–62, 66; preliminary sketches for, 56–57(figs.), 58; Visualizations of Queen Vaidehī, 59(fig.), 60, 61(fig.), 121

architecture: as cave prototypes, 90–100, 102, 108pl.11, 269n59; and symmetry, 184–85, 285n95

art: class-bound values of, 12, 15, 127, 193, 199, 213, 215–18, 220, 221, 288n3; contemporary narratives on, 9–10, 16–17, 198–202, 210–11, 227–29, 288nn2,3, 289n12, 290n23; court art, 88–90; visual comprehension of, 70–71. *See also* painting theory; performativity of art

artisans: and the government, 30–34; hierarchy of, 23, 31, 34–36; idealization of, 213, 215–18, 294n54; as patrons, 16, 22–23; payments to, 15–16, 20, 22, 28, 37–38, 42–47; portrayals of, 215–17; as professionals, 9, 17, 35, 258n5; skills, 51, 262n2; status, 27–28, 41, 50, 259–60n21; supervision of, 36; and temple system, 15–16, 22, 41, 42, 45, 46, 189–96, 287n112

ateliers: clientele, 48; evidence of, 2, 8, 23–24, 32, 54, 62, 107–8, 150; draft sketches used in, 113; labor specialization in, 77, 192, 229; for silk banner production, 132

audience, recognition of, 185–86, 190, 286nn101,103

Avalokiteśvara, 59(fig.), 140(fig.), 144(fig.), 156(pl.19), 171; and Queen Vaidehī, 59–62, 121, 263n10; sketches and paintings compared, 137–44. *See also* Amitābha's Paradise

baimiao (fine-line drawing), 6–7, 117, 119, 127, 129, 130, 272n12, 274n36

Bakhtin, M.M., 12

Baltit fort, Pakistan, xix(map), 95–96, 97(fig.), 108(pl.12)

Bāmiyān, Afghanistan, xix(map), 95, 97(fig.), 98

banners. *See* silk banners

banquets, 44–45, 46

Baotang school of Buddhism, 219–20

bells, uses of, 184–85, 285nn96,99

bian (transformation), 176, 282–83n66

bianwen literature (transformation tales): authorship of, 191, 287n118; as folk narratives, 168, 280nn36,37; Magic Competition as, 160–66, 175–76, 185, 189, 277n1, 282n65, 283nn71,74; wall paintings compared to, 179–80, 189–96, 284–85nn83,90, 286–87nn109,110

bipolarity as painting theme, 170–72, 185, 220–21, 286n100

bodhisattvas: drawings and paintings compared, 27, 29(fig.), 135–49, 274n37, 275nn5,9; examples of, 29(fig.), 108(pl. 19), 136(fig.), 138(fig.), 139(fig.), 140–41(figs.), 144(fig.), 146(fig.), 157(fig.), 156(pls.20a-b)

boshi, duties of, 35, 261n42

brush techniques: agency in, 206–12, 291n29; "awkward" brush work, 126–28; fine-line drawing (*baimiao*), 6–7, 117, 119, 127, 129, 130, 272n12, 274n36; overdrawing, 2, 114, 129, 270n73, 272n13; realism in, 219, 221, 227–29; *su* and *mi* styles of, 200–201, 220, 221; *zhanbi* (tremulous hand), 59, 263n9. *See also* freehand drawing; underdrawing

Index of Paintings and Manuscripts Cited